GREAT AMERICAN CITIES PAST AND PRESENT

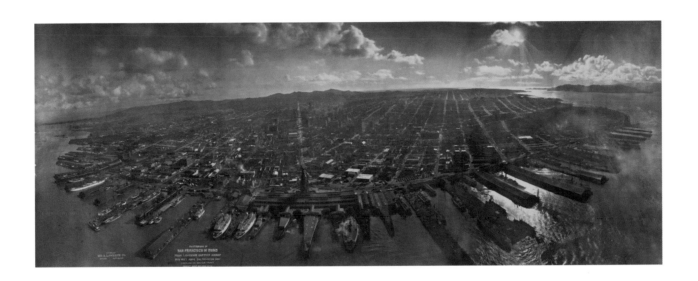

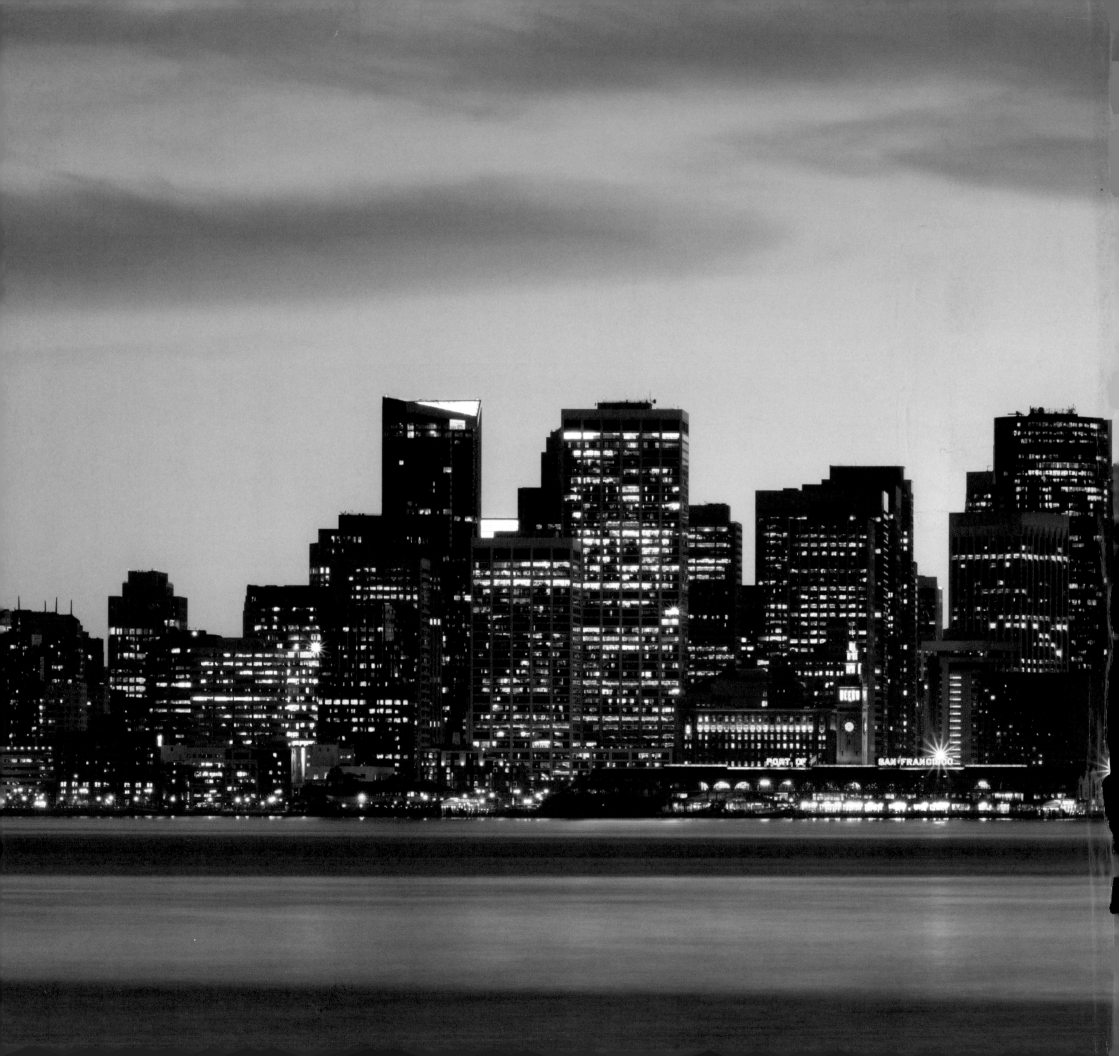

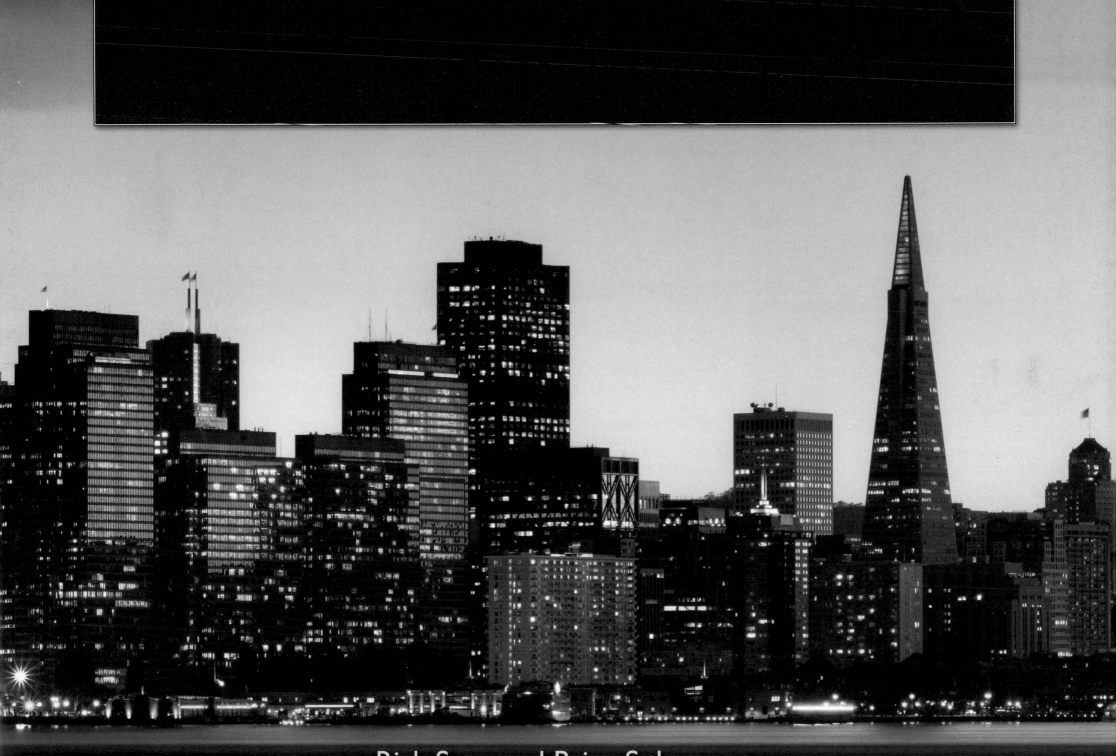

GREAT AMERICAN CITIES PAST AND PRESENT

Rick Sapp and Brian Solomon

FIREFLY BOOKS

A FIREFLY BOOK

Published by Firefly Books Ltd. 2010
Copyright © 2010 Compendium Publishing

First printing

Publisher Cataloging-in-Publication Data (U.S.)
Sapp, Rick.
 Great American cities past and present / Rick Sapp and Brian Solomon.
[256] p. : ill., photos. ; cm.
Includes index.
Summary: Past and present photographs exemplify the changes to the urban landscape over the last century. Each image is reproduced as a rough drawing with an identification key into the text.
ISBN-13: 978-1-55407-745-8
ISBN-10: 1-55407-745-1
1. Cities and towns--Pictorial works. I. Solomon, Brian. II. Title.
301.3 dc22 N8217.C35S277 2010

Library and Archives Canada Cataloguing in Publication
Sapp, Rick
 Great American cities past and present / Rick Sapp and Brian Solomon.
Includes idex.
ISBN-13: 978-1-55407-745-8
ISBN-10: 1-55407-745-1
1. Cities and towns--United States--Pictorial works.
2. Cities and towns--United States--History--Pictorial works.
I. Solomon, Brian, 1966- II. Title.
HT123.S26 2010 307.760973'022
C2010-901962-8

Published in the United States by
Firefly Books (U.S.) Inc.
P.O. Box 1338, Ellicott Station
Buffalo, New York 14205

Published in Canada by
Firefly Books Ltd.
66 Leek Crescent
Richmond Hill, Ontario L4B 1H1

Printed in China

Acknowledgments
The authors should like to thank Sandra Forty for photo research and help with captioning.

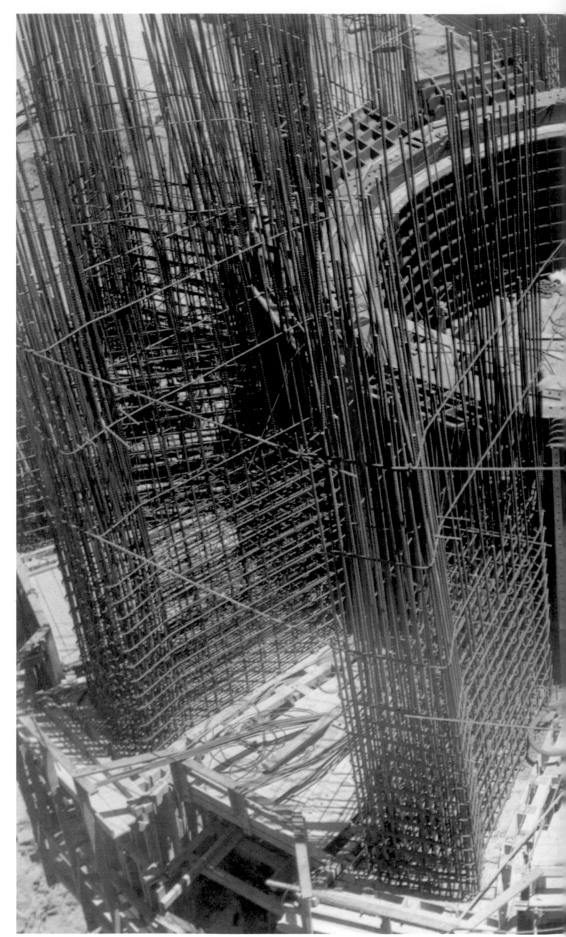

PAGE 1: *San Francisco after the earthquake, 1906. This striking image of San Francisco in ruins was taken by George Lawrence using a camera suspended from kites 2,000 feet above San Francisco. It shows the devastation caused by the earthquake and its resulting fire.*

PAGE 2–3: *The same waterfront today: a glorious testament to human endeavor.*

RIGHT: *Reinforced concrete—here being used on the Hoover Dam—has been a significant factor in the changing face of American cities. As the original caption says: "Massive steel bar columns rise in the construction of Boulder Dam. There is as much steel in the dam as is in the Empire State Building and enough concrete to lay a highway from California to Florida."*

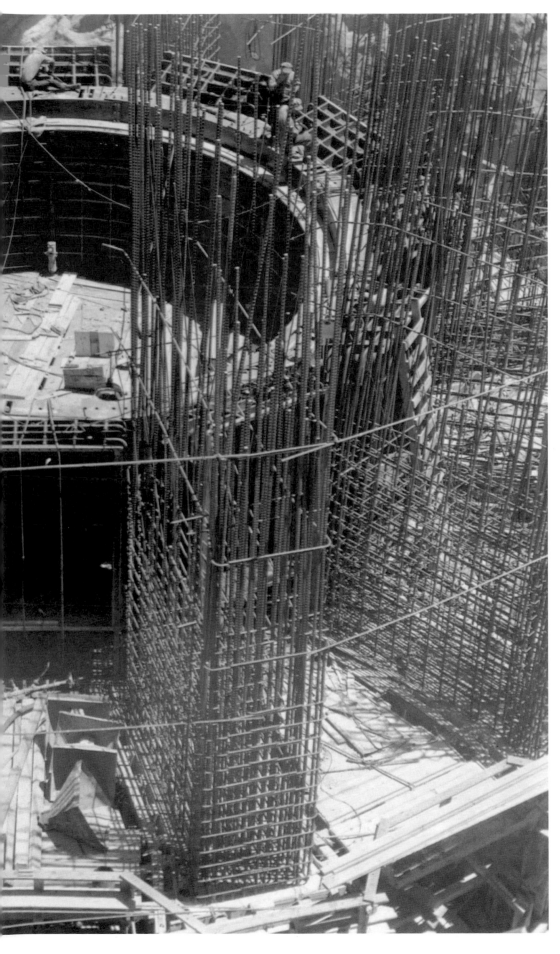

Contents

Introduction

"Things fall apart," wrote Irish poet William Butler Yeats, "the centre cannot hold." Born in Dublin, Yeats knew a thing or two about cities.

Indeed, bricks crumble. Walls fail. Even the walls of "great Uruk" before Sumeria was born. "Strong-walled Uruk," Gilgamesh said. In its time, six thousand years ago, it was the greatest city in the world. Today, it is a desert mound; rubble, little more than sand.

Although cities fail—are bound to fail—they are also bound to be rebuilt, because people are attracted to cities, are drawn to build them, as if it is genetic code. Uruk declined but Babylon grew in its place.

An urban place becomes, in the words of Carl Sandburg who described his admired Chicago as, "Player with Railroads and Freight Handler to the Nation." And if Sandburg's exact reference is ambiguous it is because cities and the individuals, the tribes who inhabit them, become one and the same; separately identifiable yet impossible without one another. The professional football team that draws 70,000 screaming fans to each home game is not just the Packers—it is the Green Bay Packers.

The city—Uruk or Urbana—is in consequence, greater than the sum of its parts.

If civilization is to endure, cities must endure, must thrive. Thus, man becomes the city-maker. Cities are the high art of human society. They are the great things, the

There are many reasons why American cities have had to be rebuilt—from war to investment, typhoon to volcano. The photographs in the Introduction illustrate some of these events.

BELOW: *In Ruins—August 1814: The ruins of the U.S. Capitol building following British attempts to burn it during the War of 1812. Except for the Patent Office, all of the public buildings in Washington were torched. Reconstruction began almost immediately and was completed by 1819. Additional construction in one form or another continued through to 1864, with the addition of the center rotunda and the first dome. Most recently a visitor center was added. Like the cities it represents, the U.S. Capitol building continues to evolve.*

RIGHT: *War is Hell—April 1865: For nearly four years, Richmond, Virginia, served as the capital of the Confederate States of America. As the Civil War ground toward its inevitable end, with federal troops closing in from all directions, Confederate President Jefferson Davis' government fled. Retreating Confederate soldiers were ordered to set fire to bridges, to the armory and to supply warehouses. In the largely abandoned city, the fires spread out of control. Large parts of the city were destroyed. The flames were not extinguished until a Richmond delegation surrendered the city.*

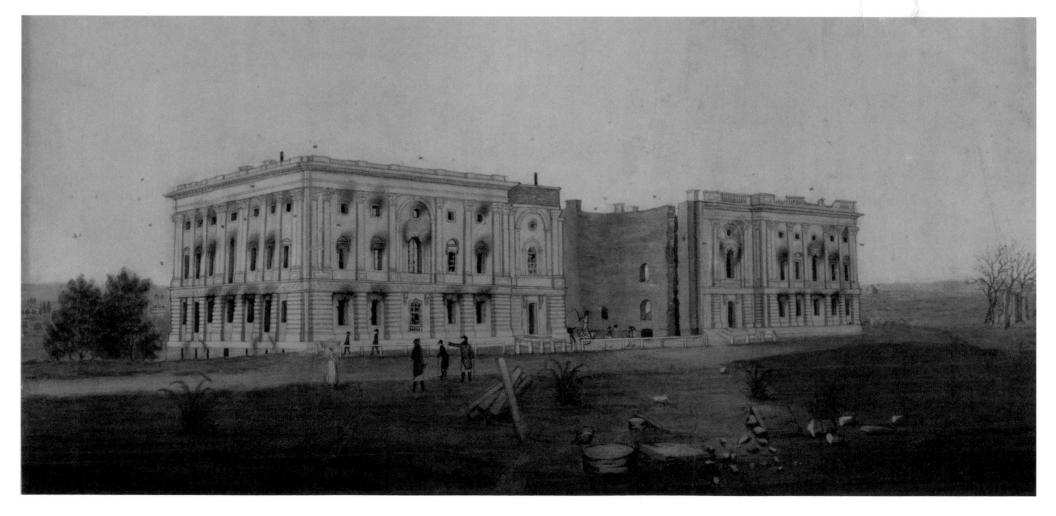

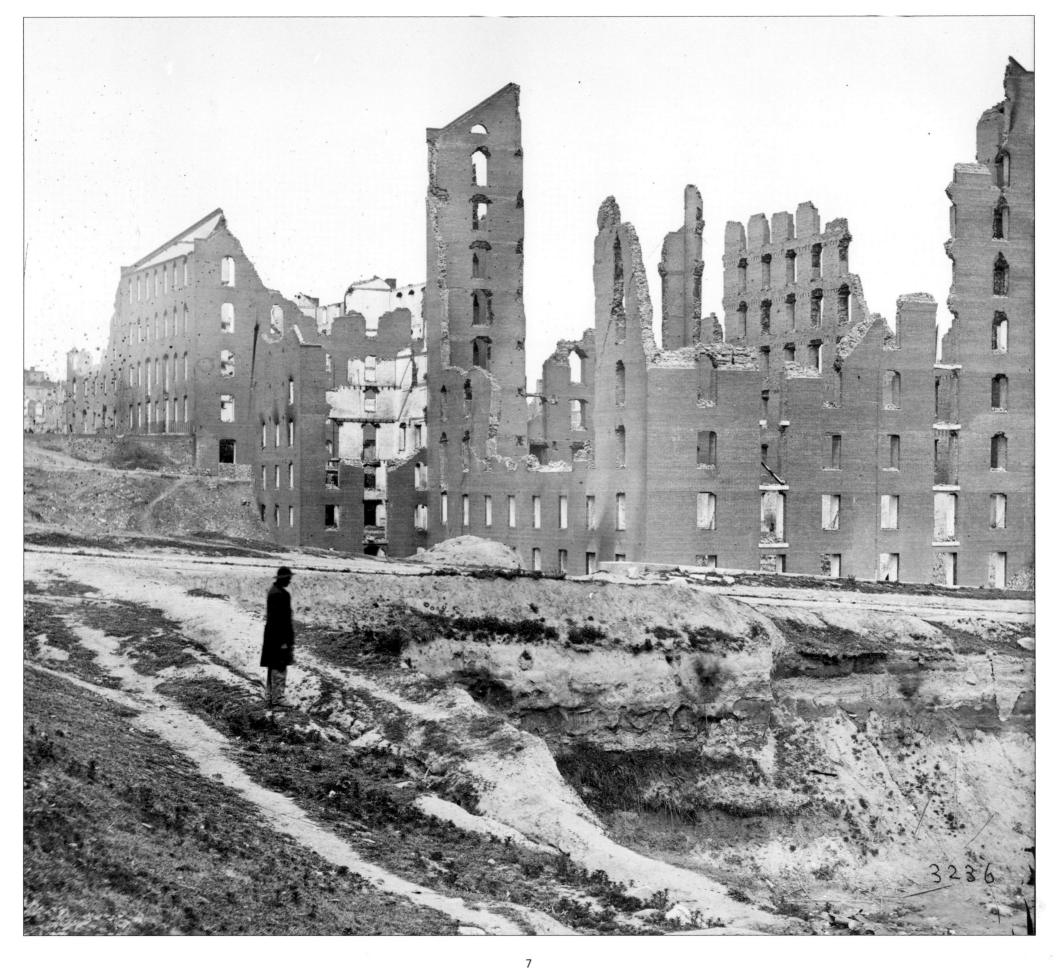

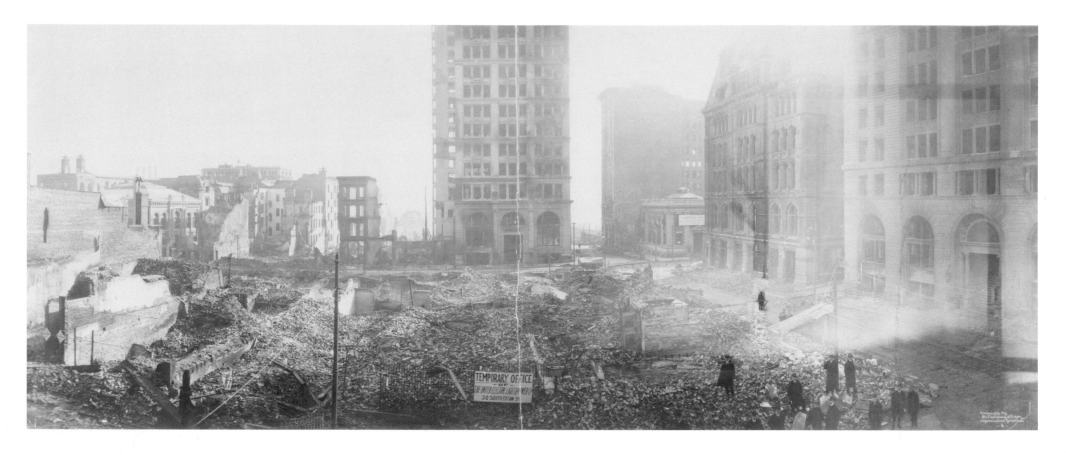

wild things, the jaw-dropping wonders about which all men and women dream. A thousand years ago people dreamed of Cahokia, the six-square-mile city of the Mound Builder civilization, the ruins of which lie across the Mississippi River from modern St. Louis. In its time it was the greatest city in North America.

The metropolis is the shining city on a hill imagined by Jesus, preached by the Puritan John Winthrop, and recalled by American presidents John F. Kennedy and Ronald Reagan. The vast towers of commerce; the parks plush with fountains and playing children; markets filled with produce; the smoke-filled back rooms where political fortunes are brokered; the financial canyons where empires are sometimes built and often crushed.

It is our cities that define us as peoples. Our capitols display our wealth and our sense of power and beauty. Our boulevards and temples, our ornamentation, become shrines to the gods. Our vision of eternal life is a city whose streets are paved in gold.

Eventually, Yeats says, the center collapses… but it inevitably reemerges, a phoenix rising from the ashes. Gilgamesh, the powerful and wise king of Uruk, would feel at home in New York City. He would understand the New Orleans French Quarter; would roll up his sleeves in Chicago; let his hair down in Las Vegas and dominate the Washington, D.C., press conference. For he was a man of a city and though men die and cities die, they are reborn, and again and again. The individual dies, is sacrificed so that the culture, the civilization the city may endure.

A city is, in a sense, a living organism. Its streets and subways pulse with life. It is alive with the cycles of day and night, summer and winter, going to and returning. Educational rhythms; spiritual rhythms; ceremonial rhythms. And always, in the background, the hum of the marketplace, of men and women building, tearing down and renewing.

Occasional cities are designed from the ground up. Others simply coalesce, attracted by some feature or another—a good harbor or a river crossing, for example. Savannah was a planned city. James Oglethorpe himself designed the grid of perpendicular streets and open spaces. Situated on the arid floor of a desert, Las

Vegas grew from a customary site used as a stopover for wagon trains trundling on toward the Promised Land. The ill-fated Jamestown, Virginia, on the other hand may only have "looked good" to the English sailors and the excited, but inexperienced settlers, who were more interested in a strong defensive position than a site at which

ABOVE: *Baltimore Burning—February 7–8, 1904: Horses that pulled fire engines shivered in the cold. Suddenly, an alarm at the John E. Hurst & Company building broke Sunday morning's routine. As firefighters entered the building an explosion blew the roof off. Burning embers flew through the neighborhood. The fire grew frighteningly out of control. Within hours the fire chief requested aid from nearby Washington, but there were more than 600 sizes and variations of fire hose couplings in the U.S. and their equipment was not compatible. The chief attempted to dynamite buildings to halt the fire, but the buildings would not fall and, pushed by a strong northwest wind, blasts spread sparks eastward. On Monday, fire engines arrived from Philadelphia and Wilmington, from York, Chester, Harrisburg, Altoona, and New York City. Firemen fought without success to save Baltimore's wharves. By Monday afternoon the fire was contained, but an estimated 140 acres of the city including 1,500 buildings had been destroyed.*

RIGHT: *The Great Chicago Fire—October 8–10, 1871: Perhaps Patrick and Catherine O'Leary's cow did kick the lantern that set the straw ablaze that ignited the barn that destroyed the city. The summer had been dry and on that Sunday evening, at about 9:00 p.m. a fire did start in that vicinity. At first, it was nothing special. Chicago averaged two fires a day and the preceding week firemen had dealt with at least twenty. This one was different. By midnight it had leapt the Chicago River. Guards and prisoners ran for their lives as the Courthouse jail collapsed. Streets, bridges, sidewalks—all built of wood—burned. Sparks spread by a steady wind flew progressively northward. Ships at anchor in the river and finally the greasy river itself caught fire. The fire might have raged forever had not a saving rain come on Tuesday morning. The National Guard was called to preserve order. Michael Ahern, the local reporter who created the cow story, admitted in 1893 that he had made it up. Four square miles of the city were destroyed along with 200 to 300 lives.*

they could build and thrive. And so a city grows, sometimes from a single log cabin, as is the case with Athens, Georgia, and Nashville, Tennessee. Detroit began as a fur-trading post. Omaha began at a picnic.

The reasons for a city's founding are as varied as the cities themselves. Religious fervor resulted in St. Augustine and St. Louis, Salt Lake City and San Antonio and Providence. Revenge motivated the settling of Asheville, North Carolina. Political compromise in an era when travel was difficult and dangerous situated Columbia, South Carolina and Tallahassee, Florida. Even the nation's capital, Washington, in the District of Columbia, was built from disagreement and compromise, and established on the banks of the Potomac River where its original ten-mile square was surveyed and platted long before serious construction began. The sturdy city of Bangor, Maine, was perhaps established following a sailor's lie and named in a minister's mistake.

Commercial transportation is the principal reason for building a city, though: the protection of a trade route (Memphis) or a natural port (Pensacola) or a pass through the mountains (Boise).

As it grows, this new town might be christened with a new name befitting its status. Jacksonville, Florida, began life simply as Cowford. Signifying a change in ownership, Yerba Buena became San Francisco. Portland, Oregon, took its name from Portland, Maine, and New Amsterdam became New York.

Cities also experience the turbulence of youth, before an institutional structure is firmly in place. Denver's first years were absorbed by the rush of gold fever and wagons filled with picks and pans following wagons filled with barrels of booze following a coach in which sat a handful of pretty prostitutes—as were Rapid City and Deadwood, South Dakota, and Juneau, Alaska, and so many cities on the ragged edge of civilization. Silver, booze, loose women, and backbreaking toil made—and then shattered—Virginia City, Nevada.

A town that wishes to become a city faces unexpected challenges, not the least of which are other towns with similar aspirations. Jacksonville out-hustled the established port city of Fernandina, luring the railroads with suitable offers of land and profit.

Not the least responsible for the founding—and sometimes the destruction—of cities is civil strife. Many American cities owe their origins to military encampments: Fort Worth, Texas, at the confluence of the West and Clear forks of the Trinity River. Fort Lauderdale, Florida, is named for the officer responsible for building a series of fortresses during the Second Seminole War.

While conflicts of an international nature utterly destroyed cities around the world and their peoples during the twentieth century, they have by and large spared

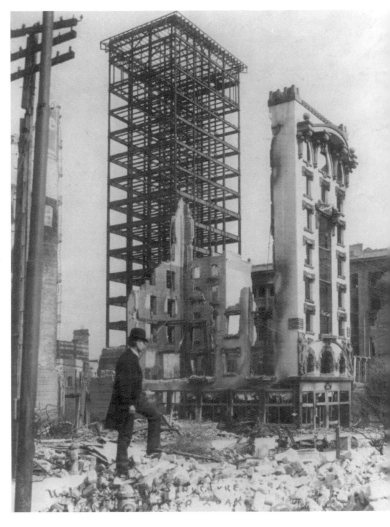

RIGHT: *The Great San Francisco Earthquake and Fire—April 18, 1906: The earth began to move while most residents slept: at 5:12 a.m. violent shaking continued for nearly a minute. It was felt from Oregon to Los Angeles and inland as far as Nevada. The Salinas River changed course. Three-quarters of the population lost their homes. 3,000 people would die. Ninety percent of the destruction was caused from thirty fires begun when gas mains ruptured: other fires were caused by an inept fire department's attempt to dynamite buildings. Because water mains were shattered, fires raged out of control for four days. For two and a half months the U.S. Army patrolled the city with orders to shoot looters on sight and an estimated 500 people were shot either looting or moving their own property from the ruins of their homes.*

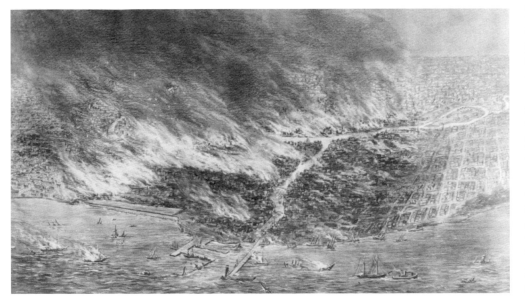

America's cities. Whereas Dresden and Nanking and Nagasaki were cruelly torched, Albany, Philadelphia, and Lincoln were spared. Still, war once destroyed Richmond and Atlanta. In the modern era, race riots have torn apart Miami and Detroit, Oklahoma City and Los Angeles.

For sheer horror little can compete with the September 11, 2001, attack by Muslim fanatics, though. Nineteen men took over passenger airplanes in flight and intentionally crashed them into the World Trade Center buildings in New York City, and the Pentagon in Washington, and targeted perhaps the U.S. Capitol. Some 3,000 people died on 9/11 and the cost to infrastructure, wealth, and lives in the resulting wars in Iraq, Afghanistan, and Pakistan will forever be incalculable. This incident, more than any other, has changed the routine, the pace of life on an international scale.

The 9/11 attacks fall into a pattern of terrorist acts elsewhere in the world: the U.S. Marine Corps barracks in Beirut, Lebanon, in 1983, the Sarin gas attacks on the Tokyo subway system in 1995, the bombing of commuter trains in Madrid in 2004, the London bombings of 2005... although London has a long history of attacks by Irish terrorists.

Once relatively insulated from the affairs of the wider world by great oceans on either side, the United States chose to become a player on the international scene. That decision has consequences and those consequences are evident in its cities. New York becomes a world center of finance; dreams are spun into vast fortunes on Wall Street; fashion is established for a generation on its model runways. The city grows and spreads, its joined suburbs stretching south and uniting Philadelphia and Washington and Baltimore, and northward to Boston. And in so doing, it becomes a target.

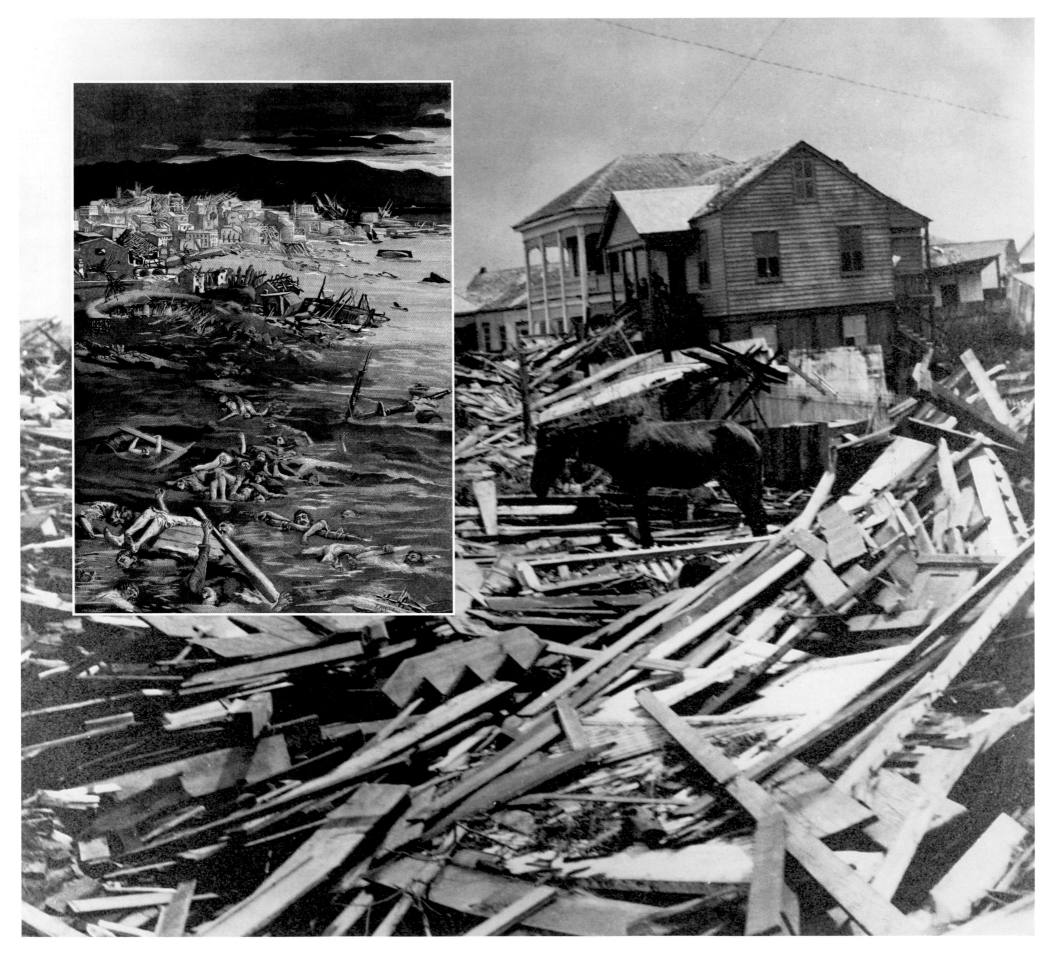

LEFT: *A few houses and a lonely horse stand amid the wreckage left after the Galveston Hurricane of 1900. The storm struck the city with winds estimated at 135mph on Saturday evening, destroying all public services and eliminating any possibility of assistance from the mainland until the following day. In 1900, the U.S. Weather Bureau used the tools it had available—eyewitness reports and the telegraph—to warn residents of the coastal Gulf that a tropical storm had moved northward over Cuba. Without aircraft or satellite surveillance, where the storm would go and how fast it might get there were not understood.*

LEFT, INSET: *Barely a few feet above sea level, the coastal city of Galveston, Texas, is at risk of flooding and ruin during any given hurricane season. This illustration from the French newspaper* Le Petit Parisien *depicts the aftermath of the Galveston Hurricane, which struck on September 8, 1900. Leaving an estimated 8,000 people dead from a population of 38,000, the hurricane was the deadliest natural disaster ever in the U.S. The health situation quickly became dire and bodies were interred en masse at sea. When the bodies washed ashore, they were stacked in great piles and burned.*

RIGHT: *Galveston has been struck by many hurricanes: on September 23, 2005, Hurricane Rita made landfall about seventy miles east northeast of Galveston between Sabine Pass, Texas and Johnson Bayou, Louisiana, as a Category 3 storm on the Saffir-Simpson Hurricane Scale. While parts of Galveston Island flooded, the seven-foot storm surge was below the top of the seawall. Because the storm hit east of the city, hurricane-force winds from the storm's counter-clockwise rotation helped minimize the rise of Gulf waters. By contrast, the storm surge east of Rita's landfall was twenty feet. Two weeks after the arrival of Hurricane Ike on September 27, 2008, a trash heap covers the grounds outside the Selay Mansion in the historic district.*

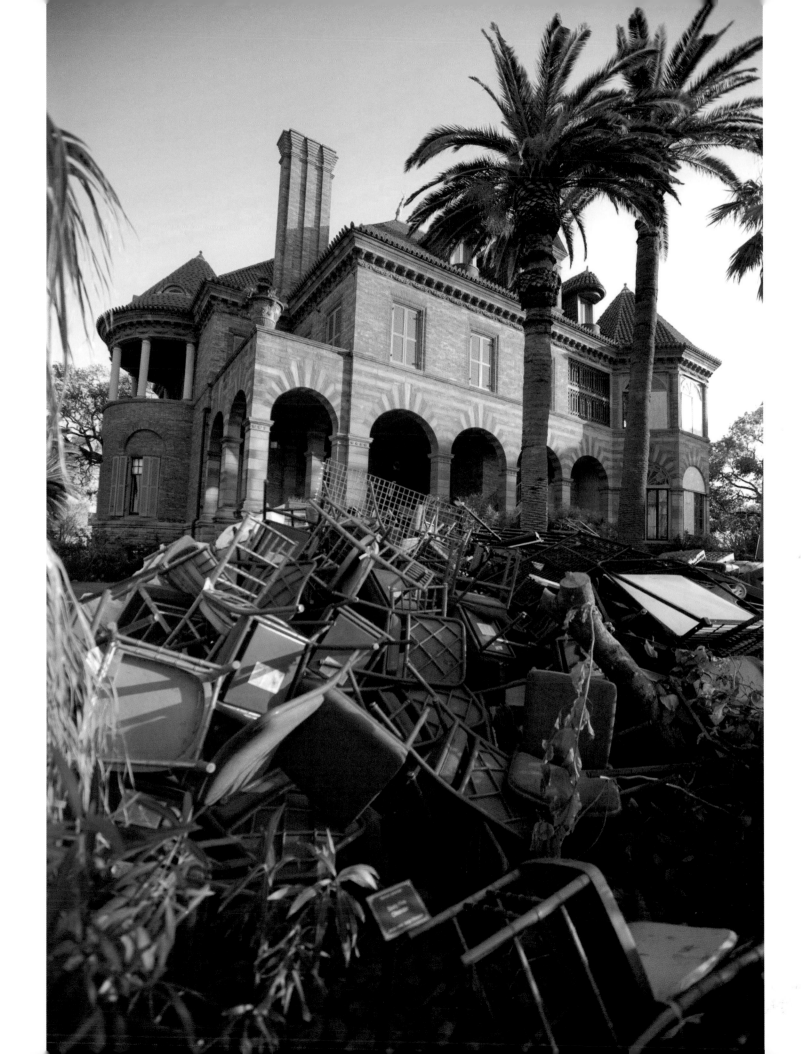

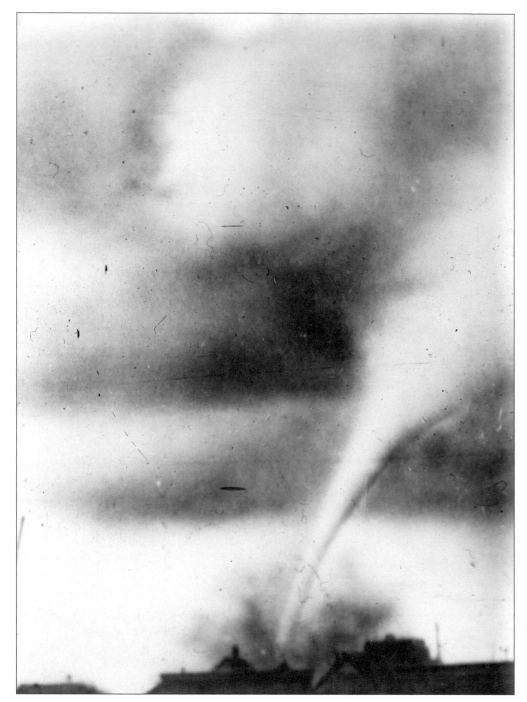

of their resistance. They do not demonstrate in the open countryside of Kansas or the farm fields of Alabama or the forests of Minnesota. The city represents the values and the structures they wish to change. The city knits the fabric of their grievance with the endless possibilities for change, for renewal.

Thus, while the dispersed populace, the small towns and villages, experience their share of violence and discord, it is the twin towers of the World Trade Center in downtown New York City that the terrorists choose to attack because the structures symbolize all that they despise. Thousands of engagements were fought by the North and the South during the Civil War, and most are memorialized, but the central efforts of strategy, of attack, and defense concentrated on the cities because within them were the rail yards and the road networks, the foundries and the ports; within them was the raw manpower of the armies and navies.

<div align="center">* * *</div>

Find a city history and it will tell you about its disasters… and its rebirth.

Atlanta's famous three-dimensional Cyclorama commemorates the battle that destroyed the city in 1864 and yet the modern skyline heralds A New South and it resisted the ripping winds of a high-end EF2 tornado that ripped through the downtown in 2008.

A series of yellow fever epidemics led to the collapse of the city of Memphis in the decades following the Civil War. The 1878 outbreak reduced the population by three-quarters as people died or fled. As a consequence, property tax revenues crumbled and the city could not make payments on its municipal debts. The state subsequently withdrew the city charter, which was restored only in 1893. Today, the city is reinventing itself with a month-long celebration called "Memphis in May." The waterfront has been rebuilt and the levees strengthened.

In the valley beneath Lookout Mountain, Chattanooga occupied a lovely landing on the Tennessee River. By offering cheap land and tax incentives, the city attracted industry and that industry brought unrivaled air and water pollution, called "the

All cities become targets. Spanish conquistadores supported by the oppressed peoples of Central America overthrew the Aztec empire and destroyed its capital at Tenochtitlan. The army of the Visigoths sacked Rome.

It is not just outsiders, however, who target cities and their institutions. Some attacks come from the inside. Born and raised in small towns in western New York, Timothy McVeigh drove a truck filled with explosive fertilizer to Oklahoma City. There, on April 19, 1995, he parked at the Alfred P. Murrah Federal Building just as its offices and the day care center opened for the day. The explosion killed 168 people and injured 450 others. Nineteen of the victims were small children in the day care center on the ground floor of the building.

Although rural areas are not immune to war and discord, it is a city that is the focus of every disgruntled minority or individual and, indeed, in many cases their complaints have a substantial foundation in practice. Still, the city receives the brunt

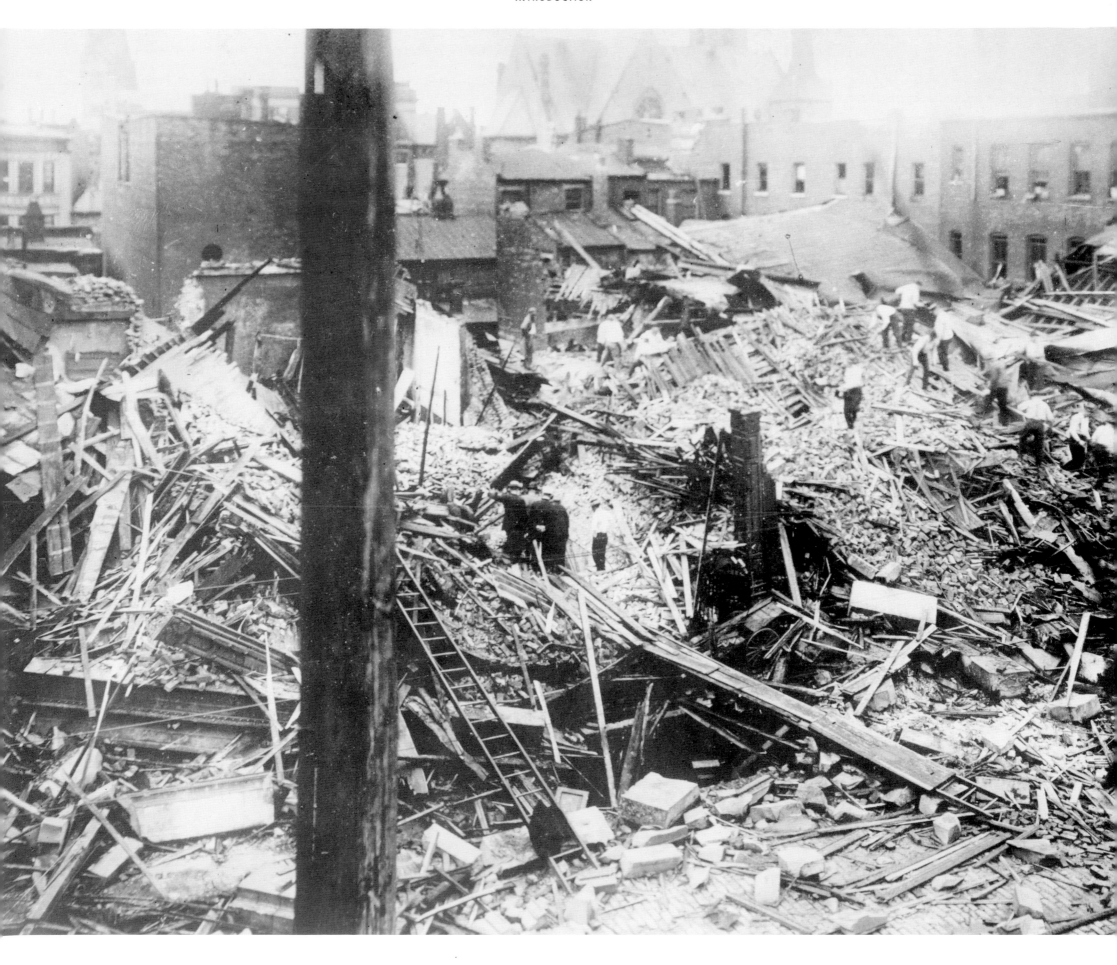

worst" in the United States. Tuberculosis was three times the national average. When the Federal Clean Air Act (1970) demanded a clean-up, the citizens of Chattanooga formed the non-profit "Chattanooga Venture" to re-imagine and rebuild their city.

Disaster of a different sort has dogged Dallas. When an assassin gunned down President John F. Kennedy on November 22, 1963, creating an international furor, this staunchly southern, conservative, business-oriented community resisted soul-searching. Nevertheless, the building from which the murderer fired, the former Texas School Book Depository, has converted its sixth floor into The Sixth Floor Museum to celebrate the life and accomplishments of the former president; more than five million people have visited the museum. Dealey Plaza, through which the Kennedy motorcade was passing when he was killed, became a National Historic Landmark District in 1993.

No city in the U.S. has faced the challenges presented to New Orleans—and the nation—as a result of the failure of the levees during Hurricane Katrina on August 29, 2005. The Class 3 hurricane and flooding of the city, much of which is built beneath the level of the Mississippi River, resulted in the death of nearly 2,000 people and caused an estimated $100 billion in damage. A million people fled the area and those who remained endured weeks of misery. To this day, thousands of displaced residents live in temporary trailers. Reconstruction has been slow.

In the life of a city, there is no anticipating the future with certainty. When its mayors championed an anti-growth philosophy in the 1970s, no one in San Jose, California, expected it to become the center of Silicon Valley. When air-conditioning became a national craze in the 1950s, no one would have forecast the building boom in Houston, Texas. When a 1947 fire destroyed the Phoenix streetcar fleet, few understood how switching to buses would prompt urban sprawl. Birmingham, Alabama, was not founded until 1871, but its growth was spectacular. Within a century a million people lived in the urban area. It was built at a railroad intersection, and Birmingham's planners intended to create an industrial phenomenon. It soon earned the sobriquet "The Magic City." Skyscrapers springing up at First Avenue and 20th Street earned the spot an identity as "The Heaviest Corner on Earth."

*　　　　*　　　　*

The story of cities in America and around the world is rich with complex, sometimes frightening and often delightful events. Nowhere is man's passion more on display, or the inherent creativity or the determination to overcome desperate circumstances. A tornado sweeping through a Kansas wheat field is interesting to storm chasers and to those farmsteads along its twisting course. Put an F5 tornado on a path for downtown Topeka, such as the one that struck in 1966, and it becomes national, if not international, news.

After the city is described and photographed, planned and dissected and studied, the outstanding feature remains a mystery. That feature is a mystery in the human spirit that causes people to come together, to assemble again after failure or disaster. That feature causes people to rebuild in the face of flood and fire and war. It causes a city's inhabitants to re-connect and re-create when common sense and sheer physical exhaustion and wilting resolve would best whisper to give up.

People are not born to give up, however. People are born to come together in cities and towns as they have done for thousands of years, to create and build—not mindlessly like ants—but thoughtfully, with goals for commerce and beauty, goals for a good life for themselves and their children, and that is the story of the city.

Rick Sapp
Florida 2010

BELOW: *Fergus Falls—June 22, 1919: A tornado exerts a shredding force when it encounters an otherwise stable structure, much like the food processor on the kitchen counter. Thus, when people ran to the shelter of the Grand Hotel, a sturdy wooden structure downtown, they signed their own death certificates. Fergus Falls was a city—a town, really—of less than 10,000 but the tornado killed fifty-seven people and left a swath of destruction hundreds of yards wide. Yet here and there a home or business stands untouched. Powerful almost beyond imagination, especially in those days before atomic weapons, these cyclones are mercurial. They touch down. They lift. They suddenly change direction. They seem to skip, almost dance and then they are gone. And the city rebuilds, the people survey the destruction, weep for the dead, and carry on.*

RIGHT: *The World Series Earthquake— October 17, 1989: By local time it is 5:04 p.m.*

Candlestick Park in San Francisco is filling with baseball fans for the third game of the World Series between the Giants and the Oakland Athletics. Suddenly, with broadcasters live on air, the surface of the earth slips. The power goes out. The crowd cheers. But this quake is no laughing matter. It measures 7.0 on the Richter scale. Interstate highways collapse. Bridges buckle and fall. Buildings fall down, burying cars and passengers and passers-by. Sixty miles from the epicenter, liquefaction of the soil destroys San Francisco's Marina District. Sand volcanoes, landslides, and ground ruptures damage 12,000 homes and 2,600 businesses. In nearby Santa Cruz, forty buildings disintegrate. Sixty-eight people die, but because so many commuters have left work early to watch the World Series game on television, the normally burdened highways are barely trafficked, which perhaps saves hundreds, maybe even thousands, of lives. The Athletics sweep in four games.

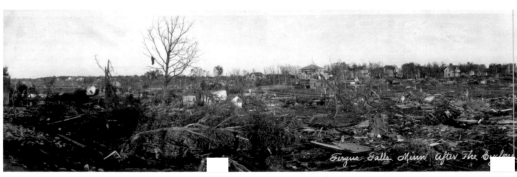
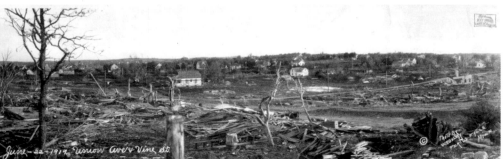

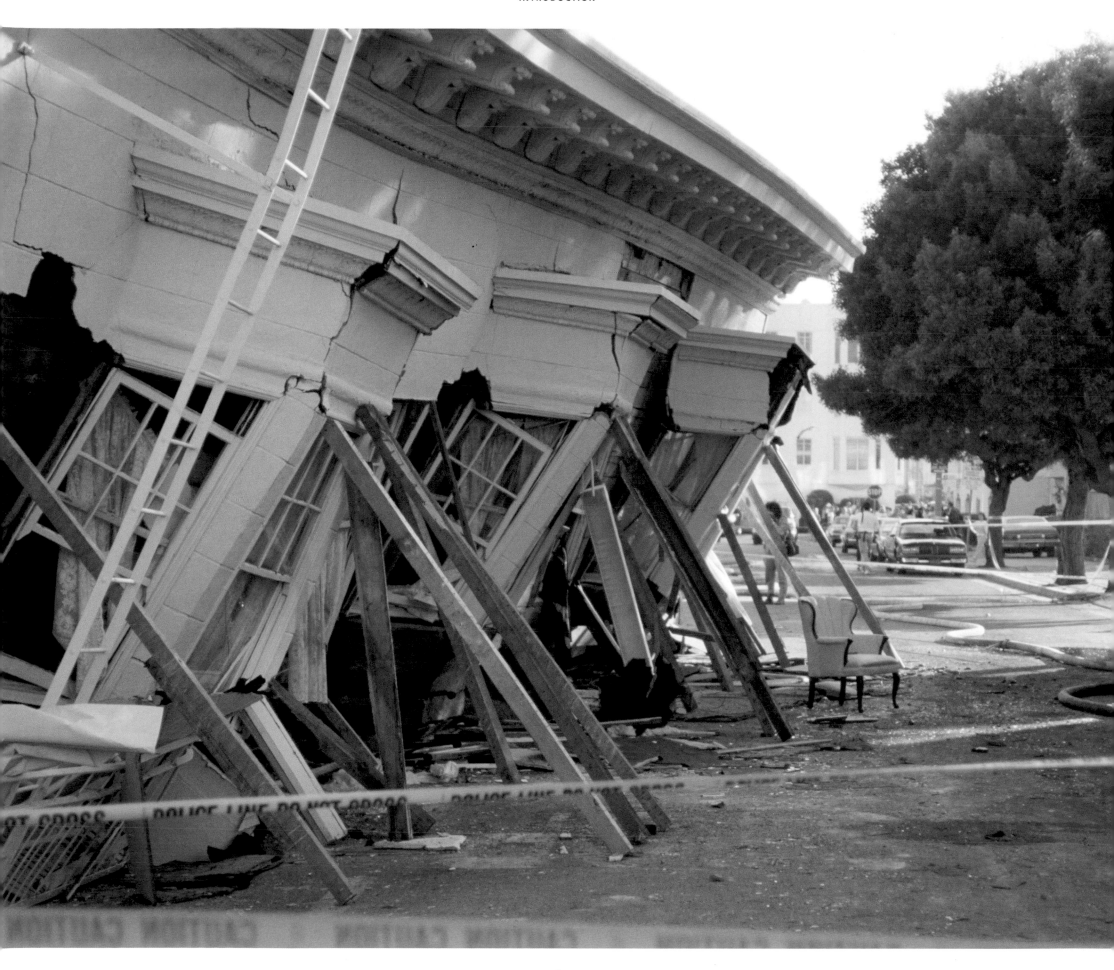

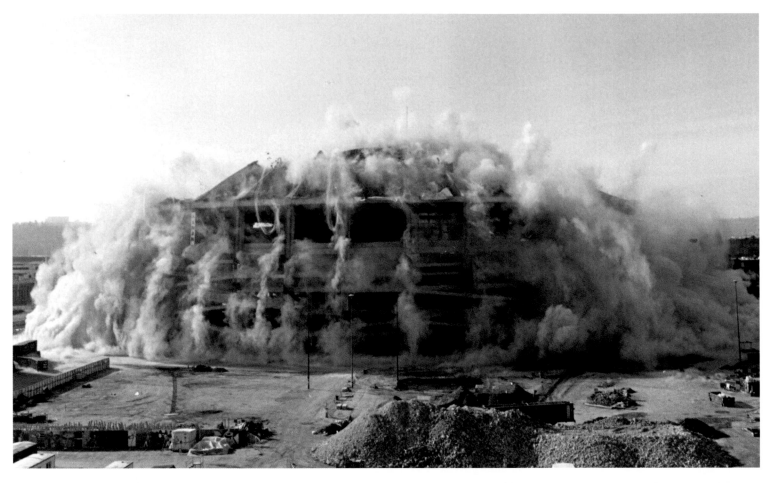

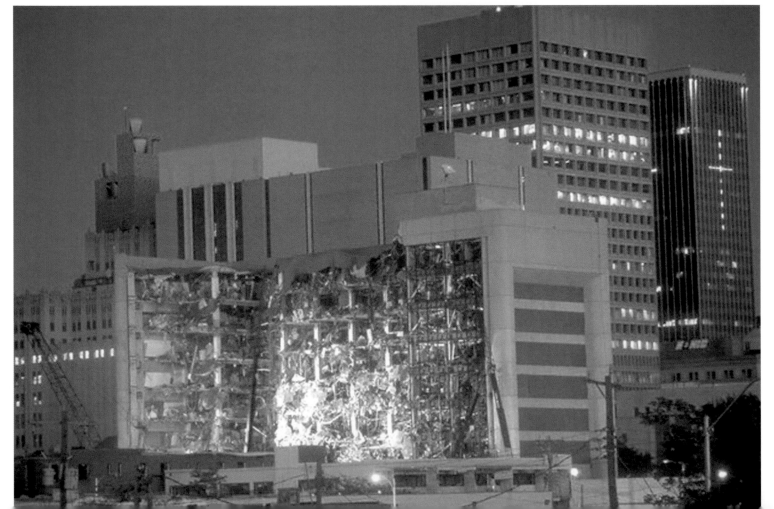

LEFT: *Bye, Bye Kingdome—March 26, 2000: Are all disasters man-made? If humans were not present to experience, to record, to name names, would an event still be "a disaster?" Certainly the history of Seattle's ill-designed Kingdome, from construction to destruction before it was paid for, all with public monies, rates as a man-made disaster. The Kingdome was barely twenty-three years old when it was demolished—by its owners or more properly the erstwhile elected leaders of its owners. During its short life-span, the stadium hosted professional football, baseball, soccer, and even basketball teams: respectively the Seahawks, the Mariners, the Sounders, and the SuperSonics. No one was happy with it, however, even when they won. The structure cost $67 million to build; in 1994, the roof was repaired at a cost of $51 million and the loss of two workers' lives; it cost $9 million to bring down. Following its implosion, an explosive technique which, by removing interior supporting columns, encourages a building to collapse inward, the Kingdome was replaced with two publicly financed structures: Qwest Field for football and Safeco Field for baseball.*

BELOW LEFT: *The first major terrorist event on the North American continent was the destruction of the Alfred P. Murrah Federal Building in Oklahoma City on April 19, 1995. The bomber performed the atrocity, he later testified, in revenge for government agencies treatment of the Branch Davidian sect near Waco that had ended with the death of leader and more than eighty of his followers two years before. The murderer, Timothy McVeigh, was tried and executed; Terry Nichols was sentenced to life imprisonment; Michael Fortier was sentenced to twelve years as an accomplice.*

RIGHT: *Ground Zero for infamy—September 11, 2001: The moment was one of those in a lifetime that people never forget. If they were alive, they remember where they were, what they were doing when they heard of JFK's murder in Dallas, or when they saw the airplanes crash into the World Trade Center and the Pentagon and the wooded slope of a lonely Pennsylvania field. Nearly 3,000 innocent people—men, women, children—died because nineteen men in a well-coordinated, well-financed attack, sacrificed themselves for a moment of fame—or infamy. Whether they were terrorists or patriots, their actions caused unending misery and huge destruction.*

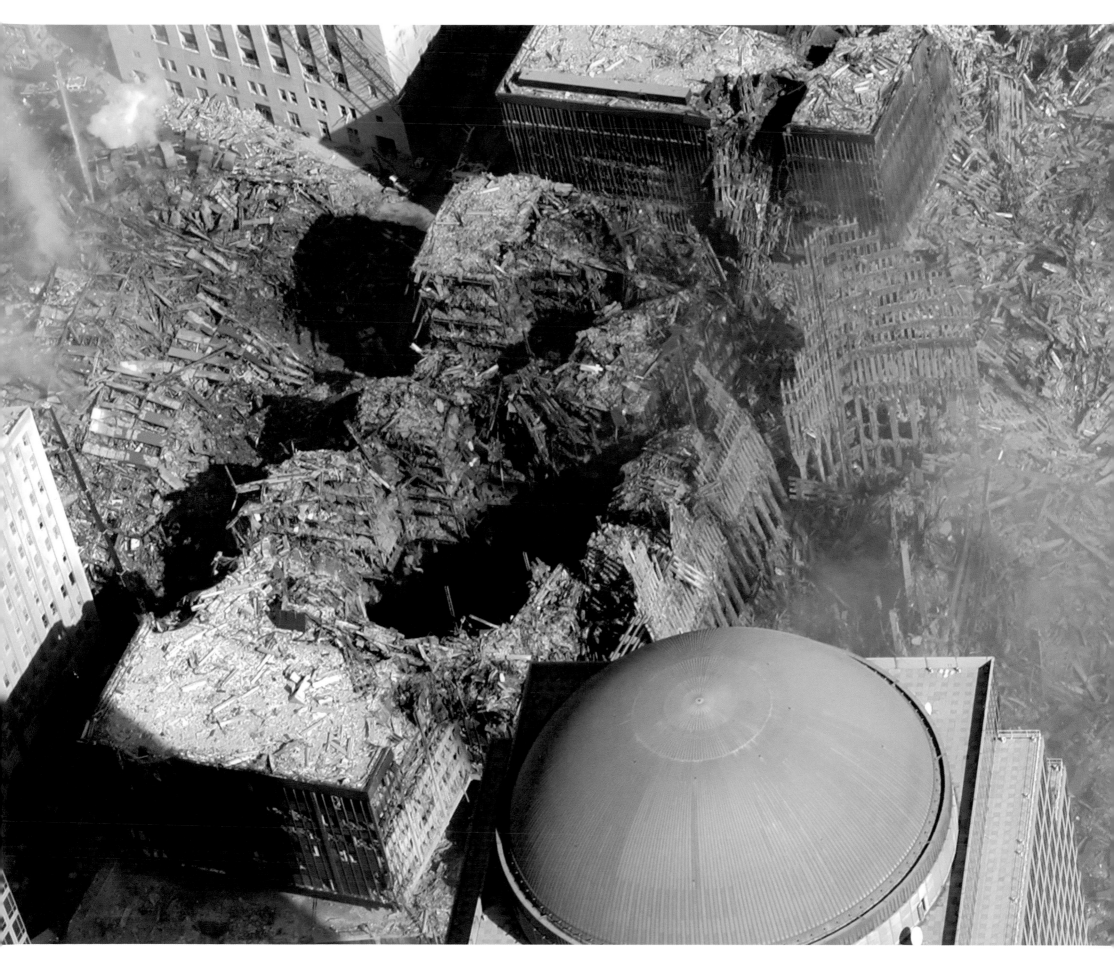

Anchorage, AK

Anchorage looking east, 1916 (below)

In 1914, Anchorage was selected for the southern terminus of the Alaska Railroad—a line funded by the U.S. Government to both assume operation of existing lines and continue construction of the region's railroad network. As a result of this fortuitous location Anchorage grew rapidly. This view, exposed about 1916 looking east toward the towering Chugach Mountains, shows Anchorage in its formative years. By 1923, the railroad was largely completed and Anchorage flourished, growing to become one of Alaska's most important cities.

Anchorage looking east, 1993 (right)

On Good Friday, March 27, 1964,

Anchorage was devastated by a massive earthquake that destroyed many of the city's buildings. Much of today's Anchorage has been built new since that time.

1 Hilton Anchorage East Tower
Overlooking the corner of West 3rd and E streets, a twenty-one-story hotel tower designed by Rolf Jensen & Associates, Inc., that ranks as Anchorage's third tallest building.

2 McKinley Tower
A fourteen-floor modern high-rise apartment on the east side of the city.

3 Third Avenue
Anchorage is largely laid out on a grid, with main avenues running east–west and numbered, lettered, and some named streets running north–south. West and east divide at A Street.

4 Hotel Captain Cook
This nine-story high-rise hotel designed by Edwin B. Crittenden & Associates was named for the famous eighteenth-century English sea captain who explored the Alaskan coast. Completed in 1965, it underwent a substantial renovation in 1995.

5 Key Bank Plaza
A nine-floor office block at the corner of West Fifth Avenue and F Street.

6 Anchorage Historic Depot
Headquarters since 1915 of the Alaska Railroad that runs from Seward in the south to Fairbanks in the north.

7 Chugach State Park
Located in the mountainous foothills east of Anchorage, this is America's third largest State Park. Nearly a million people visit every year seeking its remote vistas and abundant wildlife.

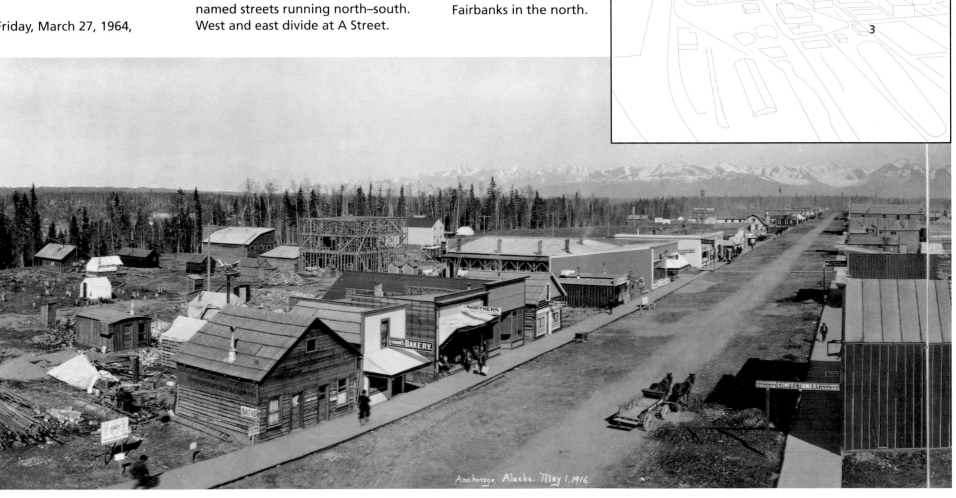

Anchorage, Alaska. May 1, 1916.

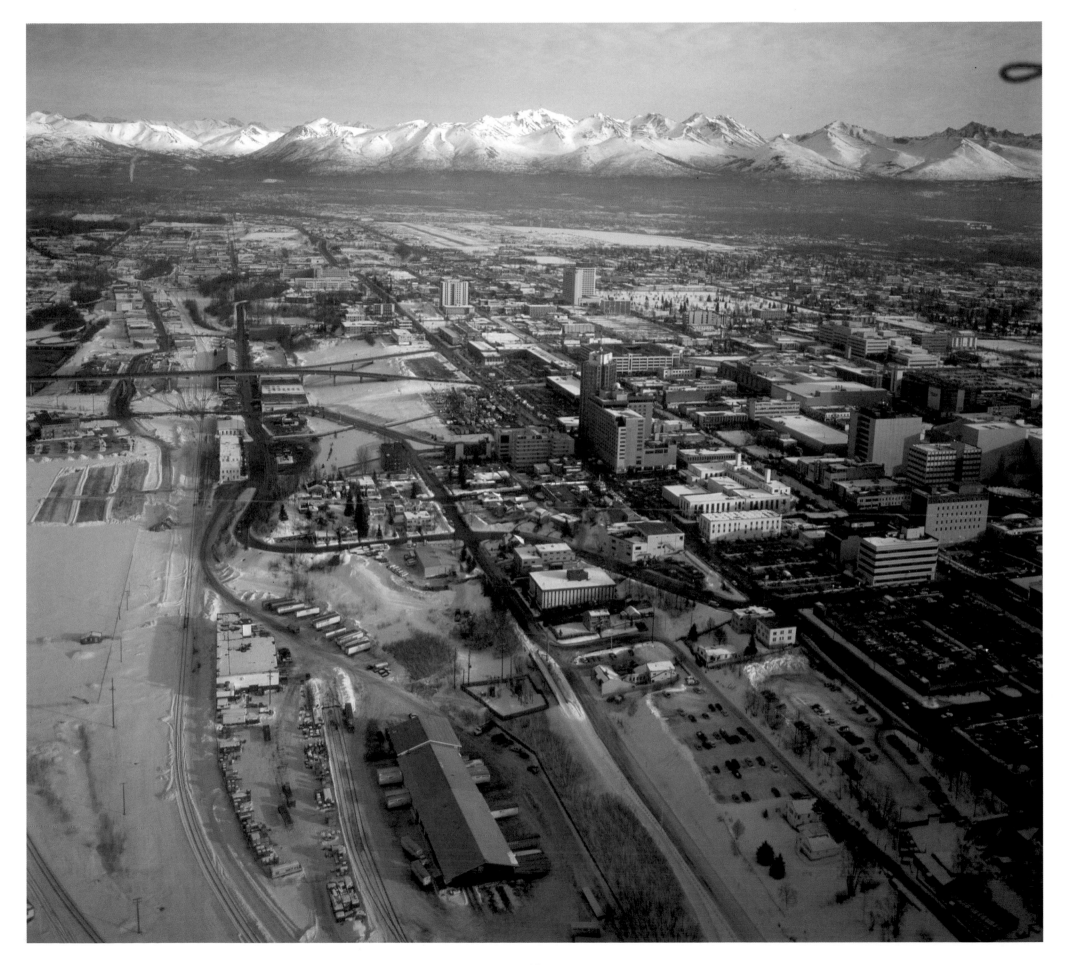

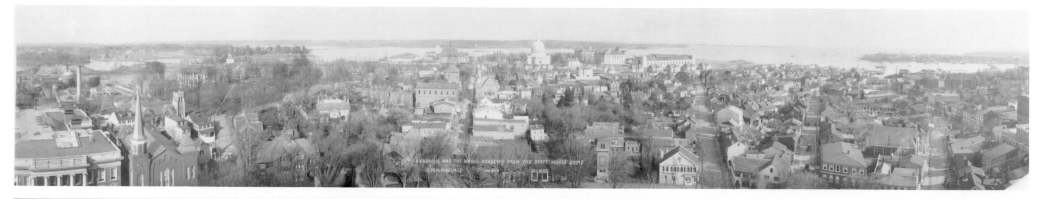

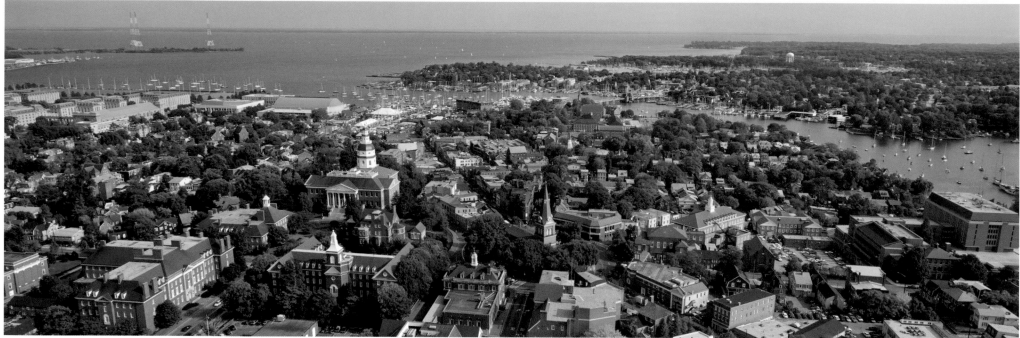

Annapolis, MD

Annapolis, 1911 (top)

This panoramic photograph of Annapolis and the Naval Academy looks east from the State House dome.

1 U.S. Naval Academy Chaplain Center
Corner stone dedicated on May 28, 1908. Famous for its copper-sheathed dome.

2 United States Naval Academy
Founded on October 10, 1845, this undergraduate college educates officers of the United States Navy including the Marine Corp. Within the military the college has become synonymous with Annapolis. It is located in the city at the confluence of the Severn River and Chesapeake Bay.

3 Chesapeake Bay
First explored and mapped between 1607 and 1609 by Captain John Smith who led the Jamestown colony in 1608–1609.

4 Acton Cove
Providing the southeastern border to the peninsula on which Annapolis is built, the cove hosts several local marinas.

Annapolis, 1988 (right)

5 State Circle
The unusual oval road that circumnavigates the State House. Annapolis' street plan was designed in 1696 by Francis Nicholson.

6 John Callahan House
Formerly known as the Pinkney-Callahan House. Built by John Callahan in the latter half of the eighteenth century, it is noted for the gable-end principle façade

and Georgian-Federalist interior design. In order to preserve this historic brick house, in 1972 it was relocated from St. John's Street to its present location on Conduit Street.

Annapolis, 1993 (opposite, below)

7 St. Anne's Parish
Built in the Romanesque Revival style during 1858–1859 to replace the previous structure destroyed by fire on St. Valentine's Day, 1858.

8 Maryland State House
Construction began in 1772 when Colonial Governor Robert Edan set the corner stone. The main building was designed by Joseph Horatio Anderson, but the dome was engineered by Joseph Clark. Although the building housed the Continental Congress in 1783 and 1784, the structure wasn't finished until 1797. It is considered the oldest U.S. State House in continuous use.

9 Rip Miller Field
An all-weather football field named in honor of E.E. "Rip" Miller, a long-time assistant director of athletics at the Naval Academy.

10 Maryland Avenue
Named for the state of Maryland, this runs a short distance from the State Circle toward the Severn River.

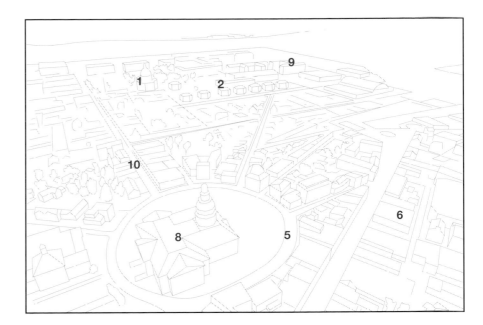

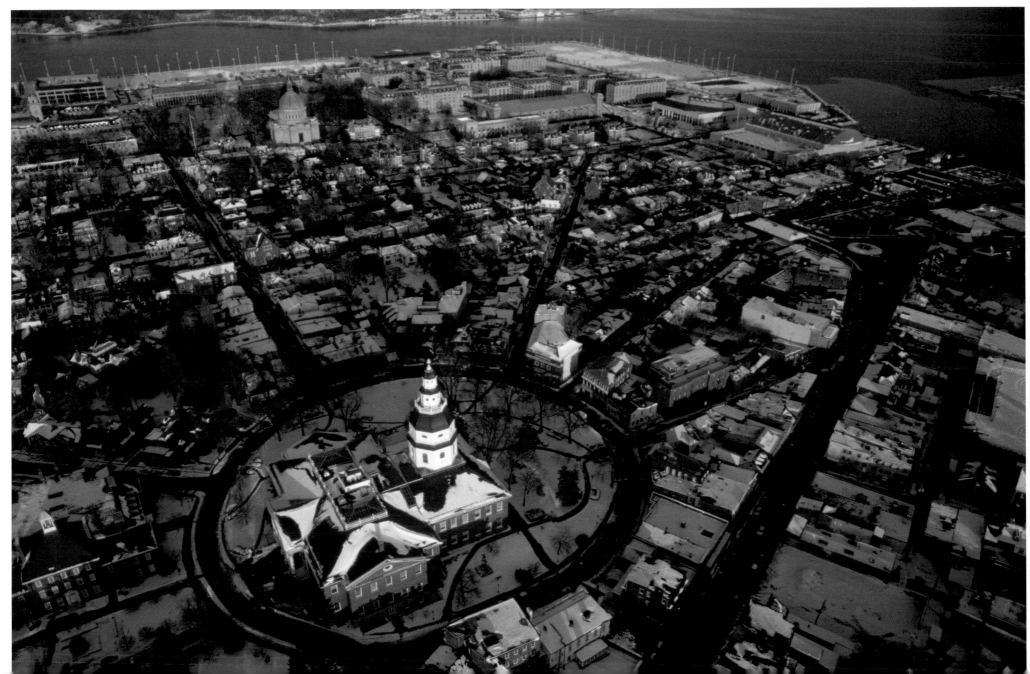

Atlanta, GA

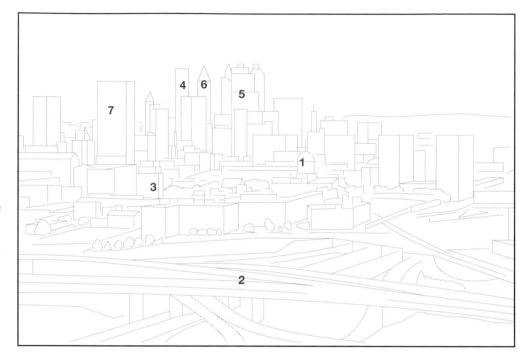

Atlanta, 1900 (lower)

1 Georgia State Capitol

A National Historic Landmark, the Georgia State Capitol in Atlanta was constructed between 1884 and 1889. With its gilded dome topped by a statue of "Miss Freedom" this monumental neoclassical structure is "the perfect expression and symbol for the capitol of the 'New South' as Atlanta considered itself to be after the Reconstruction," (the era following the American Civil War when Union troops occupied the former Confederate states). The building's design and form follow architectural precedents established by the United States capitol in Washington, D.C. Although it is now dwarfed by the skyscrapers of Atlanta's downtown, the capitol building at 206 Washington Street is distinguishable for miles because of its shining golden dome.

Atlanta, 2006 (right)

2 The Labyrinth

The junction of U.S. Interstate Highways 20 (east–west), 75 (north–south) and 85 (northeast–southwest). From this vast intersection, there are also various ramps to surface streets heading into downtown Atlanta.

3 Atlanta City Hall

Designed by G. Lloyd Preacher, Atlanta's City Hall at 68 Mitchell Street SW was completed in February 1930. It occupies the site of the house that U.S. General William Tecumseh Sherman commandeered as his headquarters during the Civil War campaign in 1864.

4 Westin Peachtree Plaza

This seventy-three-story 722-foot glass tower at 210 Peachtree Street NW is topped by a revolving restaurant. It is only steps from the CNN building, the Georgia Aquarium, Georgia World Congress Center, and the Georgia Dome.

5 Georgia-Pacific Tower

The headquarters building of Georgia-Pacific, one of the world's largest manufacturers and distributors of building and packaging materials and chemicals, was completed in 1981. At 697 feet, the fifty-two-story building designed by Skidmore, Owings & Merrill is still one of the dominant features on the Atlanta skyline.

6 Bank of America Plaza

Also called the Nation's Bank Building, it was built in only fourteen months. At 1,023 feet it is the tallest building in the southeast. Crowning the building is a stepped pyramid formed from an open steel frame that tapers to a ninety-foot-high spire, 405 square feet of which is covered with twenty-three-karat gold leaf.

7 State of Georgia Building

The tallest building in the southeast at the time of its construction, this forty-four-floor steel and aluminum building is sometimes called the First National Bank Building. At 2 Peachtree Street NW it now serves as an office tower for the state of Georgia.

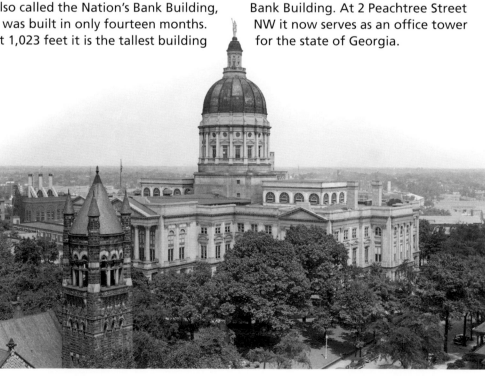

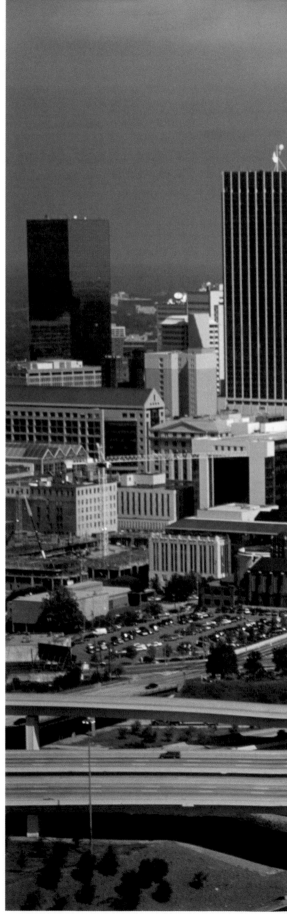

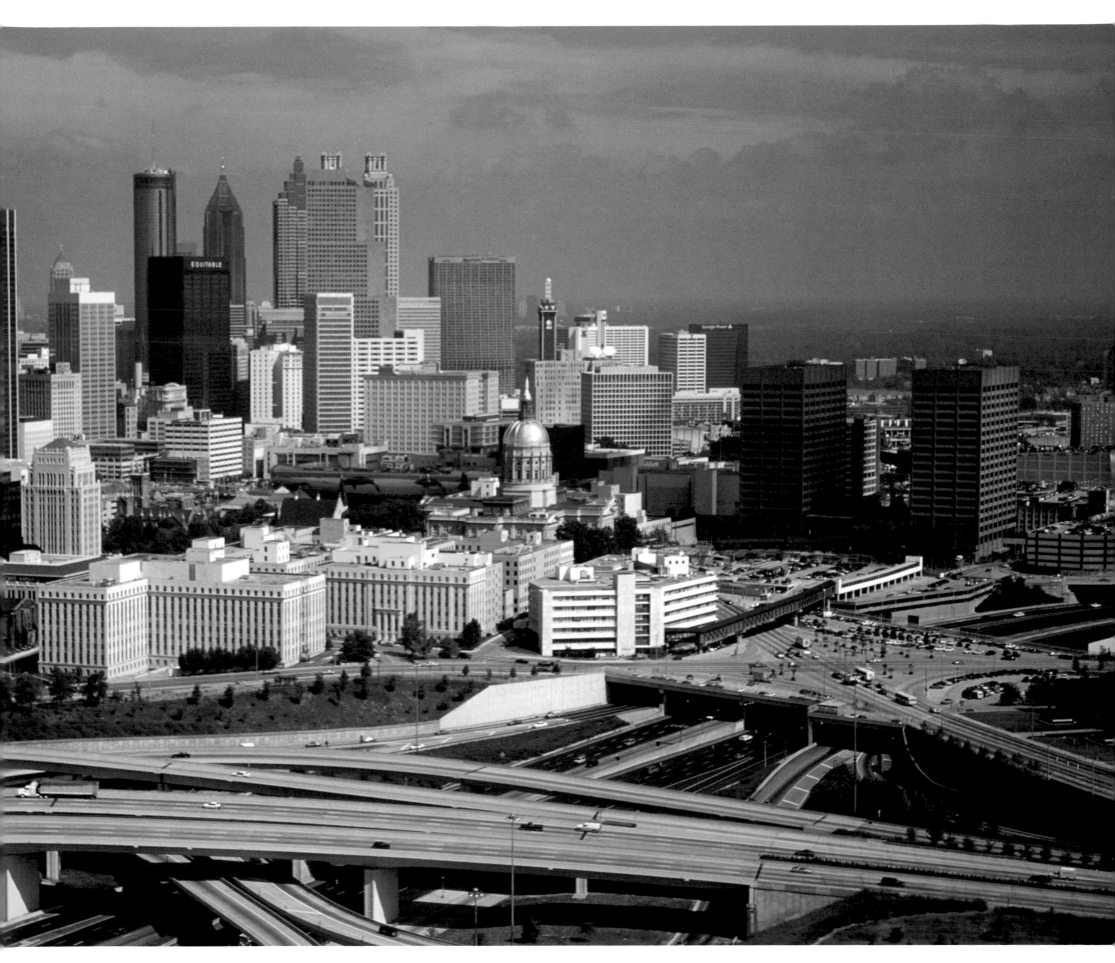

Atlantic City, NJ

Atlantic City boardwalk, ca. 1984 (below)

Atlantic City is a resort community located on Absecon Island. It was the inspiration for the popular board game Monopoly. It is famous for its boardwalk, casino gambling, sandy beaches, shopping centers, and unobstructed view of the Atlantic Ocean.

1 Boardwalk Hall
With its black curved top covering a 137-foot clear-span barrel ceiling, the hall has hosted events from the annual Miss America Pageant to basketball. It was built in 1926 as a convention center.

2 Playboy Club
The hotel and casino opened in 1981 to great fanfare but its gaming license was revoked in 1989 and this—along with other problems—forced its closure. It was demolished in 2000.

3 Trump Plaza Hotel
The hotel and casino complex was finished in 1984. It has two towers, one of which is thirty-nine stories tall. It is well-positioned on the boardwalk next to Boardwalk Hall.

Atlantic City boardwalk, ca. 1995 (opposite, above)

4 Ocean Club Condos
A condominium complex with two thirty-four-story (360 feet tall) towers that was completed in 1984.

Atlantic City boardwalk, ca. 2005 (below)

5 Tropicana Casino & Resort
The Havana Tower was officially topped off on August 28, 2003, and completed in 2004. One of the largest hotel and casino complexes in Atlantic City, it has had a checkered financial history.

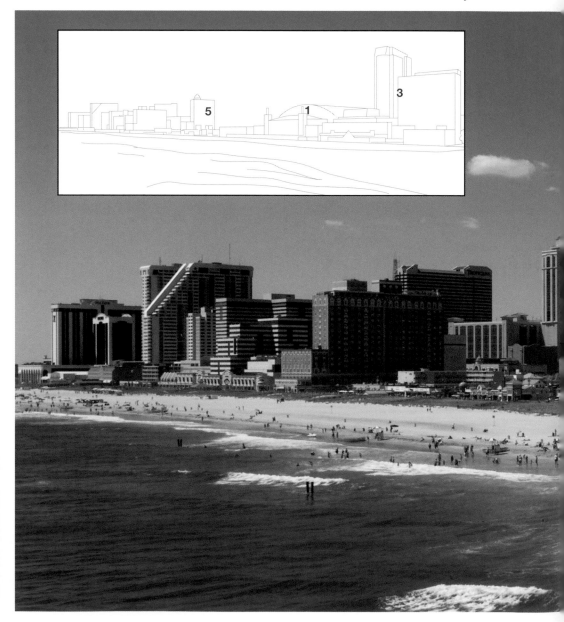

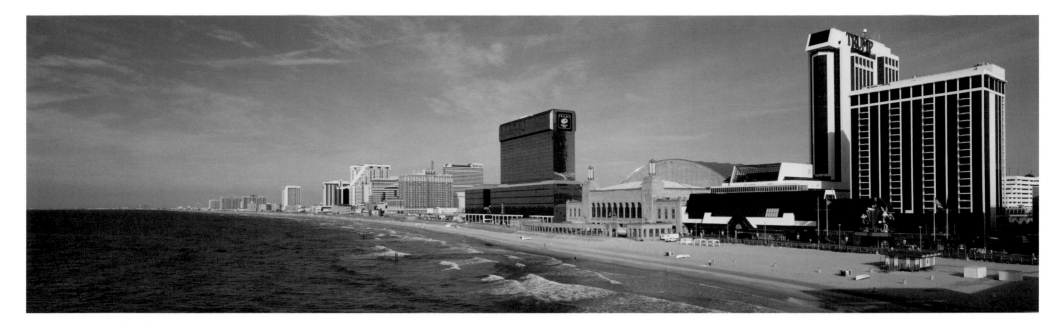

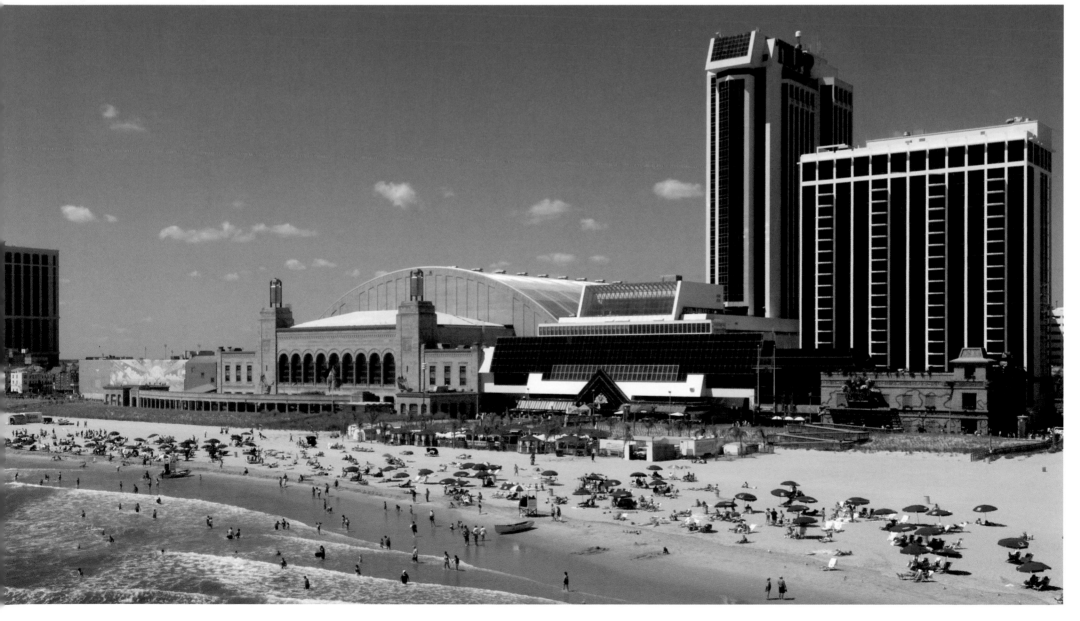

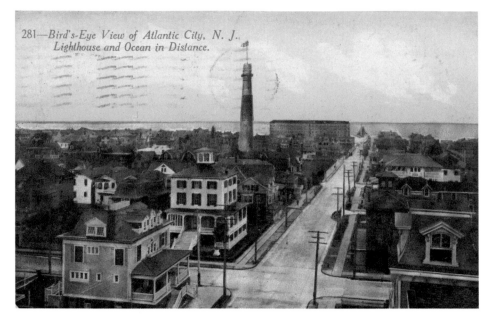

281—Bird's-Eye View of Atlantic City, N. J.
Lighthouse and Ocean in Distance.

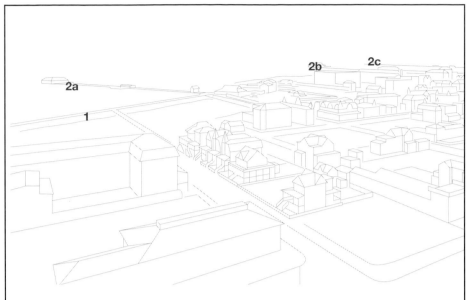

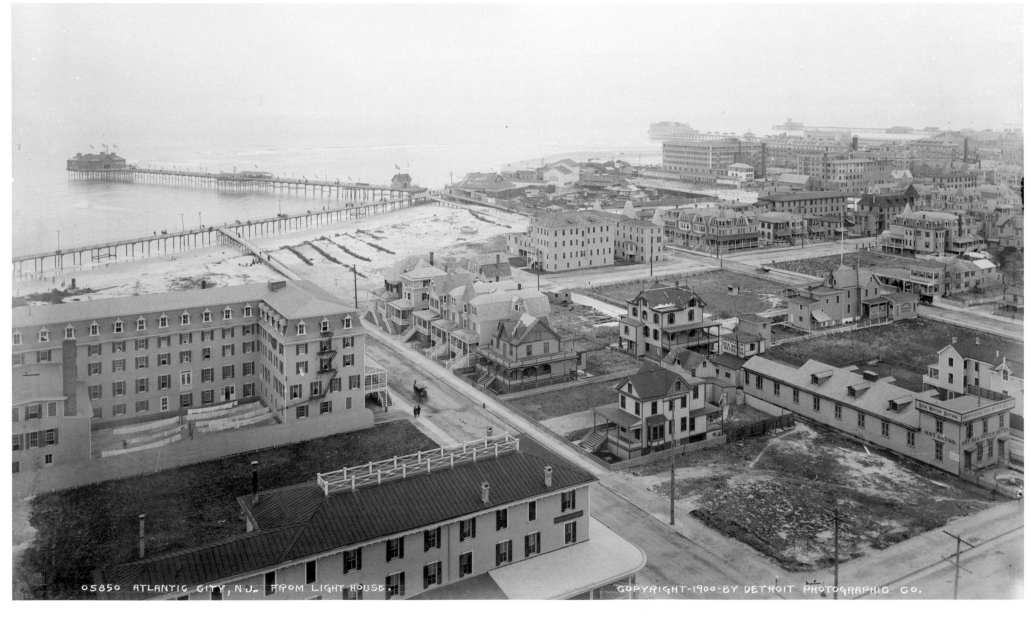

05850 ATLANTIC CITY, N.J. FROM LIGHT-HOUSE.

COPYRIGHT-1900-BY DETROIT PHOTOGRAPHIC CO.

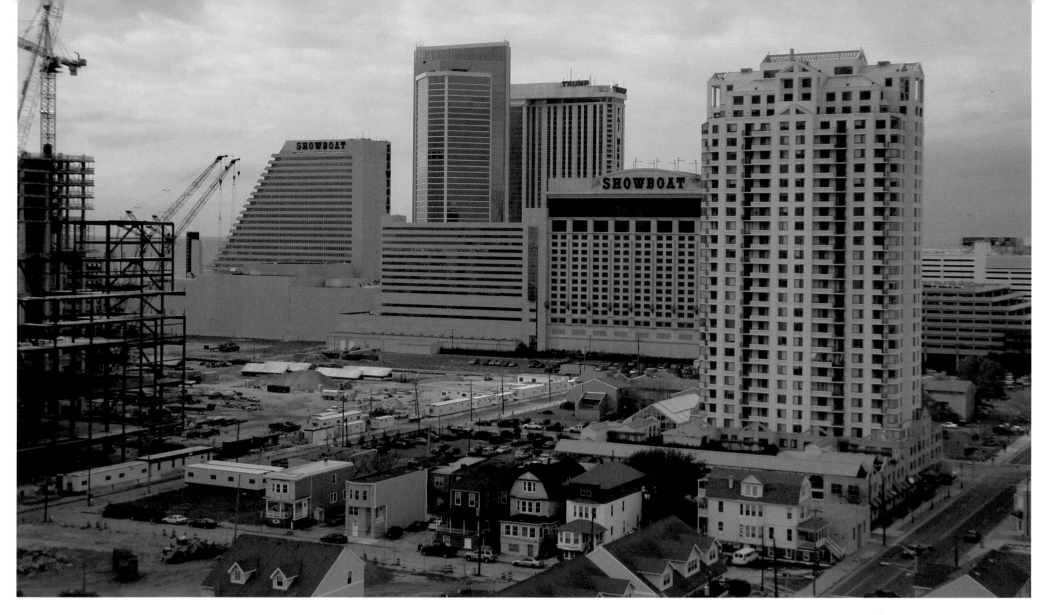

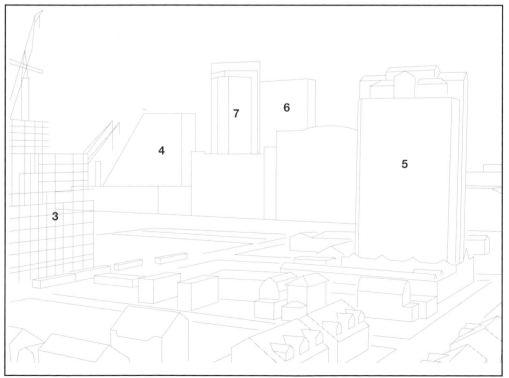

The Absecon Lighthouse, 1911
(opposite, above left)

Postcard
Atlantic City has always been a resort. It was incorporated in 1854 when railroad service began from Philadelphia. The lighthouse is the tallest in New Jersey and the third tallest in the U.S. There's quite a climb up the 228 steps (171 feet).

From the Lighthouse, 1911
(opposite, below)

1 Boardwalk
The first boardwalk was built in 1870 and at its peak stretched some seven miles to Longport. Today it is around four miles long. Three piers (**2a–c**) are visible in this photograph: Atlantic City once boasted six including the first, Ocean Pier, opened in 1882. Today those that survive are obscured by buildings.

From the Lighthouse, 2009
(above)

3 Revel Entertainment complex
From the lighthouse today, one views the construction of the twenty-acre twin-tower Revel Entertainment complex.

4 Showboat Complex
The seventeen-floor Orleans Tower, the nineteen-floor Mardi Gras Tower, and the twenty-five-story Bourbon Tower.

5 526 Pacific Avenue
The Bella apartment block has twenty-seven floors.

6 Trump Taj Mahal Casino Hotel
The forty-one-story Chairman Tower (**7**) has recently been constructed between Trump's Taj Mahal and the Showboat Complex next door.

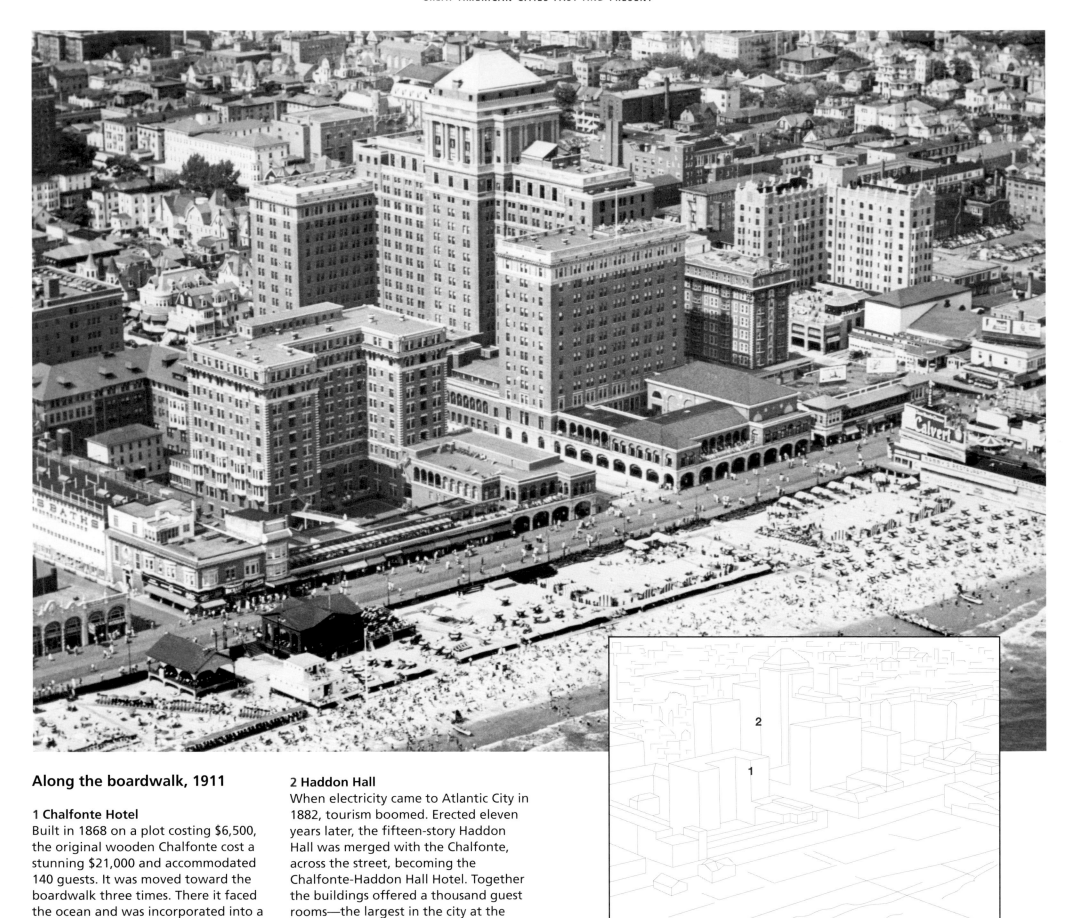

Along the boardwalk, 1911

1 Chalfonte Hotel
Built in 1868 on a plot costing $6,500, the original wooden Chalfonte cost a stunning $21,000 and accommodated 140 guests. It was moved toward the boardwalk three times. There it faced the ocean and was incorporated into a new brick and iron building designed by Addison Hutton, reopening in 1904.

2 Haddon Hall
When electricity came to Atlantic City in 1882, tourism boomed. Erected eleven years later, the fifteen-story Haddon Hall was merged with the Chalfonte, across the street, becoming the Chalfonte-Haddon Hall Hotel. Together the buildings offered a thousand guest rooms—the largest in the city at the time.

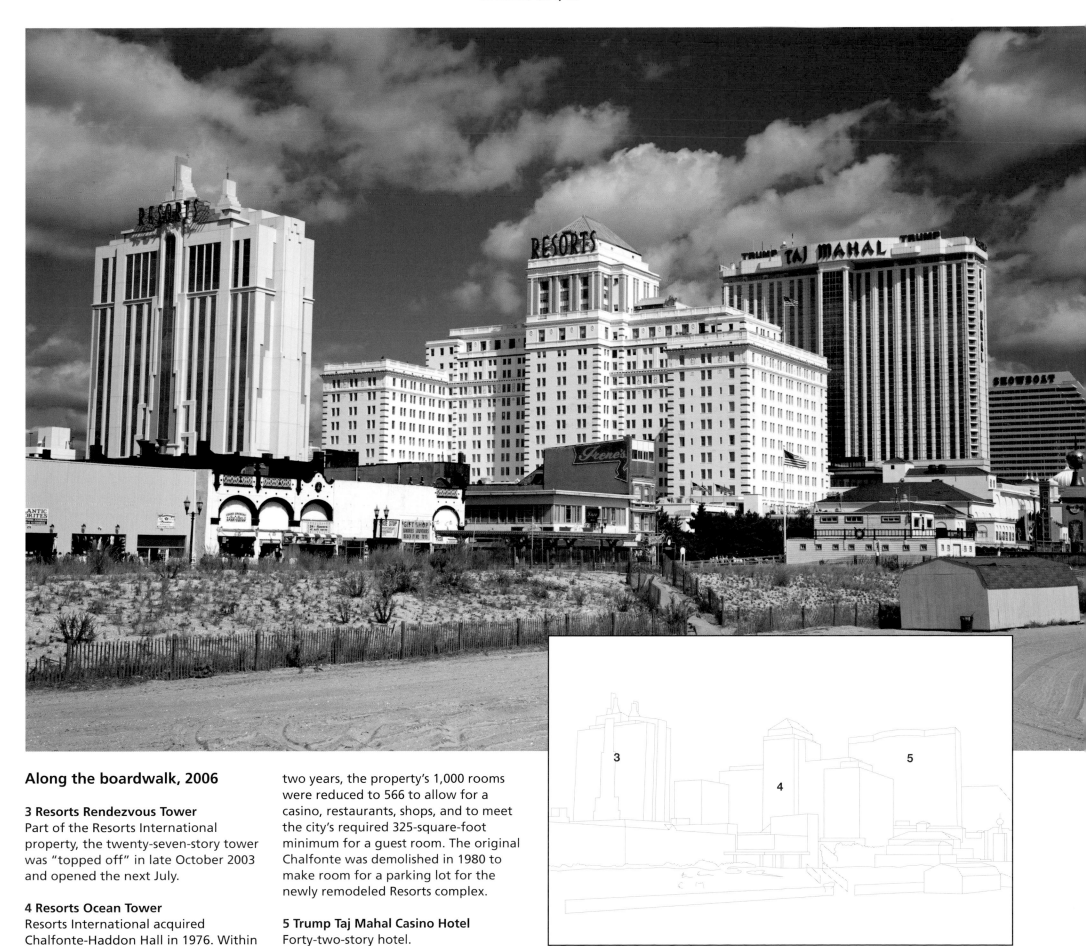

Along the boardwalk, 2006

3 Resorts Rendezvous Tower
Part of the Resorts International property, the twenty-seven-story tower was "topped off" in late October 2003 and opened the next July.

4 Resorts Ocean Tower
Resorts International acquired Chalfonte-Haddon Hall in 1976. Within two years, the property's 1,000 rooms were reduced to 566 to allow for a casino, restaurants, shops, and to meet the city's required 325-square-foot minimum for a guest room. The original Chalfonte was demolished in 1980 to make room for a parking lot for the newly remodeled Resorts complex.

5 Trump Taj Mahal Casino Hotel
Forty-two-story hotel.

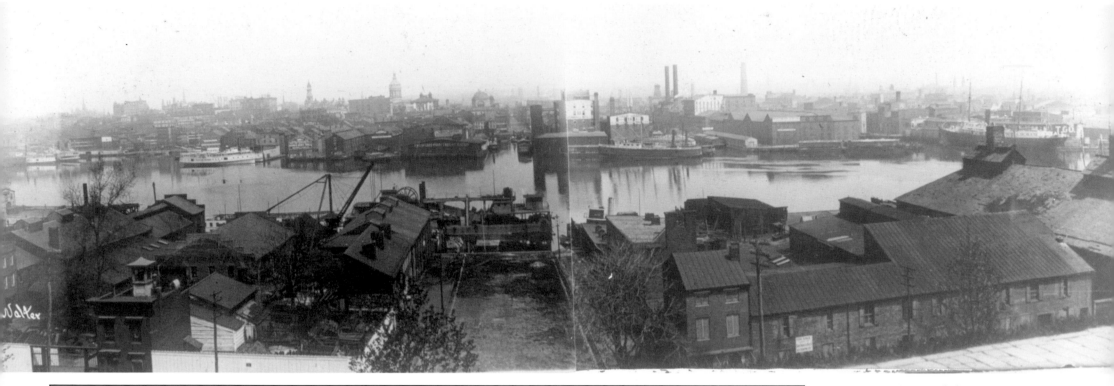

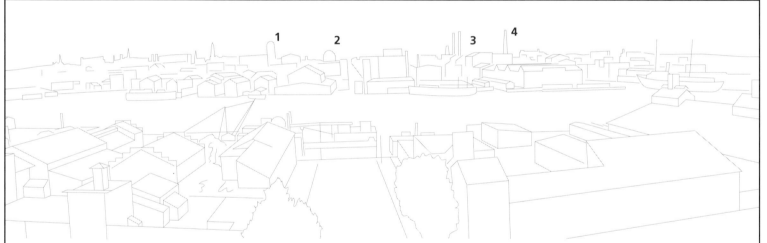

Baltimore, MD

Baltimore Harbor, 1904 (above)

Bird's eye view of Baltimore and Baltimore Harbor showing the area of downtown Baltimore that was devastated by an historic fire that began on Sunday February 7, 1904. Despite heroic efforts by Baltimore's fire department along with aid from other fire departments, the fire continued to rage. By Monday, February 8, the piers

along Pratt Street were aflame. Although finally the fire was brought under control it smoldered for weeks afterwards.

1 City Hall
This six-story structure was built 1867–1875 to the design of George A. Frederick at a cost of nearly $2.3 million. The exterior walls are faced with white marble quarried in

Baltimore itself. Nearly a hundred years later, in 1974, a complete restoration and renovation, including the dome, ensured that this remarkable building would continue to see service into the twenty-first century.

2 Pratt Street Power Plant
Built between 1900 and 1909 for the United Railways and Electric Company, it ceased working after World War II and is now used for shops.

3 Merchant's Exchange Building
This domed building was designed by Godefroy and Latrobe and built between 1816 and 1820. It housed the

Customs Service until the new U.S. Custom House was built. The new building was started in 1903, damaged by the fire, and finished in 1907.

4 Phoenix or Old Baltimore Shot Tower
In operation between 1828 and 1892, its name is used in the nearby Shot Tower/Market Place station. At that time people made shot for pistols and rifles and ammunition for larger weapons by dropping lead from a height into water.

Baltimore Harbor, 2000 (right)

5 Commerce Place
A thirty-one-floor combined parking garage and office tower at South and Commercial Streets. Completed in 1992, it is Baltimore's fourth tallest building.

6 World Trade Center, Baltimore
Considered the World's tallest pentagonal (five-sided) building, it is located at East Pratt Street on Baltimore's Inner Harbor.

7 Harborplace Pratt Street Pavilion
Offers a host of restaurants and shops in a pleasant harborside environment. It is comparable to other modern

waterfront developments, such as Jack London Square in Oakland, California.

8 National Aquarium

Opened in 1981, this popular attraction features displays of more than 16,500 animals ranging from plankton to puffins. It receives more than 1.5 million visitors a year.

9 Sloop-of-war/Corvette USS *Constellation*

Deemed the United States Navy's final all-sail warship, built in 1854, it has

been preserved in Baltimore since 1955, and in the late 1990s was given a thorough renovation.

10 Renaissance Baltimore Harborplace Hotel

A comfortable harbor-side hotel, it is part of the Marriott chain and has over six hundred rooms.

11 Columbus Center

The ill-fated Hall of Exploration did not succeed in attracting sufficient visitors.

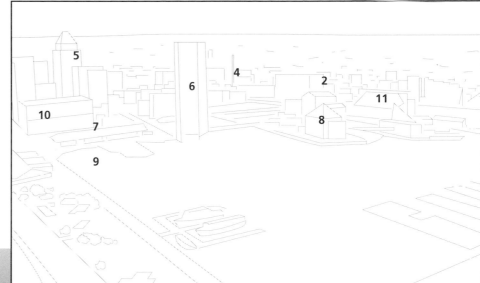

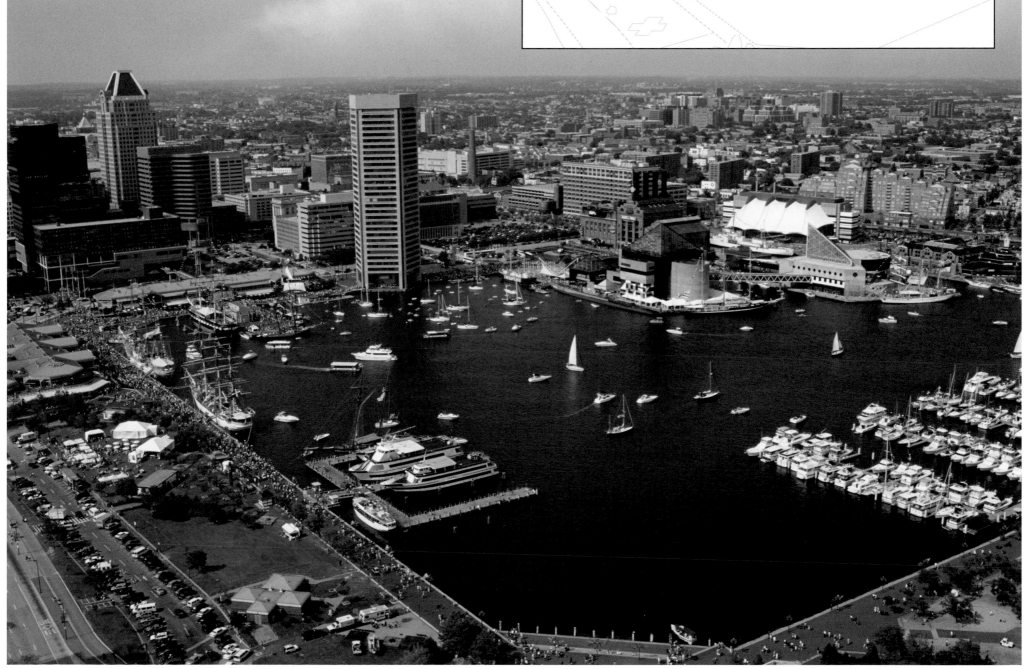

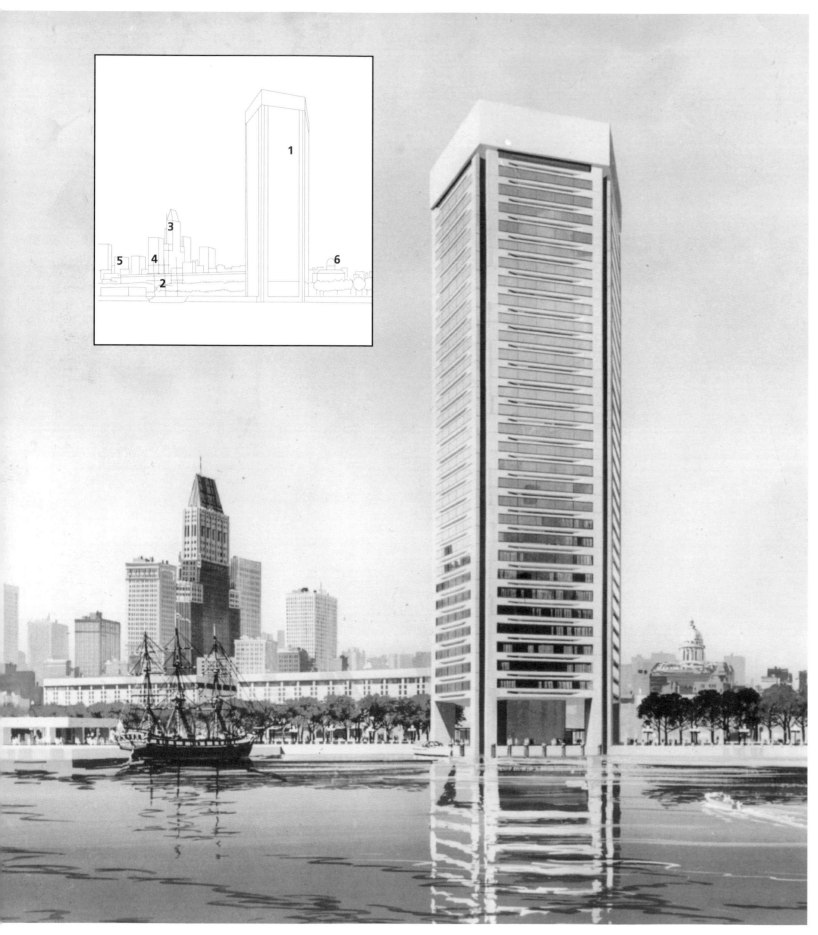

Baltimore Harbor, 1904

1 World Trade Center, Baltimore

An artist's conceptual vision of Baltimore's World Trade Center tower before the more recent development of the Inner Harborside. Designed by architects Henry Cobb and Pershing Wong, this unusual five-sided building was intended to convey maritime connotations and provide the illusion that it rises from the Inner Harbor's depths. At night lights shine from the top like a crown emulating the effect of a lighthouse. Completed in 1977, and owned by the State of Maryland, it was among the first major new buildings along the Baltimore waterfront in many years. An observation deck on the twenty-seventh floor offers panoramic views of greater Baltimore. This "Top of the World" observatory features floor to ceiling windows

2 Sloop-of-war/Corvette USS *Constellation*

Among the popular attractions of Baltimore's Inner Harbor.

3 Old Baltimore Trust Company Building

Constructed in 1924 using an Art Deco design blended with Mayan motifs, when completed it was the tallest structure in Maryland. Since 1997 it has been known as the Bank of America Building.

4 Baltimore Gas & Electric Building

Designed by Parker, Thomas & Rice with a terra cotta façade, this twenty-one-story structure opened in 1916. Originally an office tower, it has since undergone conversion to apartments.

5 First National Bank Building

Completed in 1924, a neoclassical twenty-floor (254 feet tall) office tower designed by Graham, Anderson, Probst & White—the prominent Chicago-based architectural firm that succeeded Daniel Burnham & Co. and designed many well known skyscrapers and other urban edifices in the 1920s and 1930s.

6 Baltimore City Hall

Built between 1867 and 1875 using the

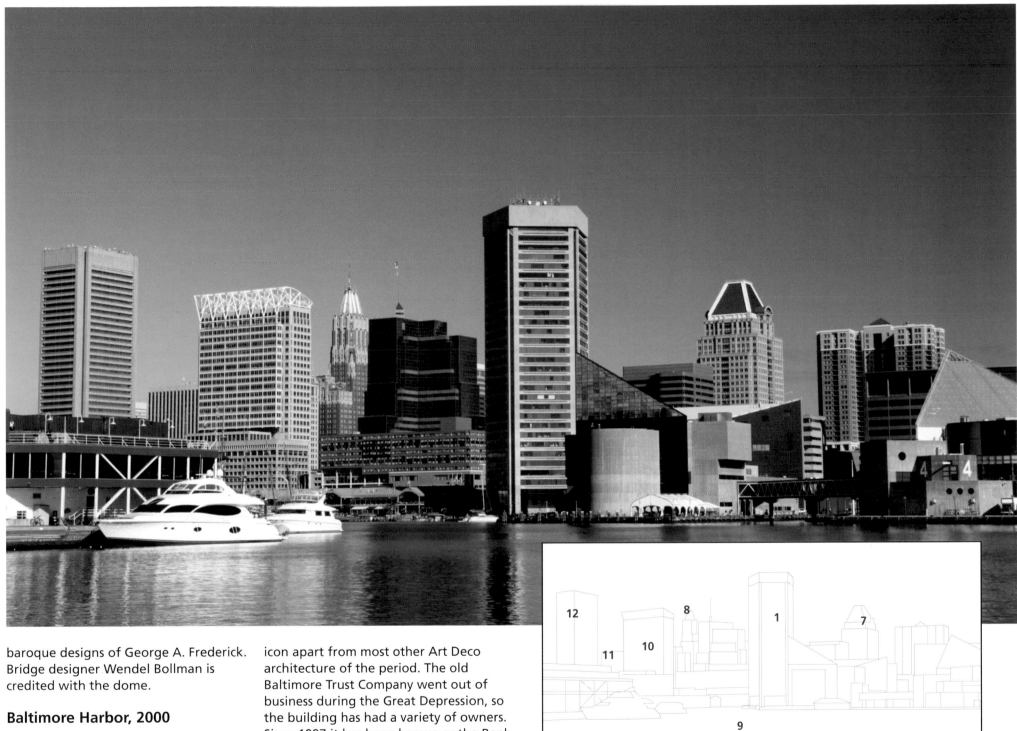

baroque designs of George A. Frederick. Bridge designer Wendel Bollman is credited with the dome.

Baltimore Harbor, 2000

7 Commerce Place
Baltimore's fourth tallest building has a prominent place on the Baltimore skyline—although at just 454 feet it would be lost in the sea of skyscrapers in either New York City or Chicago. It was completed in 1992.

8 Old Baltimore Trust Company Building
Taylor and Fisher's unusual choice of neo-Mayan décor sets this Baltimore

icon apart from most other Art Deco architecture of the period. The old Baltimore Trust Company went out of business during the Great Depression, so the building has had a variety of owners. Since 1997 it has been known as the Bank of America Building.

9 Baltimore Inner Harbor
Refers to the entire region of the city, including the water in the harbor itself. This traditional seaport area has been redeveloped as a popular tourist attraction with ample dining, shopping, and recreational activities on offer.

10 100 East Pratt Street
Although construction of this unusual building began in 1973, completion was delayed for decades and it wasn't really finished until 1992.

11 M&T Bank Building
Also known as the First Maryland Building, this modern high-rise office tower is 315 feet tall with twenty-

two floors and is located on South Charles Street. It was built in 1972 and there are currently only eighteen taller buildings in the city.

12 Legg Mason Building
Baltimore's tallest—at 528 feet—completed in 1973, it was named for the Legg Mason Investment company.

Boise, ID

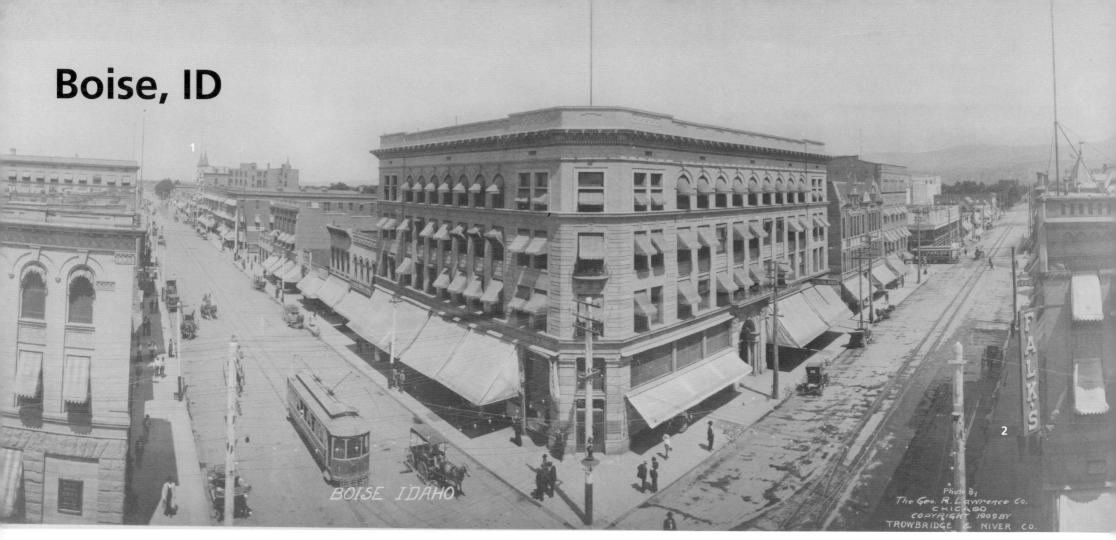

BOISE IDAHO

Photo By
The Geo. R. Lawrence Co.
CHICAGO
COPYRIGHT 1909 BY
TROWBRIDGE & NIVER CO.

Boise, ca. 1909 (above)
(locations identified on image)

The U.S. Army built a fort in this vicinity in 1863 to protect immigrants on the Oregon Trail from marauding Indians. The name Boise is possibly an Anglicized corruption of the French word for trees or woods, *bois*, as fur trappers had worked the area trapping beavers for at least fifty years. The city is located on the Boise River and sited against an arm of the Boise Mountains to the northeast.

1 Main Street
Horses, bicycles, and pedestrians compete with motor cars and electric trolleys in this photograph. Angling left is Main Street with the spires of the Idanha Hotel in the distance on the right. Opened in 1901, the distinctive hotel was once the tallest building in the state and operated Idaho's first elevator. It is now an apartment building.

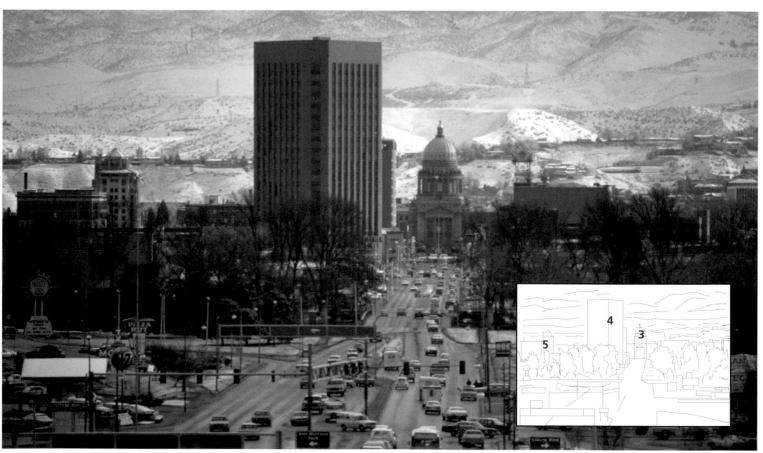

2 Falk's Store

One of Boise's more successful general stores, it started in 1868 on Main Street and remained in operation until 1982. Falk's was also involved in building the Egyptian Theater on Main and 7th.

Boise, 1980s (opposite, below)

In this photo from a generation ago, much of Boise's brick downtown still exists. Many of these buildings are only in need of bringing up to code to create homes for Marsh and Merrill Lynch, for coffee shops and boutiques.

3 Capitol Building

Like so many capitol buildings in the United States, Idaho's is modeled after the federal capitol in Washington, D.C. Completed in 1913, extensive remodeling was completed in January 2010. It is the only state capitol to be heated by a geothermal well.

4 U.S. Bank Plaza

Completed in 1978, this twenty-story highrise at 101 South Capitol Boulevard is the tallest building in Idaho. It has an all-marble and tile lobby with high vaulted ceilings.

5 Hoff Building

Completed in 1930, this fourteen-story, 164-foot building boasts a restaurant with a view of the skyline.

Boise, 2000 (below)

Flowers bloom in gardens near the old Boise Depot. The view to the north and east along Capitol Boulevard shows the Idaho capitol building and the central city: 4 the tall but partially obscured (by 6 the 252-room Grove Hotel and Qwest Arena) U.S. Bank Plaza, 7 One Capital Center, 8 Wells Fargo Center and other highrise buildings.

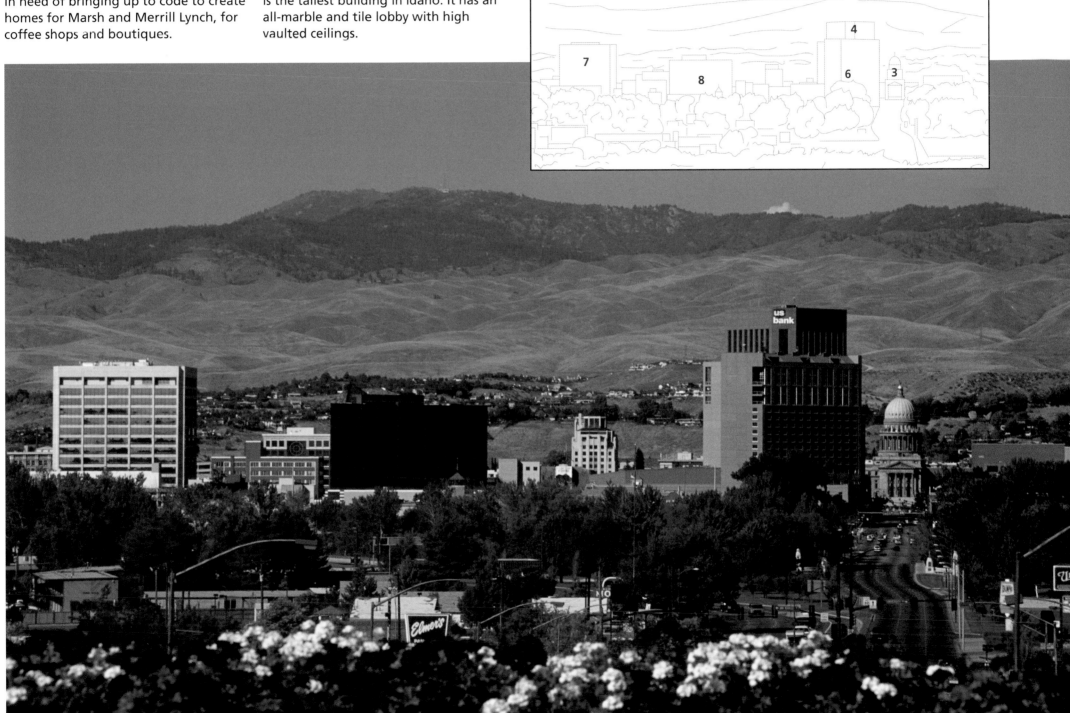

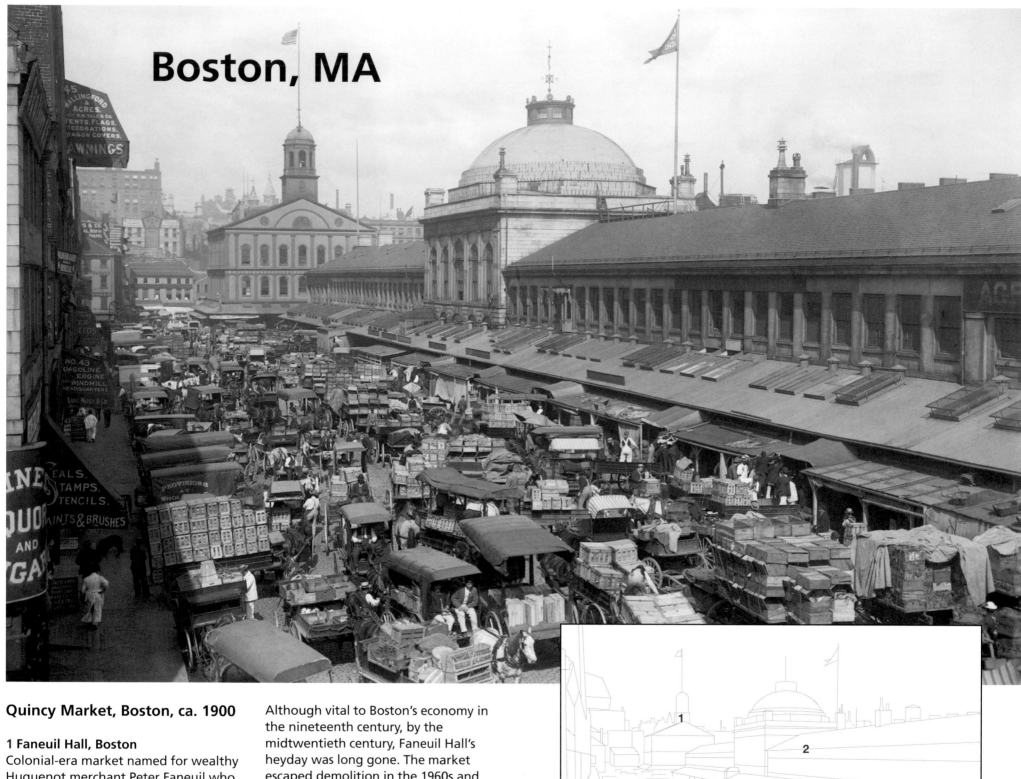

Boston, MA

Quincy Market, Boston, ca. 1900

1 Faneuil Hall, Boston
Colonial-era market named for wealthy Huguenot merchant Peter Faneuil who had it built in 1742 as a gift to Boston. It provided the venue for a bustling produce market where meats, fish, eggs, cheese, and other farm produce were sold. In the mid-eighteenth century it developed a political significance as it was the site for speech making by Samuel Adams and others agitating Bostonians for American independence.

Although vital to Boston's economy in the nineteenth century, by the midtwentieth century, Faneuil Hall's heyday was long gone. The market escaped demolition in the 1960s and early 1970s when Boston redeveloped many traditional areas. Instead, Faneuil Hall became a pioneering example of adaptive reuse and urban renewal, setting an important precedent for refurbishment of historic buildings for the public. Today, Faneuil Hall and Quincy Market attract an estimated eighteen million visitors annually.

2 Quincy Market

In 1826, the Faneuil Hall market was expanded through the addition of Quincy Market. Greek Revival was popular in New England architecture in the Jacksonian-era, and architect Alexander Parris worked with this style which contrasts with the earlier buildings around it. The new market was named for Boston mayor and early railroad advocate Josiah Quincy.

Quincy Market, Boston, 1998

3 28 State Street

Forty stories, some 500 feet tall, the building was completed in 1970. From 1996 it housed the headquarters of Citizens Bank.

4 McCormack Building

Completed in 1975, its distinctive black and white façade was designed by Hoyle, Doran and Berry Architects. At just over 400 feet and twenty-two stories, today twenty-four other buildings in Boston are taller.

5 John F. Kennedy Federal Building

This twenty-six-floor (387 feet) building is located on 15 New Sudbury Street near City Hall Plaza. It was completed in 1967 and is used for federal government offices.

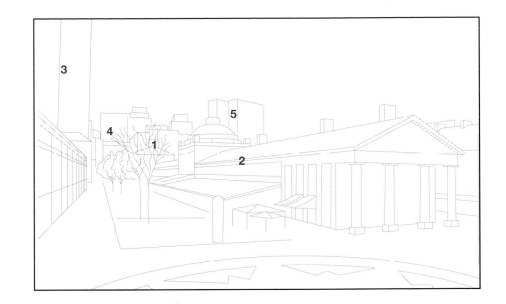

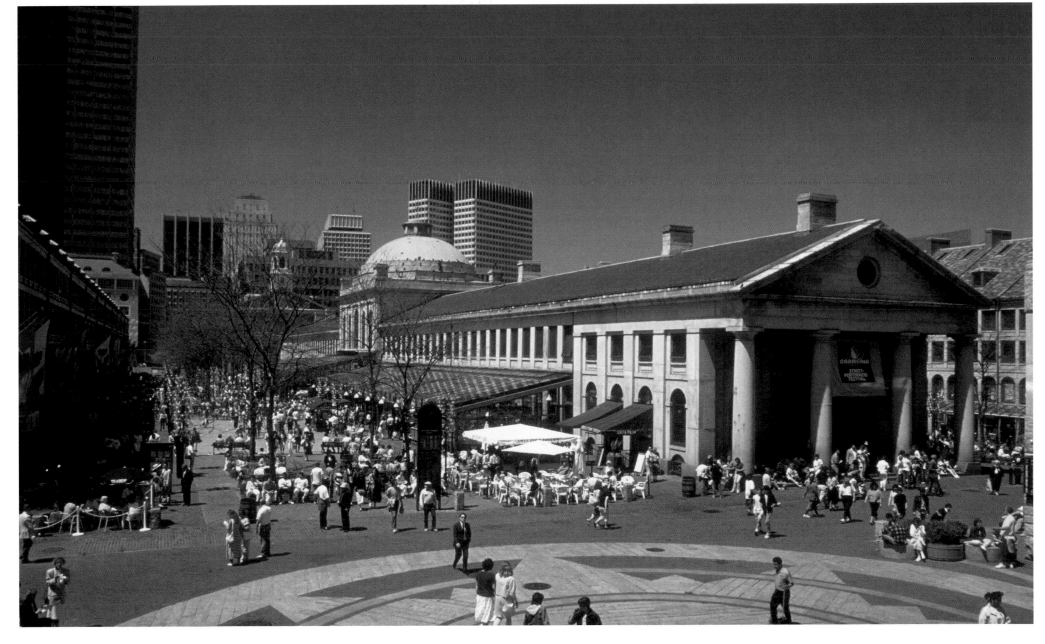

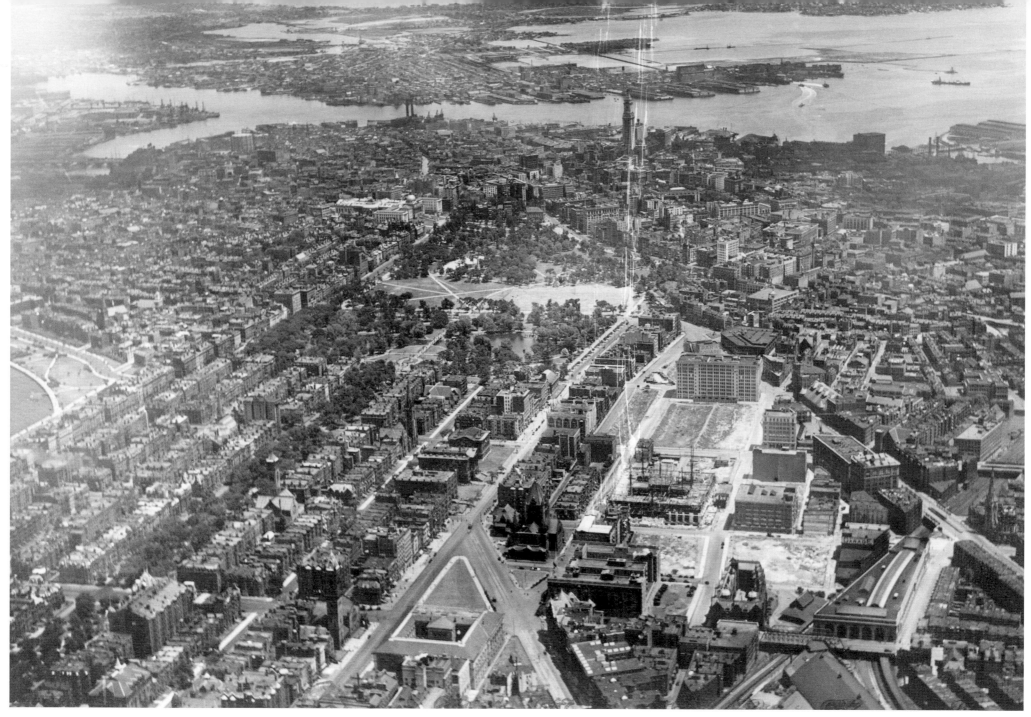

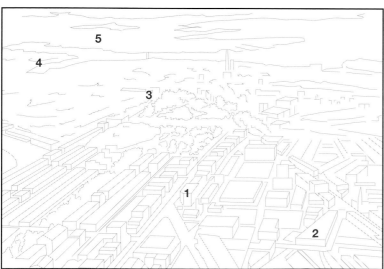

Boston Common, 1922

1 Trinity Church
Among Boston's most famous landmarks, this Episcopal church at Copley Square was designed by eminent New England architect Henry Hobson Richardson. Constructed of granite quarried at Dedham, Quincy, Rockport and Westerly, and Brownstone from Longmeadow, the church was built between 1872 and 1877. Its architectural significance forwarded Richardson's professional career while propelling him into Boston's social elite.

2 Back Bay Station
New Haven Railroad's Back Bay Station was built in 1899 to an unusual design which straddled the junction of its mainline with that of the Boston & Albany. The original station pictured here was demolished in the 1980s and replaced with a new station that today serves both Amtrak's long distance trains and local suburban trains operated by the Massachusetts Bay Transportation Authority—known as the "T."

3 Massachusetts State House
Designed by Charles Bullfinch, and situated on the top of Beacon Hill, this brick administrative building was completed in 1798. Its famous dome was originally painted wood, but later clad in copper plate. In 1874, decorative 23-karat gold veneer added a characteristic gleam to this

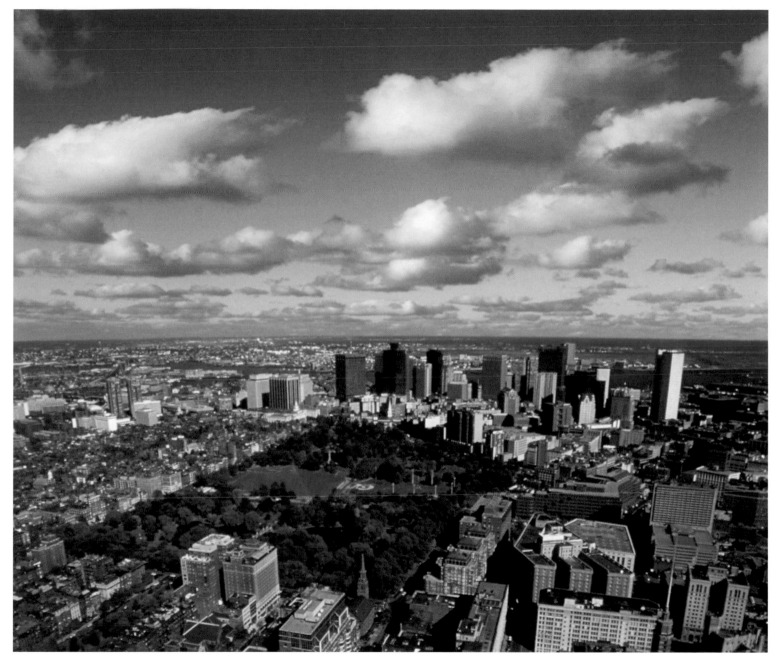

Boston Common, 2007

6 Boston Common
Covering nearly fifty acres, this is considered the oldest public park in the United States. On the eve of the American Revolution British soldiers were encamped on these grounds. As late as the 1830s, it served as a common for public grazing of livestock. Near the center is the circular Parkman Bandstand, designed by Derby, Robinson, & Shepard and constructed in the early twentieth century to honor philanthropist George F. Parkman, who provided $5 million for the upkeep of the common and Boston's other public parks.

7 Boston Public Gardens
A twenty-acre park opened in 1859, it is famous for its pedal-operated swan boats that have carried people in its shallow and picturesque lagoon since the 1870s. The boats were inspired by blending new bicycle technology with the story of Lohengrin—who crossed a river to save his lover in a boat drawn by a swan.

8 Arlington Street Church
Located on its namesake street opposite the Boston Public Gardens, the present building of this Unitarian Universalist church dates to 1859.

9 Commonwealth Avenue
One of Boston's more elegant thoroughfares, it runs from the western edge of the public gardens with the green Commonwealth Avenue Mall separating the carriageways.

10 First National Bank of Boston Building
100 Federal Street is an imposing thirty-seven-story skyscraper with a brown granite façade and prominent cantilevered mid-section. Designed by Campbell, Aldrich, & Nulty, and completed in 1971, it remains Boston's sixth tallest building at 590 feet.

11 One Financial Center
Located at 10 Dewey Square, this forty-six-story office tower is among the more prominent buildings of downtown Boston.

important civic structure. There is a wooden pinecone at the top of the golden dome to symbolize logging in Boston during the eighteenth century.

4 Charles River
Flows eastward into Boston Harbor, separating downtown Boston from Cambridge and Charlestown.

5 Charlestown
Settled by Puritans in the early seventeenth century, and famous for its Revolutionary War battles, Charlestown is one of several outlying communities annexed by Boston.

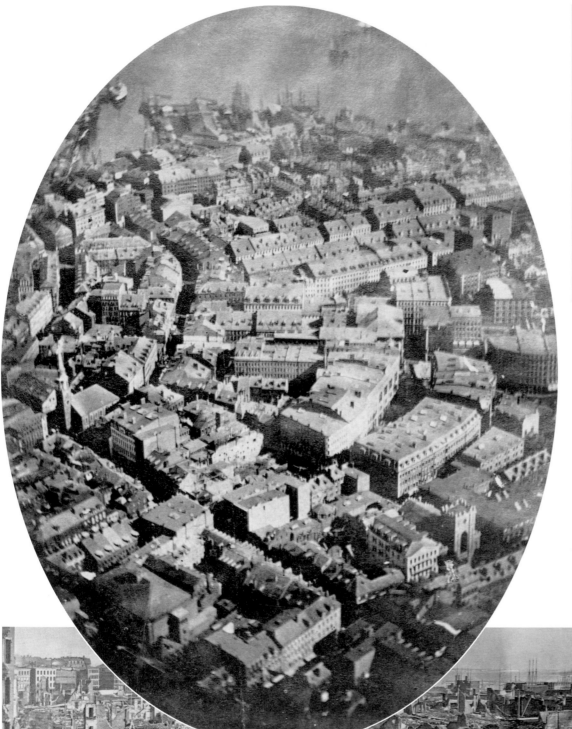

Downtown Boston, 1860 (left)

Boston has long played a central role in innovation, invention, and industry. This pioneering aerial photograph was made by James W. Black in 1860 using a plate camera in the basket of the hot air balloon *Queen of the Air*— owned by Samuel Archer King. The balloon was firmly tethered on Boston Common and looks eastward toward Boston Harbor. The scene was much altered twelve years later in the Great Boston Fire of 1872.

1 Washington Street
A long street (it stretches to the Rhode Island border) joining Boston peninsula with the mainland.

2 Old South Meeting House
The organizing point for the Boston Tea Party on December 16, 1773, it was the largest building in the city for many years. The Meeting House almost burned in the Great Boston Fire but was saved from demolition by public subscription. It has been a museum since the 1870s.

Washington Street, 1873 (opposite, below)

This albumen print photograph from a negative exposed in February 1873 depicts the aftermath of the Great Boston Fire that began on the evening of November 9, 1872. The fire started in a warehouse for women's skirts and spread rapidly as a result of poor building standards, a lack of building quality enforcement, locked fire alarms, plus difficulties with fire hydrants and ineffective firefighting equipment. Some sixty-five acres of downtown Boston were engulfed. More than 775 structures were destroyed, and at least twenty people were killed.

Downtown Boston, 2009 (right)

3 Boston Common
The handful of trees with orange leaves hints at the autumn foliage for which New England is famous. Boston's temperatures are moderated by its proximity to the Atlantic and thus the trees turn later than inland areas.

4 Parkman Bandstand
Named for philanthropist George F. Parkman.

5 Massachusetts State House
Resting atop Beacon Hill, this well-known building is seat of state government and a popular tourist attraction. Its famous dome was recently re-gilded.

6 One Beacon Street
The Employers-Commercial Union Company building, a nondescript thirty-seven-story office tower on the site once occupied by the old Houghton-Dutton department store and Carney Building.

7 BNY Mellon Center
At forty-one floors (600 feet) this is the fourth tallest building in Boston. Designed by Pietro Belluschi and Emery Roth & Sons, and built during 1970.

8 Federal Reserve Bank Building
Built in 1977 and notable for its unusual arrangement and aluminum façade designed by architects The Stubbins

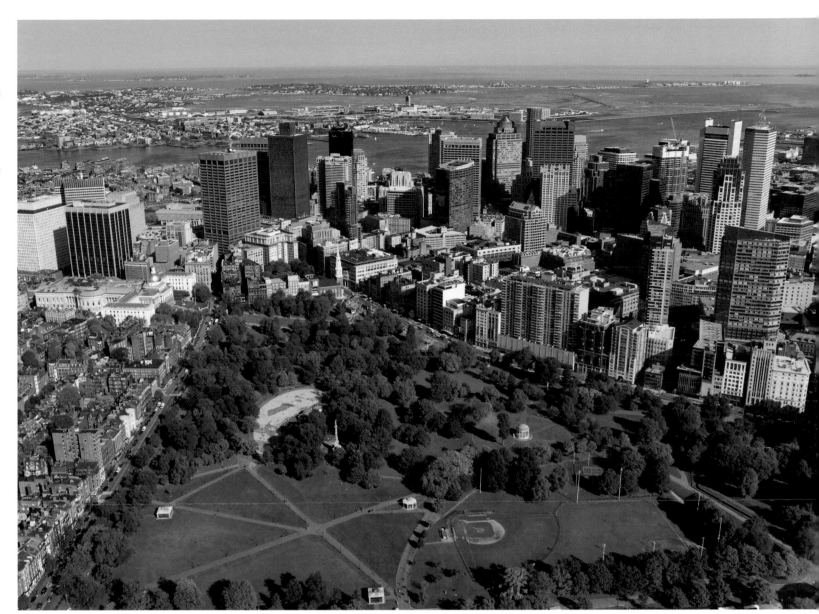

Associates, it is Boston's third tallest building. Compared with Manhattan's towering skyline, Boston's is more conservative. At just 614 feet this tower wouldn't even rank among the eighty tallest Manhattan skyscrapers.

9 Logan Airport
Located across the harbor in East Boston, this not only serves greater Boston, but most of New England. Access to the airport was improved by completion of the extraordinarily expensive "Big Dig" which resulted in relocation of expressways along the waterfront and a new tunnel under the harbor.

10 Likely tether point for the *Queen of the Air* in 1860.

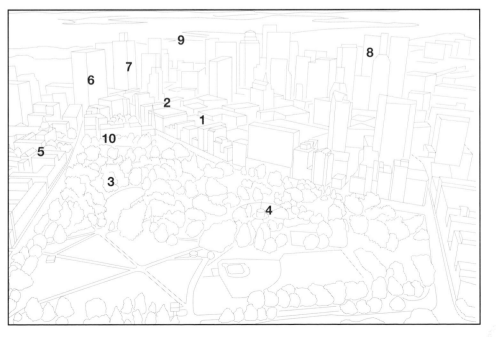

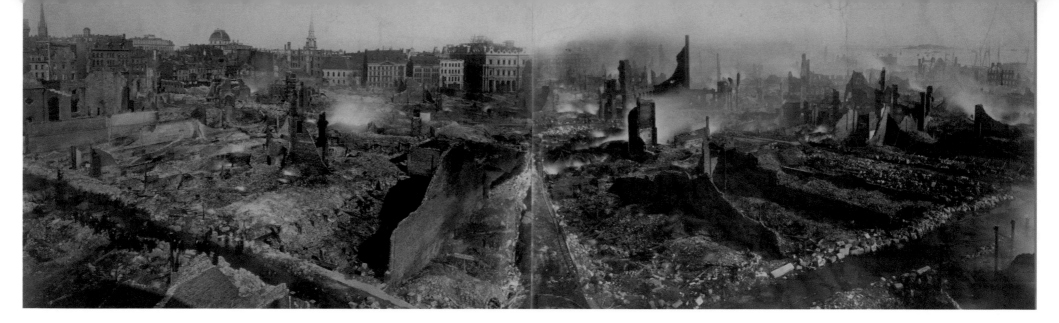

Boston from Summer Street after the fire, 1872 (above)

1 Trinity Church
The second of this name, on Summer Street—the epicenter of the fire—Trinity Church was burnt out.

2 City Hall
Or rather Old City Hall since the move in 1969 to the current City Hall.

3 Old North Church
This shows the spire that was destroyed in 1954.

Downtown Boston, 2008 (below)

4 Fan Pier
Pedestrian pier walkway to the luxury Fan Pier real estate development.

5 Federal Reserve Bank Building
A thirty-two-floor (614 feet) tall aluminum façade office tower, the third tallest building in Boston and the tallest on the waterfront. Completed in 1977, it predates most of the modern development stemming from the relocation of the Central Artery freeway below ground.

6 One International Place
Also known as Fort Hill Square, this forty-six-floor postmodern office tower is one of three connected buildings constructed in 1987.

7 Two International Place
Adjacent to the One International Place tower, but constructed five years later on a slightly smaller scale. This building is just thirty-five floors, and only 538 feet, to the earlier tower's 600 feet.

8 Rowes Wharf
Named for John Rowe, a mideighteenth century real-estate magnate who

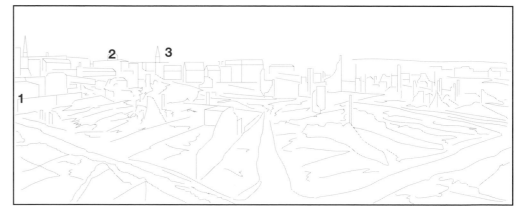

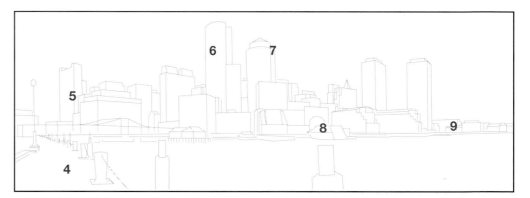

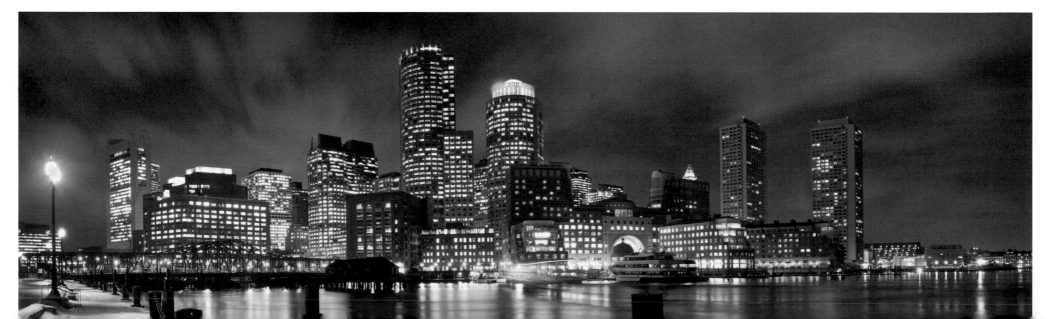

developed Boston's South Battery, as these piers were known traditionally. Historically an industrial area, today's Rowes Wharf combines a modern marine passenger terminal with the Boston Harbor Hotel and luxury condos.

9 New England Aquarium

One of Boston's top tourist attractions which features a four-story 200,000-gallon ocean tank.

Downtown Boston, 2008 (below)

10 John Hancock Tower

Boston's tallest and most prominent building, sixty floors measuring 790 feet above the street. It was designed by I.M. Pei & Partners and completed in 1976. To its right in the distance is One Financial Center.

11 Trinity Church

Located on Copley Square, this famous church—the third of this name—was designed by Henry Hobson Richardson and constructed from New England granite and brownstone 1872–1877.

12 The Westin Copley Place

This hotel, located near the Hynes Convention Center, has 800-plus rooms.

13 Back Bay Station

Today served by Amtrak and the MBTA trains, the present station was opened by Governor Michael Dukakis in 1987.

14 Massachusetts Turnpike

Built in the 1950s and 1960s, this is a primary east–west artery connecting Boston and Albany, and is part of Interstate 90.

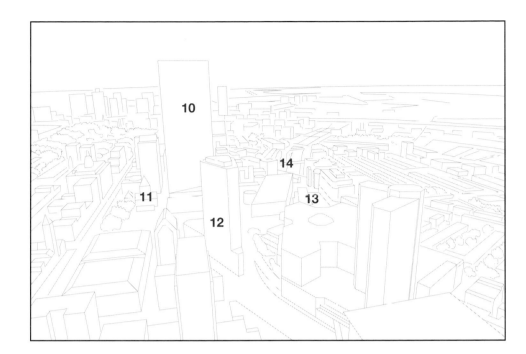

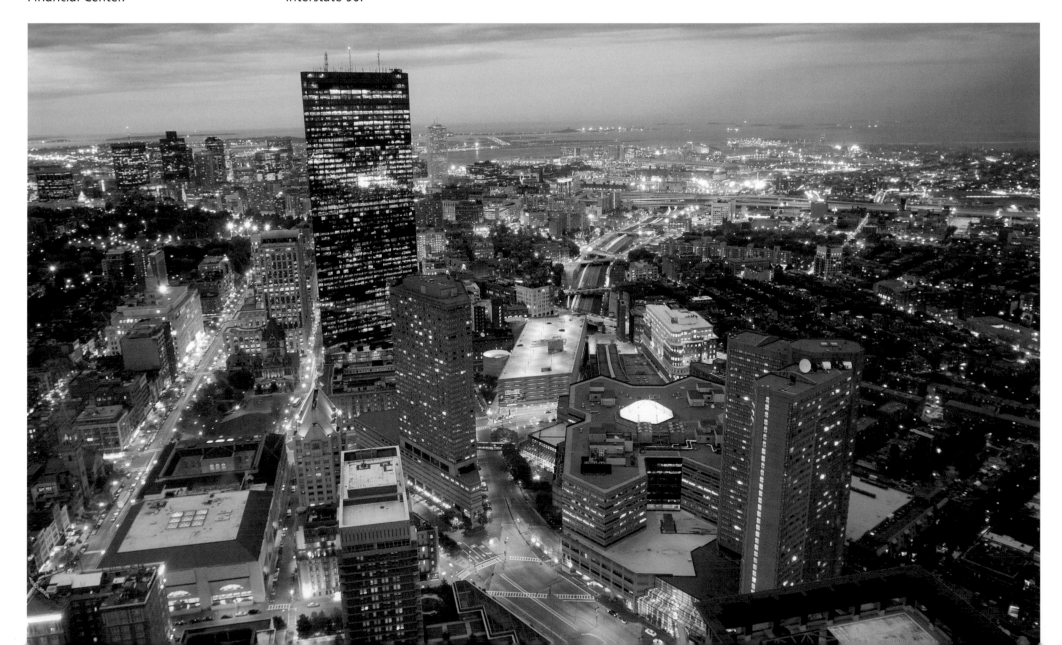

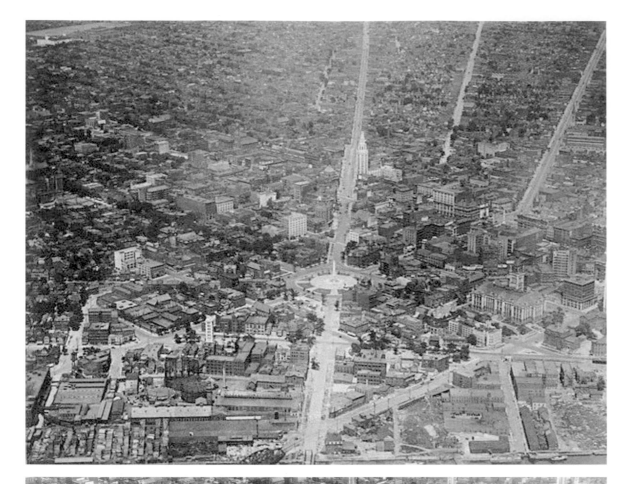

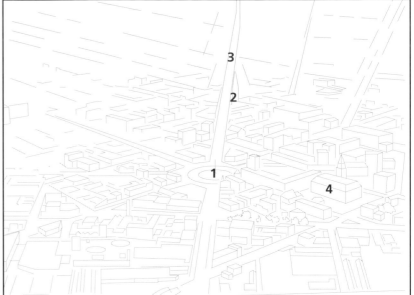

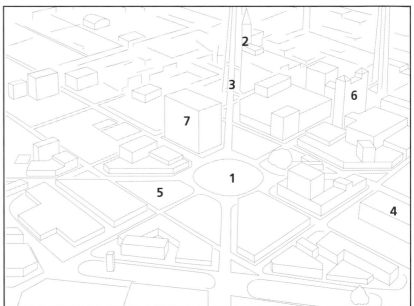

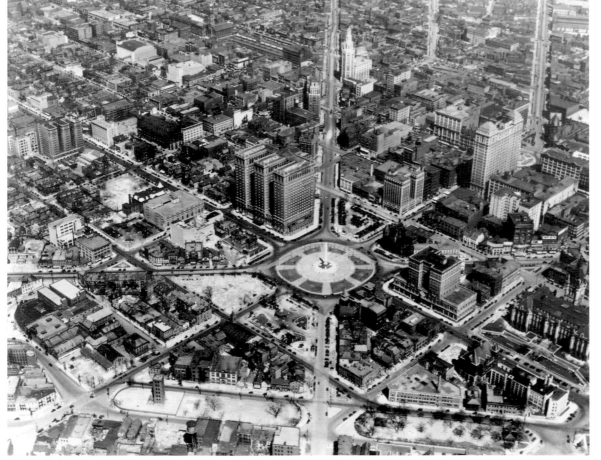

Buffalo, NY

Buffalo, 1922 (above left)

1 Niagara Square
Part of the original plan for
Buffalo drafted in the early
nineteenth century by Joseph
Ellicott and inspired by the work
of L'Enfant. Buffalo's street
system was conceived as a radial
network focused on this nexus. In
its center is the McKinley
Monument dedicated to the
president assassinated in Buffalo

in 1901. It was completed in 1907
and stands ninety-six feet tall.

2 Electric Tower
Among Buffalo's tallest historic
buildings, this fourteen-floor
Beaux-Arts highrise features a
prominent octagonal tower 294
feet tall. Headquarters of the
Buffalo General Electric
Company. Built in 1912, and
expanded twice in the 1920s,
today it is known as the Niagara

Mohawk Building, and remains Buffalo's second highest. In 2006, it was substantially renovated.

3 Genesee Street
One of Buffalo's main streets, it runs in a northeast/southeast alignment.

4 Erie County Hall
Designed by architect Andrew Jackson Warner in a Victorian-Romanesque style, it was built 1871–1875. It is among Buffalo's classic buildings and on the National Register of Historic Places since 1976.

Buffalo, 1930 (opposite, below)

5 Buffalo City Hall
This space has been cleared to start on the city hall. Designed by George Dietel, the 398-foot-tall, thirty-two-story Art Deco building completed in 1931.

6 Statler Towers
The second Buffalo Statler hotel (a wooden structure built at the start of the century) was converted to offices in 1984 and renamed Statler Towers

7 Liberty Building
This 1925 building has two replicas of the Statue of Liberty on the roof and is twenty-three stories (344ft) tall.

Buffalo, 2000 (below)

8 Coca Cola Field
Home of the Triple-A Buffalo Bisons, the field was completed in 1988.

9 Rand Building
Said to be the inspiration for the Empire State Building, this twenty-nine-floor (390ft) building was completed in 1929. It is named after a financier.

10 One M & T Plaza
Designed by Japanese-American architect Minoru Yamasaki, who also designed the Twin Towers, this twenty-one floor (318ft) bank headquarters building was completed in 1966.

11 Main Place Tower
Twenty-six stories (350 feet), designed by Harrison & Abramovitz, it was completed in 1969.

12 Saint Paul's Episcopal Cathedral
Designed by Richard Upjohn, architect of New York's Trinity Church, in a Gothic style, it was completed in 1851 and rebuilt by Robert W. Gibson after a gas explosion in 1888.

Butte, MT

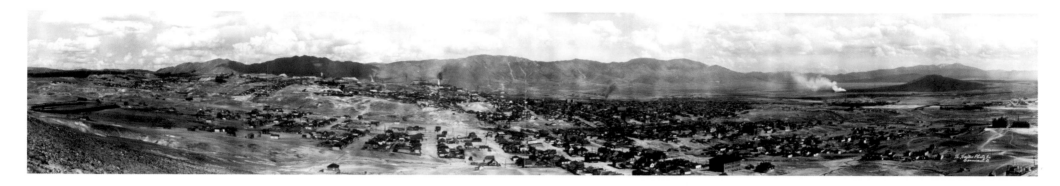

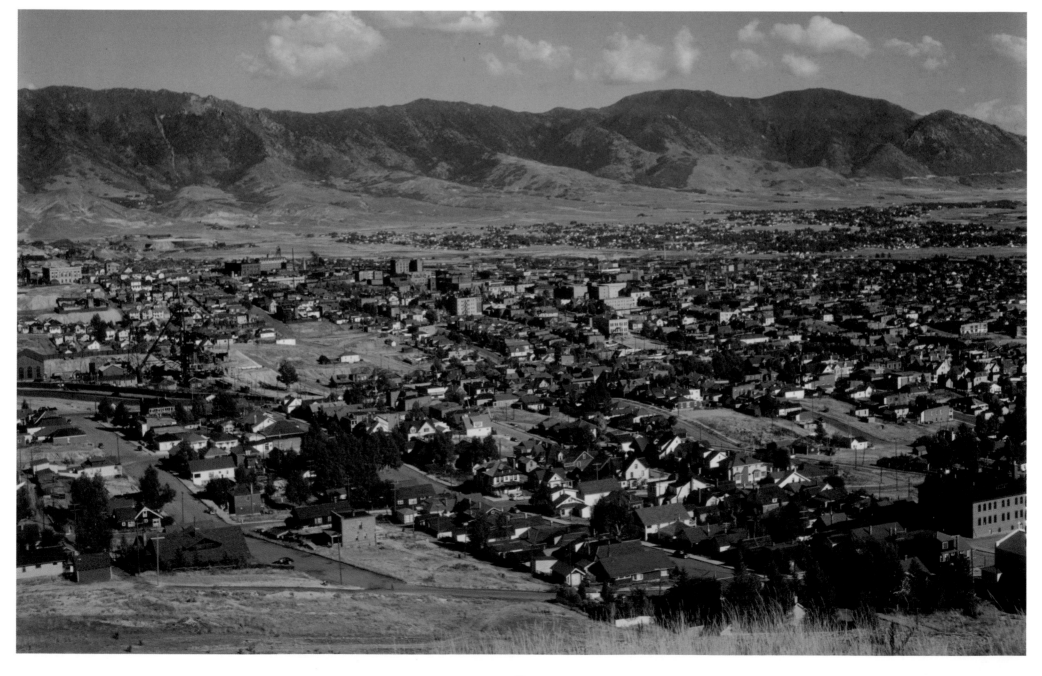

Butte, 1908 (opposite, above)

At 5,538 feet altitude, Butte, in the southwestern corner of Montana, is situated squarely among the Rocky Mountains. Although a small amount of gold and silver were discovered, it was the growing desire for electricity that made copper—a wonderful conductor—a metal of great industrial desire and drew immigrant miners from China, Poland and Syria. Although it looks small and desolate in the old photos, Butte soon became prosperous, so prosperous indeed that in the early quarter of the twentieth century it was referred to as the "richest hill on earth."

Butte, 1942 (opposite, below)

Butte was once a major mining center and one of the largest cities in the West. While gold and silver made Denver notorious, copper mining was the economic driver for Butte. Mining is never far from the mind of a Butte resident. The city and 120 miles of the downstream zone of the Upper Clark Fork River is America's largest Superfund site, contaminated with arsenic and toxic heavy metals caused by the Anaconda Copper Mining Corporation and the politicians who supported them. For generations, Anaconda's unregulated smelter released up to 36 tons per day of arsenic, 1,540 tons per day of sulfur and uncountable quantities of lead and other heavy metals, poisoning livestock and agricultural soils throughout the Deer Lodge Valley. Some scientists estimate that the environmental effects may take centuries to remedy

Butte, 1993 (below)

In 1977, city and county governments consolidated to form The City and County of Butte-Silver Bow. Population in the 2000 census was about 35,000.

1 "M"
The giant letter "M" visible on the hillside stands for Montana Tech of the University of Montana (formerly Montana School of Mines) and was constructed 100 years ago in 1910. Established in 1889, the school's nickname is, appropriately, The Orediggers. Enrollment is just under 3,000 students.

2 Neighborhood Headframe
The primary purpose of a headframe is to provide the hoisting ability to transport workers, supplies and materials in and out of a mine shaft. The World Museum of Mining is located at 155 Museum Way in Butte. The infamous Berkeley Pit, which devoured thousands of citizens' homes, can be seen across the valley to the east.

3 Immaculate Conception Church
The cornerstone of this church was laid in 1939. Up in the mountains above Butte stands Our Lady of the Rockies Statue, a 90-foot statue of the Virgin Mary.

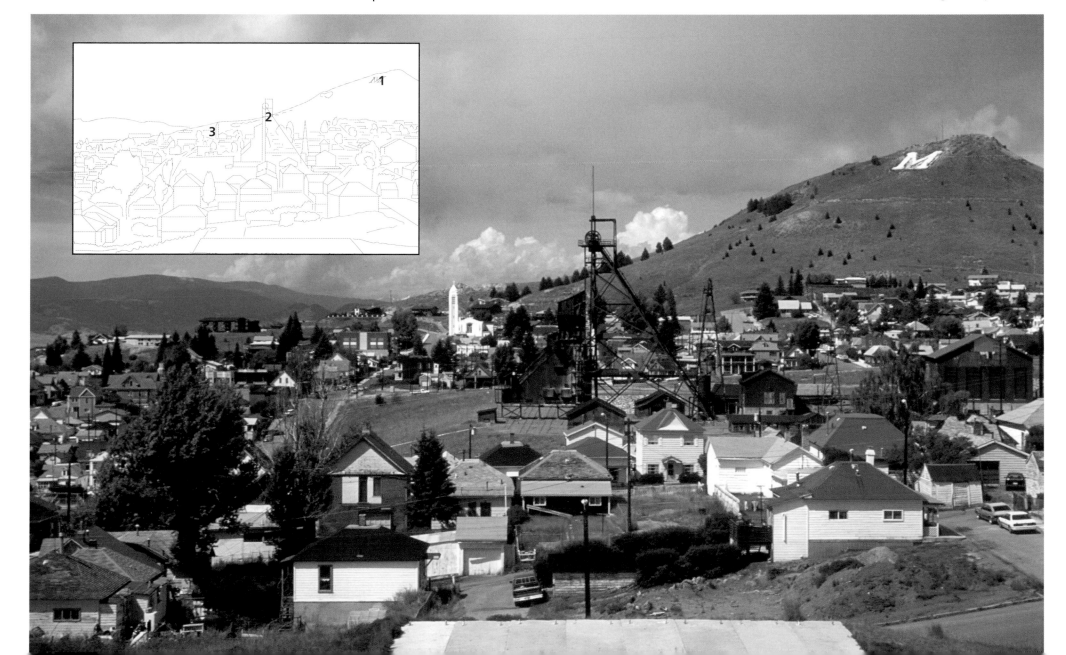

Chattanooga, TN

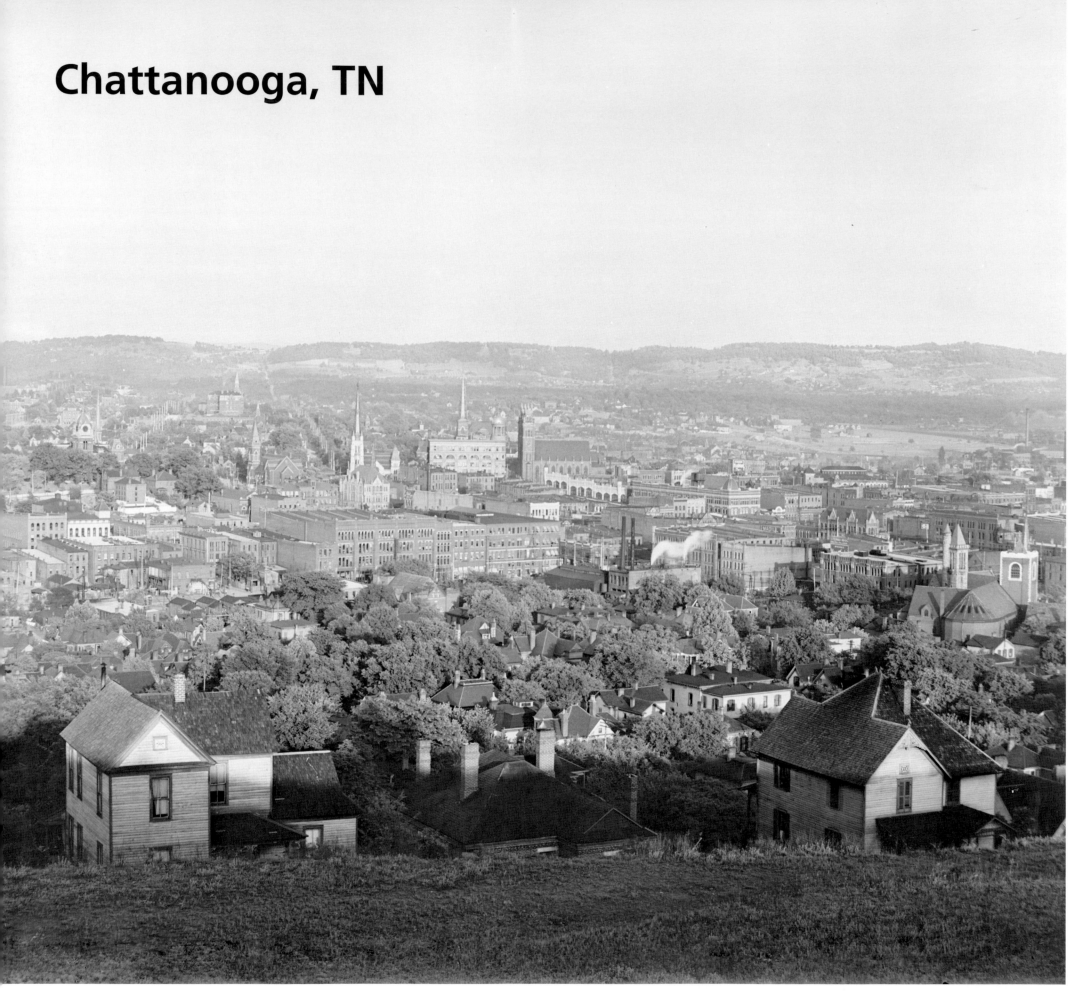

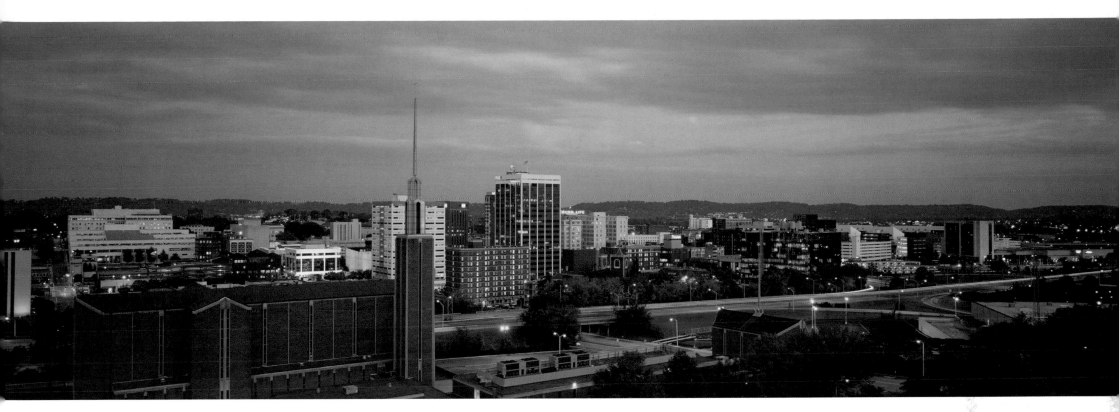

Chattanooga from Cameron Hill, 1902 (left)

By 1902, Chattanooga had become a vibrant industrial city. Smokestacks and church steeples were the tallest edifices in a city that was alive with trees. In decades the TVA, or Tennessee Valley Authority, would begin planning a series of dams on the Tennessee River that would help with flood control and deliver electrical service throughout the lower Appalachian region. Three geographer's tools help explain

Chattanooga: elevation, contour, and culture. About 680 feet above sea level downtown, the city transitions between the ridge-and-valley highlights of the Appalachian Mountains and the Cumberland Plateau. Surrounded by low mountains and ridges, it was often described as the city "where cotton meets corn."

1 Dome Building
This seven-story, brick, romanesque revival building was completed in 1892. The golden cupola is a local landmark.

2 Methodist Church
Today the Old Methodist Church steeple is all that remains of the "Stone Church"—as locals called it—on Georgia Avenue and McCallie Avenue.

3 Sts. Peter and Paul's Roman Catholic Church
Completed in 1890. The church was built with twin towers with many pinnacles as can be seen here. Unfortunately, the degradation of the sandstone led to the rebuilding of the west front in the 1930s.

Chattanooga from Cameron Hill, 2009 (above)

4 First Baptist Church
Occupying the immediate foreground at 401 Gateway Avenue is the First Baptist Church, completed in 1967. Its historic bronze bell originally hung in the tower of the first Baptist church and during the Civil War was painted black and removed from view so strangers would not realize it was bronze and take it to melt down for scrap. Behind the church is the vibrant downtown.

5 Republic Parking
The tallest building in Chattanooga stands at 633 Chestnut Street, the twenty-one-story Republic Center was completed in 1977.

6 First Tennessee Bank Building
This seventeen-storied building was completed in 1911. The architect was Reuben Harrison Hunt.

Chattanooga and the Tennessee River, 1864 (below)

1 Lookout Mountain
Although the photograph was probably taken during General William T. Sherman's Georgia campaign in 1864, this was the site of the Confederate defeat at the battle of Chattanooga on November 24, 1863. In the distance is the mountain where the battle took place.

2 Cameron Hill
The sizeable hill is at front right beyond the bend of the Tennessee River. Today, Cameron Hill has been chopped down to a gentle slope next to Highway 27,

and the hill has been circled with paved streets and invested with a crown of apartment buildings.

3 Temporary military bridge
As the supply and logistics base for their march to Atlanta to "cut the Confederacy in half" Chattanooga was essential to the Union forces.

Chattanooga and the Tennessee River, 2009 (right)

4 Bridges over the Tennessee
Three converging Interstate Highways—24, 59, and 75—and U.S. Highway 27 illustrate the critical juncture of

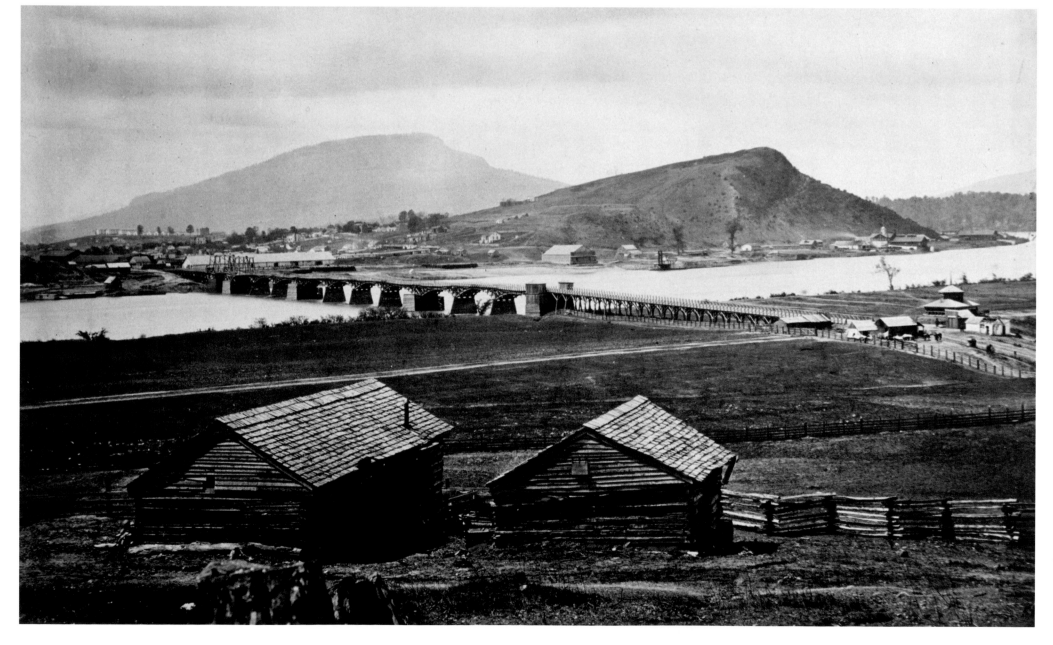

Chattanooga's position. Today's view shows three bridges spanning the Tennessee—(**4a**) Walnut Street Bridge, a truss bridge built in 1890 and currently being renovated as a pedestrian crossing; (**4b**) Market Street (or John Ross) Bridge, a bascule bridge completed in 1917 and renovated in 2005–2007; and (**4c**) Veteran's Bridge, a steel girder bridge built in 1984. Not visible here is the 1959 P.R. Oligiati Bridge.

5 Republic Parking
The tallest building in Chattanooga.

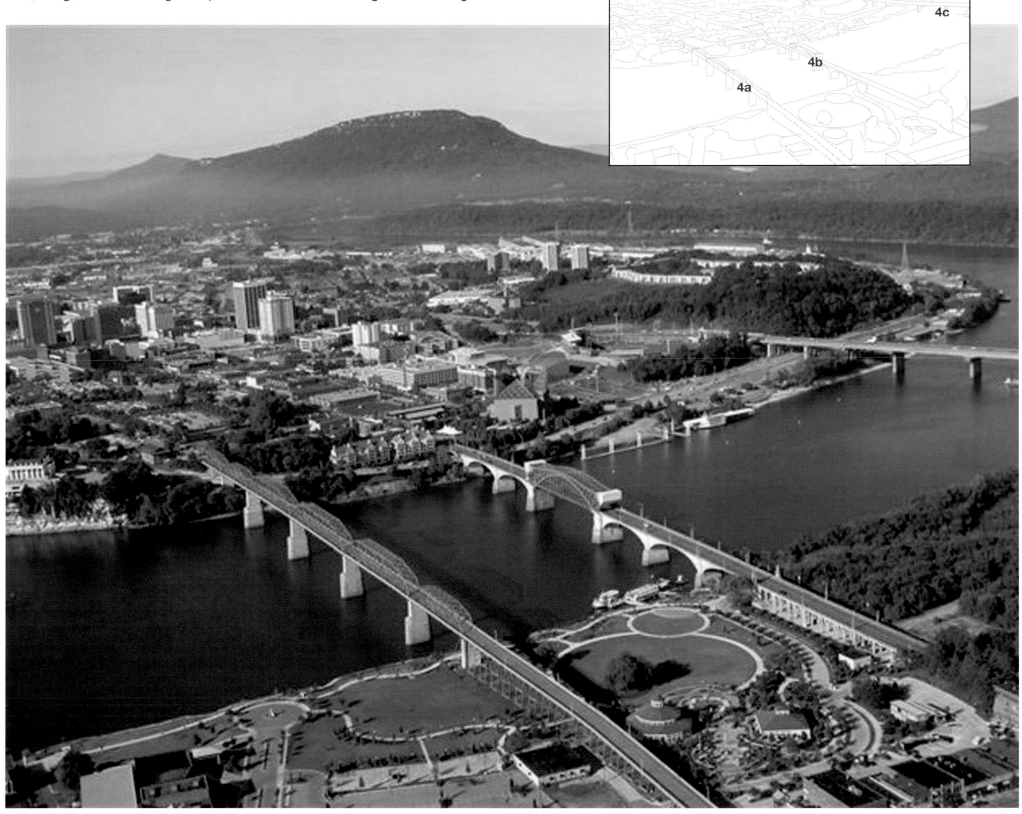

Chicago, IL

Michigan Avenue, 1935

1 Wrigley Building
Located on a triangular plot of land, the Wrigley chewing gum headquarters was designed by Graham, Anderson, Probst, and White in 1919 and based conceptually after the Giralda Tower on Spain's Seville Cathedral. The south tower—with a structural steel frame and a terra-cotta façade—was completed first in 1921, followed by the north tower three years later. Between 1922 and 1924 it was the tallest building in Chicago.

2 Medinah Athletic Club Building
Architect Walter W. Ahlschlager designed this forty-five-story tower in a Moorish Revival style that included a dome and minaret at the top. As built, this was more than 479-feet tall, but since completion in 1929 it was shortened slightly. The building only served its original owners for a few years, and today it serves the Inter-Continental Hotel.

3 Tribune Tower
The work of architects Hood & Howells, and John Vinci, this thirty-four-floor NeoGothic office tower, built with a structural steel frame, uses a limestone façade patterned after Notre-Dame's sixteenth-century Gothic "Butter Tower"

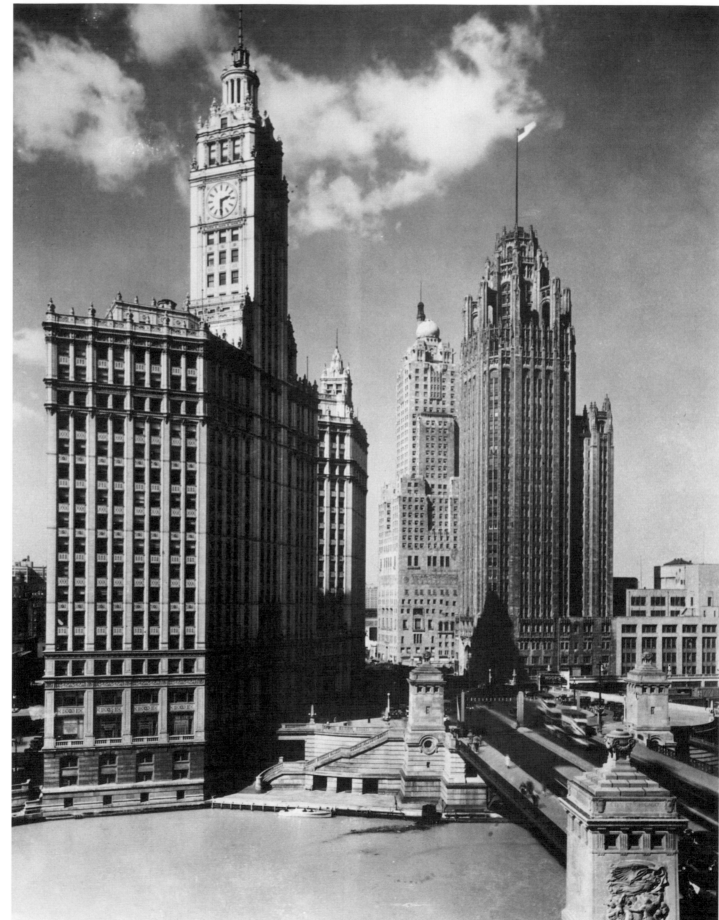

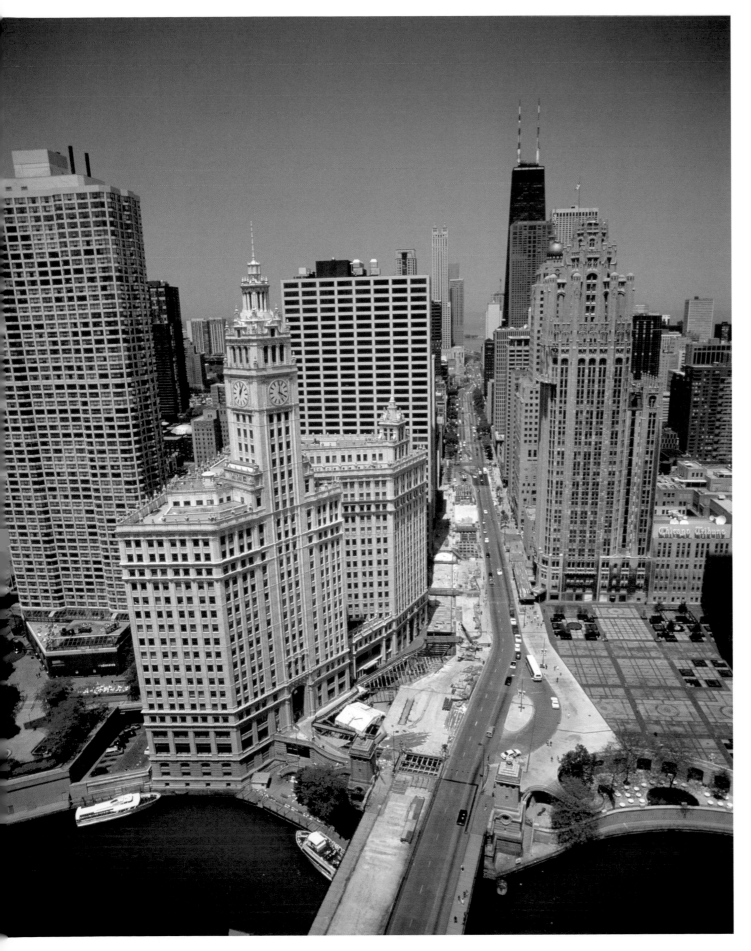

in Rouen, France. Offices for the *Chicago Tribune* newspaper.

4 Michigan Avenue Bridge
A double-deck double-leaf bascule lift span over the Chicago River carrying Michigan Avenue designed by Edward H. Bennett and constructed between 1917 and 1920. It is decorated with pictorial relief friezes.

5 Chicago River
In the nineteenth century, the flow of the Chicago River was reversed to empty into Lake Michigan, rather than its natural course into the Mississippi River.

Michigan Avenue, 2000s

6 River Plaza
A fifty-six-floor highrise residential building designed by Gordon & Levin and completed in 1977. This otherwise enormous apartment building is lost in Chicago's forest of skyscrapers and as of 2010 was only the seventy-ninth tallest building in the city.

7 John Hancock Tower
At 100 stories this is one of Chicago's tallest buildings. Designed in 1969 by Skidmore Owings & Merrill, the same architectural firm responsible for the Sears Tower, it shares aesthetical and structural characteristics with Chicago's taller and more famous office tower located several blocks to the south.

8 North Michigan Avenue
One of the city's main north–south streets.

Chicago River from Michigan Avenue, ca. 1935

1 One North LaSalle
Among the Art Deco skyscrapers in the downtown "Loop," it rises forty-eight floors above the street. Legend has it that explorer Robert Cavalier de la Salle—for whom the street and building both take their name—camped on the site of this towering edifice.

2 Jewelers Building
Built in 1927 as the Jewelers Building, this neoclassical tower was designed by Giaver & Dinkelberg, and Thielbar & Fugard. At forty stories, it was once among Chicago's tallest; today it is dwarfed by modernist monoliths. Now known as 35 East Wacker Drive, the tower made movie fame in 2005 when it was featured in *Batman Begins*—no New York skyscraper could better convey the darkness of Gotham.

3 North Wabash Avenue Bridge
Spans the Chicago River, a body of water dyed green to honor the Irish on St. Patrick's Day.

4 LaSalle-Wacker Building
Unremarkable among Chicago's skyscrapers by day, at night the top of the building is bathed in rich blue light.

5 American National Bank Building
Now known as 33 North LaSalle, the Art Deco tower was designed by Graham, Anderson, Probst & White and completed in 1930. Today it is not even among Chicago's hundred tallest buildings.

6 Randolph Tower
Constructed in 1929, in recent times its

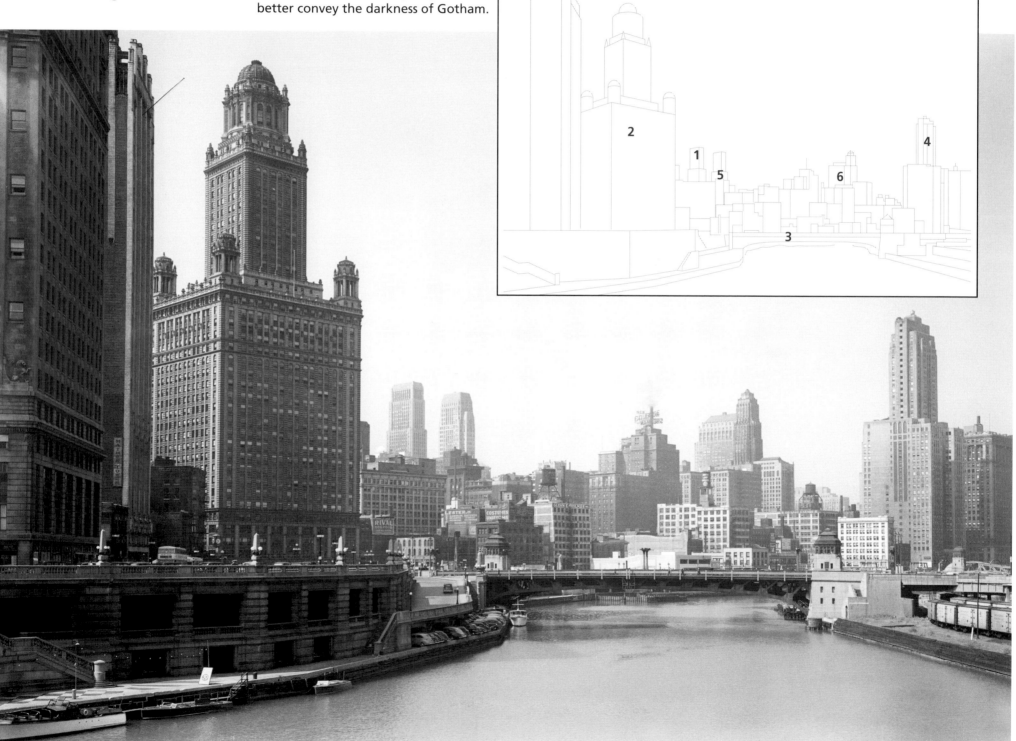

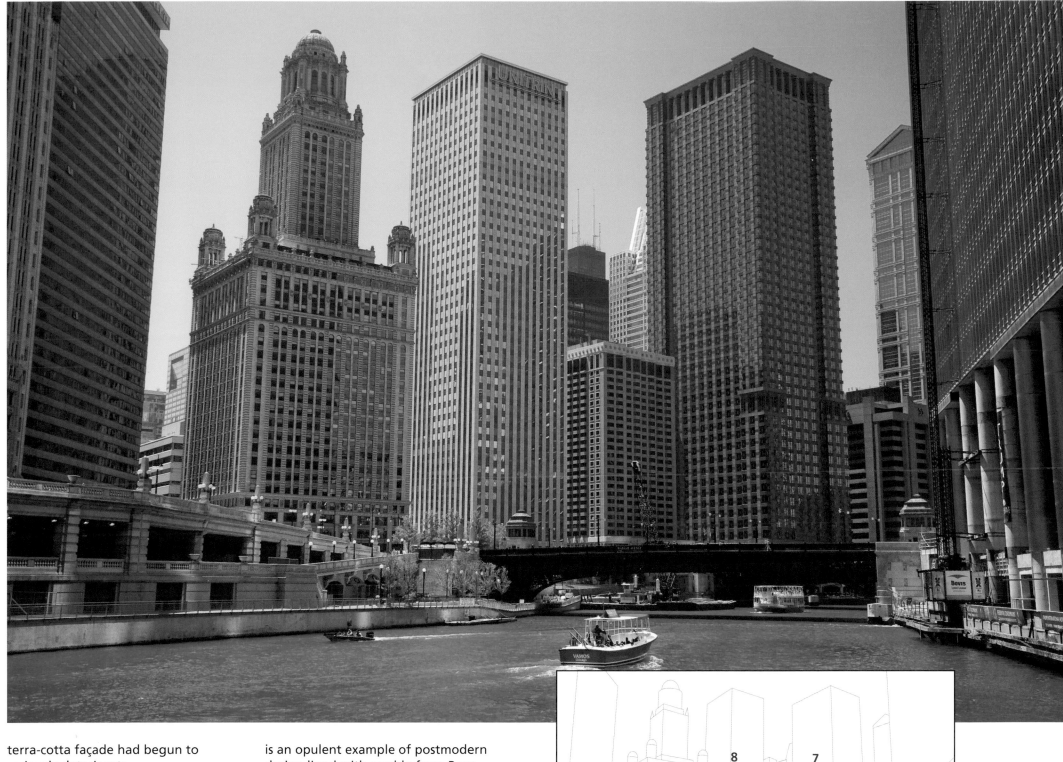

terra-cotta façade had begun to seriously deteriorate.

Chicago River from Michigan Avenue, 2009

7 Leo Burnett Building
At West Wacker Drive and Lake Street, a forty-six-story office named for the advertising agency that occupied much of the buildings' higher floors. Its lobby is an opulent example of postmodern design lined with marble from Rosa, Portugal.

8 Unitrin Building
Designed by Shaw, Metz and Associates, and Lucien Lagrange Architects to emulate a classical marble column, at forty-one floors it was the world's tallest structure with a marble façade when completed in 1962.

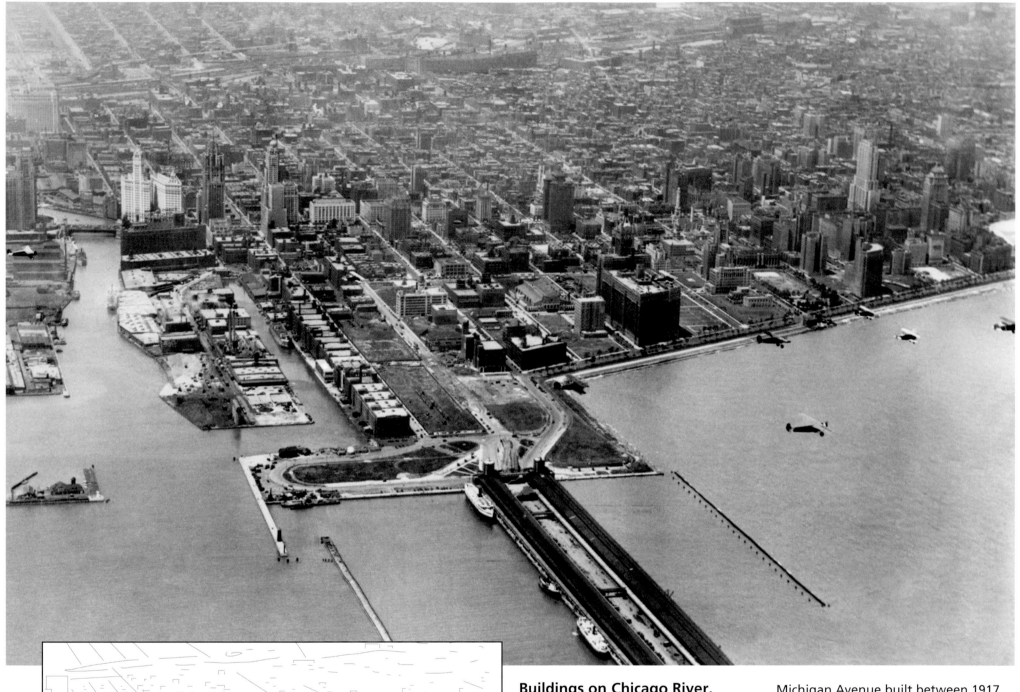

Buildings on Chicago River, ca. 1930

1 Wrigley Building
The south tower was completed first in 1921, followed by the north tower three years later.

2 Tribune Tower
A thirty-four-floor Neo-Gothic office tower.

3 Michigan Avenue Bridge
A double-deck double-leaf bascule lift span over the Chicago River carrying

Michigan Avenue built between 1917 and 1920. At this date the link bridge carrying North Lake Shore Drive and the Columbus Avenue bascule bridge (opened 1982) are yet to be seen.

4 Navy Pier
In more recent years this man-made promenade into Lake Michigan has been developed as a venue for outdoor festivals and entertainment.

5 Palmolive Building
Completed in 1929, this was one of the first tall skyscrapers built north of

Chicago's downtown "Loop." Between 1967 and 1990 it was famously the headquarters for *Playboy* magazine. Much of the building is now residential.

Buildings on Chicago River, 2009

6 Regatta
A forty-five-story condominium complex with glass façade completed in 2007.

7 North Lake Shore Drive
The double-decker Link Bridge over the Chicago River opened in 1937. The drive is a limited access highway along the Michigan lake front.

8 Trump International Hotel & Tower
As of 2009, Chicago's second tallest tower. Unlike many of the Loop's very tall buildings this is largely a residential skyscraper with some space available as a hotel. It was designed by Skidmore Owings and Merrill to appear different from every angle.

9 Aon Center
Originally the Standard Oil Building, after it opened in 1973 it was renamed the Amoco Building before becoming the Aon Center in 1999, head office of the world's second largest insurance broker.

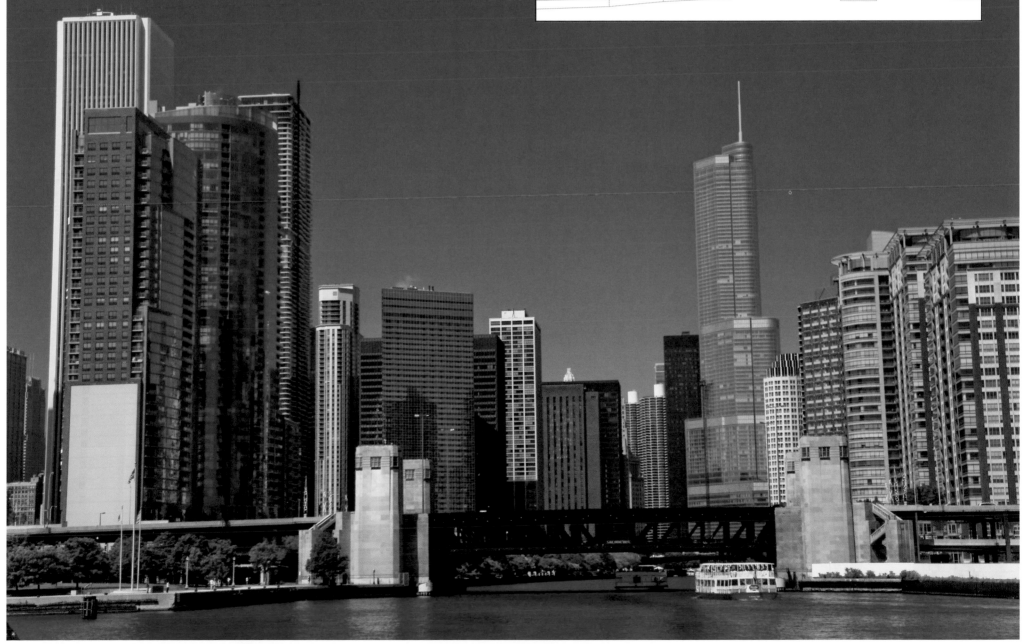

The Loop, 1936

1 Hilton Hotel
Located on the "Cultural Michigan Avenue Mile," when it opened in 1927 this massive edifice billed itself as the largest hotel in the world.

2 Art Institute of Chicago
One of America's premier fine art museums, it has one of the world's most notable collections of Impressionist and Post-Impressionist art.

3 Metropolitan Tower
Named the Straus Building when completed in 1924, the glass "beehive" ornament at the peak of the ziggurat holds a deep blue light, a prominent feature of Grant Park's night skyline.

4 Field Museum of Natural History
Incorporated in the State of Illinois on September 16, 1893, the museum was originally housed in the World's Columbian Exposition's Palace of Fine Arts. In 1905 the name was changed to Field Museum of Natural History to honor its first major benefactor.

5 35 East Wacker Drive
Also known as North American Life Insurance Building this forty-story 523-foot historic building was once the tallest building outside of New York City.

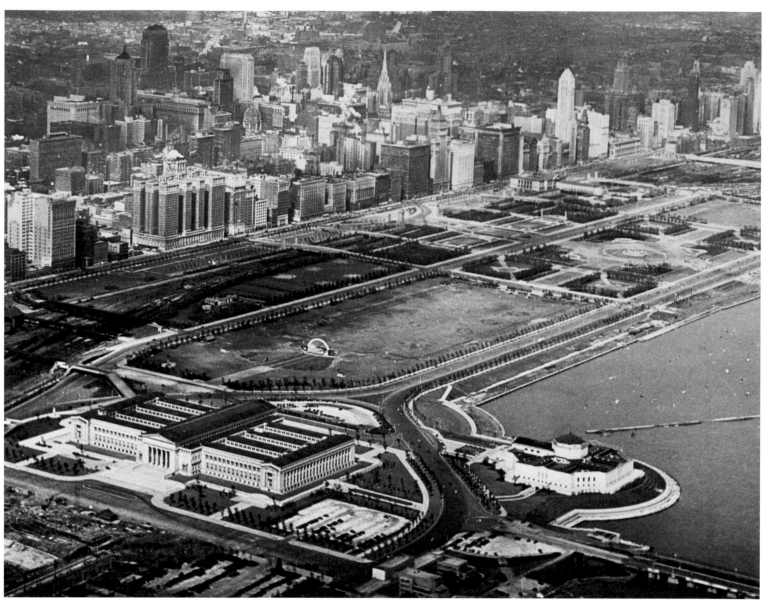

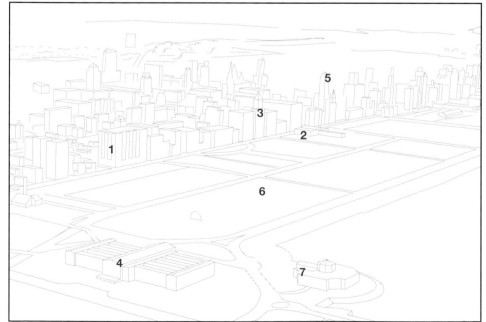

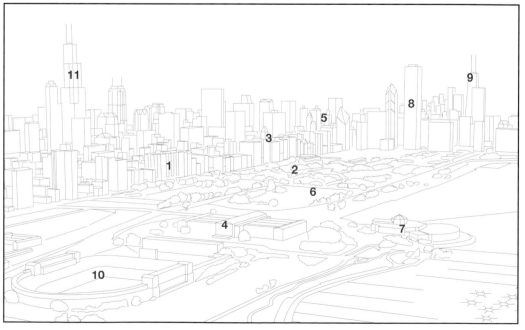

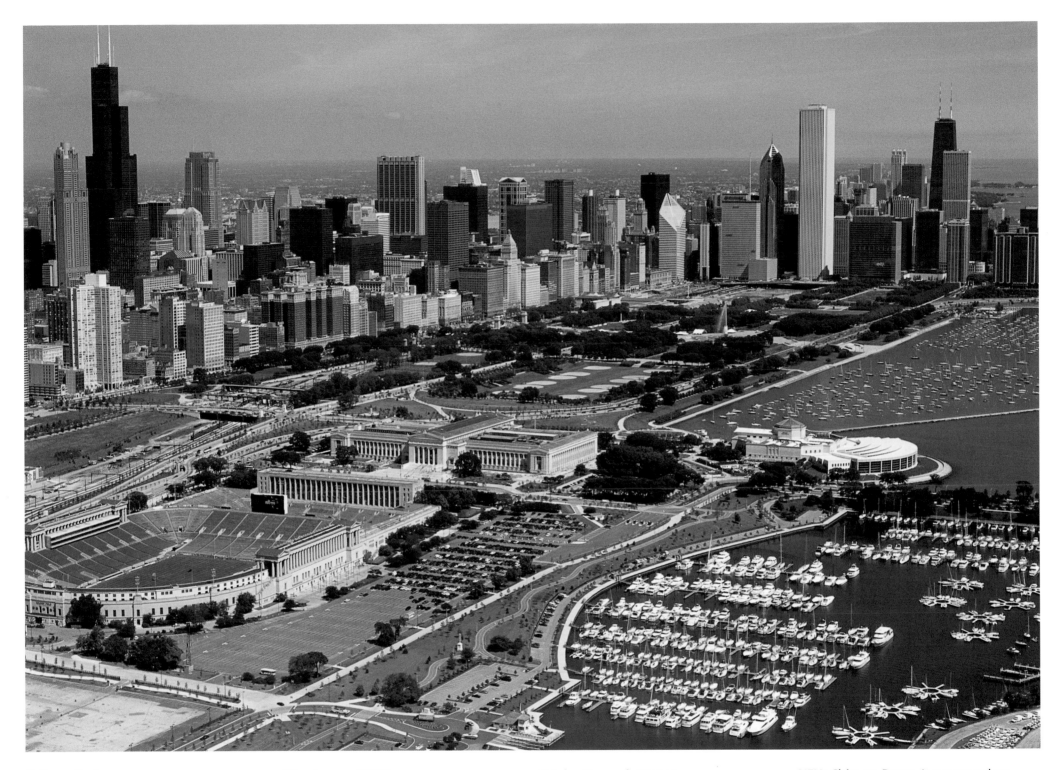

6 Grant Park
The city designated the land as a park on April 29, 1844, naming it Lake Park. On October 9, 1901, it was renamed Grant Park in honor of Galena, Illinois, resident, President Ulysses S. Grant.

7 John G. Shedd Aquarium
Opened on May 30, 1930, with 2,100 species including fish, marine mammals, birds, snakes, amphibians, and insects.

The Loop, 2000

8 Aon Center
A skyscraper designed by Edward Durell Stone and The Perkins and Will partnership, it was completed in 1973 as the Standard Oil Building. With eighty-three floors and a height of 1,136 feet, it was briefly the tallest and now is the third tallest building in Chicago.

9 John Hancock Center
A 100-story, 1,127-foot-tall skyscraper designed by structural engineer Fazlur Khan of Skidmore, Owings and Merrill when completed in 1969, it was the tallest building in the world outside New York City.

10 Soldier Field
Formerly the Municipal Grant Park Stadium, Soldier Field is home to the NFL's Chicago Bears. It reopened on September 29, 2003, after a complete rebuild (the second in the stadium's history).

11 Sears Tower
A 108-story, 1,451-foot-tall skyscraper, at the time of its completion in 1973 it was the tallest building in the world and is still the tallest skyscraper in the United States.

Churchill Downs, KY

The Kentucky Derby, 1933 (below, bottom)

Churchill Downs at Louisville, Kentucky is the horseracing track made famous by the Kentucky Derby—an annual race held during the first Saturday in May. The race track opened in 1875 and its convenience to the Louisville & Nashville Railroad facilitated easy shipment of horses to and from the

track. Looking southwest over Churchill Downs about 1933.

The Kentucky Derby, 1940 (below, top)

This 1940 view pictures the track on Derby Day. Although best known for the Kentucky Derby, that is but one event staged at this famous venue—the Breeders Cup, for example, has taken

place at Churchill Downs four times, and the Rolling Stones played there in 2006.

The Kentucky Derby, 1942 (opposite, above)

This 1942 view of Churchill Downs on the day of Kentucky Derby shows the popularity of the event—attendances of over 150,00 are not rare on Derby Day—while giving a good profile look at the grandstands personified by the famous twin spires. This grandstand, designed by architect Joseph Dominic Baldez, was built in 1895. The track is named for John and Henry Churchill who leased the land for use as a horse track.

The Kentucky Derby, 2009 (opposite, below)

"Mine That Bird" with jockey Calvin Borel passes the finish line to win 135th Kentucky Derby at Churchill Downs in Louisville, Kentucky, on May 2, 2009. The first winner, in 1875, was "Aristides." There has been much improvement of the facilities over the years and major building, only some of which is apparent in this photograph. Most decades have seen changes to the clubhouse and grandstands: in the 1950s, extra seating boxes were added to the second floor of the grandstand and 400 additional third-floor boxes in the clubhouse. In the 1960s a thousand seats were added to the north end of the grandstand and the fourth and fifth floors of the Skye Terrace "Millionaire's Row"—a sixth floor was added in the 1970s. In July 2002, a $121 million renovation started and the next years would see major changes to the spectating facilities that saw demolition and rebuilding of an 800-foot area of the clubhouse, new balconies, and an increase in the permanent seating capacity to approximately 52,000.

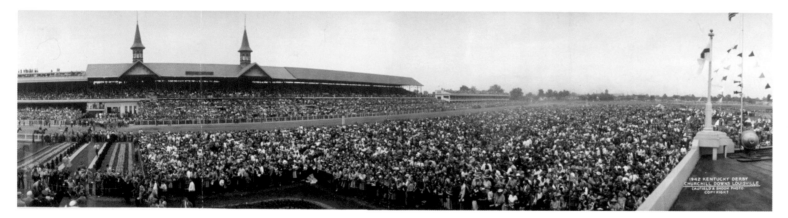

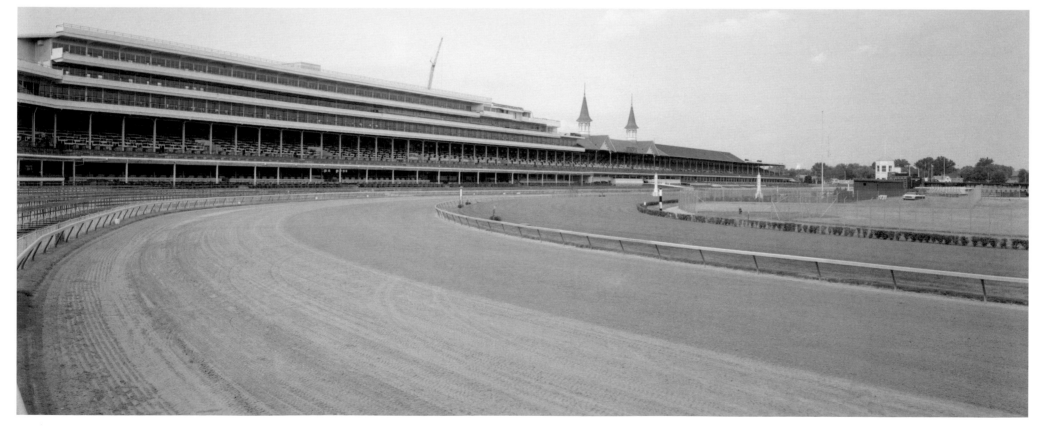

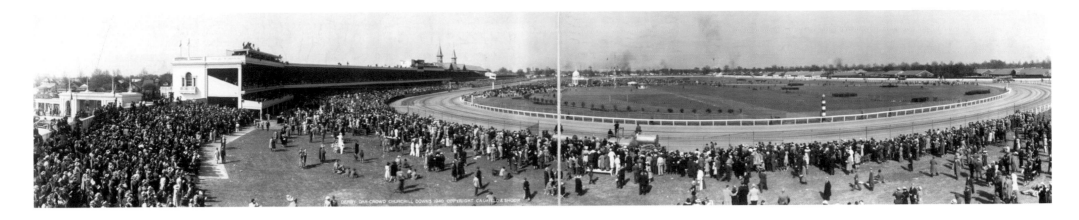

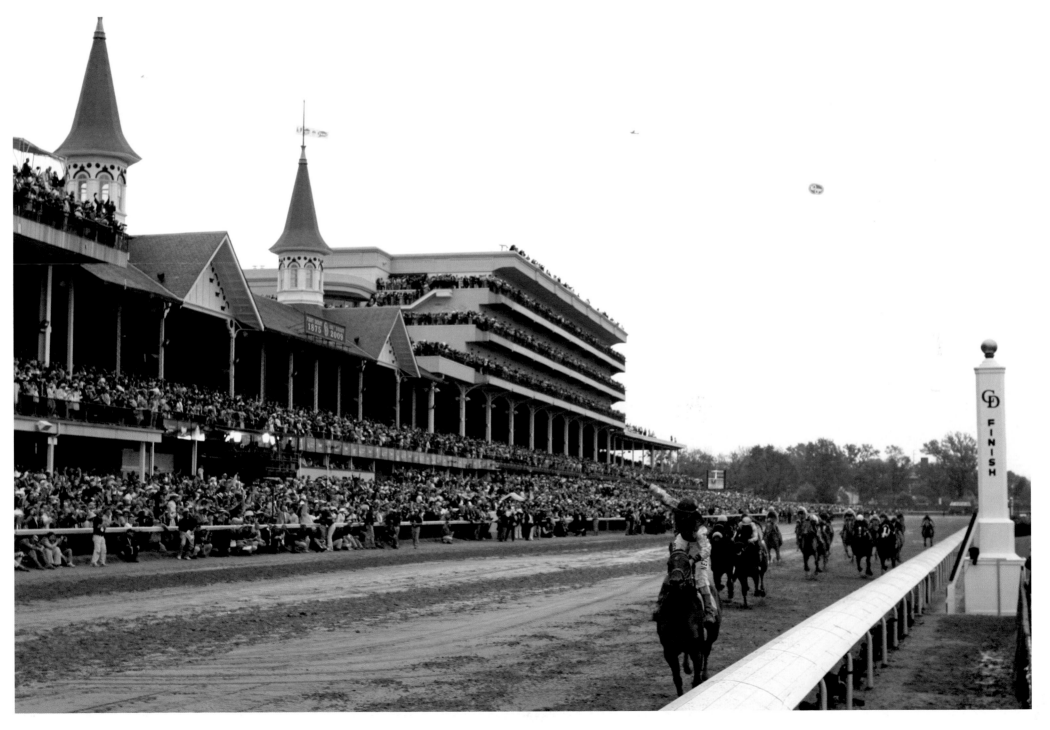

Cincinnati, OH

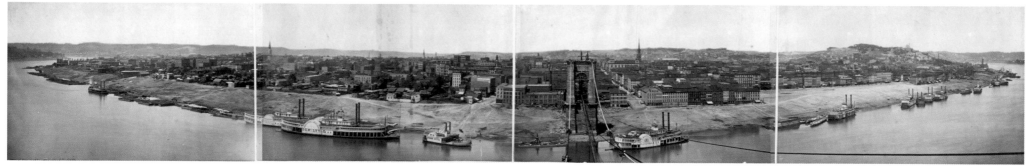

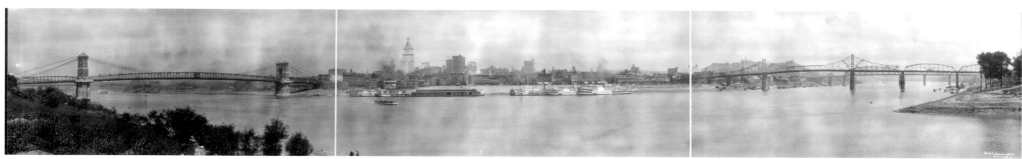

Cincinnati, ca. 1866 (above, top)

1 Suspension bridge
John A. Roebling's suspension bridge connected Cincinnati with Covington, KY. It was completed in 1866, before his better-known Brooklyn Bridge.

2 Paddle steamers
Few paddle steamers remain in existence today, but from the start of the nineteenth century they were essential river transports. Cincinnati is the location of the Tall Stacks festival that celebrates riverboats on the Ohio.

Cincinnati from Covington, ca. 1914 (above, bottom)

3 Union Central Life Insurance Company Building
When completed in 1913, it was considered the fifth largest building in the world. This thirty-one-story skyscraper of a Neoclassical style is now called the PNC Tower.

4 Central Bridge
Constructed in 1890 using a cantilever truss design. The original bridge was demolished in 1992. Today a new four-lane bridge built in 1995 spans the Ohio at this location.

5 Louisville & Nashville Railroad Bridge
The more distant of the two bridges in this image. Opened in 1872, it was the first railroad bridge over the Ohio at Cincinnati. The L&N developed into an important railroad network.

Cincinnati from Covington, ca. 2009 (right)

6 Great American Ball Park
Built in 2003 to replace Cinergy Field, it serves both the Cincinnati Reds Major League Baseball team, and National Football League Cincinnati Bengals.

7 Scripps Center
Completed in 1990, at thirty-six floors, it is the most prominent tall modern building in downtown Cincinnati.

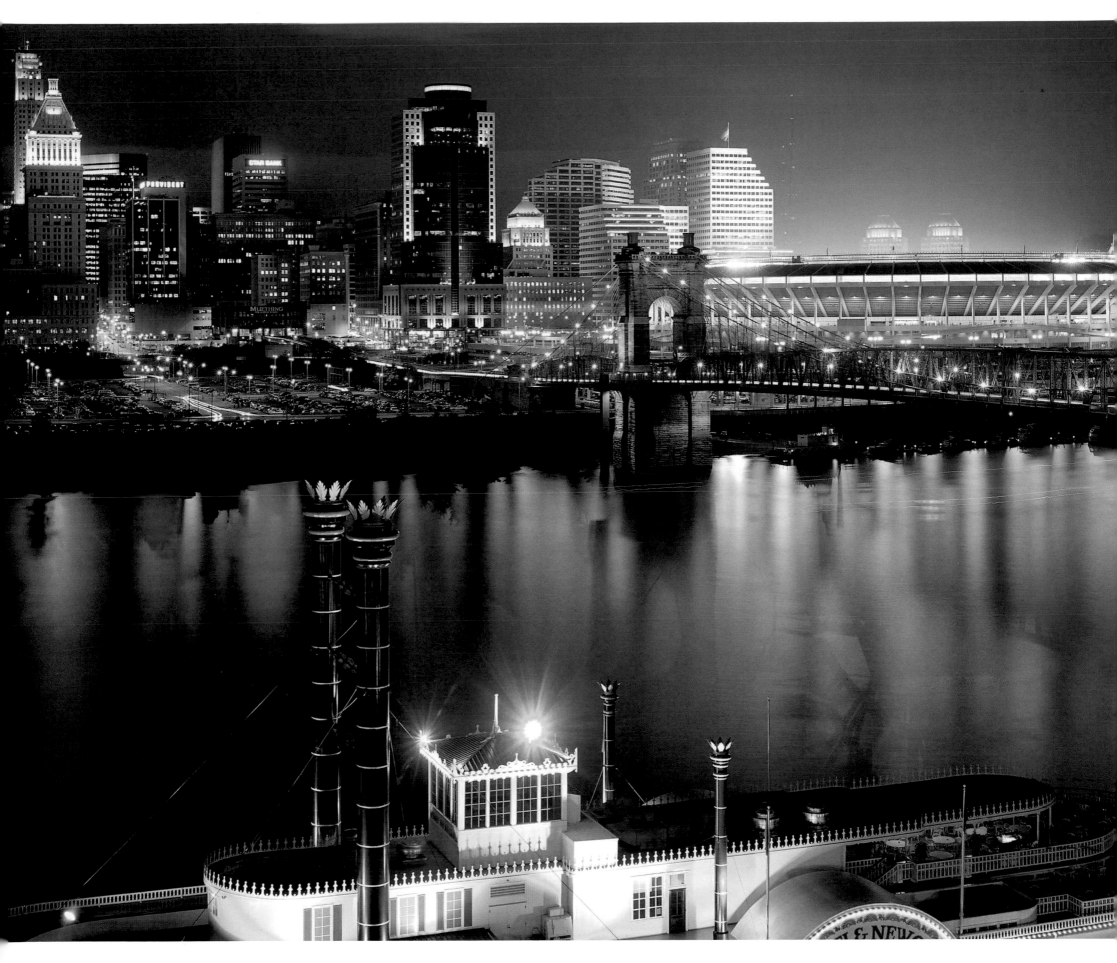

Cleveland, OH

Downtown Cleveland, 1951

1 Cleveland Terminal Tower
Testimony to the vision of the Van Sweringens' planning in the early decades of the twentieth century, the tower was built in 1928 as part of an extensive urban development scheme that included the Hotel Cleveland, Republic Building and other major structures. The tower was the city's tallest building, measuring 708 feet above the streets. Its forty-second floor featured a public observation deck equipped with telescopes for viewing the surrounding countryside.

2 Ohio Bell Huron Building
Art Deco-style office tower at Huron Road and East 8th Street. Construction of this twenty-two-story office tower began in 1925 and finished two years later. It has been offered as the inspiration for the mythical "*Daily Planet* Building" from the Superman comics. Designed by Barber & Hoffman, the old Ohio Bell became Ameritech in 1993, and is now SBC Cleveland.

3 Landmark Office Towers
Part of Otis P., and Mantis J. Van Sweringen's intensive development of greater Cleveland. These bachelor brothers developed a complex financial empire of railroads, industry, and property development. Their finances unraveled spectacularly during the Great Depression, yet they left Cleveland with some of its best planned transport and property development of the twentieth century.

4 Detroit-Superior Bridge
This double-deck thirteen-span elevated bridge over the Cuyahoga River Valley was constructed in 1917. It was renamed the Veterans Memorial Bridge in 1989. It consists of twelve reinforced concrete arches and a central steel arch 591 feet long. Designed as a double-deck structure, the top was for pedestrians and motor vehicles while the lower level carried streetcar tracks. Streetcar operations over the bridge ended in the mid-1950s.

5 Railway Bridge
Part of the Van Sweringens' vision for urban development was the electrified Cleveland Union Terminal railroad which carried passenger trains for both New York Central and Nickel Plate Road. Another electric scheme was the famed Cleveland Rapid Transit System. Both lines shared this bridge on the west side of the city to reach the 1928-built Union Terminal—part of the Terminal Tower.

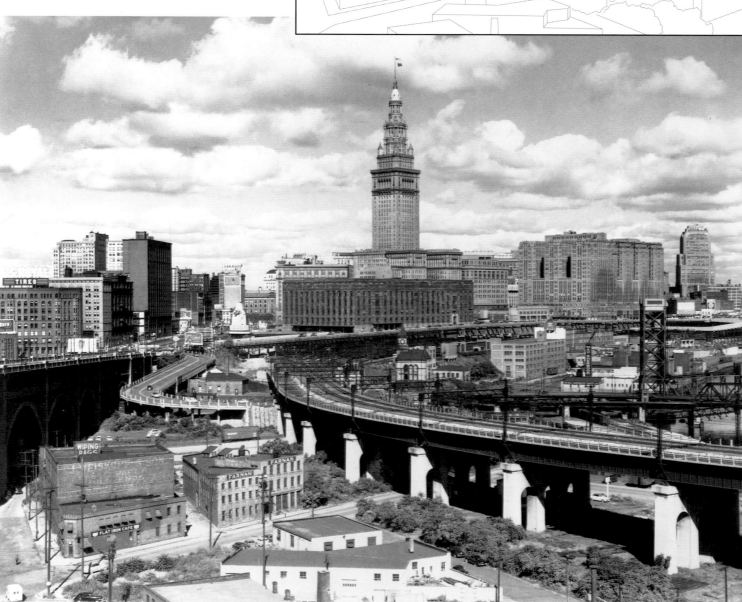

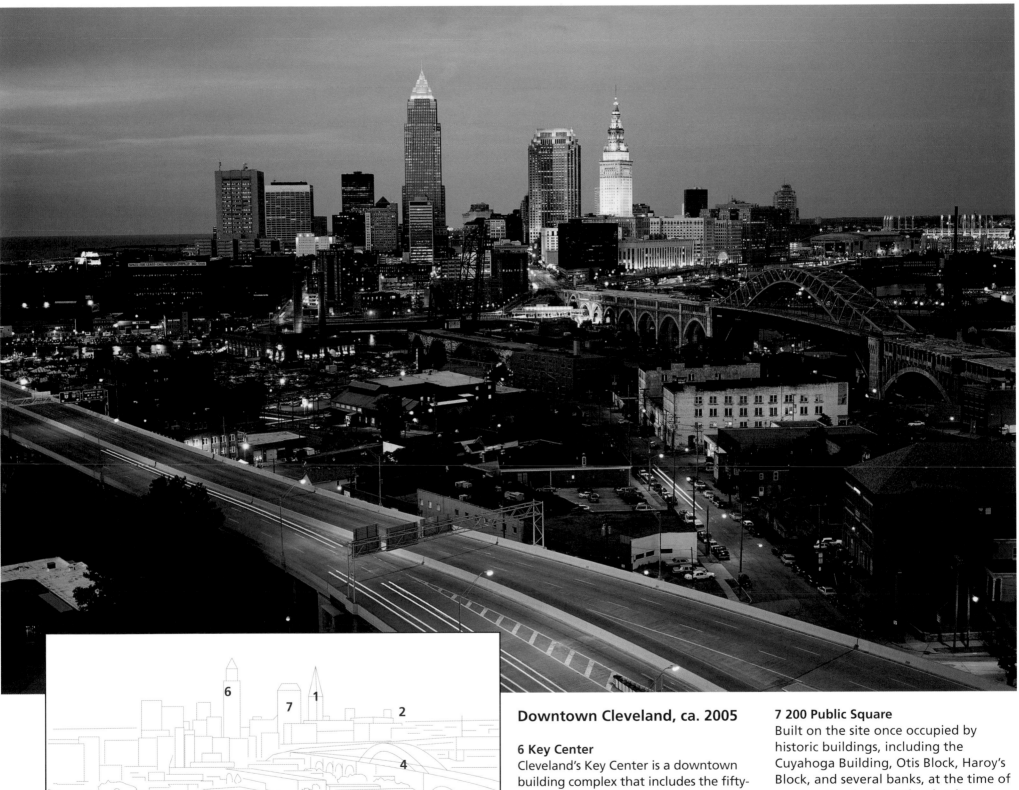

Downtown Cleveland, ca. 2005

6 Key Center
Cleveland's Key Center is a downtown building complex that includes the fifty-seven-floor Key Tower. This skyscraper, designed by Cesar Pelli & Associates, surpassed Terminal Tower as the city's tallest while it was under construction in 1990. Completed in 1991, it rises nearly 948 feet and remains to this day among the tallest buildings in the Midwest.

7 200 Public Square
Built on the site once occupied by historic buildings, including the Cuyahoga Building, Otis Block, Haroy's Block, and several banks, at the time of construction in 1985 Cleveland's building restrictions prohibited structures taller than Terminal Tower.

8 Cleveland Memorial Shoreway
Also known as the "Shoreway," it carries State Route 2 and other highway routes through the Cleveland area.

Cleveland, 1950s (below)

1 Cleveland Terminal Tower
For many years one of the tallest buildings east of New York City, it is a monument to the Van Sweringens' empire-building development strategies.

2 Justice Center
A twenty-six-story office building and court, it opened in America's bicentennial year—1976. This new building placed under one roof key regional law enforcement institutions including offices for the Cleveland Police Department, a Cuyahoga County and Cleveland Municipal Court, and a detention center.

3 Anthony J. Celebrezze Federal Building
Built on the site of the old Central Armory that once was the base for the Ohio National Guard. This thirty-one-floor international-style office tower was the joint work of several architects and completed in 1967.

4 Cleveland Law Library

5 Lake Erie
One of the five Great Lakes, Lake Erie has provided Cleveland with inexpensive transportation that aided its extensive industrial development.

Cleveland, 2000s (opposite)

6 Key Center
Also known as North American Life Insurance Building this forty-story 523-foot historic building was once the tallest building outside of New York City.

7 200 Public Square
Also known as the "BP Building" and the "Sohio Building"—for one-time petroleum company Standard Oil of Ohio, the building's first owner. Although intended to surpass Terminal Tower built in 1928, Cleveland's officials rejected the original plans and the building design was lowered.

8 Voinovich Park
The Voinovich Bicentennial Park is a Lake Front venue at North Coast Harbor that provides welcome open space north of the downtown Cleveland with outstanding views of its skyline.

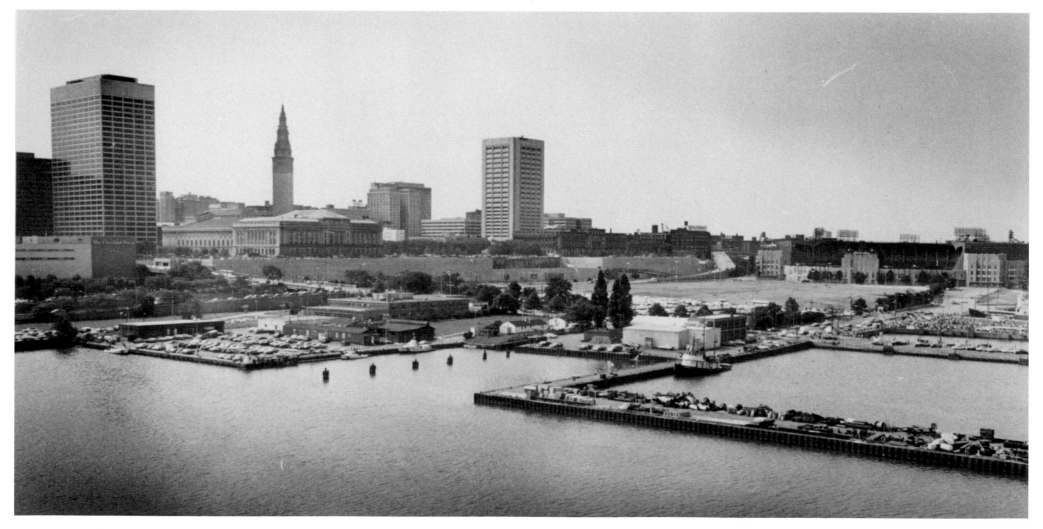

9 William G. Mather Steamship
Built in 1952, this classic lake freighter is now a museum, part of the Great Lakes Science Center (10) and docked permanently on Cleveland's waterfront opposite the Rock and Roll Hall of Fame (behind the photographer). Great Lakes shipping was key to Cleveland's development and success as a major industrial center.

11 Cleveland Browns Stadium
A thirty-one-acre stadium for Cleveland's National Football League team.

12 Cleveland City Hall
Architect J. Milton Dyer designed this Beaux-Arts building, which was completed and dedicated on July 4, 1916.

Dallas, TX

Downtown Dallas, 1982

1 George Allen Sr. Courts Building
Located in the heart of downtown, the forty-year-old, 425,000-square-foot George Allen Sr. Courts Building has received a nine-story 210,000-square-foot addition and renovation, providing a new home for the Dallas County Civil Courts.

2 Old Red Museum
Built in 1891, the Dallas County Courthouse has been converted to the Old Red Museum of Dallas County History & Culture. Today the museum is adjacent to the JFK Memorial and Dealey Plaza, a National Historic Landmark District.

3 Renaissance Tower
Centerpiece in the long-running American television show "Dallas," this fifty-six-story (885 feet tall) building was completed in 1974.

4 The Merc (The Mercantile Building)
This handsome thirty-one-story (522 feet) building completed in 1943 was the only major American office block completed during World War II because the steel had already been fabricated.

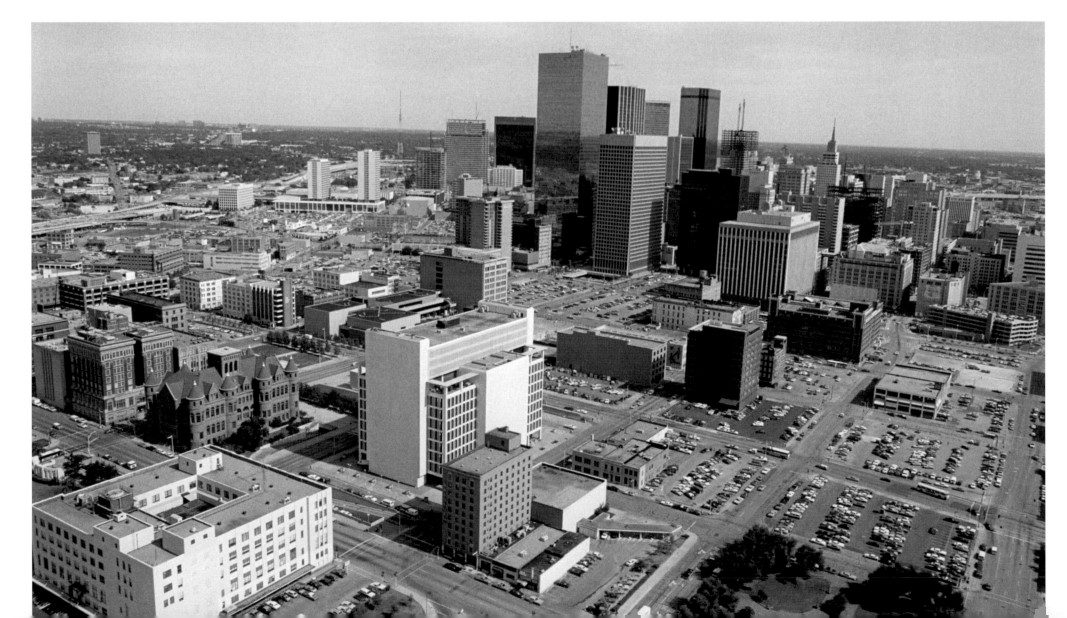

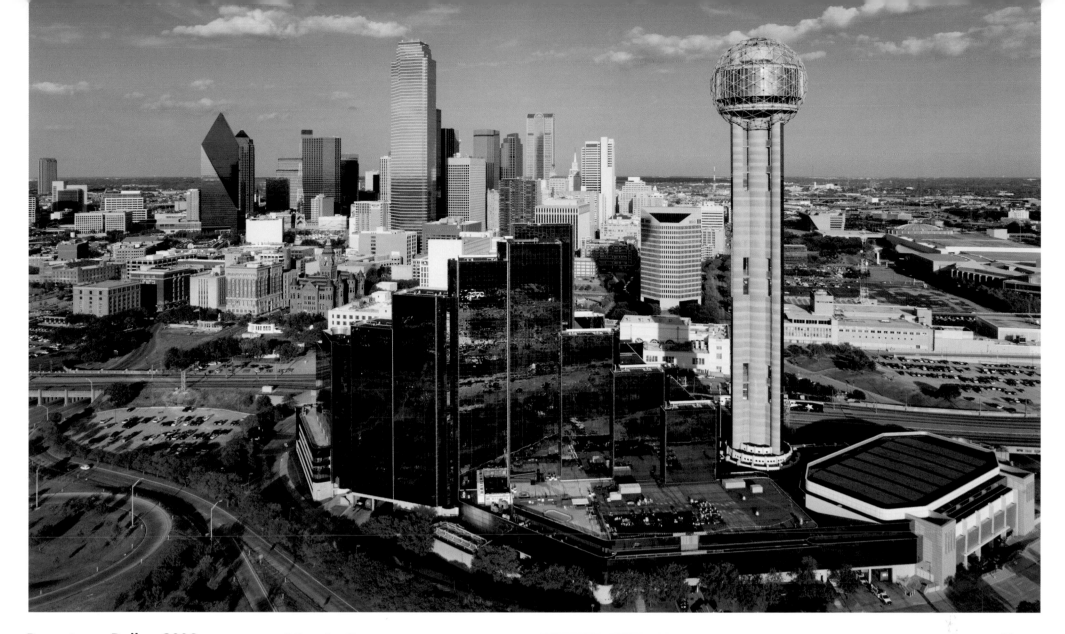

Downtown Dallas, 2006

5 Dealey Plaza
Over forty years after the assassination of U.S. President John F. Kennedy on Friday, November 22, 1963, Dallas has recovered from the shock, but will forever be remembered for nourishing the man who killed Camelot. Dealey Plaza, a Dallas city park, was completed in 1940.

6 Dallas County Administration Building
Known at the time as the Texas School Book Depository, Oswald shot the president from a sixth-floor window—now a museum.

7 Hyatt Regency
The 1,122-room Hyatt Regency Reunion is a 345-foot thirty-story glass curtain wall hotel.

8 Reunion Tower
This 560-foot observation tower was designed by Welton Becket & Associates and was completed in 1978.

9 Bank of America Plaza
Completed in 1985, this seventy-two-story 921-foot skyscraper is the tallest building in Dallas. Clad in silver reflective glass, it is outlined at night by more than two miles of radiant emerald green argon tubing visible for miles. Initial planning called for a matching tower and high-rise hotel with retail space, but it was not built because of the real estate market collapse in the 1980s.

10 Fountain Place
At 1445 Ross Avenue in the Arts District downtown, Fountain Place is a sixty-two-story glass curtain wall skyscraper. Standing 720 feet, it is the fifth-tallest

building in Dallas and has a two-acre water park. Architect Henry Cobb of I.M. Pei & Partners summarized his design as "geometry pursued with rigor."

11 Trammell Crow Center
Trammell Crow Center totals 1.2 million

square feet on fifty floors, with a polished and flamed granite exterior and garden plaza, bordered by the Crow Collection of Asian Art.

12 Comerica Bank Tower
Postmodern style glass and granite decorate this 787-foot skyscraper at 1717 Main Street. The first five floors contain a large banking and stock exchange hall. Designed by Richard Keating of SOM and completed in 1987, the tower features four-bay windows on each façade and a glass pyramid at the very top.

Daytona Beach, FL

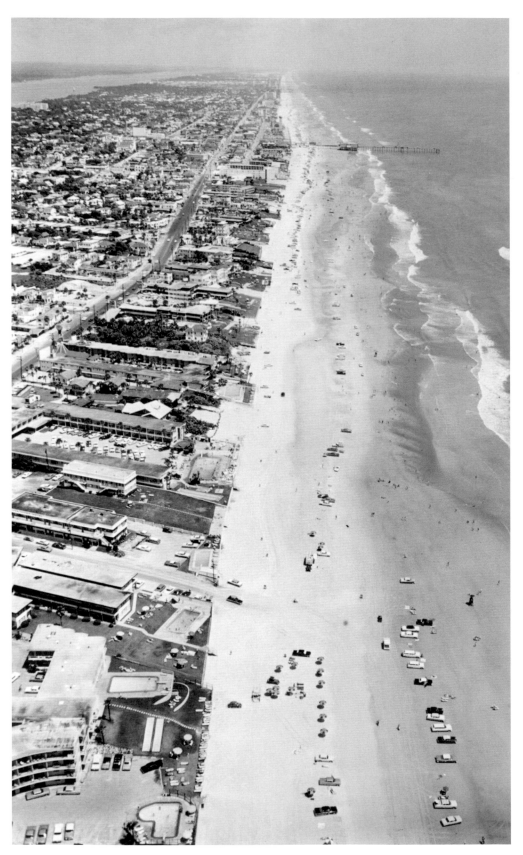

Daytona Beach, 1926 (left)

1 Sun, Sand, Sea... Automobile
Cars drove on Daytona's white sand beach in 1926. While this practice is now restricted in some areas of Florida's Atlantic Coast, even today public access to the beach has become difficult. Wall-to-wall hotels, resorts, and exclusive condominiums pay high taxes because of extraordinary property values. Politicians are forced to make access decisions weighing matters of safety, the environment, and public services. In addition, issues unheard of when this photo was taken 84 years ago—nesting sea turtles, for instance—now also impinge on public policy.

2 Intracoastal Waterway
Daytona Beach is divided by the Halifax River lagoon which is part of the Intracoastal Waterway. Geographically

the eastern part is a barrier island protecting the mainland from the winds, tides, and storms of the Atlantic Ocean.

3 Atlantic Avenue
The two-lane Highway A1A runs practically the length of Florida's east coast. It sometimes offers stunning views of the ocean but is also congested and heavily built-up.

4 Daytona Beach Pier
The pier (from which the photo at right was taken) lost 200 feet in 1999 as a result of Hurricane Floyd.

Daytona Beach, 2007 (right)

5 Bandshell
The Bandshell and Oceanfront Park Complex is located at Ocean Avenue, north of the junction of Main Street

and Atlantic. In 1999 it was added to the National Register of Historic Places.

6 Ocean Walk
The Wyndham Ocean Walk Resort is a condominium community featuring permanent ownership and vacation rentals of one–, two–, and three–bedroom suites overlooking the ocean.

7 Hilton
The Hilton Daytona Beach Resort at 100 North Atlantic Avenue is completely smoke-free. Most of the 774 guest rooms have a spectacular view of the Atlantic Ocean.

8 Driving
While the beach is accessible to pedestrians 24/7, beach driving is restricted to specific areas (weather and tides permitting) from one hour after sunrise to one hour before sunset. During sea turtle nesting season, May 1–October 31, driving hours are set from 8:00 a.m. to 7:00 p.m.

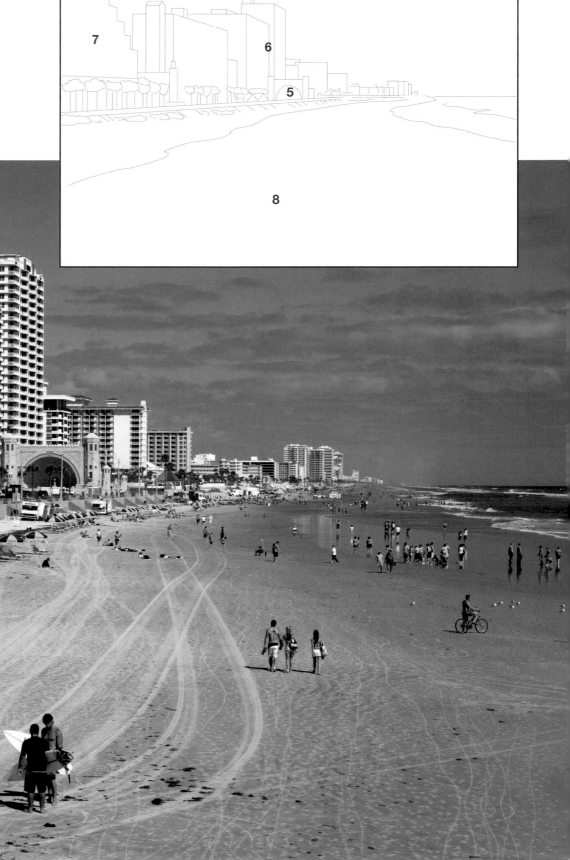

Denver, CO

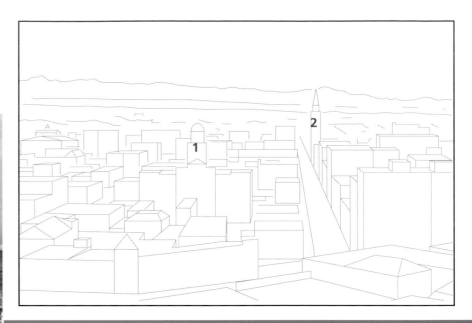

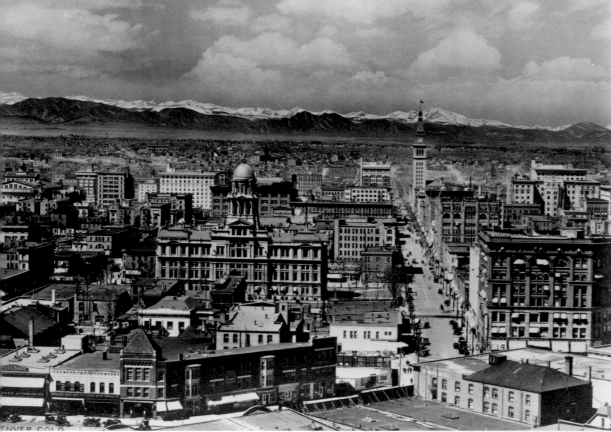

Denver, ca. 1911 (above)

Almost no one lived in the Denver area in 1850. Eight years later, two itinerant prospectors found about twenty ounces in a creek bed in what is now the southern suburb of Englewood. Within a year, tens of thousands of gold seekers were digging and panning the area; within two years, an estimated 100,000 people had flooded into Colorado to search for gold in the Pike's Peak Gold Rush. Inhabited by gold seekers, founded by land speculators and named to curry favor with the governor, Denver became the permanent state capital in 1881. Then silver was discovered and Denver became known internationally as a bawdy, anything-goes city. By the time this photograph was taken in about 1911, Denver's population was approaching 250,000.

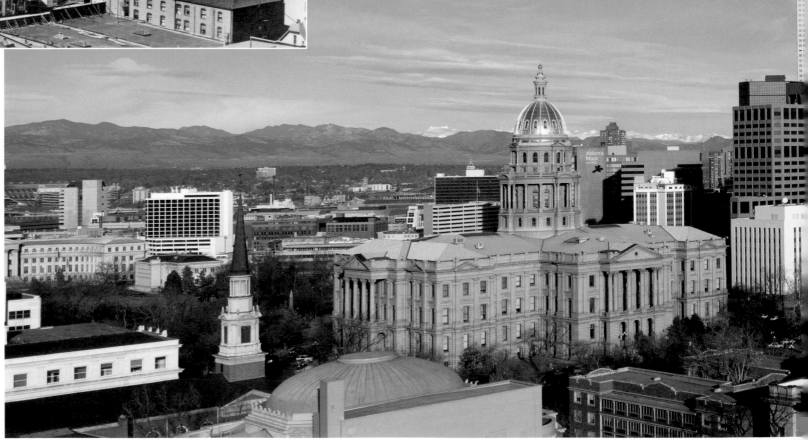

1 Arapahoe County Courthouse
A view northwest from the capitol with the intersection of 16th Street (which stretches toward the Sangre de Cristo Range of the Rocky Mountains) and Broadway in the immediate foreground. The domed building on the left side is the Arapahoe County Courthouse, which was demolished in 1933.

2 Daniels & Fisher Tower
The tallest edifice—and it is still standing—is the twenty-story Daniels & Fisher Tower at 1601 Arapahoe Street opened in 1910.

Denver, 1999 (below)

Today, Denver is referred to as the "Mile High City" and the metropolitan area is home to three million people. Denver International Airport (not pictured) is the tenth busiest in the world serving fifty-two million passengers a year.

3 Republic Plaza
The tallest building in the Rocky Mountain region of the U.S., it is 714 feet tall, has fifty-six floors, and was completed in 1984. Designed by Skidmore, Owings & Merrill, it is built of reinforced concrete clad in Sardinian granite.

4 Wells Fargo Center
Finished in 1983, this fifty-two-floor skyscraper at 1700 Lincoln Street is irreverently called the "Cash Register" building because its russet-colored granite and gray glass exterior end in a roof which resembles a U.S. Postal Service mailbox.

5 Colorado Capitol
At 200 East Colfax, the capitol was constructed in the 1890s using white granite. It opened in 1894, and the dome was gold plated in 1908.

6 The Basilica of the Immaculate Conception
Constructed of a steel frame faced with brick and Indiana limestone, it has twin spires that reach 210 feet and a large rose window.

7 First Church of Christ, Scientist
Designed in 1904 by Lester Varian and Frederick Sterner, in the Neoclassical Greek Revival style, it was constructed of white lava stone from Salida, Colorado.

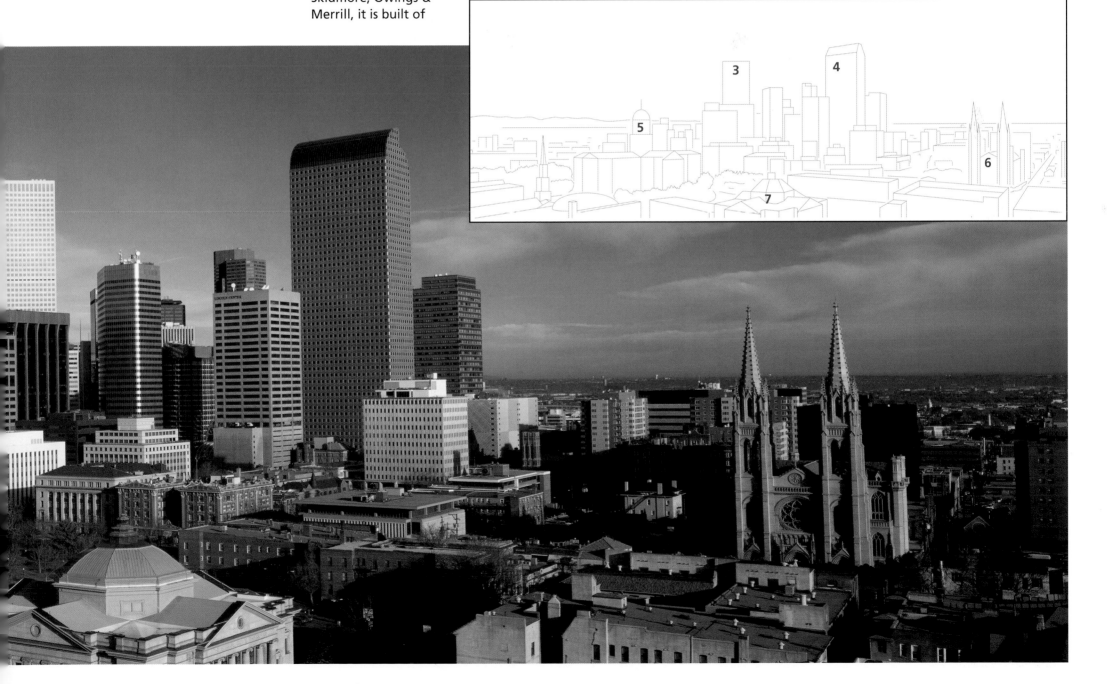

Detroit, MI

Detroit, 1931

1 Penobscot Building
Completed in 1928, this forty-seven-floor skyscraper held the title as Detroit's tallest (566 feet) until 1977 when the new Renaissance Center was completed. It embraces classic Art

Deco design that may have inspired New York's Empire State Building, some of Chicago's classics, and other skyscrapers of the period.

2 Cadillac Tower
The first building in the United States to reach forty stories that was in neither of the two

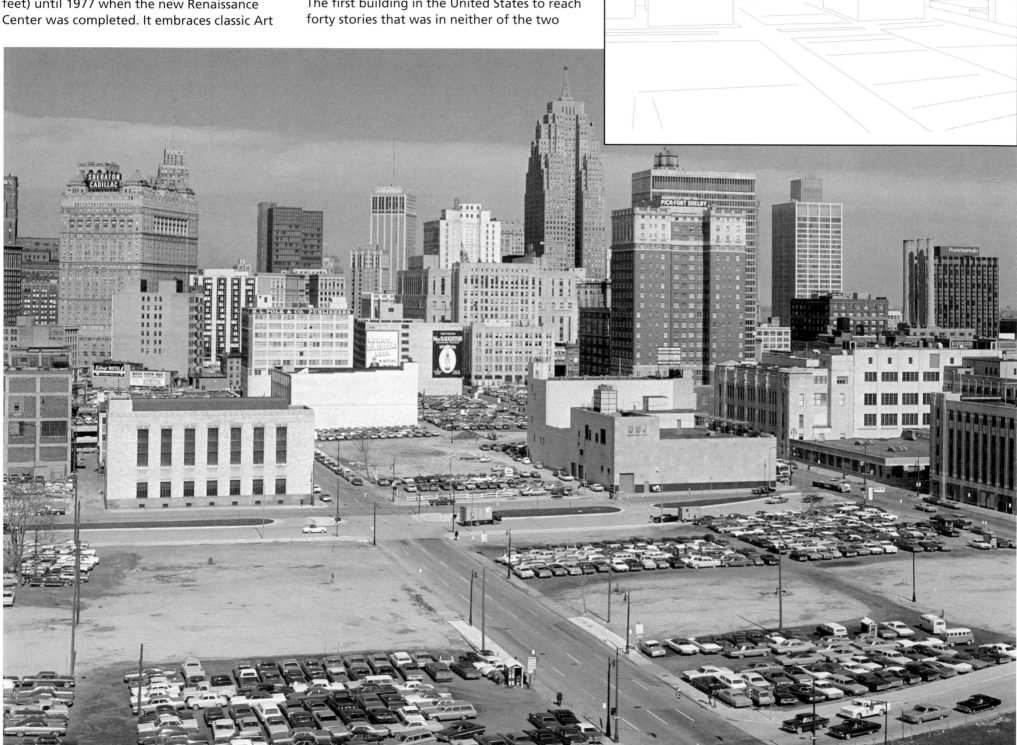

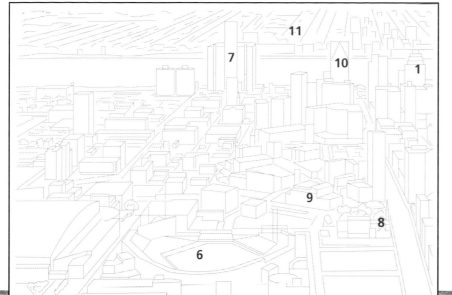

cities most closely associated with skyscrapers: New York and Chicago. The work of architects Bonnah & Chaffee who used Beaux-Arts design with an ornate terra-cotta façade.

3 One Woodward Avenue

Variously the Michigan Consolidated Gas Building, American Natural Resources Building, and the National City Center, this modern tower with its glass and marble façade is today known by its unremarkable address. Although not evident from casual observation this is a significant example of a welded steel frame skyscraper. Completed in 1963, it is twenty-eight-stories tall.

4 Book-Cadillac Hotel

Built by the Book Brothers in 1924 on the site of the old Cadillac Hotel which was demolished to make way for this massive, twenty-nine-story Renaissance revival style masterpiece. When new it featured more than 1,100 rooms. Among Detroit's famous buildings, it is now known as the Westin Book-Cadillac Hotel and underwent substantial renovations that were complete in 2008.

5 Pick-Fort Shelby Hotel

Completed in 1917 with a distinctive Beaux-Arts design, since 1983 this has been listed on the National Register of Historic Places, and is now known as the "Fort Shelby Doubletree All Suites Detroit."

Detroit, 2006 (left)

6 Comerica Park

Home of the Detroit Tigers.

7 General Motors Renaissance Center

Designed by Ghafari Associates Inc., this modern multi-tower complex has dominated the Detroit skyline since it was completed in 1977.

8 Central United Methodist Church

This prominent Neo-Gothic church on West Adams Street dates to 1866. In the midtwentieth century it found fame for its links to prominent civil rights activities.

9 Detroit Opera House

Designed by prominent theater architect, C. Howard Crane, it was built in 1922 for the Capitol Theater. Today this classic survives as the setting for Michigan Opera Theatre productions.

10 One Detroit Center

A forty-three-floor tower with imposing granite façade commonly known as the Comerica Tower. Completed in 1993, it is Detroit's second tallest structure.

11 Windsor, Ontario

Located opposite Detroit, across the Detroit River, is the Canadian city of Windsor.

Galveston, TX

Galveston, 1910 (above)

Situated on a barrier island in the Gulf of Mexico and taking advantage of a large natural harbor, the first European settlement dates from 1815. It was home to pirates before the Congress of Mexico established the Port of Galveston and opened a customs house there in 1825. This photo, taken ten years after the devastating 1900 hurricane, shows a city prepared to do business. Privateer Jean Lafitte took over the Galveston Island camp of pirate Louis-Michel Aury during Mexico's war for independence in 1817 and established the town of Campeche. It may have numbered 1,000 people at its peak. Although he lived aboard his ship, *The Pride*, Lafitte built a headquarters, surrounded it with a moat, painted it red and called it Maison Rouge. Forced out by the U.S. Navy in 1820, Lafitte torched the town. Thus, Galveston proper was founded by Michel Menard and Samuel May Williams, among others. The homes of these early island pioneers are still standing. All that remains of Maison Rouge is the foundation, located at 1417 Avenue A near the Galveston wharf.

1 Broadway Avenue J
The home of Michel Menard at 1604 33rd Street is a short way up Broadway and to the left of this photograph. It was built in 1838 and is the oldest on the island. Through a partnership with the Galveston Historical Foundation, the house is operated as a museum.

Galveston, 1910 (left)

The 1900 hurricane devastated Galveston and gave Houston an opportunity to become the primary Texas port. In the 1920s, Galveston was on the verge of its "open era," the years when illegal activities—rum running, prostitution, gambling, and a local movement promoting the "Free State of Galveston"—gave the city a colorful aura.

Galveston, 2005 (below)

2 Pelican Island
Galveston and its port in 2005 with the Houston Ship Channel in the background. Just across the channel from the Port of Galveston, Pelican Island is the site of industrial and recreational development. The Pelican Island National Wildlife Refuge was created as the nation's first national wildlife refuge by President Theodore Roosevelt in 1903.

3 Pelican Island Causeway
Joining Galveston and Pelican Island, the causeway is three miles long.

4 St. Patrick Catholic Church
The second Catholic Church in Galveston was completed in 1871 but destroyed by a storm. The replacement was completed in 1877, but this was badly damaged in the Great Storm of 1900 and rebuilt.

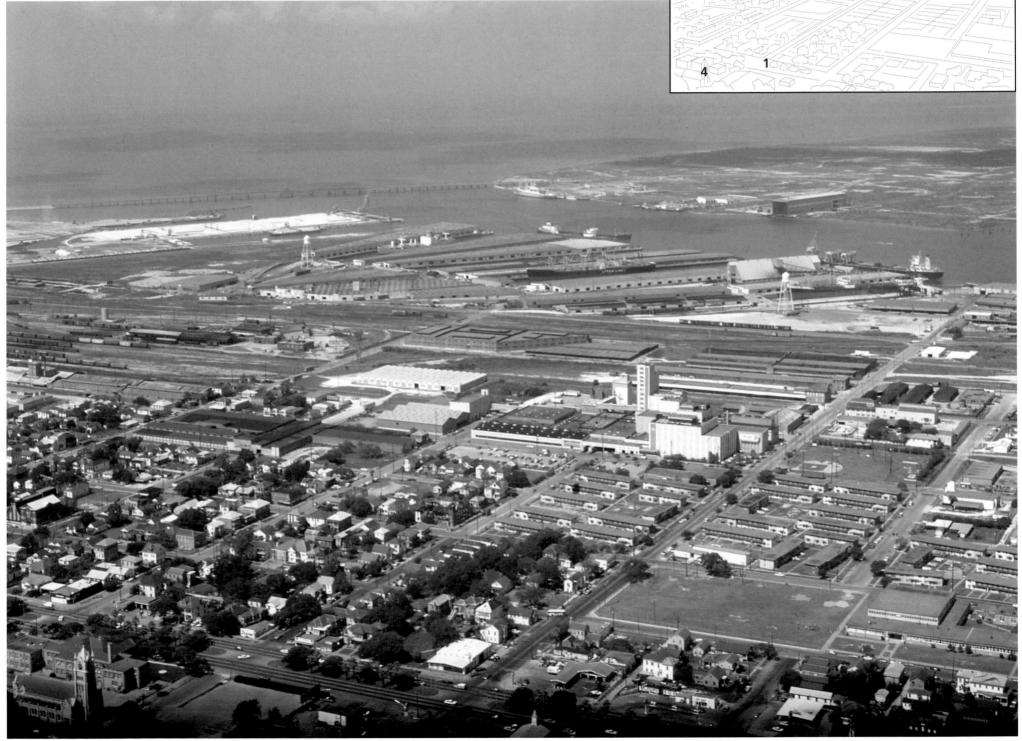

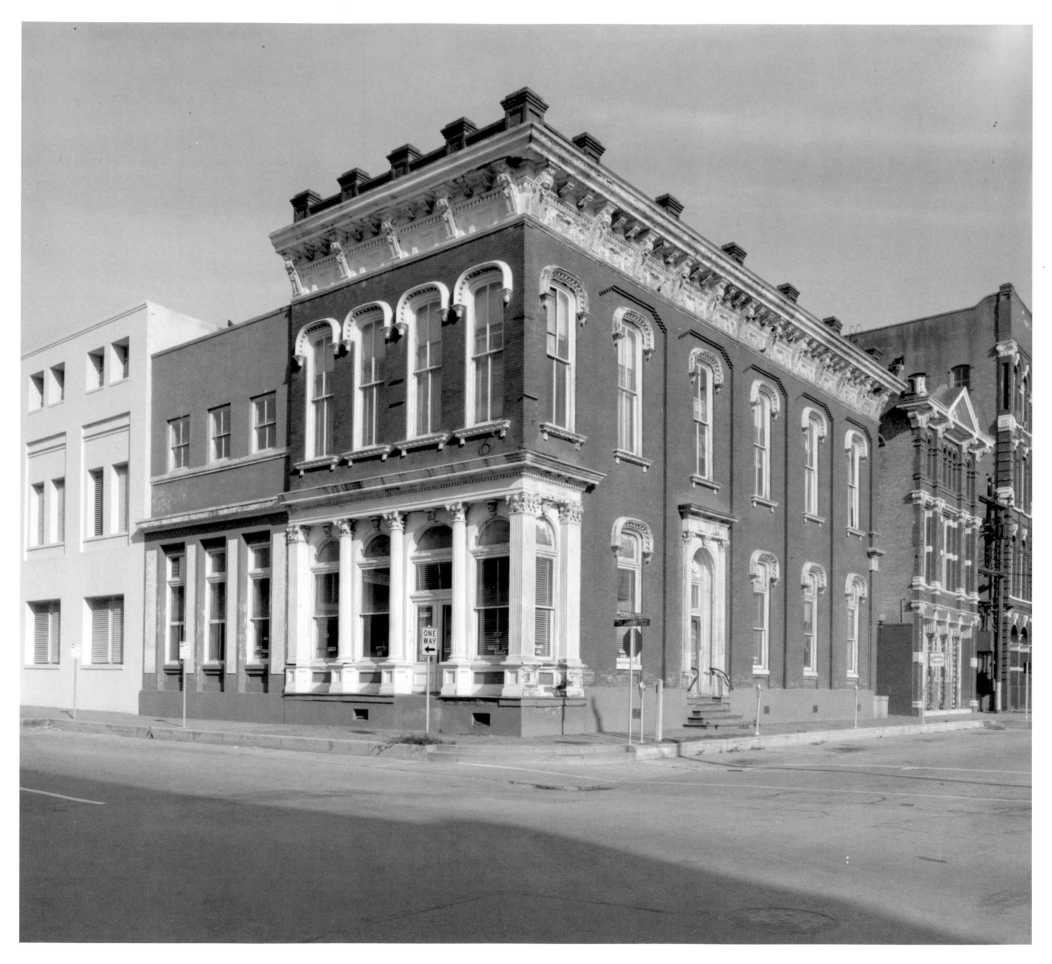

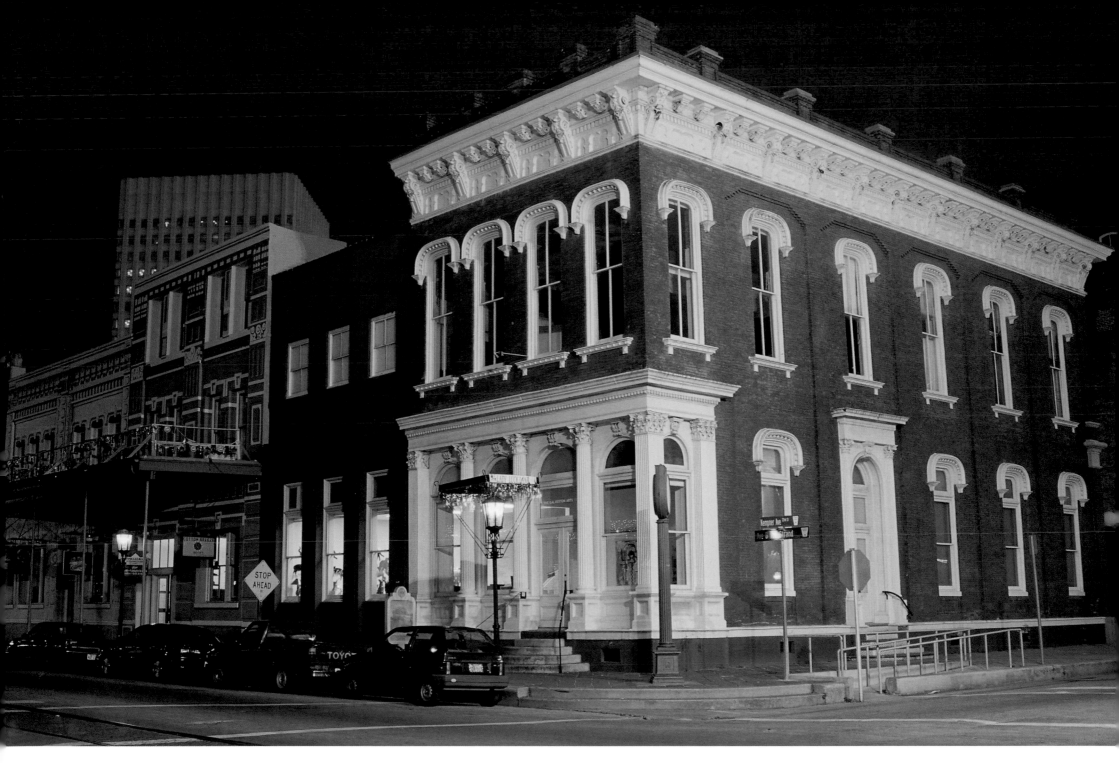

The Strand, 1960 (left)

The First National Bank building at 2127 Strand was designed by Comegys and built by Thompson Harden McMahan, a local banker and merchant. A National Historic Landmark District, the Galveston Strand is principally comprised of Victorian era buildings that now house restaurants, antique stores, museums, and eclectic shops. A major island attraction, The Strand hosts two popular festivals, the annual Old England-flavored Christmas festival known as Dickens on the Strand, and Galveston's Mardi Gras—in some neighborhoods known as "Carnival." The hundredth Galveston Mardi Gras will take place in February 2011.

Galveston, 2008 (above)

Peeking above the First National Bank today is American National Life building, Galveston's lone skyscraper. Completed in 1972, the twenty-three-story highrise office is 358 feet high. Each year the Galveston Historical Society presents a family festival in celebration of the life work and memorable characters developed by English writer Charles Dickens. The festival takes over The Strand and 2010 marks the thirty-seventh annual event. "For an entire weekend," festival organizers write, "hundreds of costumed vendors and performers provide a look at the pomp and pageantry of the British Empire at a time when commercial and cultural ties provided a strong connection between London and Texas' largest and richest city...Galveston." Galveston's port is the eleventh largest cruise port in the world, the number four U.S. cruise port in world rankings, and the busiest cruise port in the Gulf of Mexico. The port's industrial growth continues at facilities and terminals operated by ADM Grain, Agriliance LLC, Del Monte Fresh Produce, Galveston Railroad, Galveston Terminals, Gulf Copper Drydock and Rig Repair, Holcim Cement, "K" Line, Malin International Ship Repair and Drydock, and Wallenius Wilhelmsen Logistics along the Galveston Harbor.

Grand Coulee Dam, WA

There are many examples in North America of major feats of engineering that have changed the face of the country. These images show one of the great projects that were created in the 1930s—in part to help take the United States out of the Great Depression by providing state-sponsored work.

Grand Coulee Dam, 1940s (above right)

This aerial view shows the dam just after construction. Begun in 1933 after President Franklin D. Roosevelt authorized it as a Public Works Administration project. It wasn't finished until 1942. Among the greatest difficulties was diverting the flow of the mighty Columbia—America's second largest river. The dam is 550 feet high, 5,223 feet long and when completed it was the largest masonry structure in the world. Located 92 miles west of Spokane, Washington, the base of Grand Coulee Dam was built by the Bureau of Reclamation.

Grand Coulee Dam, 1967 (opposite)

Between 1967 and 1974 a third power plant was installed and today it is the greatest single producer of hydro-electricity in the United States and has a total generating capacity estimated at 6,809 megawatts. It is now considered the fourth largest hydroelectric dam in the world, with China's Three Gorges Dam taking the top spot. Grand Coulee Dam holds back Franklin D. Roosevelt Lake, 1,290 feet above sea level, and spreads out over 82,300 acres.

Grand Coulee Dam, 1980s (lower right)

View of the dam, looking southeast. New powerhouse number three is lit up at the lower left of the dam.

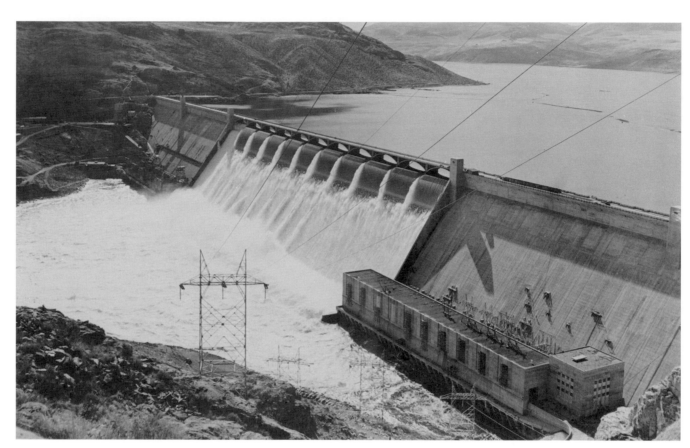

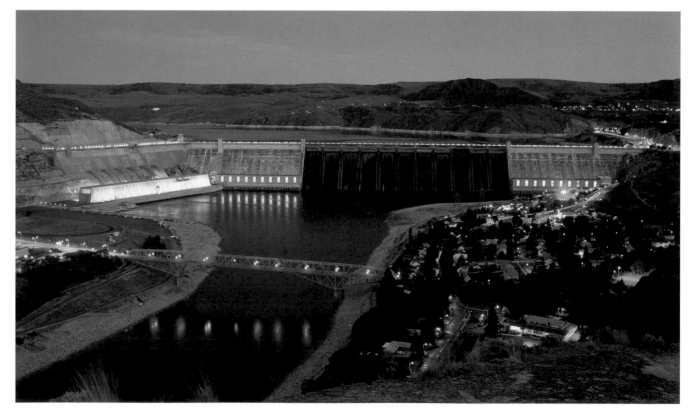

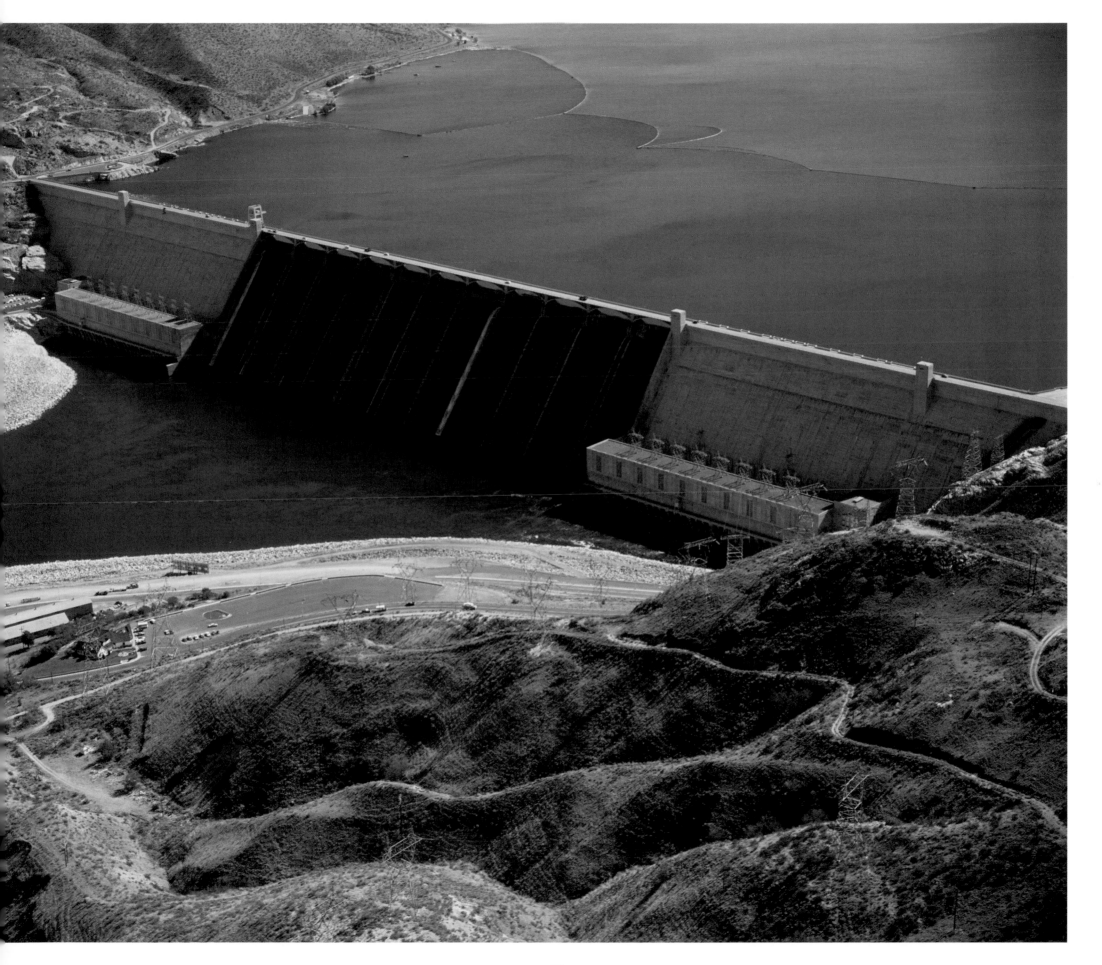

Honolulu, HI

Honolulu, 1900s (below)

The city of Honolulu on the island of Oahu is the capital of the state of Hawaii. It commands the sheltered anchorage of Mamala Bay. The Hawaiian Islands had been settled for perhaps a thousand years—first by Melanesian explorers before the Polynesians conquered and enslaved them—when in 1778 British explorer Captain James Cook became the first known Westerner to sight the island of Oahu. King Kamehameha forcibly united the islands under his rule and moved his capital from the big island of Hawaii to Oahu to grapple with the growing Western influence.

1 Aloha Tower

Aloha Tower, a clock tower and lighthouse, has greeted visitors to Honolulu Harbor since September 1926. Located at Pier 9, the 184-foot tower is ten stories high. Today it is bordered by the Aloha Tower Marketplace (2) and the Hawaii Maritime Center, which

includes the *Falls of Clyde* (3), the only iron-hulled, four-masted sailing schooner in the world, and the area around the tower has undergone extensive redevelopment.

4 Iolani Palace

Built in 1871, after the monarchy was overthrown in 1893, the palace was used as the capitol until 1969. It was opened to the public as a museum in 1978.

5 Piers 10 and 11

At 502 feet and 472 feet respectively, these piers allow large ships to dock here. Today they are berths for visiting cruise ships.

Honolulu, 2007 (opposite)

6 Marin Tower/Chinatown

At 60 North Nimitz Highway, the striking twenty-eight-floor tower is a 235-unit public building used as rental housing for low income families. It was finished in 1996. It backs onto the Chinatown Historic District. Within a

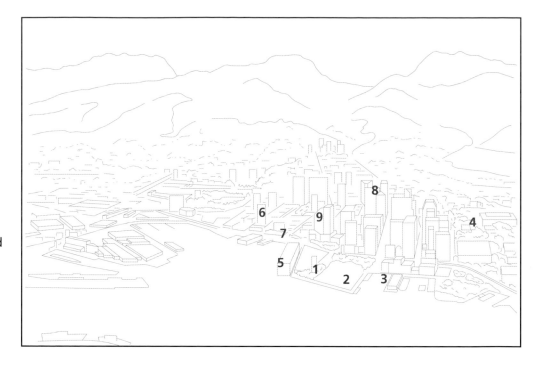

fifteen-block area, one may consult a herbalist, view an art exhibit, photograph a dragon procession, make an offering at a Buddhist temple, or buy precious jade.

7 Nimitz Highway

Named for Chester Nimitz, the World War II commander-in-chief of the U.S. Pacific Fleet, this major highway isolates the northern city from the bay.

8 First Hawaiian Center

At thirty floors and 430 feet, the tallest building in Hawaii was designed by Architects Kohn Pederson Fox.

9 Harbor Court

In 1994 architect Norman Lacayo and developer Mike McCormack built a thirty-one-floor building that fronts on 1212 Nuuanu Avenue. Its blue glass exterior makes it a distinctive landmark.

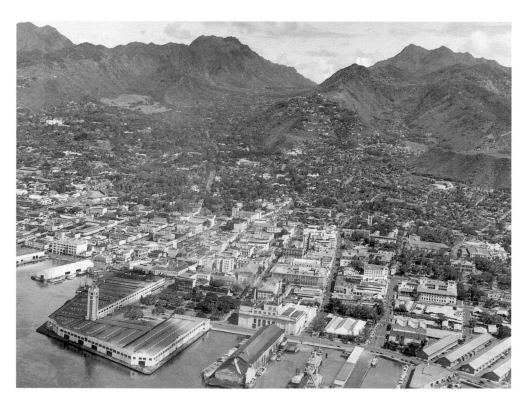

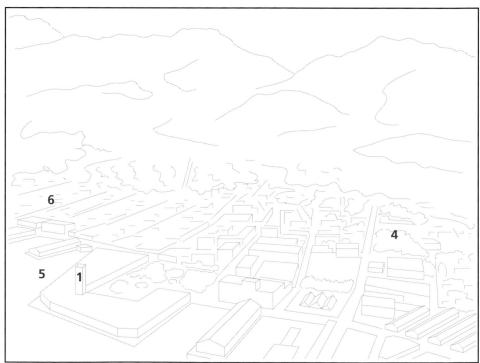

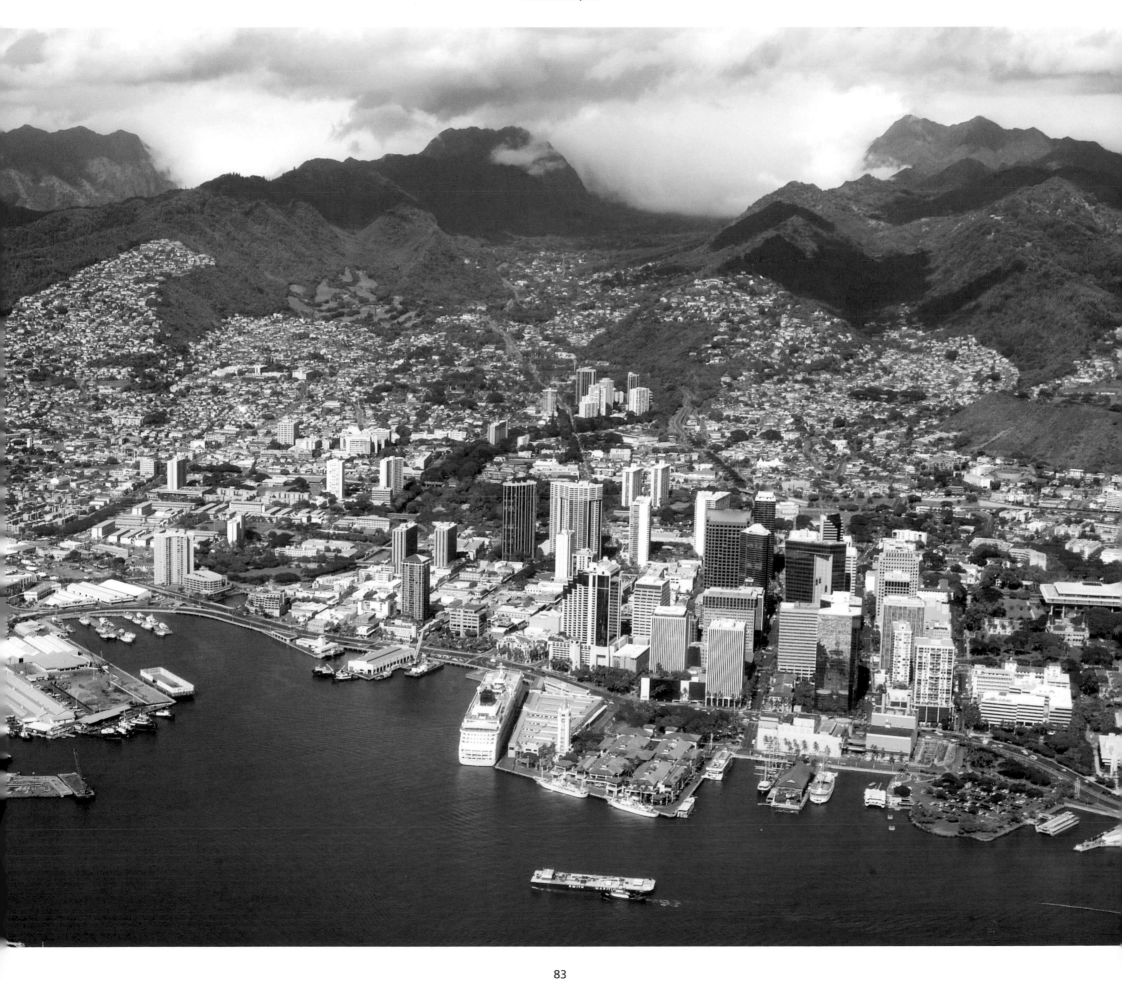

Diamond Head, Honolulu, 1960s (below)

1 Ala Wai Canal

The view is southeast across Waikiki to Diamond Head, one of the world's most famous volcanic craters. The Ala Wai Canal is in the lower quadrant and was created to drain the rice paddies and swamps that were thought insanitary.

By doing this, the resort area of Waikiki was created. Construction was by Walter F. Dillingham's Hawaiian Dredging Company. It took seven years,1921–1928, to finish.

2 Diamond Head

A thousand years ago, the Hawaiians called this extinct volcano Laeahi, which means "brow of the tuna." The current

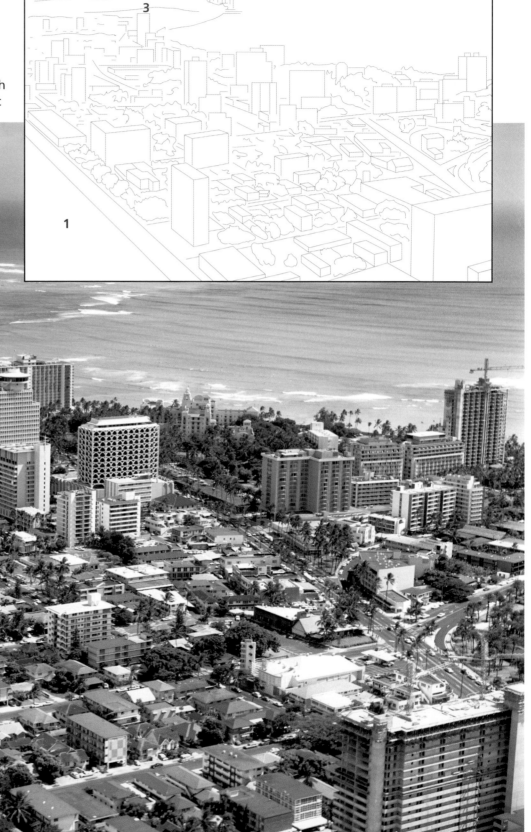

name was given when, from a distance, British sailors thought the calcite crystals in the lava glimmered in the sunlight like diamonds. Extinct for 150,000 years, Diamond Head crater is 3,520 feet in diameter with a 760-foot summit. The U.S. annexed the Hawaiian Islands in 1898 and immediately proceeded to build military installations, including a base inside Diamond Head. In 1909, Fort Ruger, the first U.S. Army reservation on the islands, was built in and on the sides of the old volcano. Fort Ruger was the site of Battery Harlow, armed with eight 2-inch mortars. The fort's prominent location made it a natural fire control station, with several posts built into the 760-foot high summit.

3 Park District
Kapiolani Park, the Honolulu Zoo and the Waikiki Marine Life Conservation District are located here. Kapiolani was created in 1876 and it is home to the oldest sporting club on the Hawaiian Islands—the Honolulu Cricket Club, formed in 1893.

Honolulu, 2005 (below)

4 Highrise Forest
In one generation, from the mid-1960s to the mid-1980s, Honolulu grew at an astonishing rate. Backed by the mountains of the Honolulu Watershed Forest Reserve and faced with the Pacific Ocean, there is little choice for the area's million residents except to erect highrise buildings.

5 Ala Wai Golf Course
The eighteen-hole, par 70 Ala Wai Golf Course has 6,208 yards of open fairway. The course rating is 67.2 and it has a slope rating of 116 on Bermuda grass.

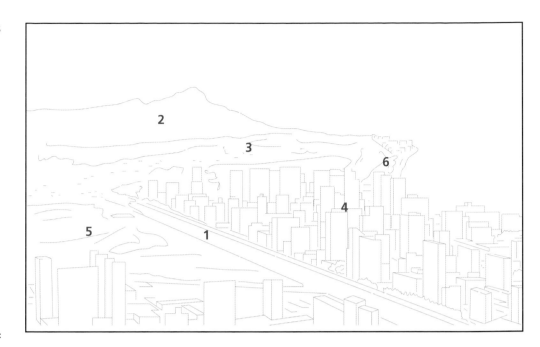

Designed by Donald MacKay, the Ala Wai opened in 1931.

6 Kalakaua Avenue
The heart of Waikiki, named after the last monarch, David Kalakaua (1836–1891).

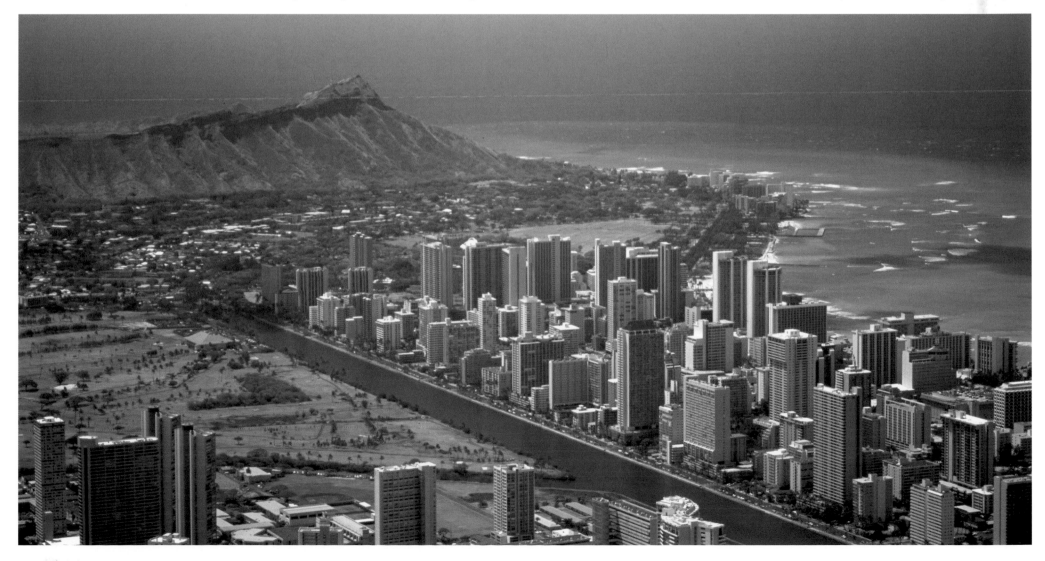

Houston, TX

Downtown Houston, 1929 (below)

Today six million people live in the Houston area, making it the fourth largest U.S. urban area. By the time this photo was taken, it was already the most populous in Texas.

1 Niels Esperson
Constructed two years before the photo, this thirty-two-floor Neoclassical structure is still a landmark downtown. Although today it seems lost in a forest of skyscrapers it was once the tallest building in Texas. It features a gold-leaf tower topped by an elaborate six-story

tiered monument. Inside are terra-cotta urns, bronze elevator doors, arabesque obelisks and imported Roman marble. Air conditioning was added in 1938.

2 J.P. Morgan Chase
This thirty-six floor office highrise at 712 Main Street, opened in 1929, is celebrated for its Art Deco architecture.

3 City Hall
The fourth Houston City Hall—with two towers—and Market House were built in 1904 and served until 1939 when the present building took over. The old City Hall became a bus station.

Downtown Houston, 2001 (right)

4 Minute Maid Park
Featuring a 242-foot high six-acre retractable roof, this 40,950-capacity stadium has been home to the Houston Astros since 2000. Originally Enron Field, it was

renamed for Minute Maid, a division of The Coca-Cola Company, in 2002. Minute Maid is headquartered in Houston.

5 Annunciation
Seemingly lost among giant commercial and entertainment establishments, the Annunciation Catholic Church serves a 326-household parish. It was established in 1869.

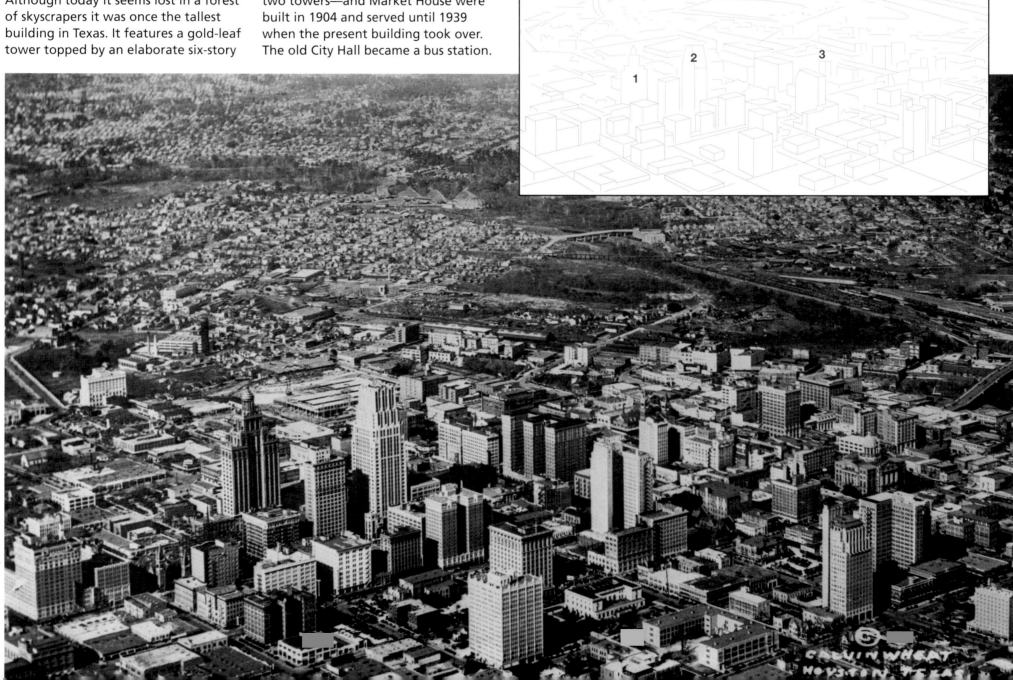

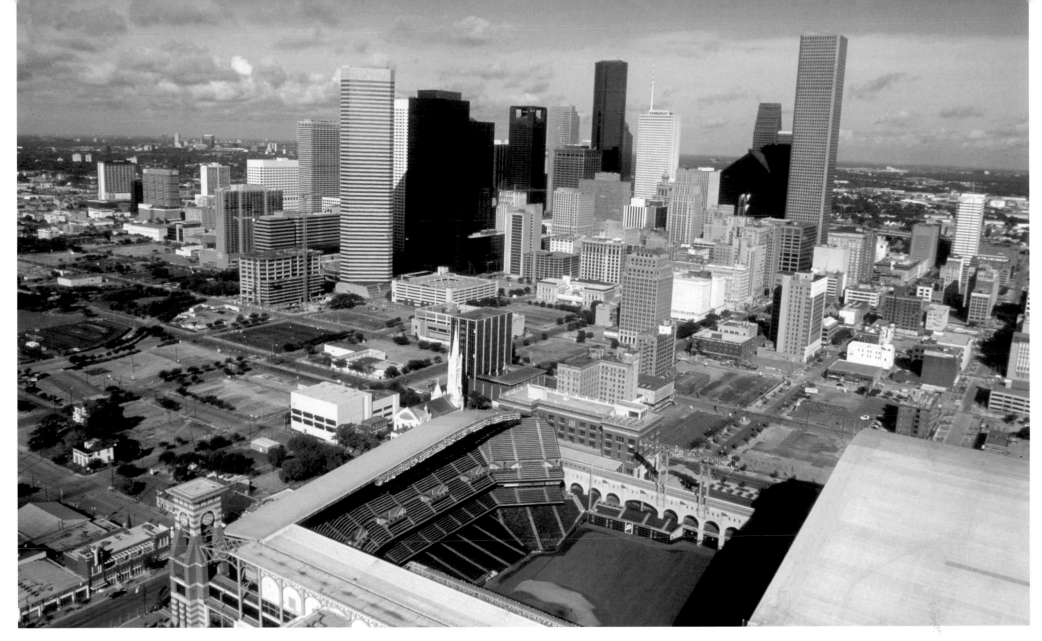

6 J.P. Morgan Chase Tower
At 600 Travis Street, this seventy-five-floor, 1,000-foot tower, built in 1982, is the tallest building in Texas and the tallest five-sided building in the world.

7 Bank of America Center
Completed in 1983, construction of the fifty-three-floor center took three years. Encased at the Louisiana-Capitol corner is a preexisting two-story building, which accounts for the extremely high—120-feet—level of the second floor.

8 Pennzoil Plaza
The plaza includes two late-modernist style thirty-six-story office trapezoidal towers of dark bronze-tinted glass connected by a 115-foot high enclosed courtyard.

9 One Shell Plaza
At 910 Louisiana Street, the fifty-floor plaza was completed in 1971. Faced with marble, the windows are glazed with bronze-colored glass.

10 Wells Fargo Plaza
Finished in 1973, this seventy-one-floor structure is the tallest all-glass building in the Western Hemisphere. The building's footprint forms an abstract version of a dollar sign.

11 Centerpoint Energy Plaza
In 1974 the building was completed with fifty-three floors; in 1996 it was extended another ninety feet including a six-story top with a hole in the roof.

12 1 and 2 Houston Center
Completed in 1978 and 1974 respectively.

Indianapolis, IN

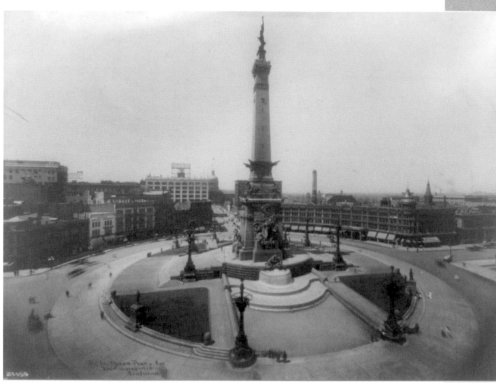

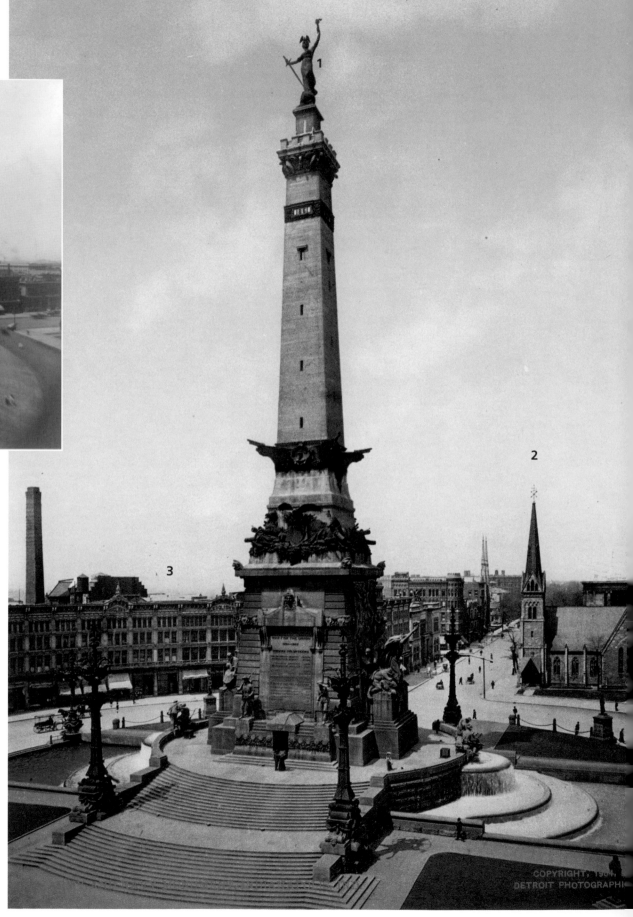

Soldiers and Sailors Monument, 1904 (right)
(locations identified on image)

Designed by German engineer Bruno Schmitz, for many years this was the tallest structure in the Indiana State capital. Near the top is a public observatory, while around the base are decorative fountains. Located at Monument Circle, formerly known as Governor's Circle, the monument is on the National Register of Historic Places. Completed in 1901, it is

constructed of stone and bronze. It commemorates Indiana citizens who fought in wars from the Revolution through the Spanish-American War (1898). It rises nearly 284.5 feet.

1 Statue of Victory
This 38-foot high statue representing "Victory" (although Hoosiers call her "Miss Indiana") was designed by George W. Brewster. Her torch signifies the light of civilization; the eagle on her head, freedom; the sword, the victorious army. She faces south, supposedly to look over the battlefields.

2 Christ Church Cathedral
The oldest building on Monument Circle, the Episcopalian cathedral was constructed in 1857.

3 English Hotel and Opera House Cathedral
This building was demolished to make way for the JC Penney Department Store (built in 1950), now known as 120 Monument Circle.

Soldiers and Sailors Monument, 1911 (opposite, far left)

Soldiers and Sailors Monument, 2002 (right)

4 Chase Tower
Completed in 1990, it remains Indiana's tallest building. It has forty-nine floors and rises to 810 feet.

5 Chase Circle Building
Unusual for its concave curtain-wall front façade, this building was completed in 1959.

6 One Indiana Square
Since this 2002 photograph, the façade of this building has been renovated and altered.

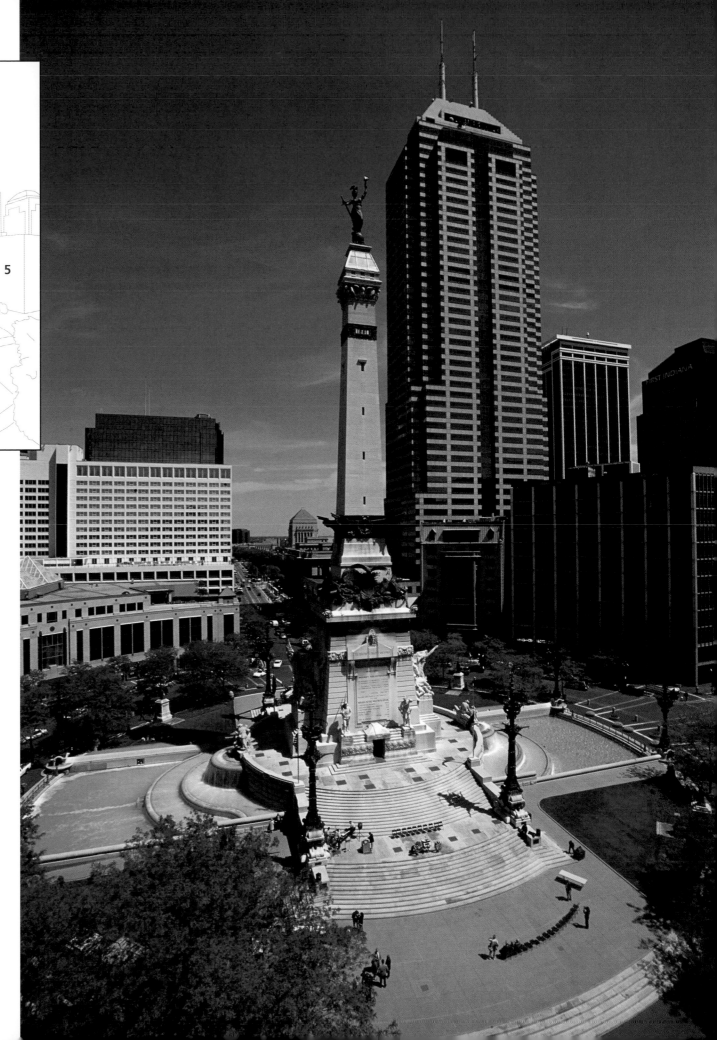

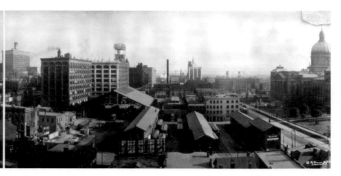

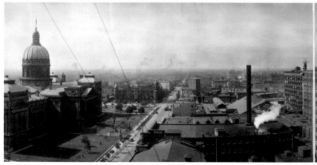
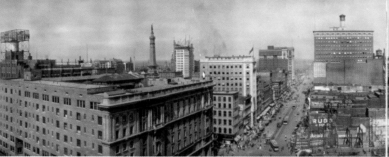
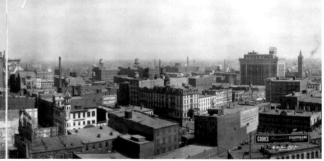

Indianapolis, 1900s (top and above)

1 Indiana State House
Designed by architect Edwin May with a cross-like floor plan with the dome at the center. Following eight years of construction it was completed in 1888. It is located a few blocks from central Indianapolis and until construction of tall office towers in the 1980s and 1990s was among the city's most prominent structures.

2 Soldiers and Sailors Monument
Completed in 1901, for many years the tallest structure in Indianapolis.

3 Barnes and Thornburg Building
Designed by Daniel H. Burnham & Company, this traditional Neoclassical style seventeen-story brick highrise was completed in 1909. The tallest occupied building in Indianapolis until 1962, it still stands today, more than a hundred years after it was built.

4 B. F. Keith's Theatre Building
In modern times known as the Consolidated Building, this fifteen-story building originally served as a vaudeville theater.

Indianapolis, ca. 2000 (right)

5 One America Tower
For eight years beginning in 1982, this thirty-eight-story limestone-covered office building was the tallest in Indianapolis. Previously the old Plaza Hotel stood at this site.

6 Chase Tower
Completed in 1990, this 49-floor (811-foot) Postmodern office tower is the tallest building in both the city of Indianapolis and the state of Indiana. It was built in downtown Indianapolis on the site once occupied by the old Hume-Mansur, Board of Trade, and Bankers Trust buildings.

7 Indiana Government Center North
A concrete government office block completed in 1993.

8 Military Park
A fourteen-acre open space that is the city's oldest park; traditionally it was a military training ground. In 1900, William Jennings Bryan initiated his unsuccessful presidential campaign at a rally in this park.

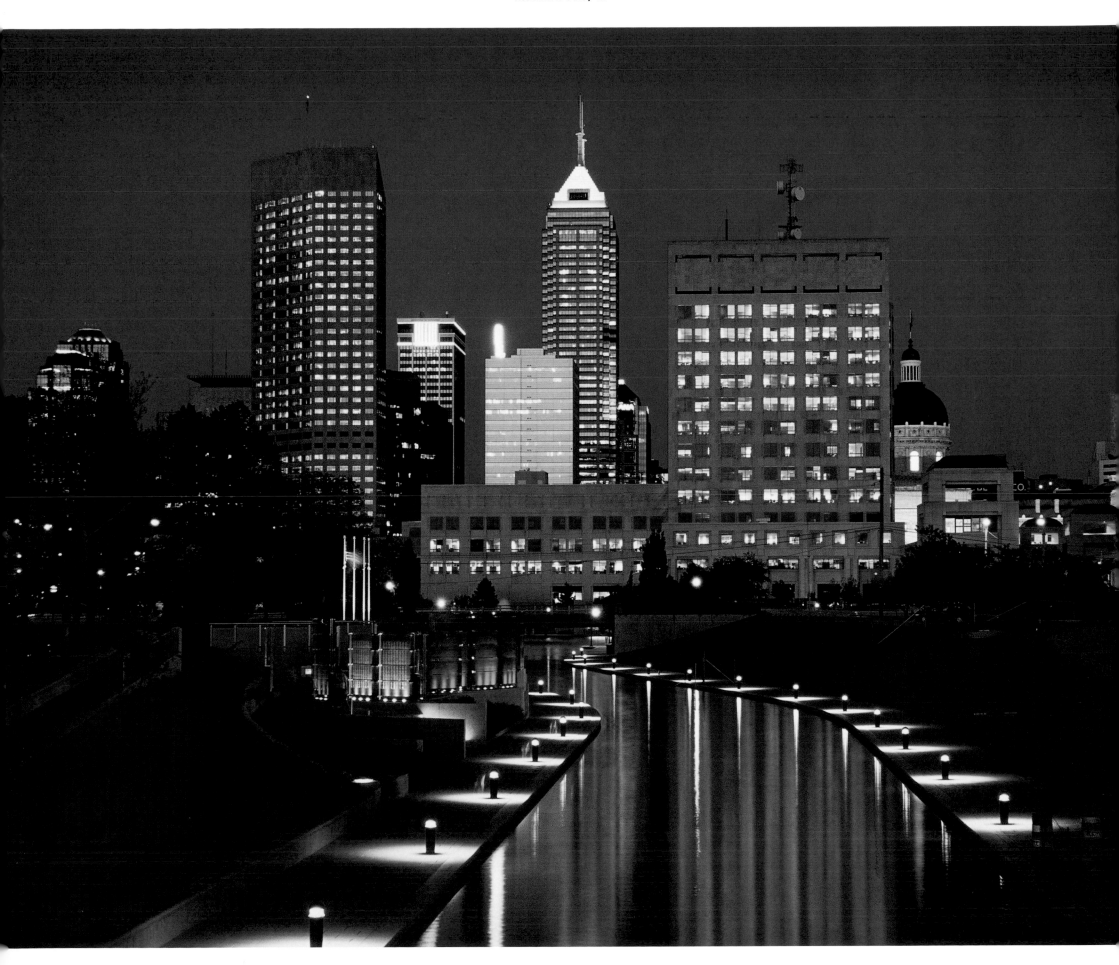

Jacksonville, FL

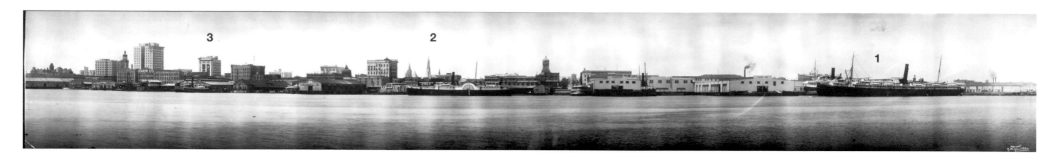

Jacksonville riverfront, 1913 (above)
(locations identified on image)

Cowford was established on the banks of the St. Johns River in 1791. Just thirty-one years later, after the U.S. purchased Florida from Spain, the city was named after Andrew Jackson, its governor.

1 Port of Change
In 1913 Jacksonville still entertained a variety of merchant watercraft from modern steamers to side-paddle steam boats to five-masted sail boats.

2 Immaculate Conception Catholic Church
Jacksonville's tallest building until 1913.

3 Bisbee Building
The Bisbee Building was completed in 1909. Just behind it is the Heard National Bank Building (now demolished)—the first building taller than the Immaculate Conception Church spire, at 177 feet. Today the Modis building stands between here and the river.

Jacksonville riverfront, 1963
(opposite, upper)

4 Main Street Bridge
Named the John T. Alsop, Jr Bridge in honor of a former mayor, this four-lane steel lift bridge is 1,680 feet in length and opened in 1941. The center span of the bridge can be raised and lowered for ocean-going vessels to pass beneath.

Jacksonville riverfront, 2008
(below)

5 Modis Building
On 1 Independent Drive, the Modis

Building is thirty-seven stories tall, enough to make it the tallest in Florida from when it was built in 1974 till One Tampa City Center overtook it in 1981.

6 AT&T Tower
Opened in 1983, designed by KBJ Architects, it has thirty-two stories and—thanks to its stepped edge—each of them has sixteen corner offices.

7 Jacksonville Center
Opened in 1989, it is another KBJ Architects' design, and has twenty-four stories that reach 357 feet above the ground. KBJ Architects are credited with creating "Jacksonville's modern skyline" and are responsible for seventeen of the city's thirty tallest buildings.

8 CSX Transportation Building
A seventeen-story building at 500 Water Street, this 251-foot office for CSX Transportation—a railroad company that owns approximately 21,000 route miles on the East Coast of the United States—was completed in 1960.

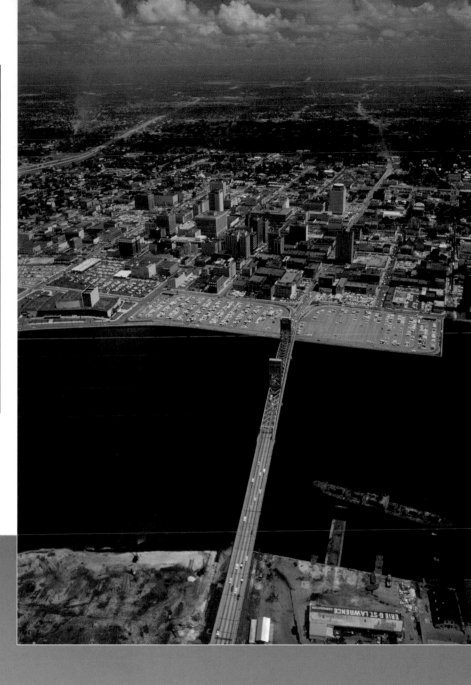

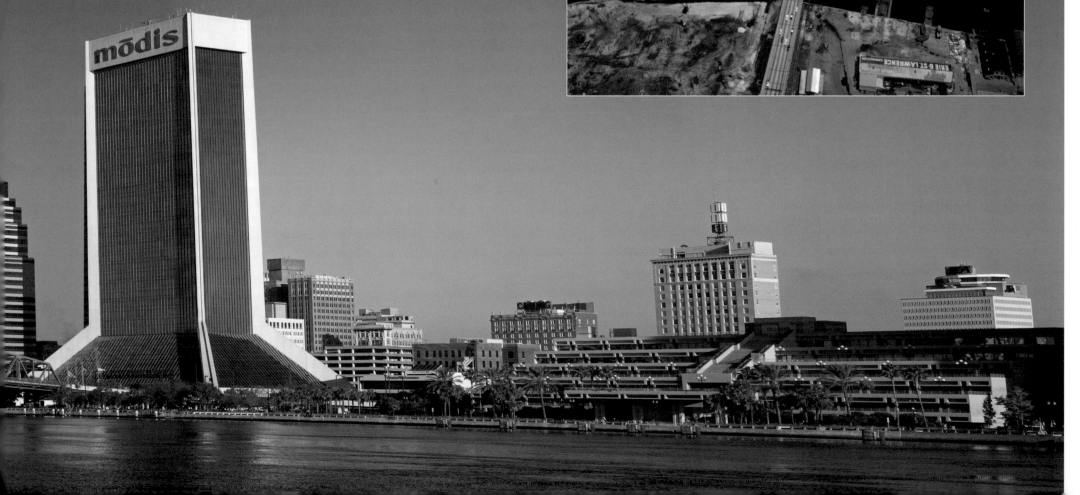

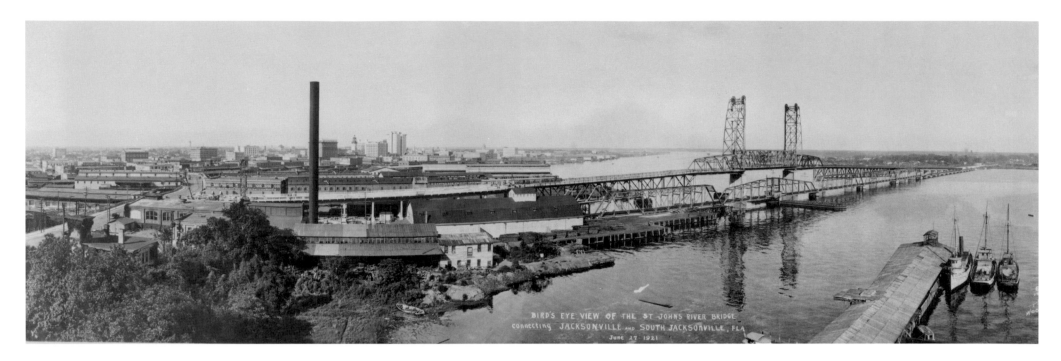

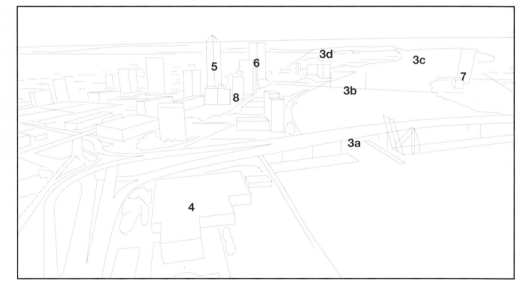

St. Johns River Bridge, Jacksonville, 1921 (above)

Prior to the invention of artificials—rubber and plastic—many products were made from pine trees. "Naval stores" were resin-based components—turpentine and tar, and products with pine sap such as varnish and shoe polish —and the tall, straight masts used in building and maintaining wooden sailing ships. Jacksonville was a center of shipping and milling the yellow or longleaf pines that contributed enormously to naval store production.

1 St. Johns River Bridge
Later (in 1949) renamed the St. Elmo W. Acosta Bridge after the city commissioner who convinced voters to pay for it, this first bridge opened in 1921.

2 Seminole Hotel
With the U.S. Post Office and Federal Building to the left and the Heard Building to the right, the hotel was completed in 1910 and demolished—as were so many other landmarks—-in the 1970s.

Acosta Bridge, Jacksonville, 2006 (opposite)

3 Bridges of Duval County
With a population of 1.5 million spread on both sides of the St. Johns River, numerous bridges knit the Jacksonville community together: (**3a**) the Acosta Bridge (next to small bascule or draw bridge that it replaced), (**3b**) the Main Street or John T. Alsop, Jr. Bridge (bright blue), (**3c**) the Isaiah David Hart Bridge (a green cantilever bridge), and (**3d**) the Mathews Bridge. (The Fuller Warren Bridge is just out of the picture.)

4 Florida Times-Union Building
From the top of the Haskell Building, headquarters of an international team of planners, architects, and builders, the Florida Times-Union Building appears to be surrounded by Interstate Highways and the St. Johns River. The *Times-Union* is Jacksonville's daily newspaper and dates to 1883.

5 Bank of America Tower
Since its completion in 1990 this forty-two-story glass, steel and concrete tower has been the tallest building in Jacksonville. At night, four of the tower's eight top triangular panels are illuminated.

6 1 Independent Drive
The Modis Technologies Building was known as the Independent Life building until the 1990s.

7 South Bank
Riverplace Tower, completed in 1967, has twenty-eight floors and wonderful views of the city and the river. Designed as a "pre-cast, post-tension concrete structure," most of the building's structural support is on the exterior, leaving more space for the interior.

8 AT&T Tower
Originally the Bell South Tower, the structure was opened in 1983. Each floor has sixteen corner offices. It was also designed by KBJ Architects.

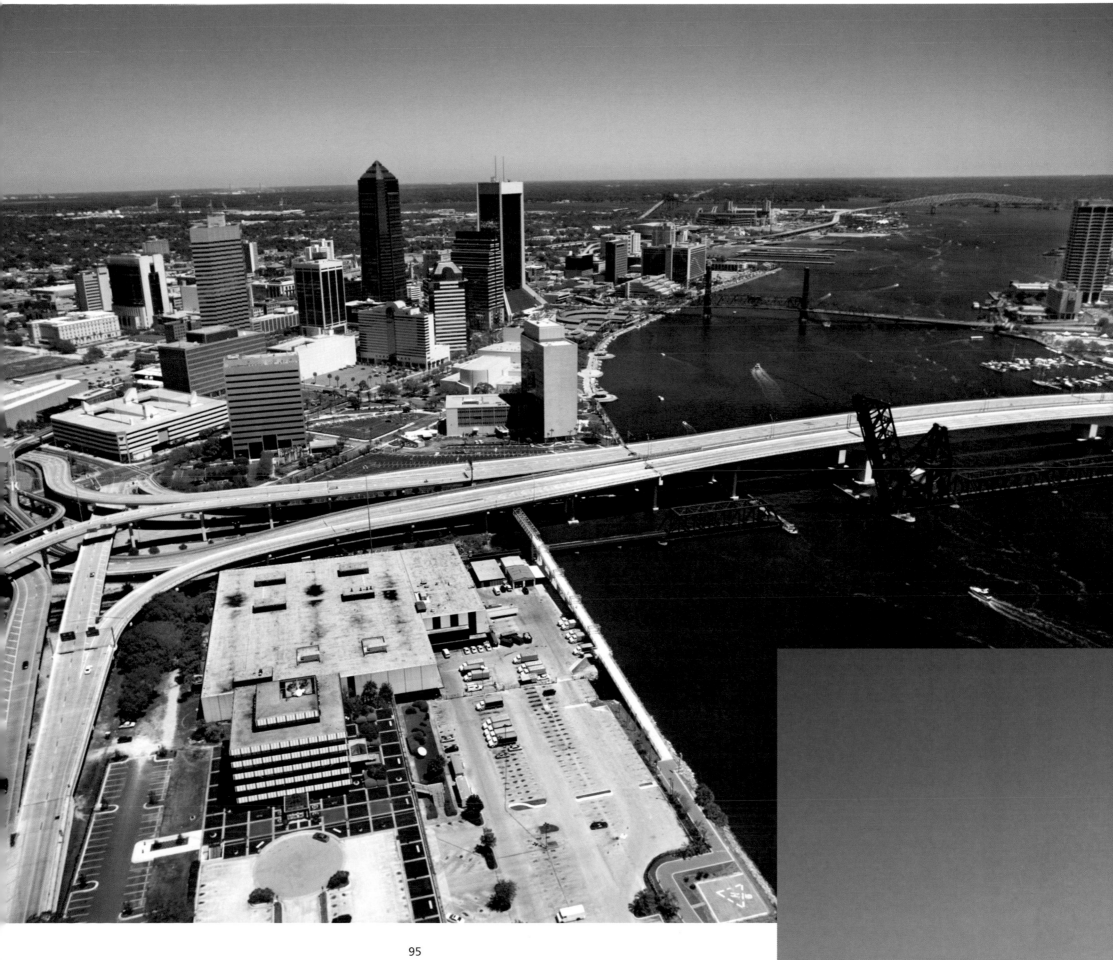

Juneau, AK

Juneau, 1951

Alaska's capital, one of the few cities in the region, was born out of a fever-inspired gold rush in the 1880s. Built along the side of its namesake mountain it has been described as a "Little San Francisco," and despite a population of approximately 30,000 people retains a feeling of a frontier town. A territory since being purchased from Imperial Russia in 1867, Alaska was finally admitted as the forty-ninth state on January 3, 1959.

1 Gastineau Channel
A natural deepwater channel separating Juneau from Douglas Island.

2 Juneau–Douglas Bridge
A pre-stressed concrete highway bridge 620-feet long spanning the Gastineau Channel between its namesake points. Built between 1975 and 1980, it offers a maximum clearance at its apex of over 220 feet.

3 Douglas Island
A natural deepwater channel on the southern coast of Alaska separating Juneau from Douglas Island.

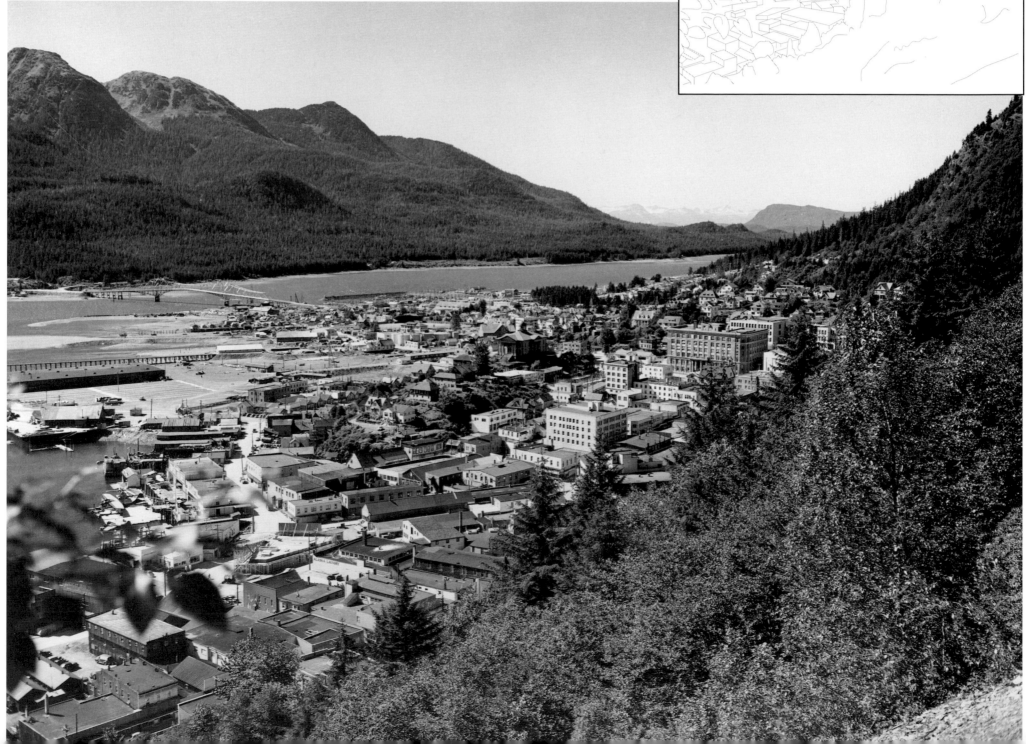

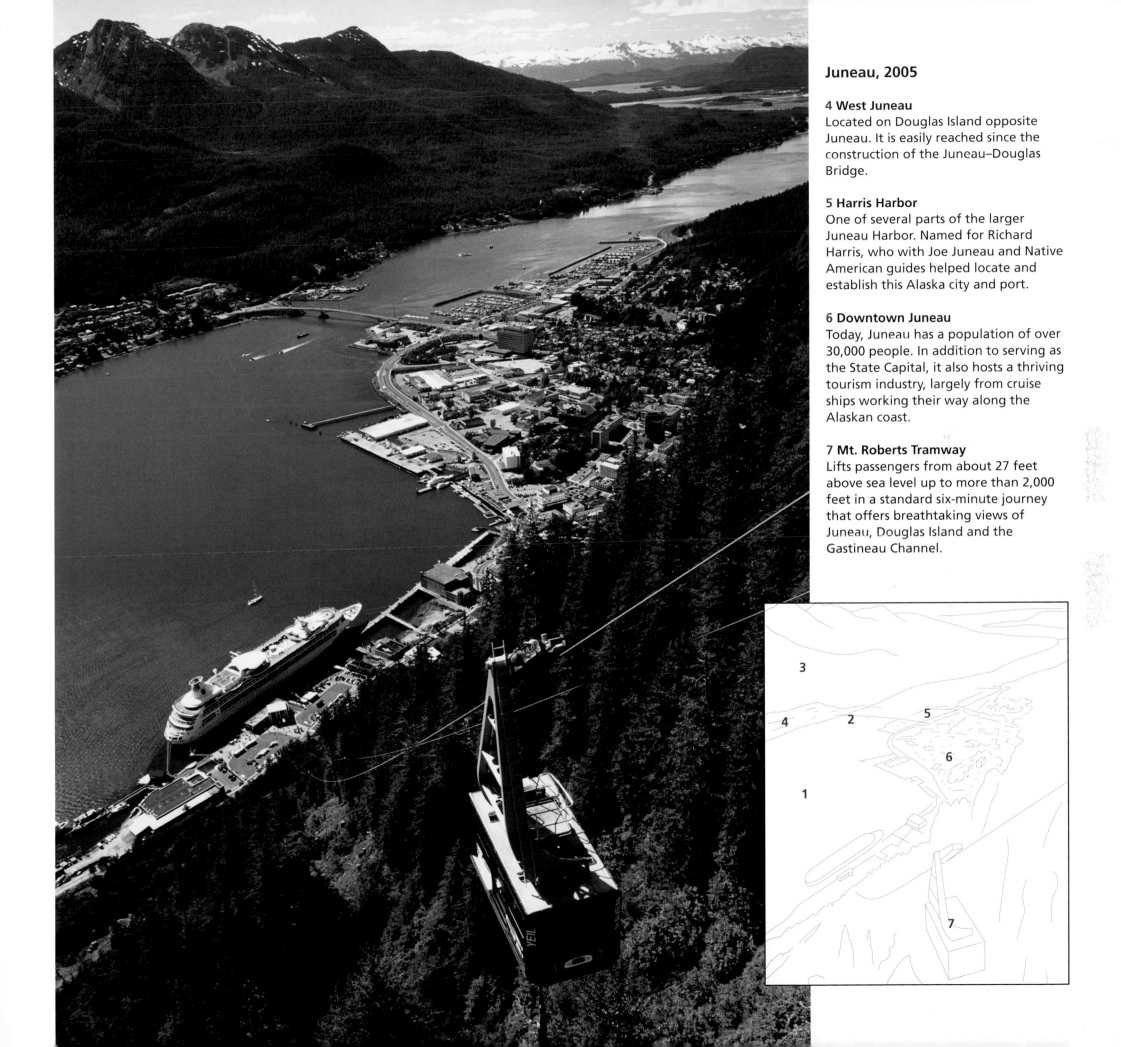

Juneau, 2005

4 West Juneau
Located on Douglas Island opposite Juneau. It is easily reached since the construction of the Juneau–Douglas Bridge.

5 Harris Harbor
One of several parts of the larger Juneau Harbor. Named for Richard Harris, who with Joe Juneau and Native American guides helped locate and establish this Alaska city and port.

6 Downtown Juneau
Today, Juneau has a population of over 30,000 people. In addition to serving as the State Capital, it also hosts a thriving tourism industry, largely from cruise ships working their way along the Alaskan coast.

7 Mt. Roberts Tramway
Lifts passengers from about 27 feet above sea level up to more than 2,000 feet in a standard six-minute journey that offers breathtaking views of Juneau, Douglas Island and the Gastineau Channel.

Kansas City, MO

Union Station, 1939

1 Union Station

At 30 West Pershing Road south of downtown, Union Station is one of many "union stations" in the U.S. The 850,000-square-foot building opened in 1914. Designed in the Beaux-Arts style, the ceiling of the Grand Hall is 95 feet high, with three 3,500-pound chandeliers. In 1945, annual passenger traffic peaked at 678,363; by 2008, passenger totals had fallen to 130,459. Barely 32,842 passengers used Union Station in 1973 when passenger train service was run entirely by Amtrak. The building was beginning to deteriorate; even Amtrak moved out. The city hired a company to renovate and when, after several years, little work took place, it filed a lawsuit which, after six additional years, was settled in the city's favor. Residents in two states ultimately voted for a special renovation tax that raised $250 million. Renovation began in 1997 and was completed in 1999. Today Union Station receives no public funding and is home to a planetarium, museums, theaters, and the arts. In 2002, Amtrak restored passenger train service to Union Station, including two long-distance named trains, "The Southwest Chief"(daily Chicago– Kansas City–Los Angeles) and "The Texas Eagle" (daily Chicago–St. Louis– Dallas–San Antonio).

2 Kansas City Power & Light Building

The thirty-four-floor Kansas City Power & Light Building at 106 West 14th Street/1330 Baltimore Avenue bridges the generations of our fathers to our children. When completed in 1931, it was Missouri's tallest building. It

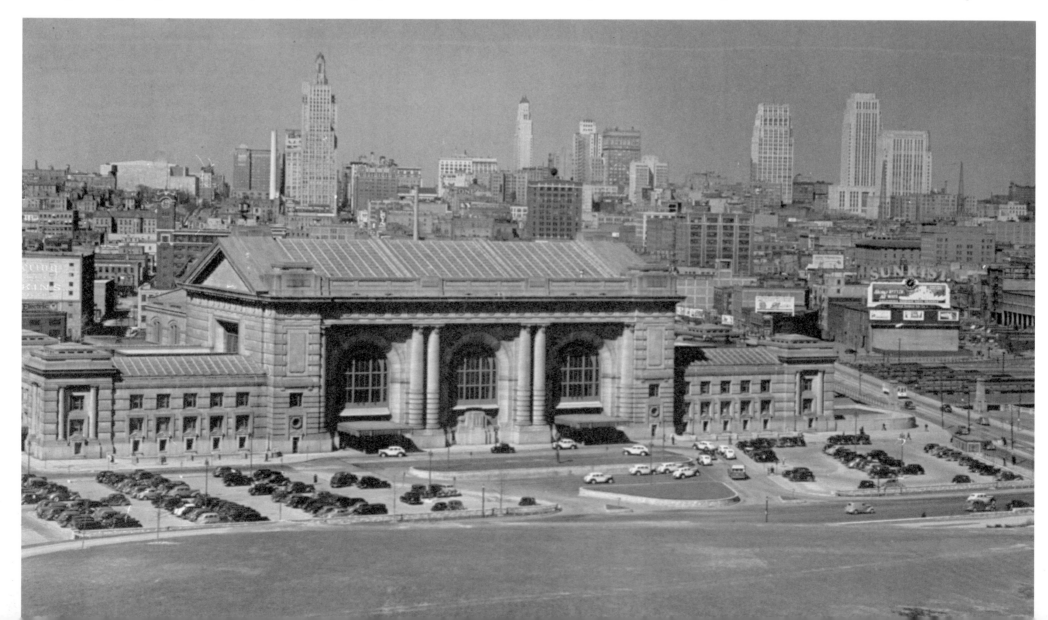

includes a 97-foot pillar that changes colors: red, white, amber, and green. The west wall has no windows because a twin was proposed, but that fell through during the depression of the 1930s. Kansas City Power and Light no longer occupies the building, having moved in 1992 to the 1201 Walnut highrise.

3 Oak Tower Building

Built to fourteen stories (189 feet) in 1913, the height was increased to twenty-eight stories (380 feet) in 1929. In 1974 the original terra-cotta skin was covered over in white.

4 City Hall

City Hall is a 30-floor building opened for the public's business in 1937. It is located at 414 East 12th Street.

5 Jackson County Courthouse

A twenty-two-story building completed in 1934, three of the upper floors were once the county jail, with a capacity of 450 inmates.

Union Station, 2005

6 One Kansas City Place

Among the downtown skyscrapers, this forty-two-floor building finished in 1988 stands out. It has clear glass atriums at corner setbacks while the inside has black marble and rosewood with chrome and rose marble accents.

7 Town Pavilion

At 1111 Main Street, this thirty-eight-story building was finished in 1986.

8 Bartle Hall Pylons

Bartle Hall is a convention center named

after the city mayor who served 1955–1963. The building is suspended over Interstate highway I-670 by four 335-feet-tall pylons. The pylons were modeled after the Art Deco design of the ornamentation inside the next-door Municipal Auditorium. They are finished off with "Sky Stations," metal sculptures designed by artist R.M. Fischer. Bartle Hall was completed in 1994.

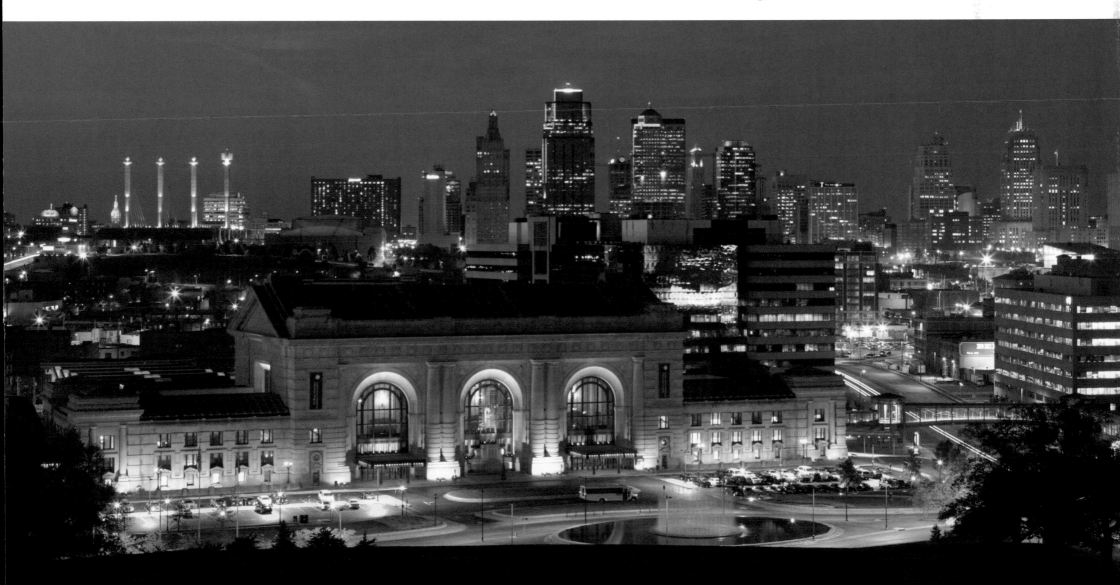

Kodiak, AK

Kodiak, 1920s

Located on Kodiak Island—largest Island in Alaska, and second largest in the United States after Hawaii—is the village of the same name. This was established as the governing capital of Russian America in 1792, which it remained for only a dozen years before being transferred to Sitka. It developed as a fishing port with processing plants and canneries located in the village. For such a small place it has experienced more than its fair share of natural disasters. It was rocked by a massive volcanic explosion in 1912 that covered the town in a thick blanket of ash, then in 1964 it was leveled and drowned by the catastrophic Good Friday Earthquake and ensuing tsunami, after which the town had to be largely rebuilt.

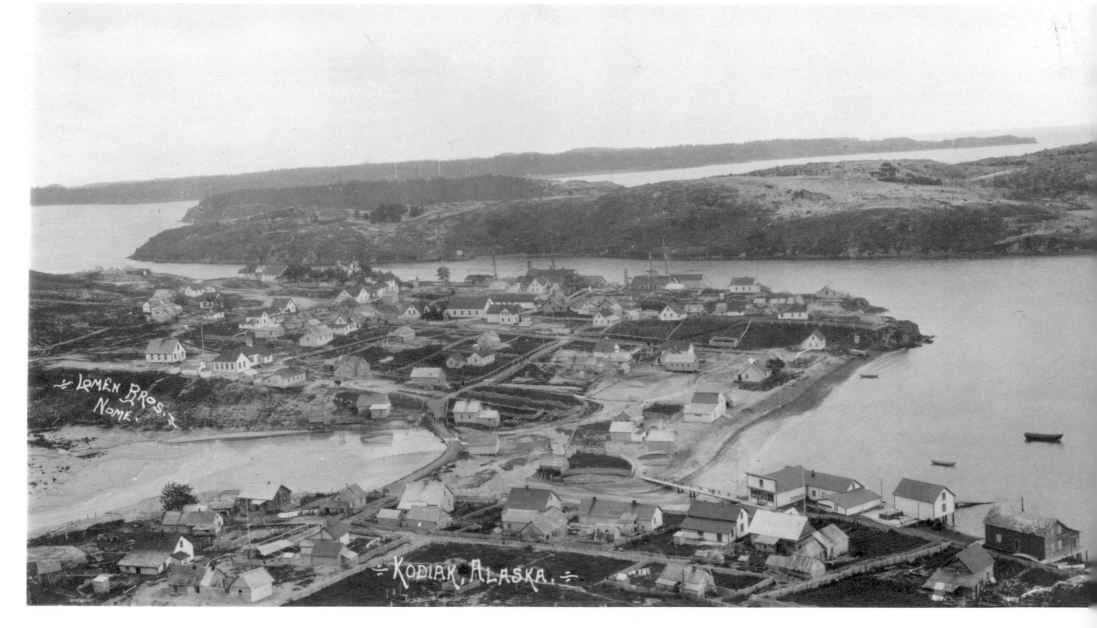

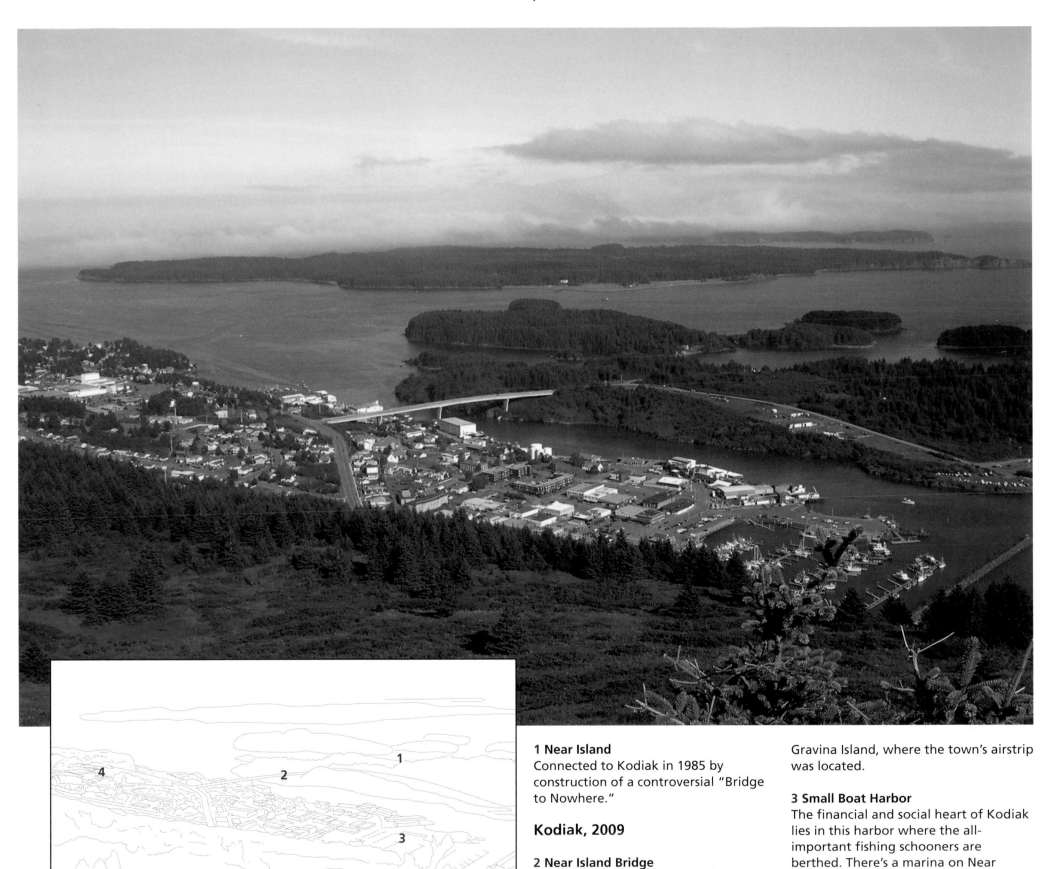

1 Near Island
Connected to Kodiak in 1985 by construction of a controversial "Bridge to Nowhere."

Kodiak, 2009

2 Near Island Bridge
The so-called "Bridge to Nowhere" on Dog Bay Road—not to be confused with the later Alaskan bridge controversy that raged in 2009. That one would have joined Ketchikan and nearby

Gravina Island, where the town's airstrip was located.

3 Small Boat Harbor
The financial and social heart of Kodiak lies in this harbor where the all-important fishing schooners are berthed. There's a marina on Near Island.

4 Kodiak High School
Home of the Bears!

Las Vegas, NV

Flamingo Hotel, 1968 (below)

The hotel and casino that essentially started it all has colorful roots. Billy Wilkerson owned an entertainment newspaper and nightclubs in Los Angeles. Attracted to the possibilities in Las Vegas, he began the Flamingo project in 1945, but soon ran into money troubles. Enter a pack of mobsters led by Benjamin "Bugsy" Siegel who took over the project. Murder, corruption and crime preceded the opening of The Pink Flamingo Hotel and Casino in December 1946. Benjamin "Bugsy" Siegel was a murderer and low-life criminal; but he had a vision that would one day become the famous Las Vegas Strip. During his 1939 trial for killing a police informant, newspapers referred to the gangster as "Bugsy," implying that his famously erratic behavior was, in the slang of the day, "bugs" or crazy. Siegel hated the nickname, however, and no one called him Bugsy to his face. Although the casino eventually proved to be a prosperous investment, Bugsy Siegel was shot to death in his Hollywood home in 1947. That year, the hotel/casino was renamed The Fabulous Flamingo. In 1967, aviation and real estate entrepreneur Kirk Kerkorian purchased and remodeled it. Here, the Flamingo shows a new million dollar facade and the Flamingo Sky Room in 1968.

Flamingo Hilton, 1999 (right)

The Hilton Corporation purchased The Flamingo in 1972 and renamed it the Flamingo Hilton. By the time a series of remodeling projects were completed and the last of the original Flamingo was torn down in 1993. Six years later, the hotel/casino's relationship with the Hilton name ended and the property is part of Harrah's Entertainment. In January 2008, Harrah's and its 85,000 U.S. employees were acquired by affiliates of private-equity firms TPG Capital and Apollo Global Management. Today's Flamingo Hotel & Casino at 3555 Las Vegas Boulevard South has been reinvented. Still, a bronze memorial plaque honoring Siegel and The Mob stands at the end of an open-air fuchsia canopy, set in front of the Flamingo Hotel/Casino wedding chapel.

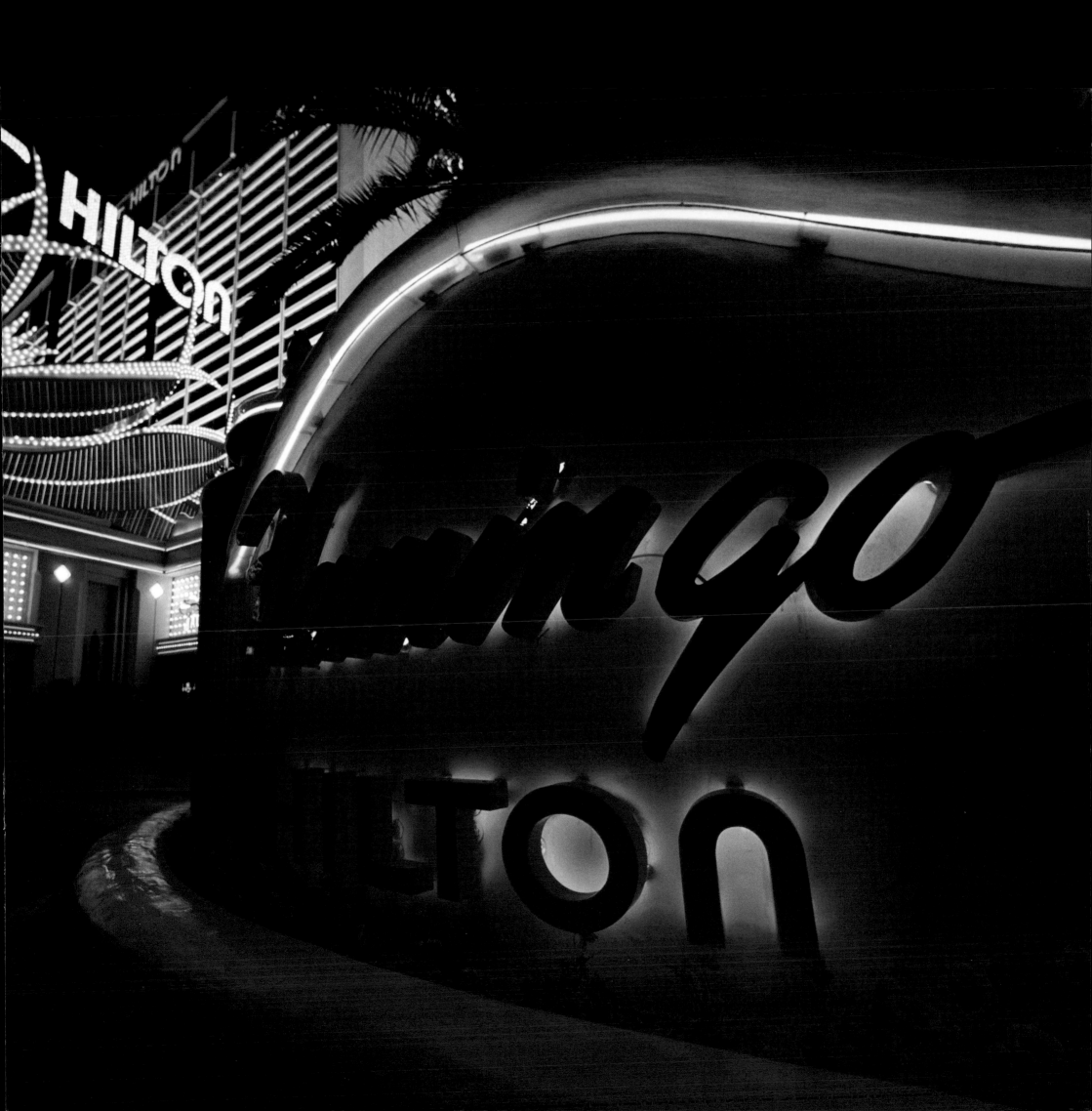

North on the Strip, 1960s (below)

This street-level view looks north along Las Vegas Boulevard (also known as the Las Vegas Strip), from just south of the intersection with East Desert Inn Road. Visible establishments include the Stardust Auditorium and casino, Aku Aku (a Polynesian restaurant), the Gold Key Motel, Fashion Square shopping mall, the Riviera hotel and casino, the sign for the La Concha Motel, and several gas stations (including Texaco, Phillips 66, and Shell). Behind the camera to the left is the Frontier, recently demolished. To the right today is the Encore at Wynn Las Vegas (4), started in 2006, the city's fourth tallest building at 630 feet.

North on the Strip, 2000 (opposite)

1 The Stratosphere

An aerial view looking toward the north of the famous Las Vegas Strip. Lined with hotels and casinos, the Strip is anchored on the north end by the Stratosphere. Growing toward the south, the Strip no longer ends at the Tropicana, but now extends past the Luxor pyramid to Mandalay Bay.

2 The Luxor

Opening in 1993, rooms line the interior walls of the pyramid tower in this Egyptian-themed hotel/casino. Mandalay Bay to the south and Excalibur to the north are connected by free express and local trams. All three properties were built by Circus Circus Enterprises, which later became Mandalay Resort Group.

3 Mandalay Bay

This resort, casino, and convention complex opened in 1999 and is grounded on a forty-three-story luxury hotel whose windows are covered with gold leaf. An older complex called The Hacienda was imploded in 1996 to make room for Mandalay Bay.

4 Encore

This resort opened in December 2008.

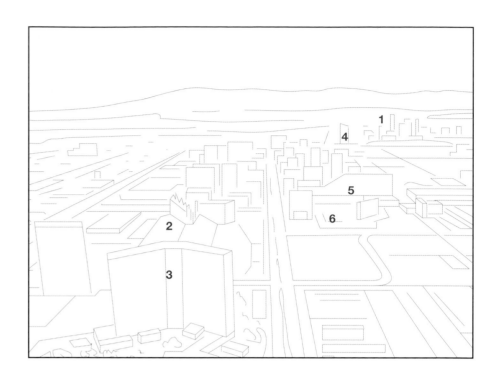

5 MGM Grand

The MGM Grand was the largest hotel in the world before the Venetian was built in 1997–1999. Its main building has thirty floors and is 293 feet tall.

6 Tropicana

The original building was built in 1957; the Paradise Tower in 1979; and the twenty-one-story Island Tower was constructed in 1986.

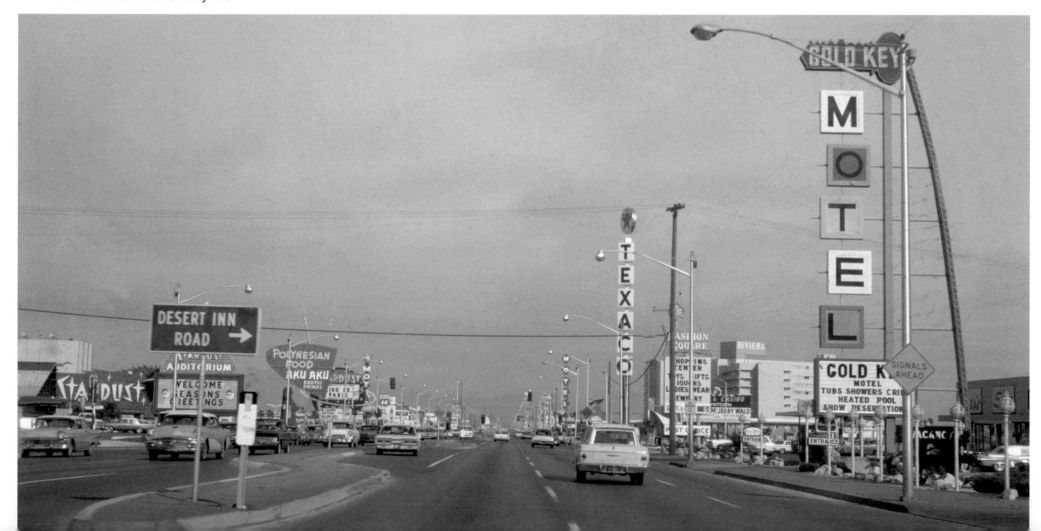

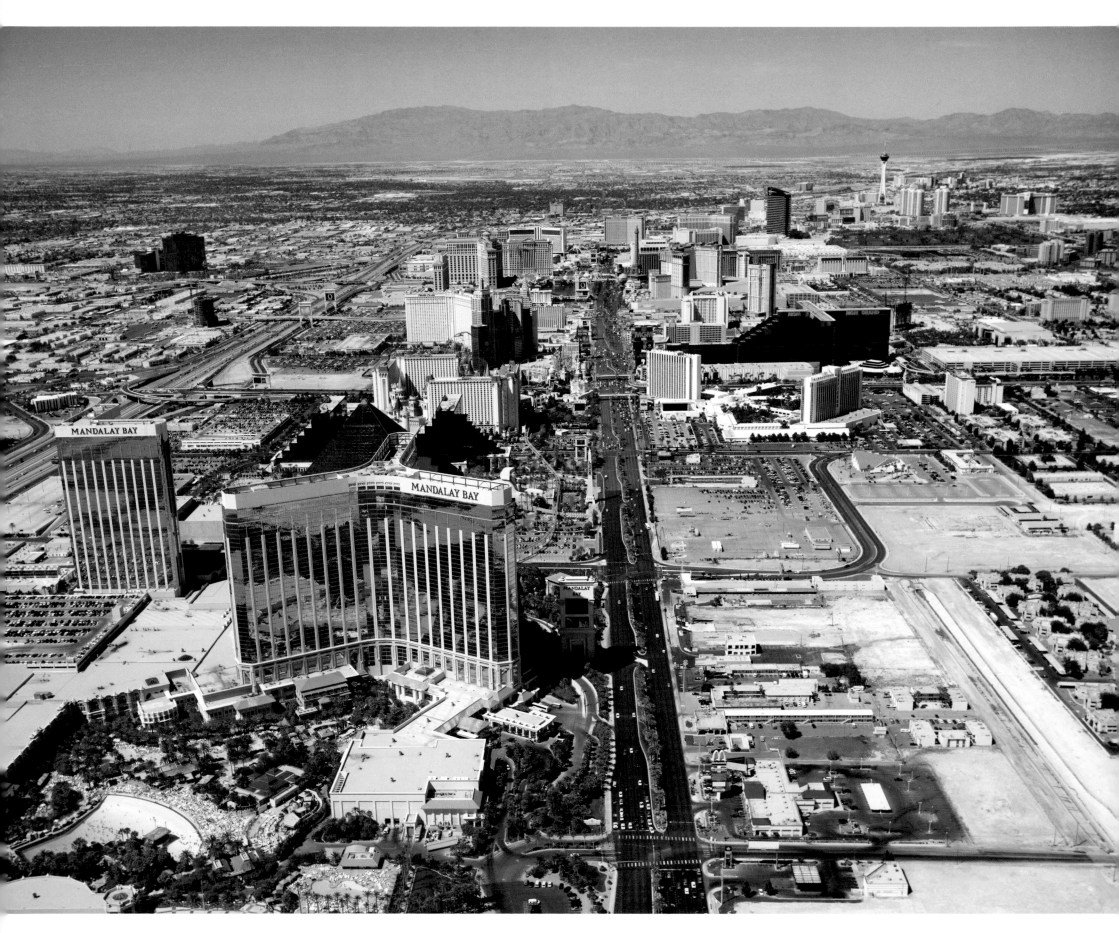

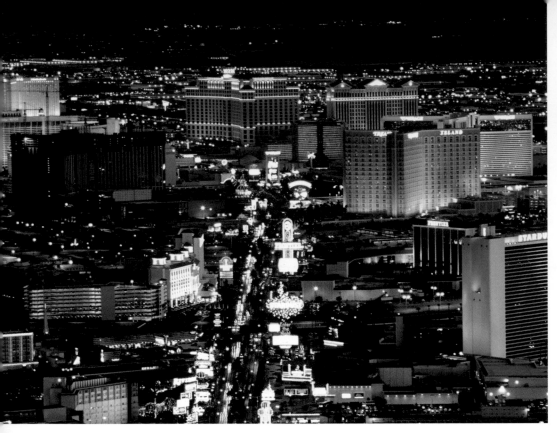

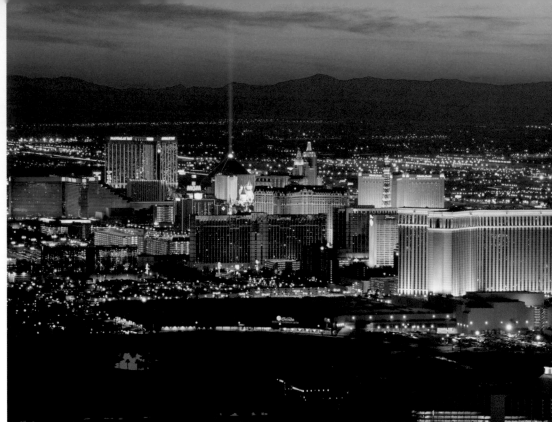

South on the Strip, 2001 (above, left)

A view from the Stratosphere Tower at 2000 Las Vegas Boulevard—the tallest free-standing observation tower in the U.S. The 1,149-foot tower is topped with three thrill rides and a revolving restaurant. At night The Strip comes alive with each hotel, night club, and casino vying for attention. Each attempts to have the most spectacular sign. The famous Stardust sign (1) cost a half million dollars when erected in 1965. At night, incorporating neon and incandescent bulbs in the animation sequence, light fell from the stars, sprinkling from the top of the 188-foot tall sign down over the Stardust name. In March 2007 the Stardust, which opened in July 1958, was imploded in a ceremony that included fireworks.

2 Treasure Island
Opened in 1993, it is connected by pedestrian bridge to Fashion Show Mall.

3 The Mirage
Opened 1989, it has the largest free-standing marquee in the world in front of the resort. The site has been used before—by the Castaways casino.

4 The Bellagio
The Italian-styled Bellagio (barely visible at right) opened in 1998 with 3,933 guest rooms and 116,000 square feet of gaming space.

5 The Monte Carlo
The Monte Carlo opened in 1996 with 3,003 guest rooms and 90,000 square feet of gaming space. It imitates the style of the French Riviera.

6 The Flamingo
Between the Venetian and the Flamingo (the oldest resort, opened in 1946) are smaller properties, Harrah's (opened 1973) and Imperial Palace (opened 1979).

7 The Venetian
In good weather, the Venetian features gondola rides. Opened in 1999, it occupies the site of the old Sands Hotel.

The Strip, 2004 (above, right)

8 The Scenic Desert
Looking toward the southwest and the Sierra Nevada Mountains. Las Vegas is in the Mojave Desert at about 2,180 feet above sea level. Summer temperatures average 91 degrees.

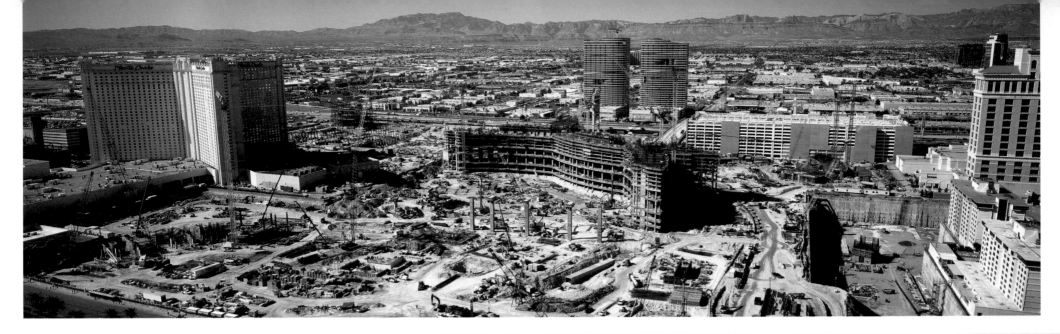

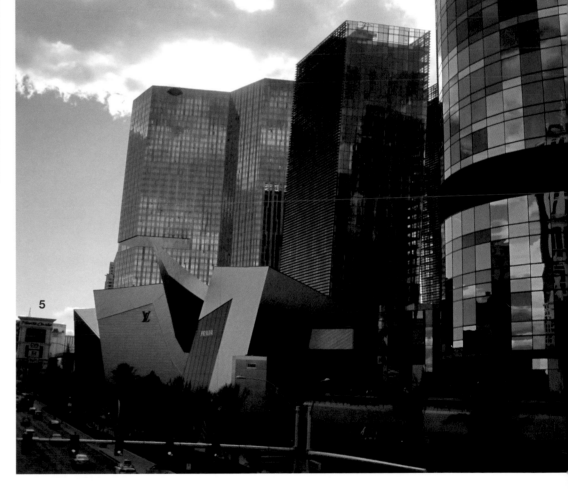

9 Luxor Light
The tip of the Luxor pyramid contains a fixed-position spotlight pointing directly upward. At forty-two-billion candle power, it is the brightest beam of light on earth; it is even visible in space. Opened in 1993, the Luxor has 4,407 rooms and a replica sphinx outside.

10 The MGM Grand
Lighted green at night, it opened in 1993 and has 6,852 rooms.

11 Mandalay Bay
Sparkling gold during the day, the resort opened in 1999 with 3,309 rooms.

12 The Tropicana
Aging—it opened in 1957—and oft-remodeled, the hotel has 1,878 rooms.

13 The Excalibur
The 4,008-room Excalibur is themed as "Camelot." It opened in 1990.

14 New York-New York
With a mini-Statue of Liberty out front, it opened in 1997 with 2,024 rooms.

15 Paris-Las Vegas
It features a 5/8-scale Eiffel Tower: opened 1999, 2,915 rooms.

16 Planet Hollywood
Formerly the Aladdin, it reopened in 2007 with 2,600 rooms.

CityCenter, 2006 (top)

17 CityCenter
Construction begins on the CityCenter on the west side of the Strip. Referring to itself demurely as "The Center of the World," a grouping of highrise glass-sided hotels were to form the core of the CityCenter: the forty-seven-story non-gaming Mandarin Oriental with 392 guest rooms and 225 residences, multi-tower Aria Resort & Casino with 4,004 guest rooms, the non-gaming all-suite Vdara (1,495 suites), the two distinctively angled thirty-seven-story Veer Towers with approximately 335 residences each, the luxurious non-gaming hotel the Harmon with 400 "magnificently appointed guest rooms and suites," and Crystals retail and entertainment complex with 500,000 square feet of "the world's most famous elite retailers."

18 Panorama Towers
These luxury highrise condominiums are west of Interstate Highway 15. Prices in 2010 ranged from a modest $267,900 for a one-bedroom to $7.5 million for Penthouse F on the 45th floor.

CityCenter, 2010 (above)

This 2010 image of the CityCenter shows the front of the complex on the Strip. From front to back: Harmon (architect Lord Norman Foster), Crystals (Daniel Libeskind), Mandarin Oriental (KPF). In the distance can be made out the entrance to the Monte Carlo (**5** identified on the image).

Lincoln, NE

Lincoln panorama, ca. 1915 (below)
(locations identified on image)

The story goes that the town of Lancaster was renamed Lincoln because Omaha business interests believed the state would never allow the capital to go to a town named after a Yankee

president. They were wrong and Lincoln, née Lancaster, became the state capital upon Nebraska's admission to the Union in 1867. The Burlington & Missouri River railroad reached Lincoln in 1870, when the population was 2,500.

1 St. Mary's Catholic Church
Built with two asymmetrical towers, today St. Mary's is opposite Lincoln's First Baptist Church (2) built in 1888 at 14th and K streets.

Lincoln panorama, ca. 1980s (bottom)

3 The Capitol in the Capital
The twenty-two-story Nebraska state capitol at 1445 K Street took ten years to build, from 1922 to 1932. From the

day it was opened, it was the tallest building in the state until the thirty-story Woodmen Tower opened in Omaha in 1969. It is 433 feet to the top of the spire.

4 University Towers
Former Stuart Building, built 1929 and renovated 1988: placed on Historic Places Register in 2003.

5 University of Nebraska
Founded in 1969, UN now has four campuses: Lincoln, Omaha, Kearney and Curtis. The Lincoln City Campus, just north of downtown, and the East Campus support 23,000 students with 1,500 faculty. Includes (5a) Memorial Stadium which has an ongoing NCAA-record 304 consecutive sellout streak.

Lincoln panorama, ca. 2000 (right)

6 Lincoln Metro
The 300,000-person Lincoln metro area includes Lancaster and Seward Counties. Seward was added in 2003. Little development has taken place outside the city limits of Lincoln, and it has no contiguous suburbs, because most of the property that might be developed as a suburban town has already been annexed.

7 U.S. Bank
Built in 1970 in the International Style at 233 South 13th Street, the U.S. Bank building is nineteen stories high. The "international style" was developed from Modernist architecture in the 1920s and 1930s. Those who wrote about it defined three principles: the expression of volume rather than mass, balance rather than preconceived symmetry, and the expulsion of applied ornament.

8 North to West
Skypark Manor apartments at 1301 Lincoln Mall provide great views of the capitol.

9 Cornhusker Marriott
A no-smoking ten-floor hotel named for the nickname for a Nebraskan.

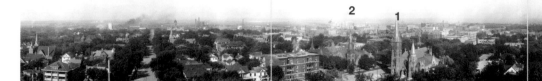

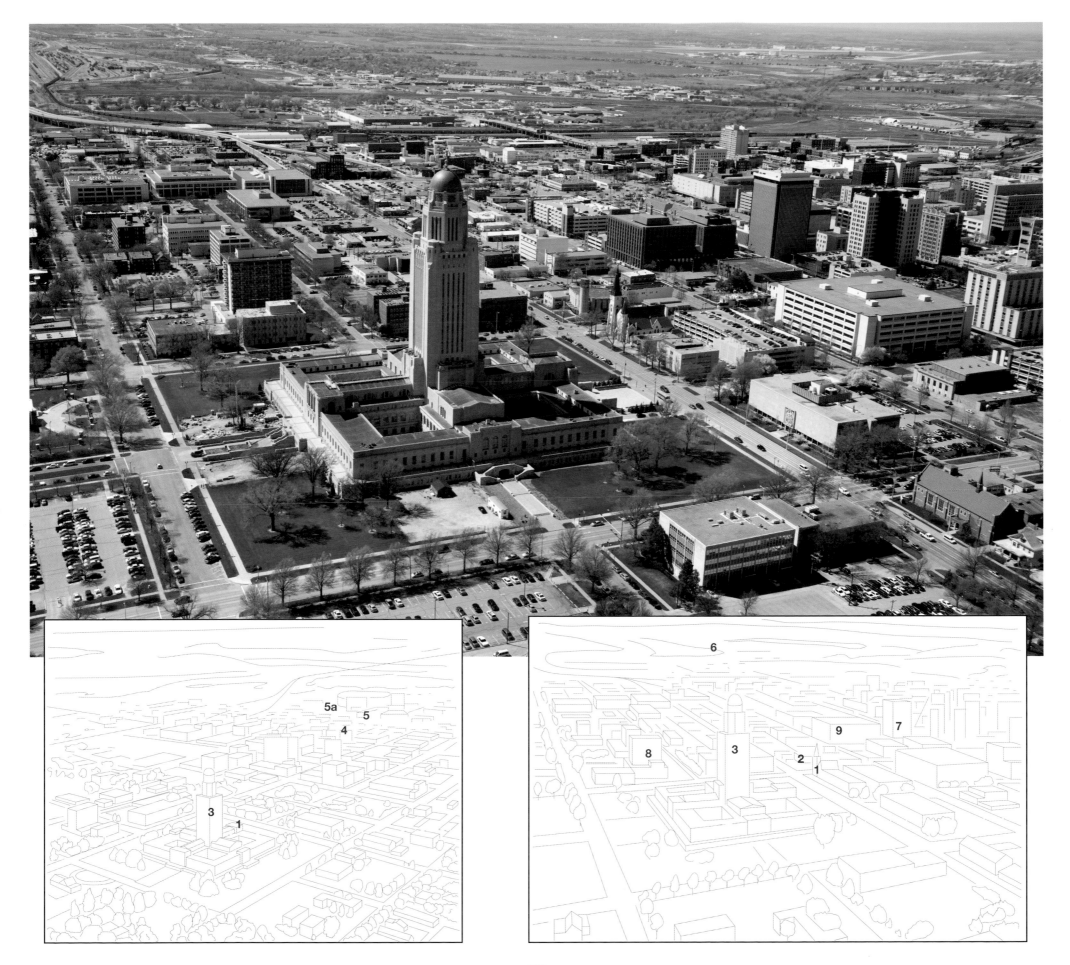

Los Angeles, CA

Los Angeles panorama, 1973 (below left)

1 On a Clear Day

It is March 21, 1973, and you can see forever. Washed clean of smog by recent rain, the highrise skyline of downtown Los Angeles stands out crisply against the backdrop of snow-covered Mount Baldy, more than forty miles to the east. At 10,068 feet, twin-peaked Mount Baldy in the San Gabriel Mountain Range hosts skiers in the winter; in the summer, nature lovers of all sorts enjoy its canyons, cliffs and views of southern California.

2 The Aon Center

At 707 Wilshire Boulevard, the sixty-two-floor highrise was ready for business in 1974 with thirty-two elevators and five basement floors. All skyscrapers in LA are required to have helipads for emergency evacuation.

3 City National Plaza

City National Plaza is the twin-tower highrise complex built where the 371-foot Art Deco Richfield Tower stood until demolished in the late 1960s. The complex covers 4.2 acres bordered by Flower and Figueroa to the east and west, and by Fifth and Sixth to the north and south, The towers—City National Tower (3a) and Paul Hastings Tower (3b)—were designed by Albert C. Martin & Associates. They are both of fifty-two floors, around 700 feet tall, and were the tallest buildings in Los Angeles until overtaken by the Aon Center.

4 Bank of America Plaza

Under construction in 1973, the Bank of America Plaza opened as part of the ARCO (Atlantic Richfield Company—an oil company) Center in 1975. This fifty-five-story tower and plaza is positioned diagonally to the surrounding street grid and is built on a nine-story parking garage that is both above and below ground.

Los Angeles panorama, 2008 (right)

5 U.S. Bank Tower

The tallest building in Los Angeles, this seventy-three-floor tower was completed in 1989. It stands 1,018 feet and at night the glass crown lights up the Los Angeles skyline. The building can withstand an earthquake measuring 8.3 on the Richter scale. In theory, the San Andreas Fault cannot produce an earthquake greater than 8.0, but a newly discovered fault runs right through the downtown financial district.

6 Gas Company Tower

Designed by Richard Keating of Skidmore Owings And Merrill, who had been architect of Wells Fargo Plaza in Houston and JP Morgan Chase Tower in Dallas, this fifty-two floor (750 feet) building opened in 1993.

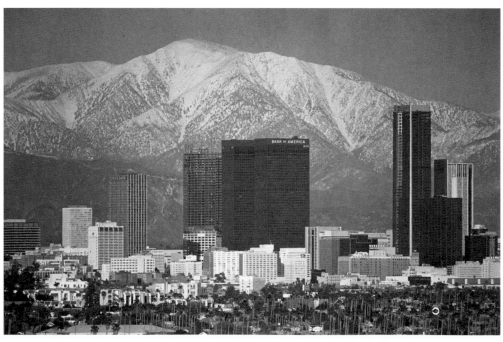

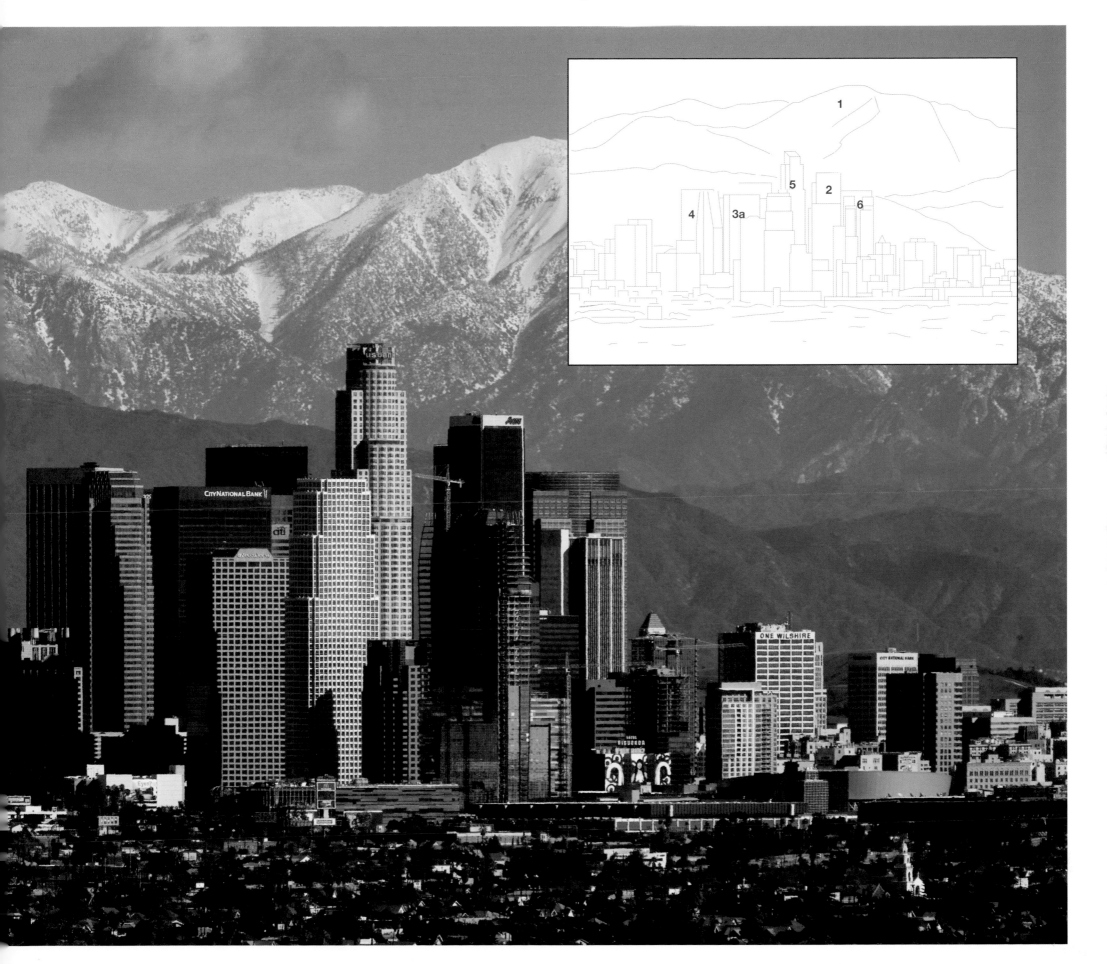

Aerial view of Los Angeles, 1928

1 City Hall
An overview of downtown Los Angeles on January 14, 1928, clearly shows the recently completed twenty-eight-floor City Hall at 200 North Spring Street. From 1927 to 1968 when the Union Bank Plaza was finished, City Hall was the tallest building in town.

2 Elysian Park
Created in 1886, Los Angeles' second largest park after Griffith Park is also its oldest. Controversially, in 1959–1962 Dodger Stadium was built on the Chavez Ravine area.

3 Echo Park
Construction of the 101 Freeway (4) cut off the park's lower third and the Echo Park community. Dozens of picturesque Victorian-era homes and a new Latin flavor nevertheless make this a dynamic neighborhood. In addition, more than two dozen public stairways cross the hillsides of Echo Park, reminders of a neighborhood designed before

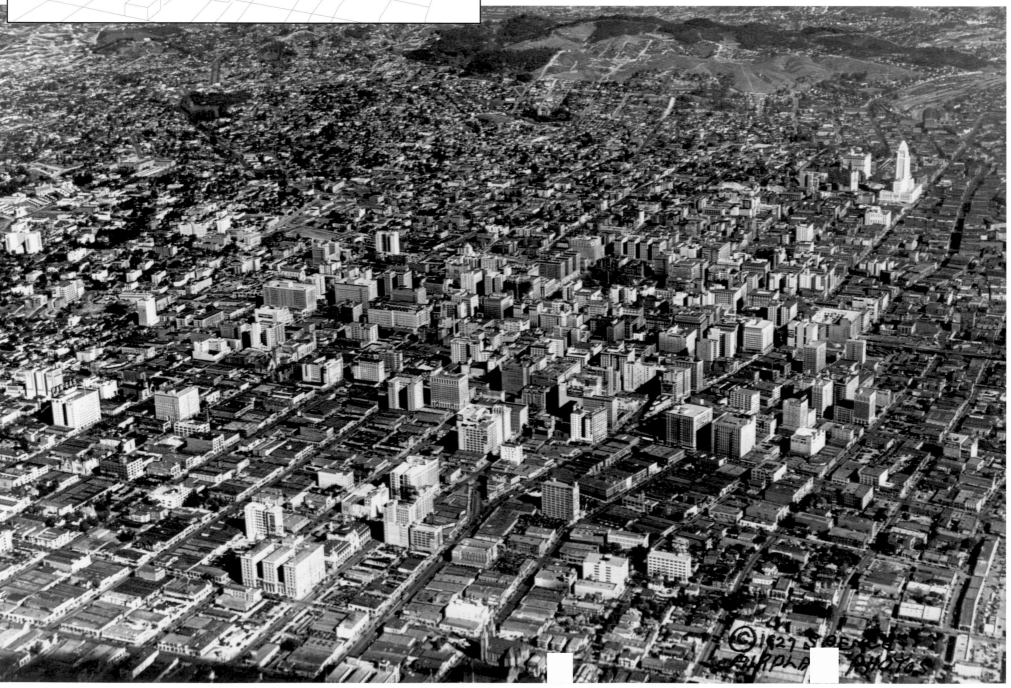

automobiles. While many are small and practical in scale, rising only a few steps to provide a quick shortcut to the next street or a secluded corner, others such as the 230-step Baxter Stairs are impressive and stylish public landmarks that reward those who climb them with stunning views.

5 Downtown

The growth of Los Angeles in the twentieth century mirrors the growth of the United States. Centered around the Spring Street Financial District in the 1920s, today the financial district is south of Bunker Hill and boasts a host of highrise towers and corporate headquarters.

Aerial view of Los Angeles, 1998

6 Neighborhoods

Although it is an urban area of fifteen million, Los Angeles is a city of neighborhoods with local groceries, places of worship and parks where it is possible for the individual to feel at home. Immediately west of downtown, Angelino Heights (6) and Echo Park were some of the city's earliest suburbs. The first film studios west of the Mississippi were located here. Today they are home to Latino immigrants, but much distinctive architecture has been preserved from the early years, including the restored Victorian homes in Angelino Heights. This region is the most densely populated area in LA.

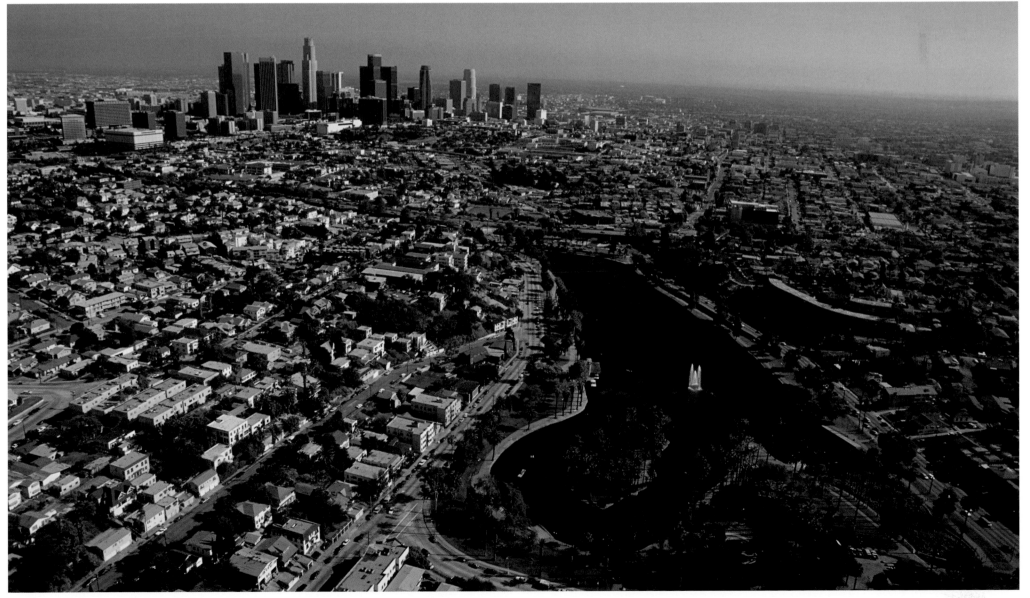

Los Angeles from the Zelda, 1908
(below)

1 The Zelda
Viewed from the roof of the Zelda, at W 4th Street and Grand in the old Bunker Hill neighborhood looking east, Los Angeles. But who or what was the Zelda? Zelda La Chat (née Keil) was born in 1870 and arrived in Los Angeles some time in her 20s. She built the eponymous Zelda, a modest bargeboard building at the southwest corner of Fourth and Grand and launched a thirty-nine-unit brick apartment complex. Zelda lived there until her death in 1926.

2 Pershing Square
In 1908 the square would have been known as Central Park. It was renamed for the leader of U.S. forces in Europe after World War I in 1918.

3 756 Broadway
According to the *Los Angeles Express*, May 23, 1908, Hulett C. Merritt had purchased from the Hamburger Realty and Trust Co. the northwest corner of Broadway and 8th Street for a consideration of $234,000. The lot had a frontage of sixty-five feet on Broadway and extends back 115 feet. The price paid, therefore, is at the range of $3,600 a foot for the Broadway frontage. It is understood that the tenants of the old building now on the property already have been ordered to vacate and that a large business block will be erected on the site. The sale was made through the agencies of W.L. Hollingsworth & Co. and Bryan & Bradford. The site is now occupied by The Chapman, a 1912 highrise with retail on the ground floor and apartments above.

Los Angeles from W. 4th and Harbor, 2009 (right)

4 Today at W. 4th and Harbor Freeway
Zelda would have been astonished. The position of the photographer is on West 4th Street at Harbor Freeway. At left is the glass thirty-five-floor Westin Bonaventure Hotel completed in 1976 with a six-level atrium and revolving restaurant/observation deck. Immediately behind the Westin is the tip of the forty-eight-floor Citigroup Center (5) and finally the seventy-eight-floor U.S. Bank Tower (6).

7 Union Bank Plaza
At 431–459 South Figueroa Street, this forty-floor office tower was completed in 1994. The first building in the Bunker Hill redevelopment project, it promoted the growth of the downtown skyline through the early 1990s.

8 601 South Figueroa
The 717-foot Figueroa at Wilshire is a fifty-three-floor highrise completed in 1994: Albert C. Martin and Associates architects.

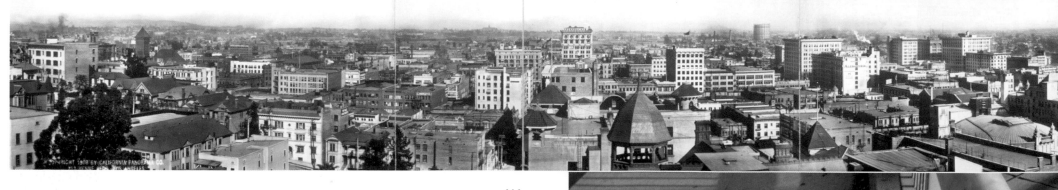

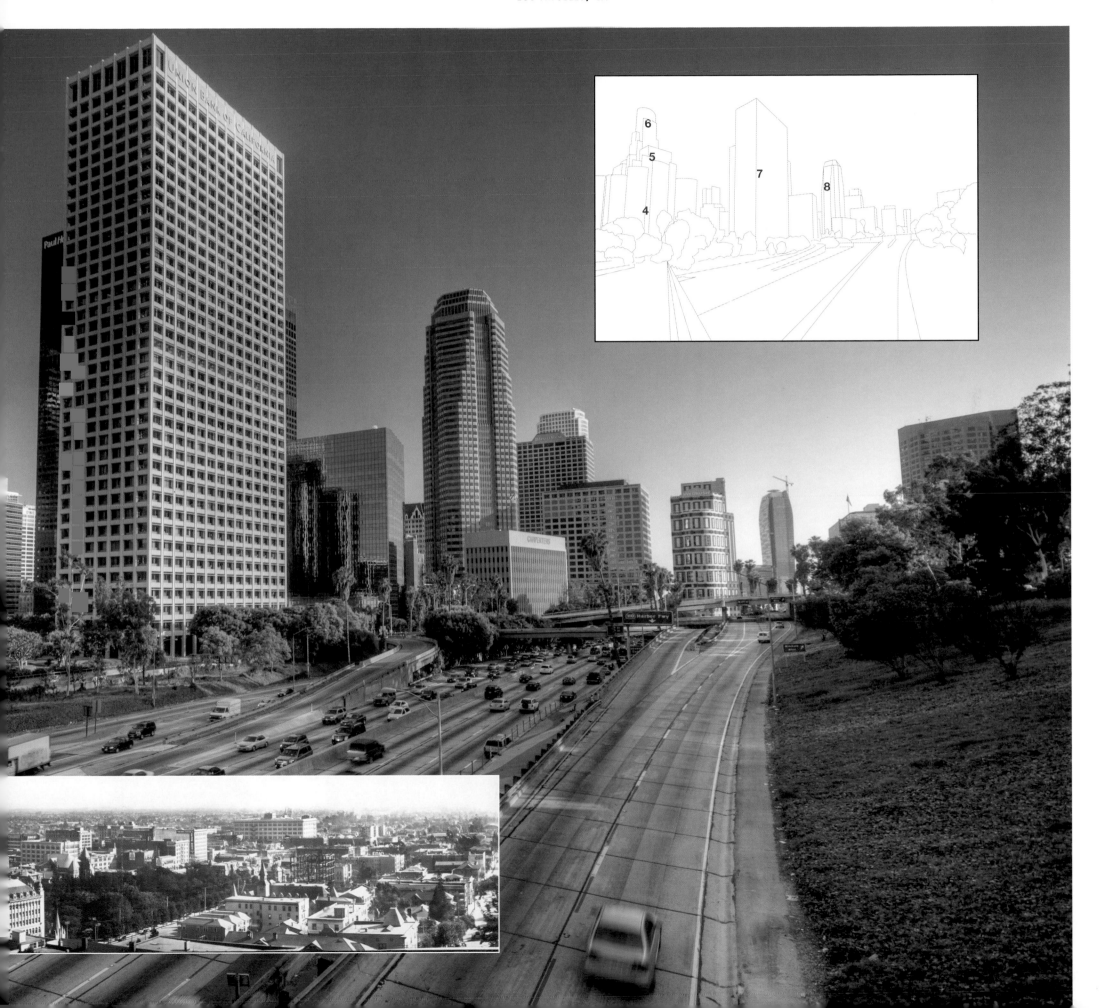

Los Angeles from Griffith Observatory 1964 (below)

Griffith J. Griffith was born in Wales in 1850. He came to America as a teenager and worked as a journalist and mining advisor before making his fortune in Mexican silver mines and California real estate. In 1912, he offered Los Angeles $100,000 for an observatory to be built on the top of Mount Hollywood. Owned and operated by the city, it would include an astronomical telescope open to free viewing, a Hall of Science designed to bring the public into contact with exhibits about the physical sciences, and a motion picture theater which would show educational films about science and other subjects. This last aspect of the plan would eventually evolve into the planetarium, a technology not invented until the 1920s.

Located on the south-facing slope of Mount Hollywood in Griffith Park, the popular observatory at 2800 Observatory Road opened in 1935. It overlooks the entire Los Angeles Basin and the Pacific Ocean. It features the recently renovated 300-seat Samuel Oschin Planetarium with a Zeiss Universarium IX Star Projector, said to be the most advanced in the world. The padded reclining seats look upward to a large seamless dome. The new, 200-seat Leonard Nimoy Event Horizon multi-media theater recognizes the intention of the observatory's original architects to have a second theater to complement the planetarium.

This 1964 view from above Hollywood looks directly toward the ocean; the string of taller buildings (left to right) identifies Wilshire Boulevard.

Los Angeles from Griffith Observatory 2008 (right)

Los Angeles is located in a circum-Pacific zone of geological instability called the Ring of Fire. Within this zone nearly 10,000 earthquakes—shifts in the earth's crust—take place each year. In fact, the U.S. Geological Survey records small earthquakes, usually never felt by residents, in Los Angeles every day. Parts of the city are also vulnerable to Pacific Ocean tsunamis; harbor areas were damaged by waves from the Valdivia earthquake in 1960. The Equitable Life Building (454 feet tall) designed by Welton Becket & Associates was built on Wilshire Boulevard in 1969.

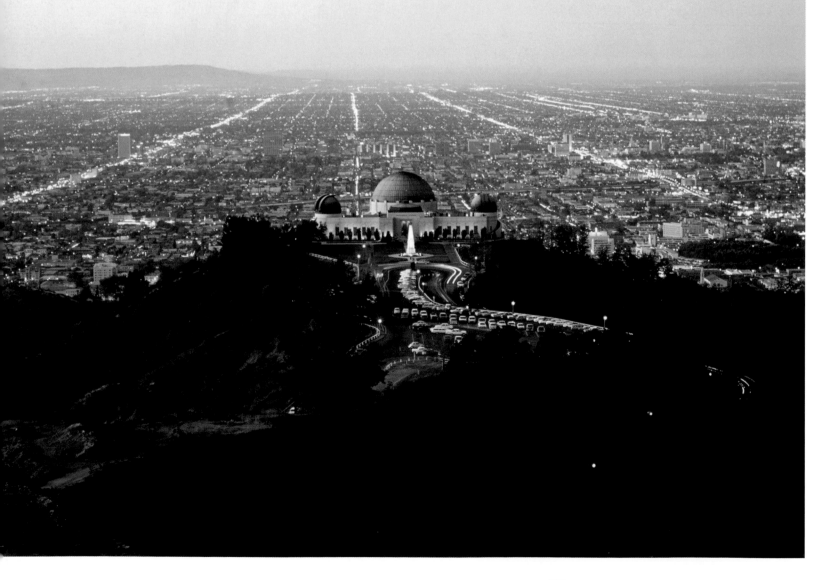

Madison, WI

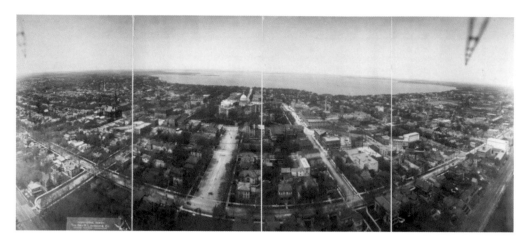

Madison from Lake Monona, 1908 (above)

1 Lake Mendota
Mendota—or "Fourth Lake"—is the largest of the lakes that define Madison, the City of the Four Lakes. The others are Monona (Third), Waubesa (Second), and Kegonsa (First).

2 Wisconsin State Capitol Building
Designed by George B. Post, this building was begun in 1906 to replace a previous building destroyed by fire. It was completed in 1917. The top of the dome is just over 284 feet high. The exterior is faced with Vermont granite.

3 St. Raphael's Cathedral
Irish Roman Catholic church for which the cornerstone was placed in 1854, and spire constructed by 1885. In 2005, the church was devastated by arson and, controversially, demolished in 2008. It will be replaced with a larger church in the future.

4 Wisconsin Avenue
Among Madison's main streets in 1908, this was divided by the position of the State House and continues on toward Lake Mendota.

5 Grace Episcopal Church
Designed by James O. Douglas in the Neo-Gothic style, this dates to 1862 and is among Madison's best known historic structures.

Madison from Lake Monona, 1999 (right) and 2006 (inset)

6 Lake Monona
This picturesque body of water—also known as Third Lake—is one of Madison's defining elements.

7 The Monona Terrace Community and Convention Center
Pictured on the shore of Lake Monona at the end of Wisconsin Avenue, this striking building had been proposed by Wisconsin-native and world-renowned architect Frank Lloyd Wright in the 1930s. It was finally completed in 1997 almost four decades after Wright's death.

8 State Office Building
Using an Art Deco design by Arthur Peabody, this state office complex was built in three phases with the prominent thirteen-story tower completed in 1939. The South Wing was the last to be finished, in 1959.

9 Hilton Madison Monona Terrace
Kahler Slater Architects were employed to produce this hotel, completed two years after the main photograph was taken. The twelve-story building can be clearly seen in the 2006 photograph that shows how the backdrop to Wright's terrace has been balanced attractively.

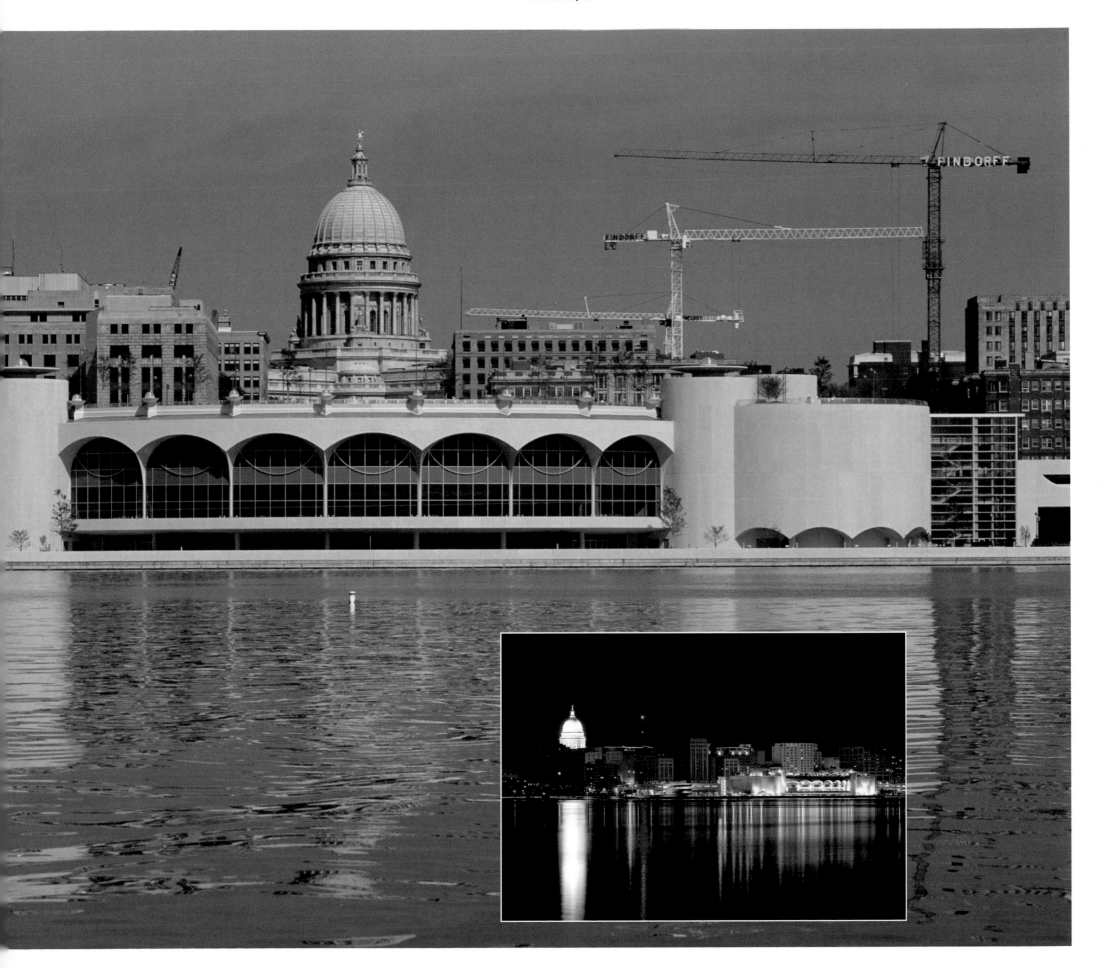

Memphis, TN

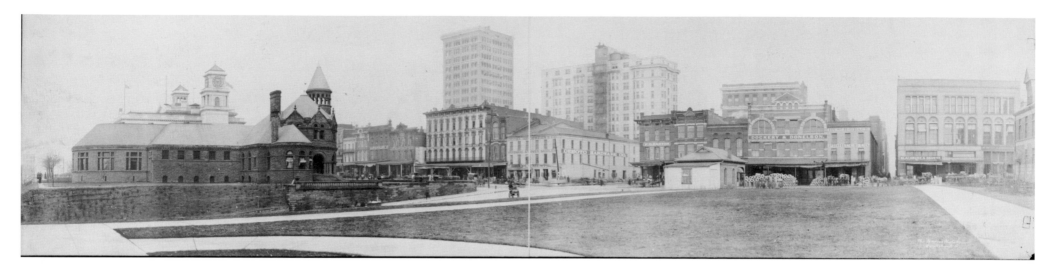

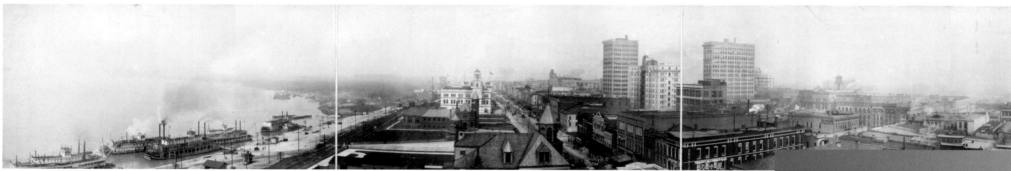

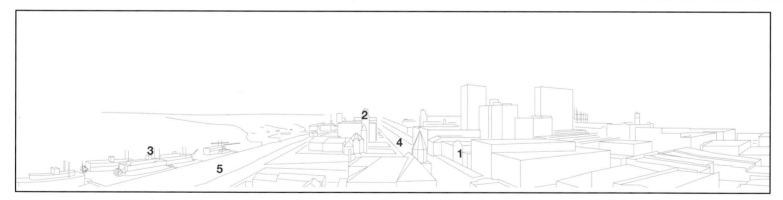

Memphis riverfront, 1910 (top and above)

1 Solidly Commercial

With merchant names proudly painted directly on storefronts—Cummins Grocery, DeSoto Hardware, F.G. Barton Cotton Company, Dockery & Donelson, Busch-Grace Produce, Blackburn & Browne, Jones & Rogers—before the turn of the twentieth century Memphis had positioned itself to become a commercial success.

2 Custom House

The Custom House and Post Office were erected in the classic style of the 1890s. A series of yellow fever epidemics had swept away nearly 75 percent of Memphis' population in 1878 causing property tax revenues to collapse and the city to default on its municipal debts. It took fifteen years to regain its municipal charter.

3 Port of Memphis

In the 1850s, with a population of barely 10,000 Memphis was already a leading port city for steamboat traffic on the Mississippi River, second only to New Orleans. Today, the paddleboats are only for tourists.

4 Horse and Buggy and Automobile

By 1910, downtown Memphis was booming. On busy Front Street, gasoline-powered vehicles competed for right of way with the horse and buggy.

5 Mud Island
A century ago, Mud Island had not yet been formed by the wayward Mississippi River, and railroad tracks lined the waterfront.

Memphis riverfront, 2000

6 Memphis Yacht Club
Founded in 1902 as the Memphis Canoe Club, boats still anchor at the club's Mud Island Marina in Wolf River Lagoon south of U.S. Interstate 40. Mud Island and the Lagoon separate downtown Memphis from the Mississippi River.

7 Tourist Kiosk
This kiosk serves a chain of parks, multi-use paths and memorials, with an amphitheater, museum, shopping and restaurants on the Memphis waterfront. South—and to the right in the photo—is Jefferson Davis Park. After the Civil War, the former president of the Confederate States of America became president of an insurance company and lived in Memphis from 1869 to 1878.

8 Mud Island Monorail
Also called the Memphis Suspension Railway, this elevated monorail connects downtown Memphis with Mud Island River Park. Opening in 1982, its two stations are at the convention center on Front Street and at the Mississippi River Museum on the island.

9 Morgan Keegan Tower
Built to a height of 403 feet, which includes the spire on top, it is Memphis' second highest building even though it only has twenty-one stories. Construction was finished in 1985 on the former site of the demolished Hotel King Cotton.

10 100 North Main
Completed in 1965, this thirty-seven-story, 430-foot building is currently Memphis' tallest skyscraper. It was formerly known as the "UP" building because of the large Union Planters sign on top. The sign was removed in 2006.

11 99 Tower Place
Located at 99 N. Main Street, this urban highrise community of 245 apartments is now called Renaissance Apartments. It has a rooftop swimming pool and balcony views of the Mississippi River and the cityscape.

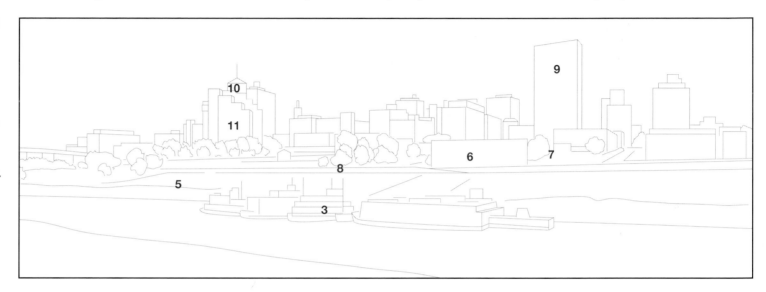

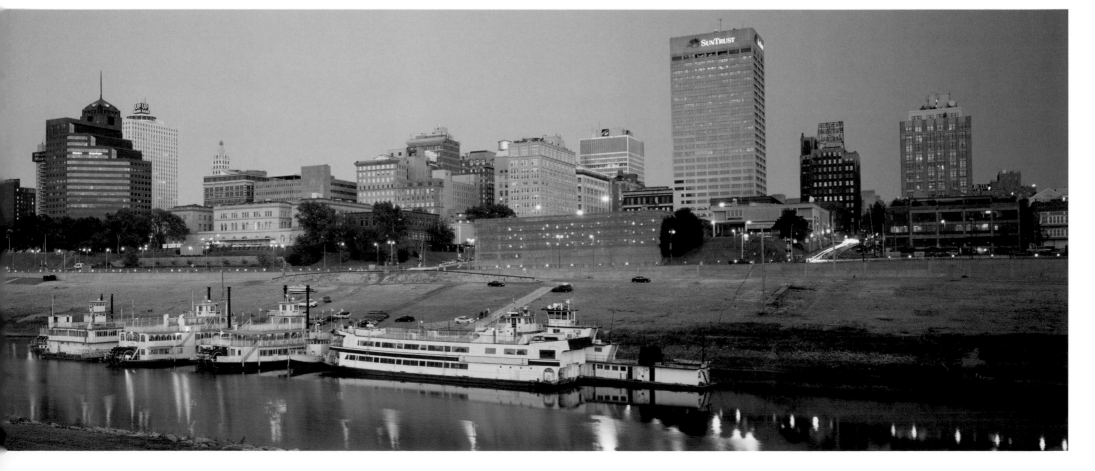

Miami Beach, FL

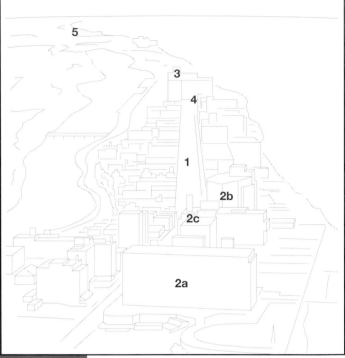

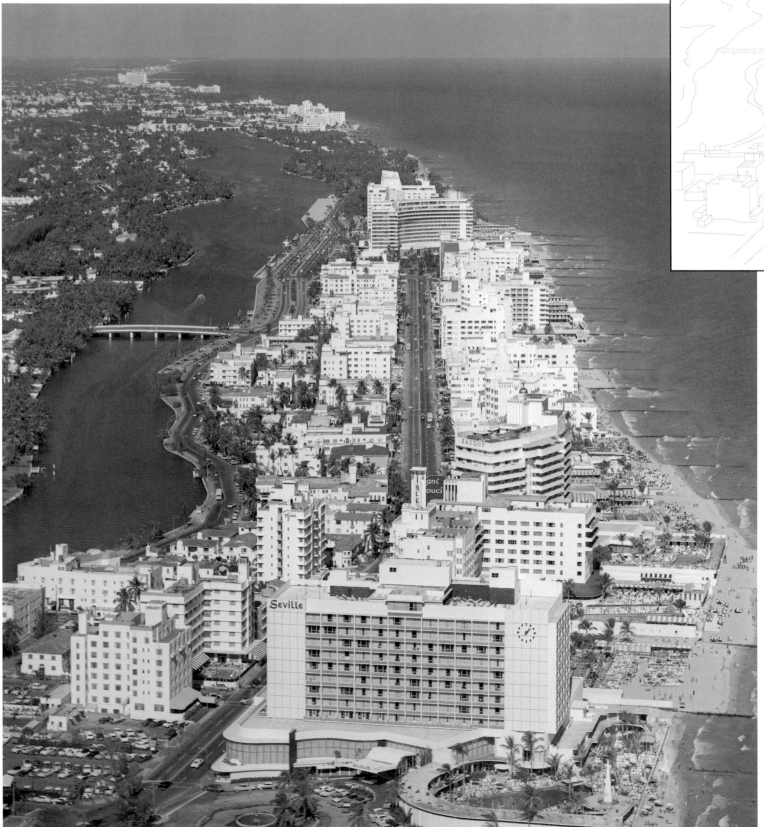

Miami Beach, 1957

It was always hot in Miami Beach in the 1950s. The night clubs, the grand hotels along Collins Avenue, and the beach were in the public eye and imagination. This stretch of beach—bright sun, white sand and those wonderful hotels and night clubs—isn't called the Gold Coast for nothing!

1 Collins Avenue
Prominent in the foreground is the imposing Hotel Seville (**2a**); farther up are the Saxony (**2b**) and Sans Souci (**2c**) hotels.

3 Eden Roc
In the background is the Eden Roc. This resort hotel was designed by Morris Lapidus, the Russian immigrant and architect of many of the beach hotels. The Eden Roc opened in 1956. Today it is owned by Marriott International, but it became famous for a lawsuit against the neighboring Fontainebleau which expanded and blocked sunlight to the Eden Roc's pool. The courts eventually ruled that the Fontainebleau's vertical property rights trumped the Eden Roc's claim to an easement allowing sunlight.

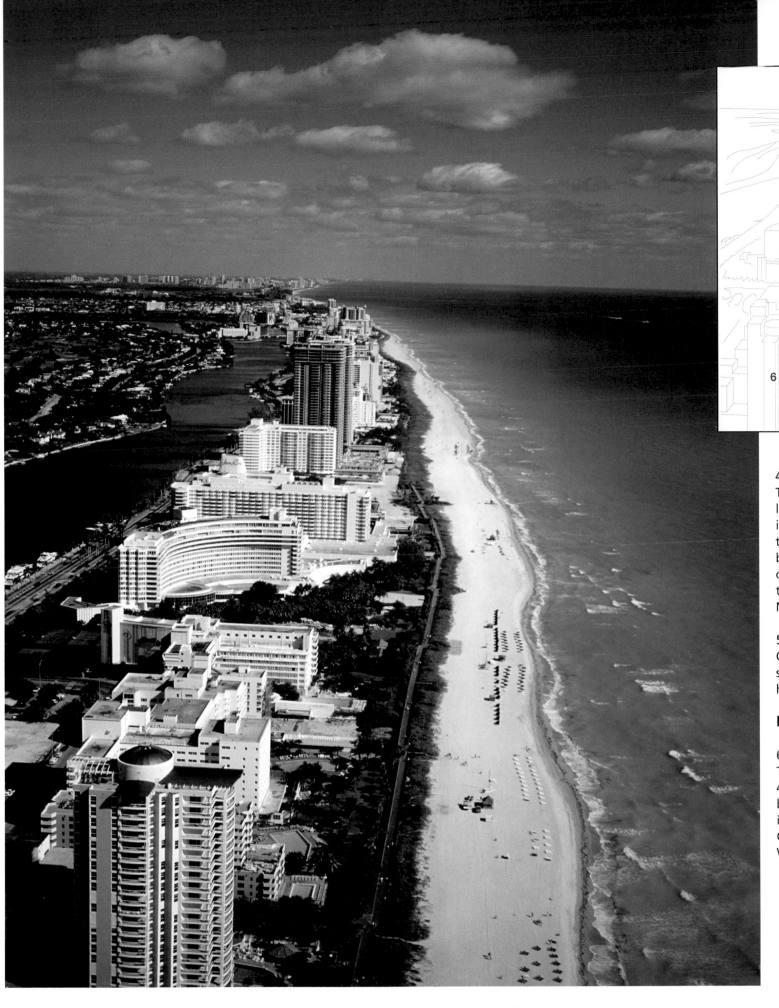

4 Fontainebleau

This hotel was considered the most luxurious on the strip. Opened in 1954, it was designed by Morris Lapidus and is thought to be the most significant building of his career. A delightfully curved masterpiece of 1,504 rooms with towers, it is now listed on the U.S. National Register of Historic Places.

5 Bal Harbor

Outside Miami Beach and across a small strip of land in 1957 is Bal Harbor with hotels Americana and Godfrey's.

Miami Beach, 2006

6 La Tour

The La Tour highrise condominiums at 4201 Collins Avenue are sandwiched between hotel brands representing an increasing democratization of the Gold Coast brand: Days Inn, Holiday Inn, Best Western....

Miami, FL

Miami, 1950

An aerial view of Miami in May 1951. It is precisely that moment in the year when temperatures climb from warm and pleasant to hot. It is that moment when clientele changes: snowbirds have returned home, spring break is over and families with children invade the hotels and resorts.

1 Courthouse
Once the most imposing building in Miami, the Dade County Courthouse was opened at 73 W. Flagler Street in 1928. Now the Miami-Dade County Courthouse, it is twenty-eight floors and 360-feet high.

2 Biscayne Bay
Actually a lagoon with many inlets to

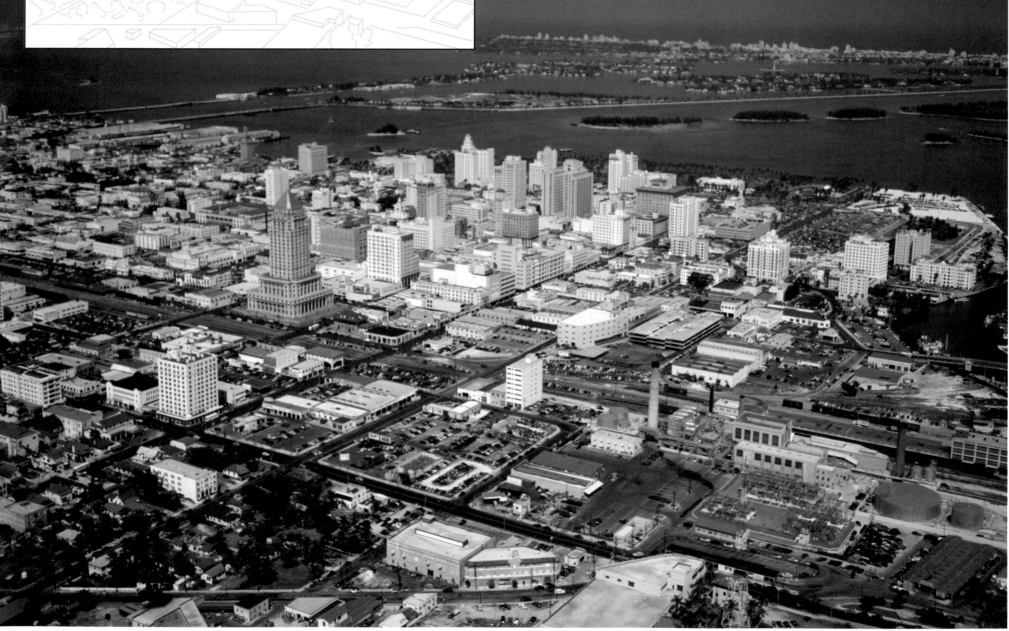

the Atlantic Ocean, the Bay is crossed by multiple causeways. Here the two-lane Venetian Way hops residential islets to connect Miami to Miami Beach. MacArthur Causeway is a four-lane connector for all of these heavily subdivided islands.

Miami, 2007

An urban area of five million, most live in segregated ethnic neighborhoods that often cooperate, but are occasionally hostile. In the night club heyday of the 1950s Miami was a city of white and black Americans with a strong Latin flair. Since then, waves of immigration boosted the area's population and incorporated neighborhoods of exiled peoples from Cuba and Haiti and other islands of the West Indies as well as Central America

and today Miami is a city where one will hear English, Spanish, French and Creole spoken daily.

3 The 5-Mile River
Today the Miami River is barely 5.5 miles long. It drains out of the Everglades near the airport, slowly flowing through downtown Miami to Biscayne Bay. Tequesta Indians lived along its shores before Europeans arrived, but dredging and the river's pollution level have become so intolerable that residents and even businesses have lobbied for a clean-up. The commercial-industrial Port of Miami is at the mouth of the river.

4 Causeways to Miami Beach
There are many causeways between Miami and Miami Beach. These three are Julia Tuttle (**4a**), Venetian Way (**4b**), and MacArthur (**4c**).

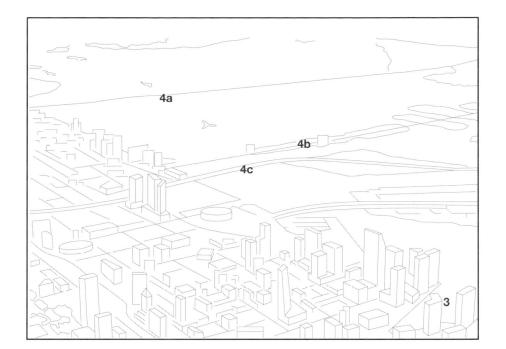

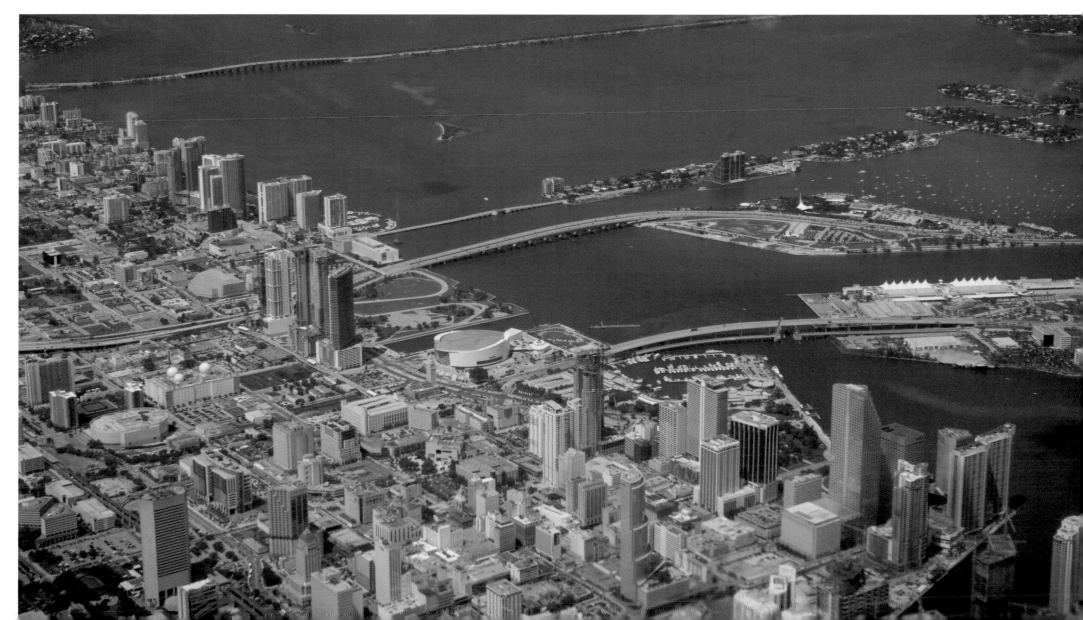

Minneapolis, MN

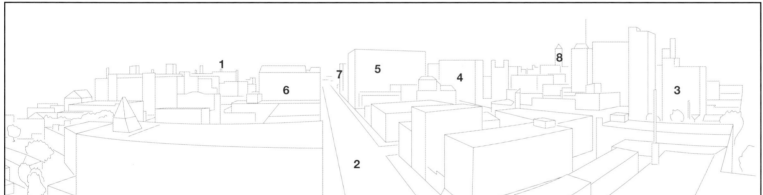

Minneapolis, 1911

1 Kickernick Building
Located in the Minneapolis Warehouse District, this seven-story building was designed by Long & Long; portions were built by C.F. Haglin in 1902. Now listed on the National Register of Historic Places it survives today.

2 Hennepin Avenue
One of the city's main thoroughfares; in the first decades of the twentieth century it hosted electric street cars as seen in this 1911 view.

3 Dayton Building
An eight-story concrete Neoclassical commercial building designed by Bertrand & Keith. It was demolished in 1935, in what is considered one of the

first large-scale urban-renewals in Minneapolis. Today this site is occupied by the City Center.

4 Hotel Dyckman
A prominent ten-floor highrise downtown hotel, it was deliberately demolished on November 18, 1979, by controlled internal explosion.

5 Plymouth Building
Completed in 1911, this thirteen-floor building was renovated in 1936 when the terra-cotta cornice and other ornament was removed to be replaced by brick.

6 Masonic Temple
A Richardson Romanesque building constructed at Sixth Street and Hennepin Avenue in 1888. It underwent

a substantial renovation in 1978, and today serves as the Hennepin Center for the Arts.

7 Lumber Exchange
Built in 1885, and considered the earliest "skyscraper" in Minneapolis, originally it had ten floors but later expanded to twelve. Located on Hennepin it was damaged by a disastrous fire a few years after completion. In 1983 it was listed on the National Register of Historic Places and is considered the oldest building of this height built beyond New York City.

8 Minneapolis City Hall
At 341 feet the tallest building in Minnesota until 1929, it was built from red granite, and in the Richardsonian Romanesque style. The original terra-

cotta roof was replaced in the 1950s with a copper roof. The building was added to the National Register of Historic Places in 1974.

Minneapolis, 2005

9 Capella Tower
A fifty-six-floor glass façade tower designed by James Ingo Freed and located on 6th Street South. Originally the headquarters for U.S. Bancorp, in 2009 the name was changed to the Capella Tower.

10 Wells Fargo Tower
Completed in 1989, it was originally the Norwest Bank and occupies the site of the old Northwestern National Bank Building destroyed in a towering inferno on Thanksgiving Day in 1982. The present building was designed by Cesar Pelli.

11 Campbell Mithun Tower
This forty-two-floor skyscraper, originally the offices for Piper Jaffray, is known for its distinctive angular crown and three-story atrium-style lobby.

12 Accenture Tower
Built in 1987 on the site of the old Senator Hotel, at 456 feet it has thirty-three floors.

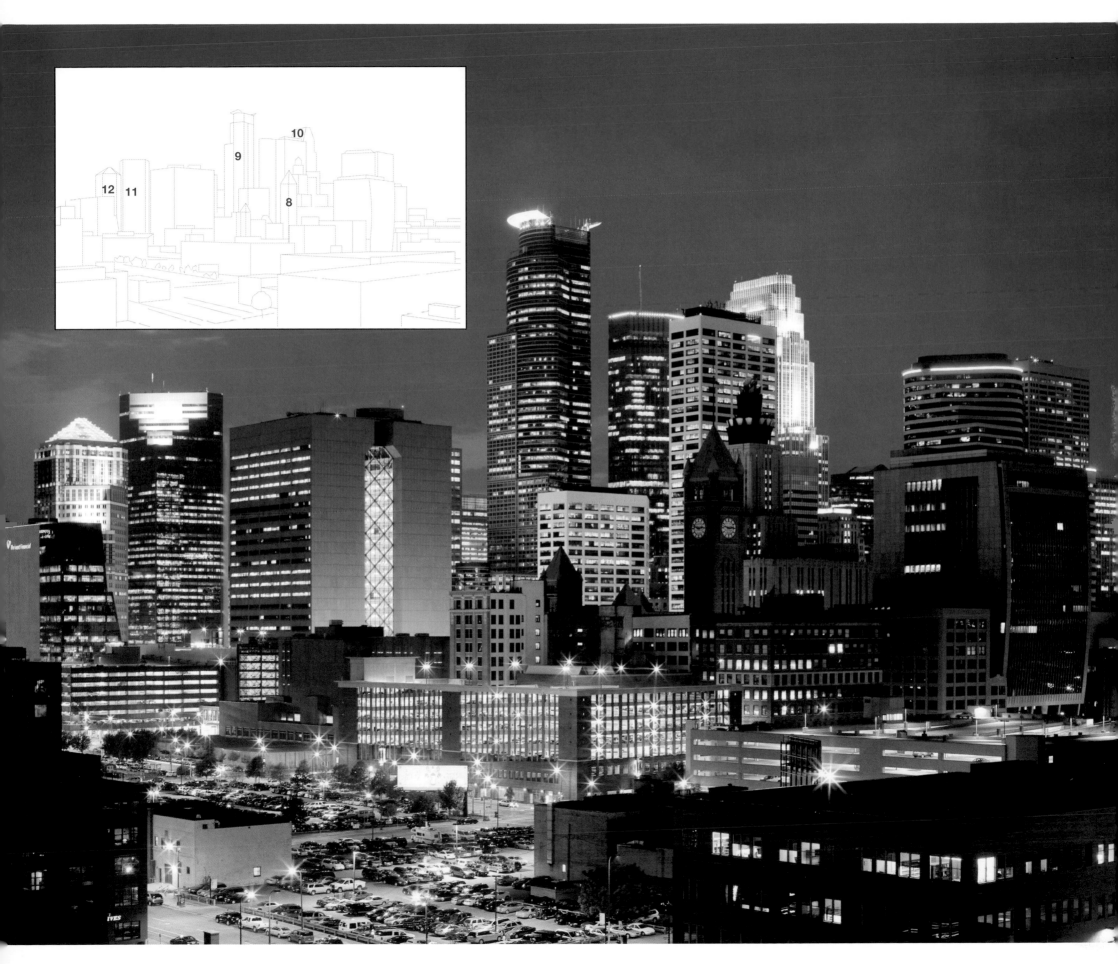

Mobile, AL

Mobile riverfront, 1909 (above)
(locations identified on image)

In August 1864, the Federal navy fought its way past Confederate guns, mines, armored gunboats and torpedoes, into Mobile Bay, closing the last remaining southern seaport. Mobile's nineteenth-century fortunes were made and

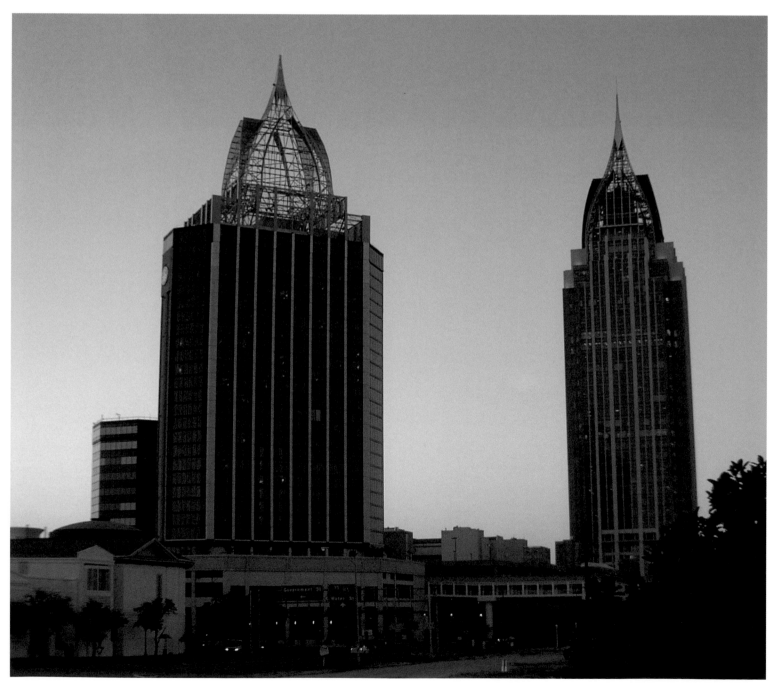

sustained by shipping cotton to mills in Europe. At the start of the twentieth century the Mobile waterfront was still dominated by brass-bottom wooden ships, steam and canvas.

1 Van Antwerp Building
Completed in 1907 for the pharmacy of Garet van Antwerp, this was the first steel skyscraper in Mobile. Designed in Beaux-Arts style, it is 120 feet tall.

2 Battle House Hotel
Completed in 1908, a recent renovation has linked it with the RSA Battle House Tower. It reopened in 2007 and is now painted white.

Mobile riverfront, 2005 (below) and 2010 (below opposite)

3 RSA Battle House Tower
Begun in 2004 and finished three years later, the thirty-five-floor tower was built for RSA, the Retirement System of

Alabama. With twenty-five floors of office space, three lobby floors, four floors of hotel space and one service/mechanical floor, it is the tallest building in Alabama. See photo opposite of completed building in 2010.

4 AmSouth Bank Building
With thirty-four floors, it is 423 feet to the roof of this concrete office building at 107 St. Francis Street. Mobile's tallest building 1969–1986, it was renamed the GM Building in 2009.

5 Convention Center
Mobile's 315,000 square-foot Arthur R. Outlaw Convention Center at One South Water Street has a 100,000-square-foot exhibit hall and 45,000 square feet of outdoor and riverfront terrace.

6 Renaissance
The new Renaissance Riverview Plaza Hotel by Marriott has twenty-eight floors with 363 rooms, eleven, and a

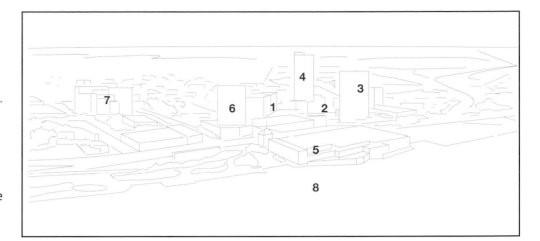

tower. See photo oposite for view of the newly installed tower, completed in 2008, that increased height to 374 feet.

7 Mobile Government Plaza
Built in 1994, the postmodern City-County Administration Building was designed by Harry Goleman and Mario Bolullo, in cooperation with Mobile architect Frederick C. Woods.

8 What You Can't See
Two tunnels run beneath Mobile River to Blakeley Island, the two-lane Bankhead which opened in 1941 and the four-lane George Wallace Tunnel, opened in 1973. Both have forty feet of overhead clearance for ships. The Wallace tunnel carries Interstate Highway 10.

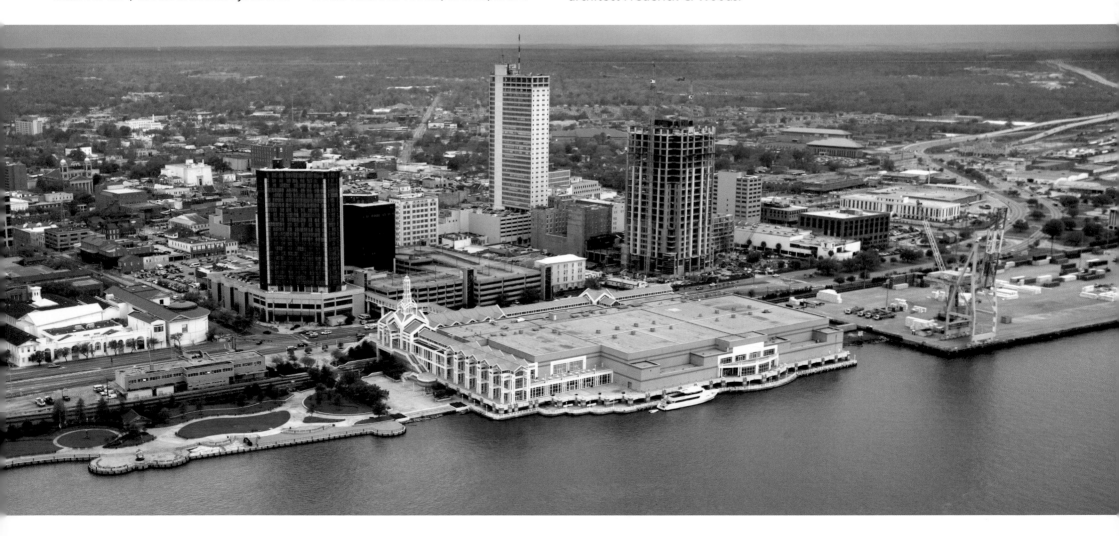

Nashville, TN

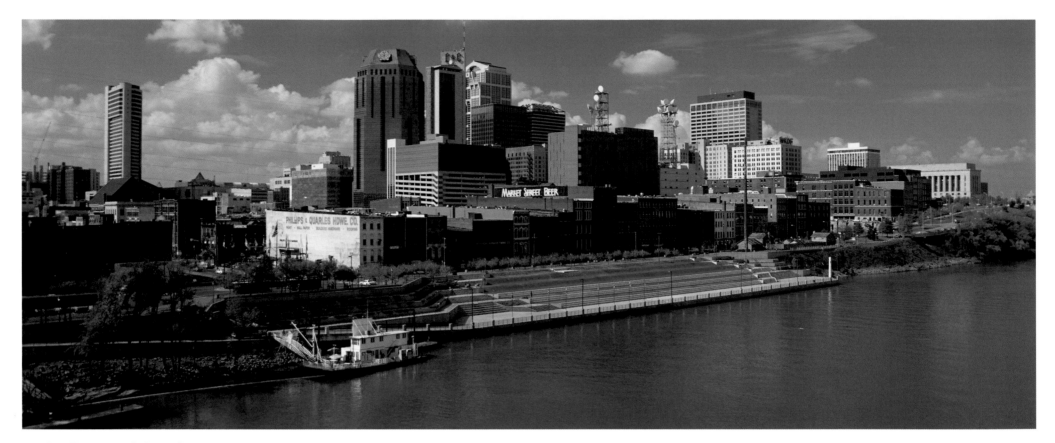

Nashville, 1990 (above)

1 Riverfront Park
At present, Nashville has 113 park properties on 10,570 acres, plus seven municipal golf courses. The twenty-year Riverfront Concept Plan will transform the riverfront and east banks with expanded parks, trails, water recreation and environmental preservation.

2 Showboat
Cruising the scenic Cumberland River on a showboat such as the *General Jackson* or the *Music City Queen* can be arranged from Riverfront Park.

3 Renaissance Nashville
The thirty-one-floor, 673-room Renaissance Nashville Hotel at 611 Commerce Street was finished in 1987 and is partnered with the Nashville Convention Center.

4 One Nashville Place
This twenty-five-story building was completed in 1985. Also known as the U.S. Bank Tower, it is 345 feet high and sided with dark reflective glass.

5 Life & Casualty Tower
At 401 Church Street, the 1957 L&C was once the tallest building in the South. It is built in the International Style with glass, limestone, aluminum, and granite.

6 Fifth Third Center
The thirty-one-story 490-foot skyscraper on Church Street and Fifth Avenue North was constructed in 1986. Nashville's first "post-modern" skyscraper with a typical gable roof at the crown, uses decorative motifs adapted from historic structures.

7 James K. Polk State Office Building
The twenty-four-story 392-foot skyscraper is named after the eleventh president of the United States who started his working life as a lawyer in Nashville.

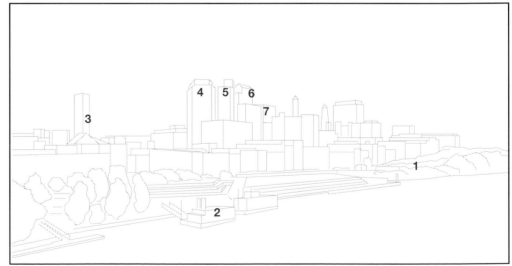

Nashville, 2006 (opposite)

8 AT&T Building
Finished in 1994, the majestic thirty-three-floor (617 feet) AT&T Building is the tallest building in Tennessee. The architect was Earl Swensson Associates. Previously known as the BellSouth Building, its nickname—for the pointed ear-like spires—is the "Batman" Building.

9 Regions Center
This 345-foot-tall headquarters of Regions Financial Corporation was finished in 1974. During construction the remains of a saber-toothed tiger were found: they are on display in the lobby.

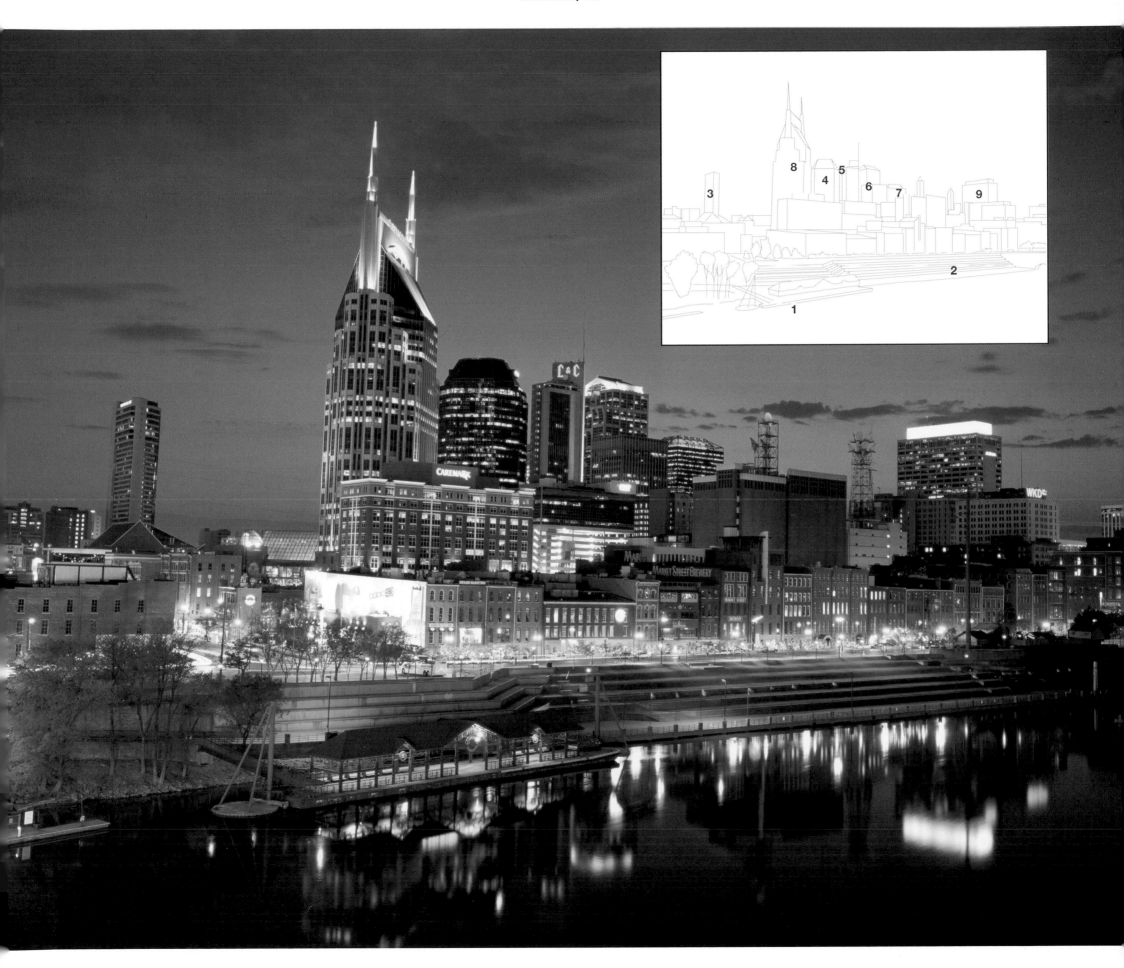

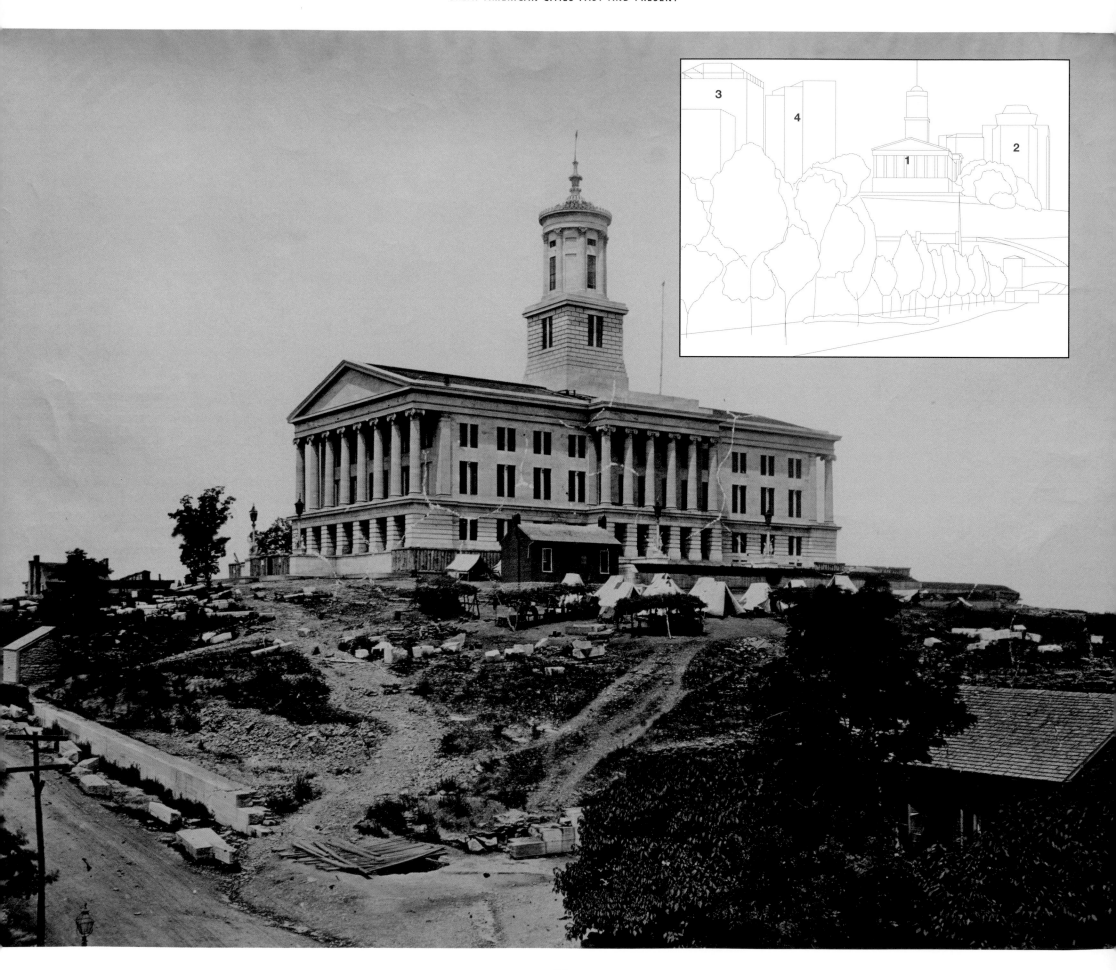

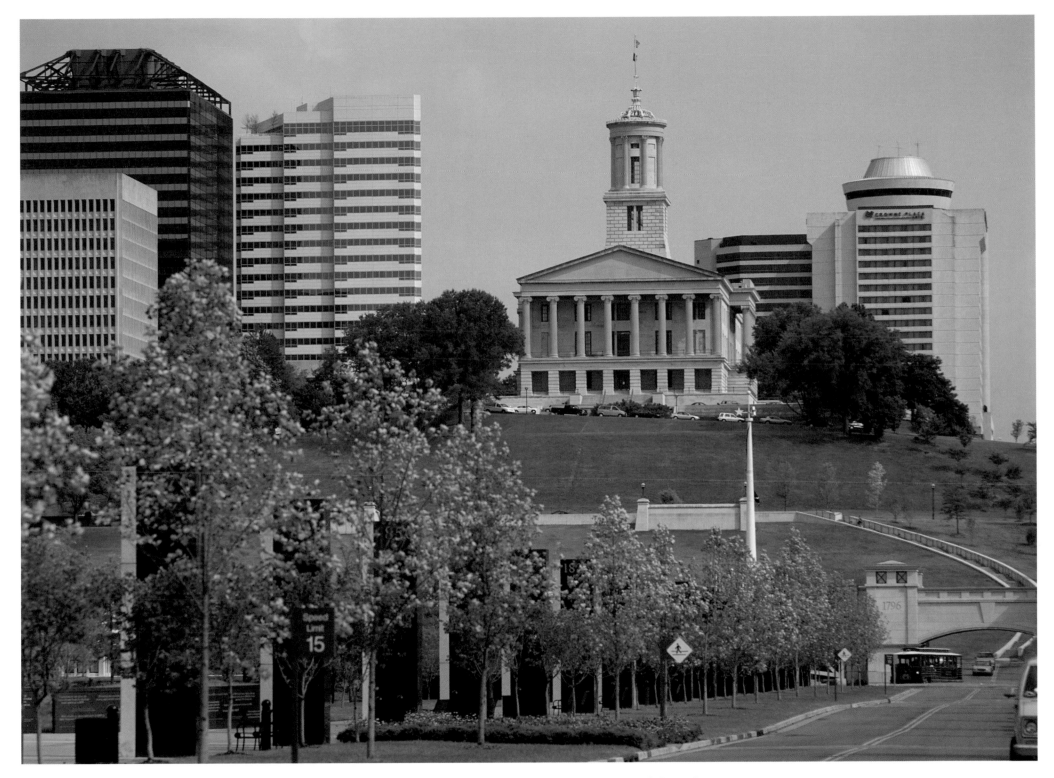

Tennessee State Capitol, 1990 (opposite)

Nashville has been the capital of Tennessee since 1843. Tennessee was the last of the thirteen southern states to break from the Union to form the Confederate States of America—and in 1862 Nashville was the first of the state capitals to be retaken by Union forces.

Two years later the Confederate Army of the Tennessee attempted to retake Nashville but failed.

1 The Capitol
The Tennessee State Capitol stands atop Capitol Hill in downtown Nashville. Built in 1859 with limestone from a local quarry, the architectural style is Greek Revival.

Nashville, 2006 (above)

2 Sheraton Hotel
Completed in 1975 the Nashville Sheraton has 470 guest rooms, twenty-seven floors and is almost 300 feet high.

3 James K. Polk State Office Building
This distinctive office building is at 505 Deaderick Street in a cluster of state buildings near the capitol. The floors and glass curtain wall of the office tower are suspended from a central concrete core by exposed structural members.

4 Nashville City Center
Designed by Hugh Stubbins, completed in 2008, the twenty-seven-story highrise houses the First Tennessee Bank.

New Orleans, LA

400 Bourbon Street, 1954 (right)

U.S. Navy sailors stroll past the Original Old Absinthe Bar at the corner of Bourbon and Conti Streets in the French Quarter. The bar had started life in the early nineteenth century at 240 Bourbon but moved here during Prohibition.

400 Bourbon Street, 2009 (left and below)

The sign and the tablet (below) on the corner of Bourbon and Conti streets identifies the Original Old Absinthe Bar from 1954. In 2004 it moved back to its original home at 240 Bourbon. Today, therefore, the actual Absinthe House restaurant is situated on the corner of Bienville and Bourbon.

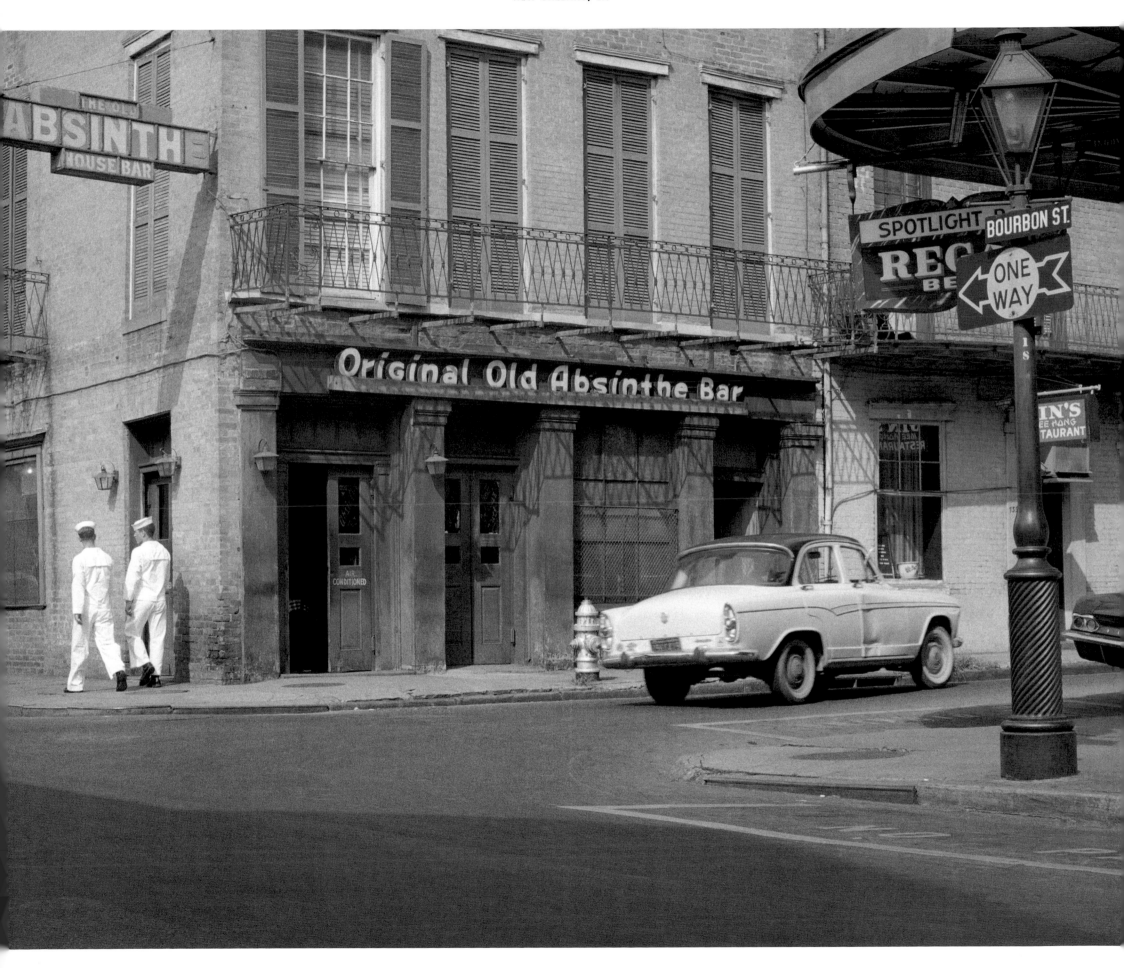

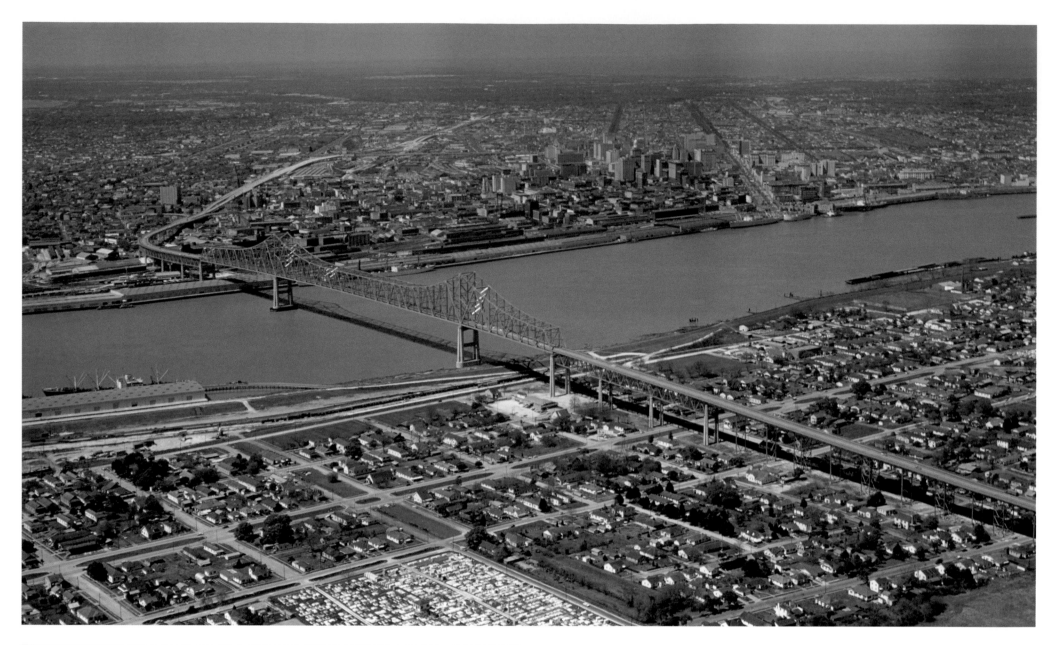

New Orleans, 1954 (above)

1 Greater New Orleans Bridge
Construction on the four-lane Greater New Orleans Bridge across the Mississippi River began in November 1954. It opened to vehicular traffic in April 1958. At almost 2.5 miles in length it was, at the time, the longest cantilever bridge in the world.

2 Downtown New Orleans
Downtown in New Orleans has a more specific meaning than in other cities. Canal Street divides the city into "Uptown"—upriver from Canal Street—and "Downtown," downriver.

3 French Quarter
The French Quarter—or "Vieux Carré" as it was called—is the oldest part of New Orleans, the site of the original foundation. La Nouvelle Orléans was founded in 1718 by Jean-Baptiste Le Moyne de Bienville, whose name is commemorated as a street in the French Quarter. A wonderful area of bars and restaurants, the French Quarter is a National Historic Landmark district and covers an area roughly boundaried by Canal Street, Esplanade Avenue , and North Rampart Street. Fortunately, it was less affected by Hurricane Katrina in 2005 than many areas of the city.

New Orleans, 2006 (below)

A year after Hurricane Katrina struck New Orleans in August 2005, the city struggles to rebuild. In the area of the Crescent City Connection, twenty-three-foot floodwalls protect the city from flooding. The fabled Ninth Ward, which the hurricane virtually destroyed, is to the extreme right of the photo (7) with Lake Pontchartrain in the distant background (8).

4 Crescent City Connection

With New Orleans' skyline in the background, twin cantilever bridges carry U.S. Highway 90 over the Mississippi River. Originally built in the 1950s as the single Greater New Orleans Bridge, the second four-lane span was opened in September 1988. Each bridge in the renamed Crescent City Connection carries traffic in one direction. They are the furthest downstream bridges over the Mississippi River.

5 One Shell Square

At the heart of the central business district, the 700-foot fifty-one-story One Shell Square is the tallest building in Louisiana. Mimicking One Shell Plaza in Houston, it was designed by the architectural firm Skidmore, Owings & Merrill and opened in 1972.

6 Capital One Tower

Completed in 1984, 646 feet tall, the fifty-three-story tower was designed by Moriyama & Teshima Architects.

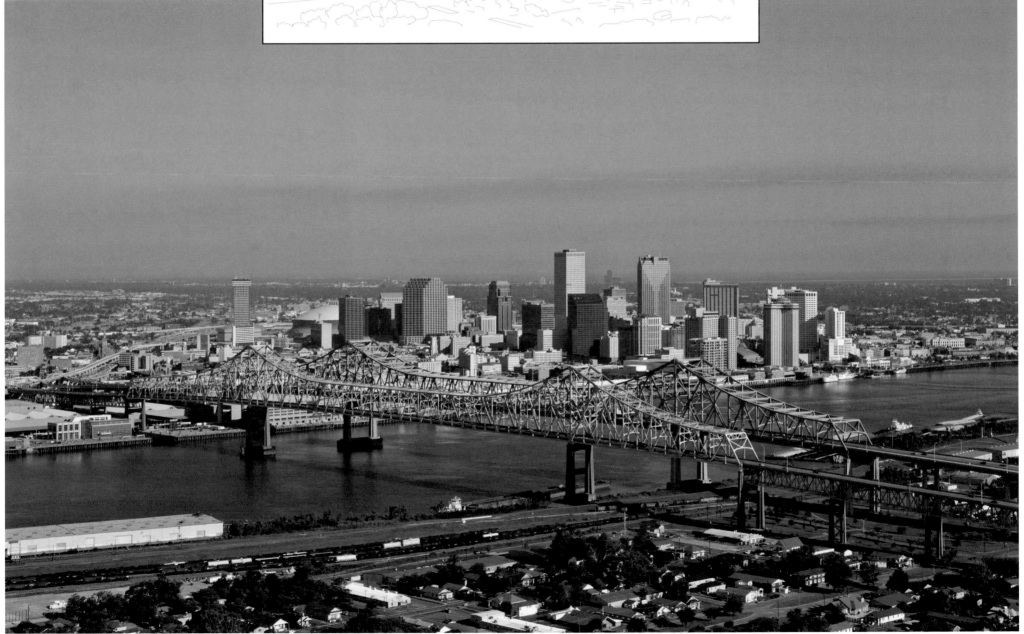

New York City, NY

Statue of Liberty, 1954 (below)

1 The Statue of Liberty
Commissioned by France in 1876 as a gift to commemorate the centenary of America's Declaration of Independence, the statue was designed by sculptor Frederic Auguste Bartholdi with structural assistance by engineer Alexandre Gustave Eiffel—famed for the steel tower that carries his name in Paris. The statue was constructed in France and shipped to the United States in 350 individual pieces. As result of delays in funding, and slow construction of the pedestal, the Statue wasn't erected until 1886. This view from November 18, 1954, looks toward the Battery in Lower Manhattan.

2 Fort Wood
During the War of 1812, America built Fort Wood on Bedloe Island in New York Harbor. Portions of this star-shaped fortification now serve as the base for the Statue of Liberty. Although the statue is one of New York City's most memorable icons, in fact the Island is within the state of New Jersey, just a short distance west of the New York State line. In 1965 the island was renamed Liberty Island.

3 Battery Park
The historically significant southernmost area of Manhattan was expanded with landfill in the nineteenth century and developed into a park.

4 Brooklyn Bridge
John A. Roebling and Washington Roebling's famous suspension bridge connects lower Manhattan with Brooklyn.

5 The Empire State Building
Built in 1931 and located off Fifth Avenue between 33rd and 34th streets, this 102-story building was the tallest in the world until 1972. Following the terrorist attacks that brought down the World Trade Center, the Empire State Building regained its status as New York's tallest building, although it could no longer hold the title as the world's tallest.

6 Governor's Island
Located in New York Harbor, off the tip of Manhattan Island, the island's strategic military location long served the U.S. Army. In 1966, it was conveyed to the U.S. Coast Guard.

Statue of Liberty, 2001 (opposite)

With the towers of the World Trade Center standing tall, this is obviously a pre-September 11, 2001, image of New York Harbor showing the Statue of Liberty with the skyline of Lower Manhattan. The statue was restored in 1986 in time for its centenary.

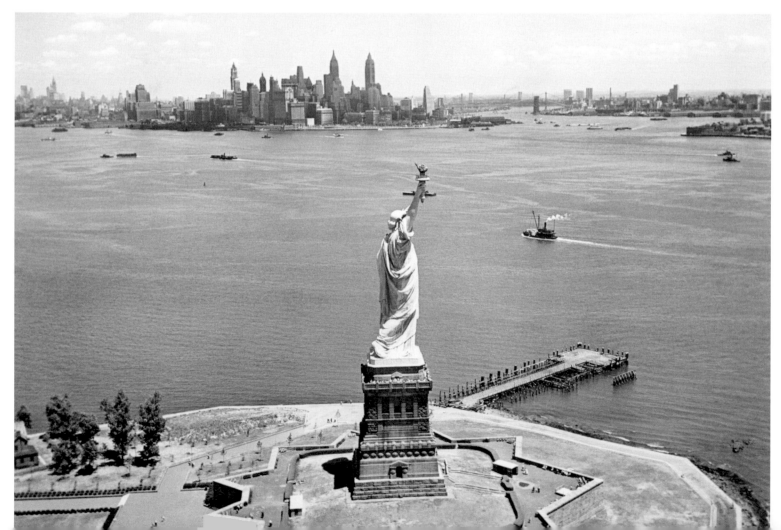

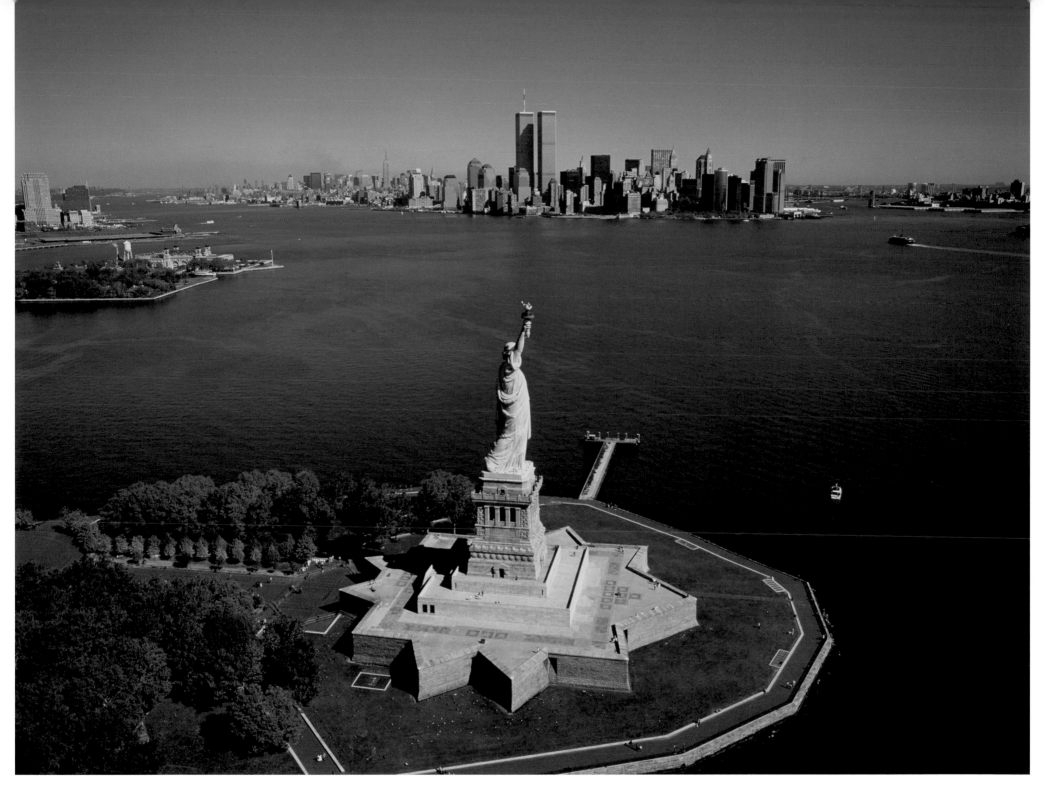

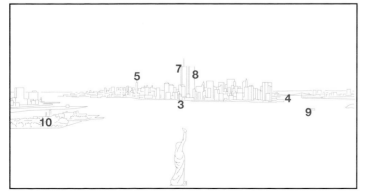

7 World Trade Center North Tower
WTC 1 was the tallest building in the world when completed in 1972, surpassing the Empire State Building.

8 World Trade Center South Tower
WTC 2 was completed in 1973.

9 Staten Island Ferry
Connecting Manhattan's Whitehall Terminal at South Ferry with St. George Terminal on Staten Island, the ferry service operates on half-hour intervals throughout most of the day. Staten Island is one of New York's five boroughs and the one most isolated by virtue of its geography.

10 Ellis Island
Named for Samuel Ellis who owned the island in the eighteenth century; from 1892 to 1954 it was the largest federal immigration station in the United States and processed an estimated twelve million immigrants. Today the main building on the island serves as the Ellis Island Immigration Museum.

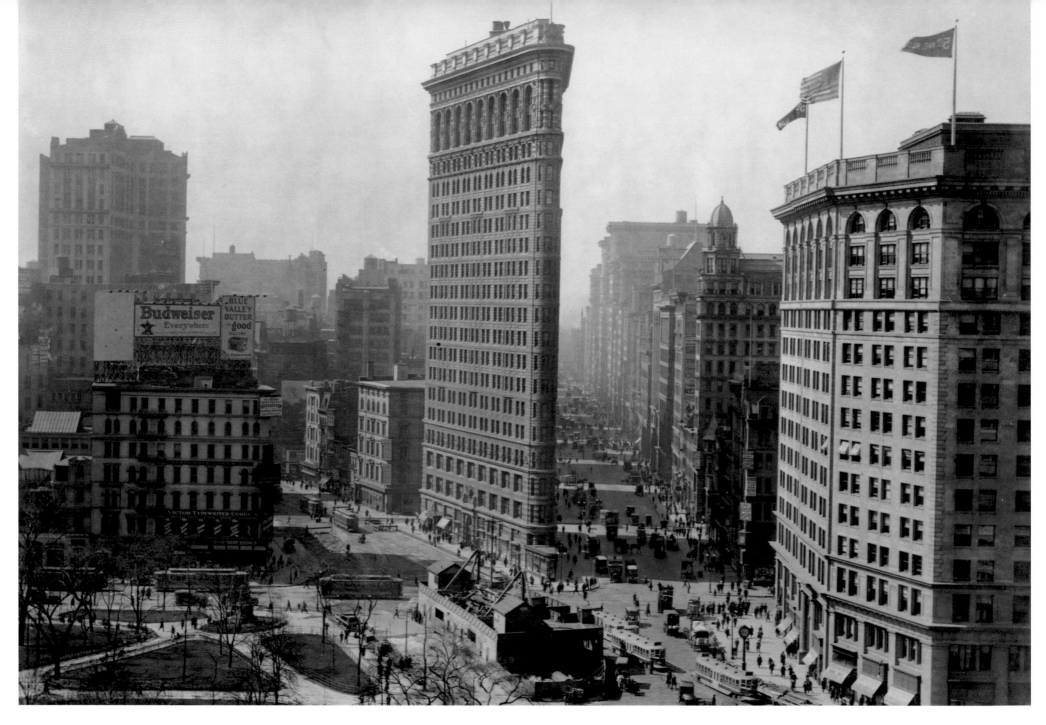

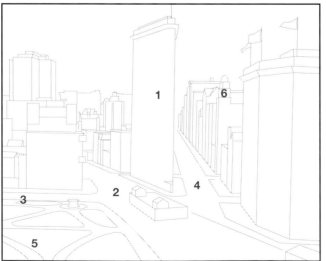

Flatiron Building, 1915

1 Flatiron Building

View looking south of the Flatiron Building on Fifth Avenue and Broadway. Designed by Daniel H. Burnham—one America's foremost architects working in the Beaux-Arts style—it was originally called the Fuller Building. Completed in 1902, it is one of New York's iconic structures and was one of the earliest large applications of load-bearing structural steel. Its façade consists of a mix of decorative terra-cotta and limestone. At twenty-one stories, the building measures 285 feet tall, which made it one of the city's tallest buildings at the time of construction although it was soon eclipsed by much taller skyscrapers. There are more than a dozen famous "Flatirons" built in American cities. The buildings get their name from their shape which resembles an old fire-heated iron.

2 Broadway

Manhattan streets north of 14th Street adhere to a rigidly defined grid. The exception is Broadway which wanders diagonally between the north–south avenues and east–west numbered streets. New York, like most American cities, benefited from a network of electric street cars. However, where most street cars were powered by overhead wires, a Manhattan ordinance

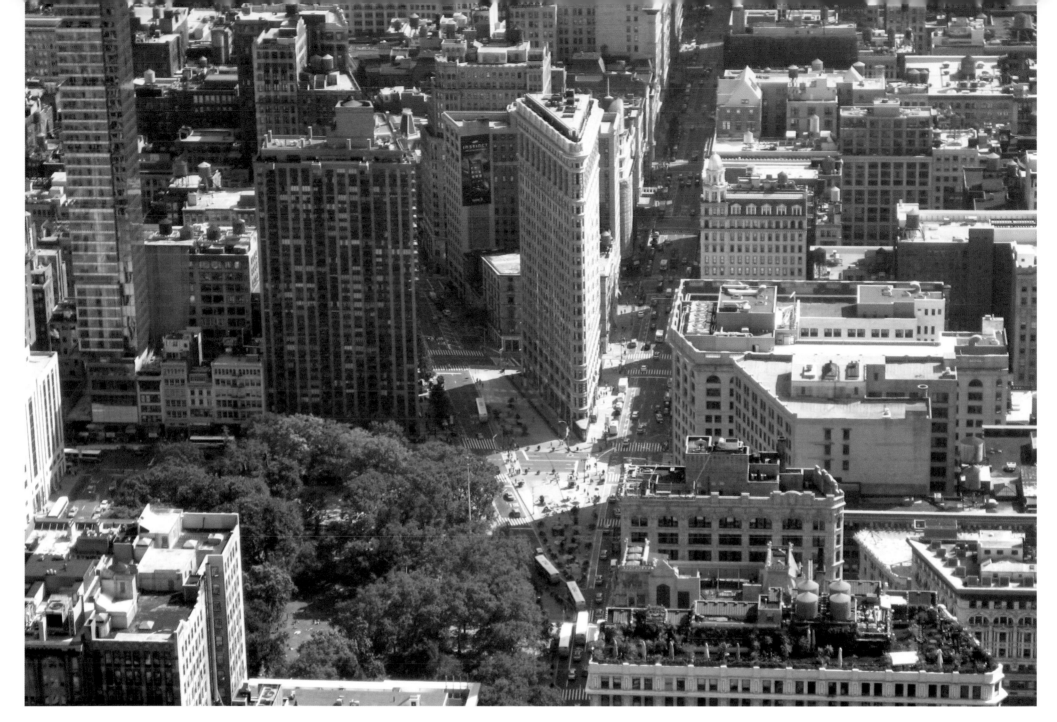

precluded the use of wires, so cars tapped an electric third rail located below street level in a narrow conduit—similar to that used by San Francisco's cable cars. Most of the streetcars were replaced by less colorful buses during the 1940s and early 1950s.

3 23rd Street
Two-way crosstown street, to the left of the Flatiron it is East 23rd St, to the right it becomes West 23rd St.

4 Fifth Avenue
The main axis through Manhattan is the zero point for street addresses which radiate east and west increasing in number.

5 Madison Square Park
The famous green area located north of the Flatiron Building between its namesake Madison Avenue and Fifth Avenue and between 23rd and 26th streets.

6 Sohmer Piano Building
An 1897 Beaux-Arts building at 170 Fifth Avenue, at 22nd Street, it was designed by Robert Maynicke and is recognizable by its gold dome.

Flatiron Building, 2009 (above)

7 Madison Green Condominiums
Thirty-one floors, completed in 1982.

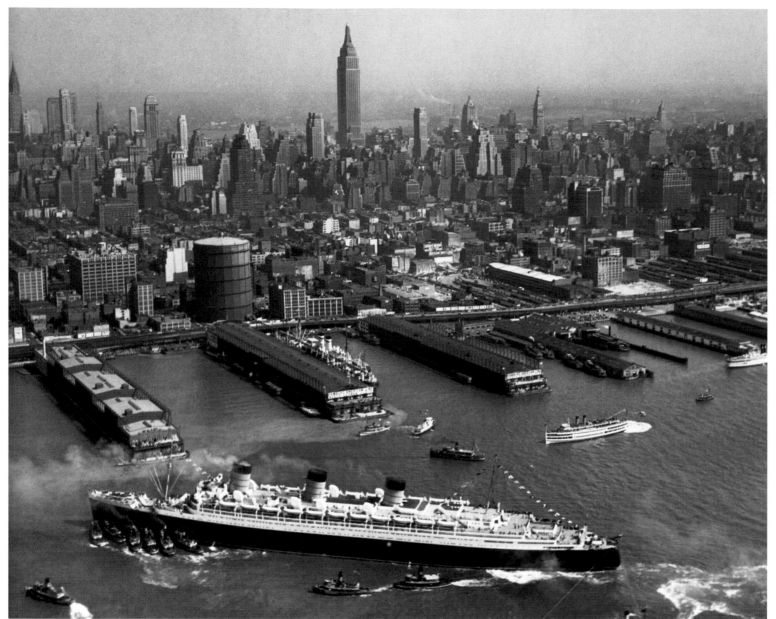

Midtown, 1936

1 Chrysler Building
This beautiful Art Deco building spent some eighteen months as the world's tallest until the Empire State topped out in 1931.

2 Empire State Building
The tallest building in the world before the Twin Towers were built. It is now the tallest in New York State, from whose nickname—the Empire State—is derived.

3 New York Life Insurance Company
Built on the site of the first Madison Square Garden, this thirty-four-story Gothic tower was completed in 1928.

4 Metropolitan Life Insurance Co.
The 54-story tower at 1 Madison Avenue was modeled after the campanile in St. Mark's Square, Venice.

5 New York Passenger Ship Terminal
This consists of North River Piers 88, 90, 92 and 94 on the Hudson River between West 46th and West 54th streets.

6 RMS *Queen Mary*
The Cunard liner was named after Mary of Teck, the Queen Consort of George V. Retired in 1967, she is berthed in Long Beach, California, serving as a museum ship and hotel.

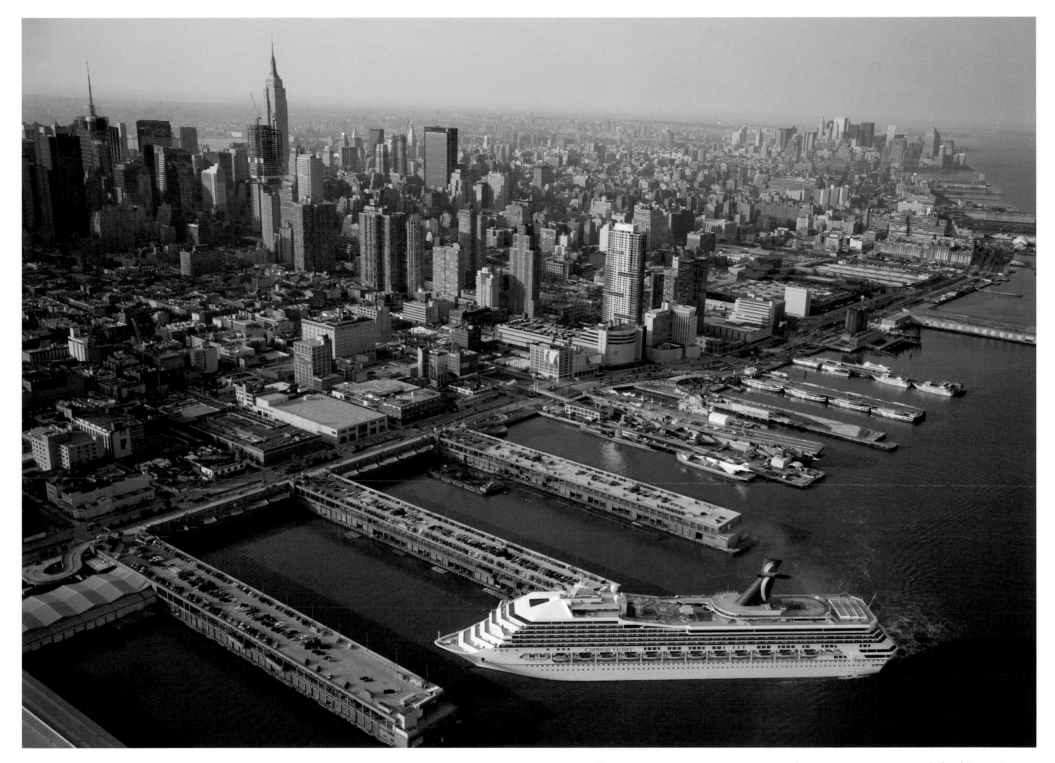

Midtown, 2006

7 One Penn Plaza
Designed by Kahn & Jacobs and completed in 1972, this is New York's twentieth tallest building.

8 643 W 43rd Street
UPS's New York hub, the area sees many of the characteristic brown-liveried vehicles. Opposite at 635 W 42nd Street is the Atelier new development condo building that would open in 2007. The architect was Costas Kondylis and his successful design has 478 apartments.

9 Pier 86
Once used by United States Lines, it is now home to one of twenty-four Essex-class aircraft carriers built during World War. In 1982 USS *Intrepid* became a Sea-Air-Space Museum.

10 Bank of America Tower
Seen under construction, the second-tallest building in the city reached its maximum height on December 15, 2007, when the final portion of the spire was put in place.

11 *Carnival Destiny* enters port
When she entered service in 1996, *Carnival Destiny* was the largest passenger ship ever built as measured by gross tonnage—and the biggest since *Queen Mary*.

12 Condé Nast Building
Officially 4 Times Square, the structure was finished in January 2000 as part of a larger project to redevelop 42nd Street. The antennae takes its height to 1,143 feet, making it the third tallest structure in the city.

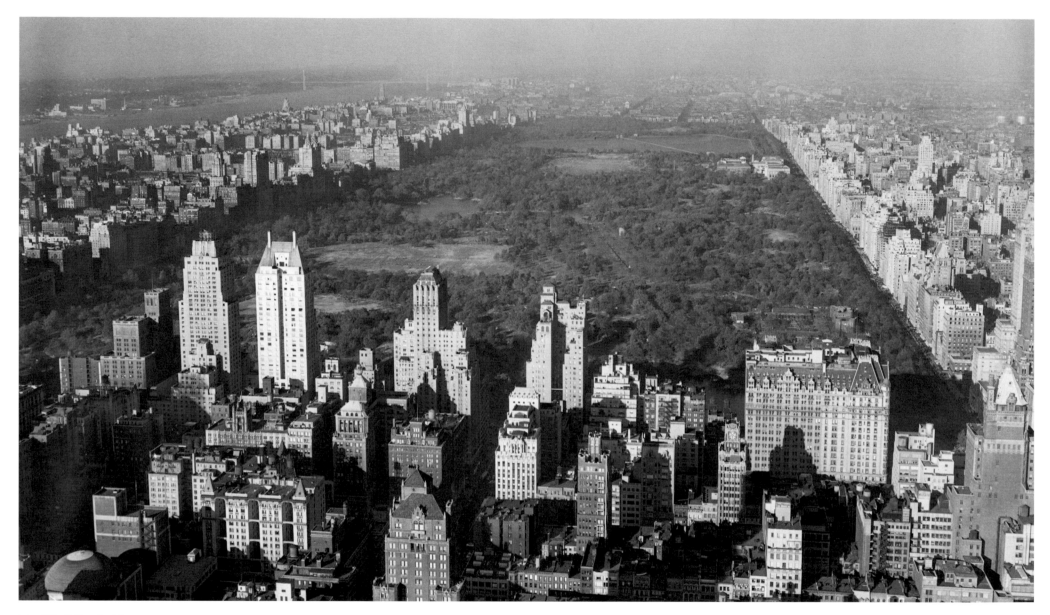

Central Park, 1950

1 Central Park
Manhattan Island's largest park was built 1859–1873 using the landscape design of Frederick Law Olmsted and Calvert Vaux. Perhaps the best-known landscape architect of his generation, Olmsted was awarded Central Park as result of a 1857 competition hosted by the New York City's Central Park Commission. The park is bordered on the east and west by Fifth and Eighth Avenues (Central Park West), on the north by 110th Street, and on the south by 59th Street.

2 Essex House
A forty-two-floor hotel and apartment building built at Central Park South (59th Street) in 1931.

3 Hampshire House
This thirty-seven-story hotel and apartment building was designed in a Beaux-Arts style by Caughey and Evans and constructed in 1937. By just a few feet, it was the tallest building at Central Park South in 1950.

4 Barbizon Plaza Hotel
Located at 106 Central Park South, and constructed in the Art Deco style in 1930, it rises thirty-eight floors above the street. Its northward-facing apartments command spectacular views of the park. The old hotel was bought in 1986 by real-estate mogul Donald Trump who converted it to owner-occupied apartments. It is now called Trump Parc Condominiums.

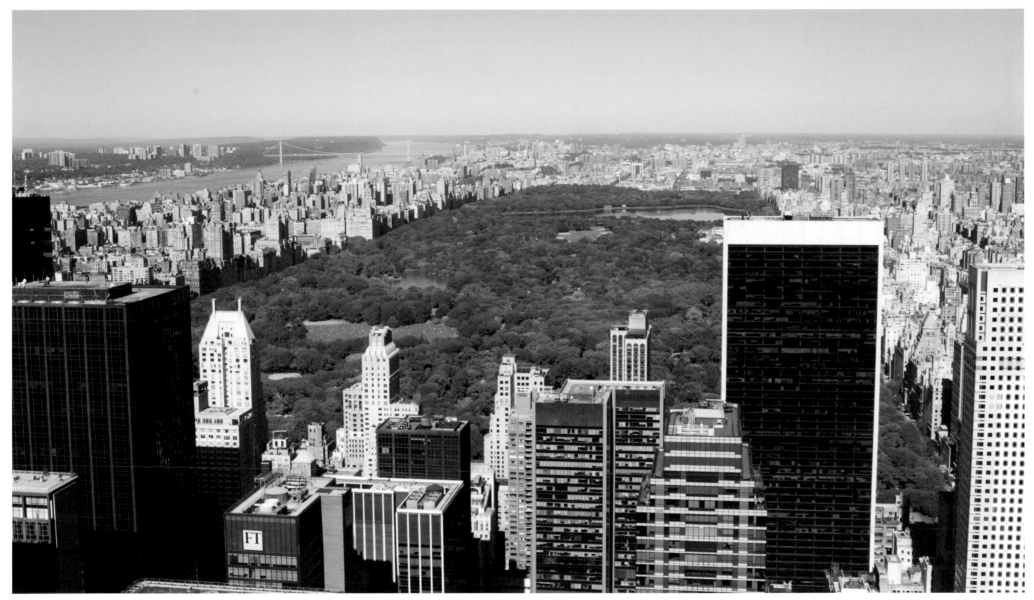

5 Sheep Meadow
One of Central Park's largest open spaces, this area hosted grazing sheep as late as 1934.

6 Central Park Reservoir
A 106-acre man-made lake built along with the park between 1858 and 1862. With a capacity for more than one billion gallons, it was designed to supply water to the city. It is the largest of several lakes in Central Park. Central Park Reservoir was decommissioned as an active water supply in 1993, and in 1994 it was named in honor of former First Lady Jacqueline Kennedy Onassis (1929–1994) who occupied apartments overlooking the water.

7 Hudson River
The largest river in New York State and traditionally a primary conduit of commerce.

8 George Washington Bridge
Engineer Othmar Ammann's masterpiece that opened in October 1931, this 4,760-foot suspension bridge connects Manhattan with Fort Lee, New Jersey.

Central Park, 2008

9 Solow Building
On West 57th Street, this fifty-story (689 feet) skyscraper was designed by Skidmore, Owings and Merrill's Gordon Bunshaft. Built in the 1970s, it houses notoriously expensive office space.

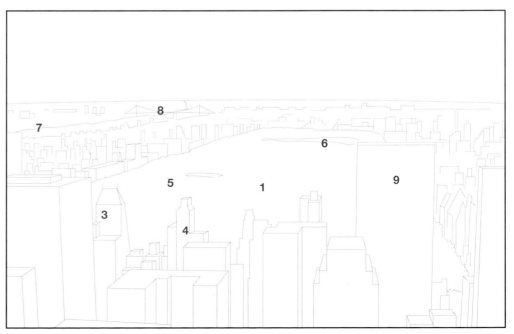

Wall Street toward Trinity Church, 1890 (left)

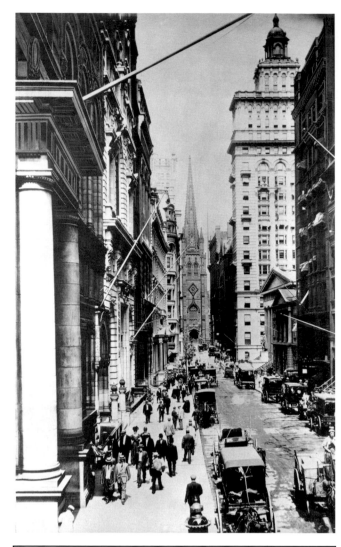

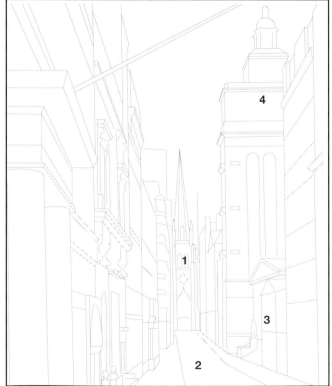

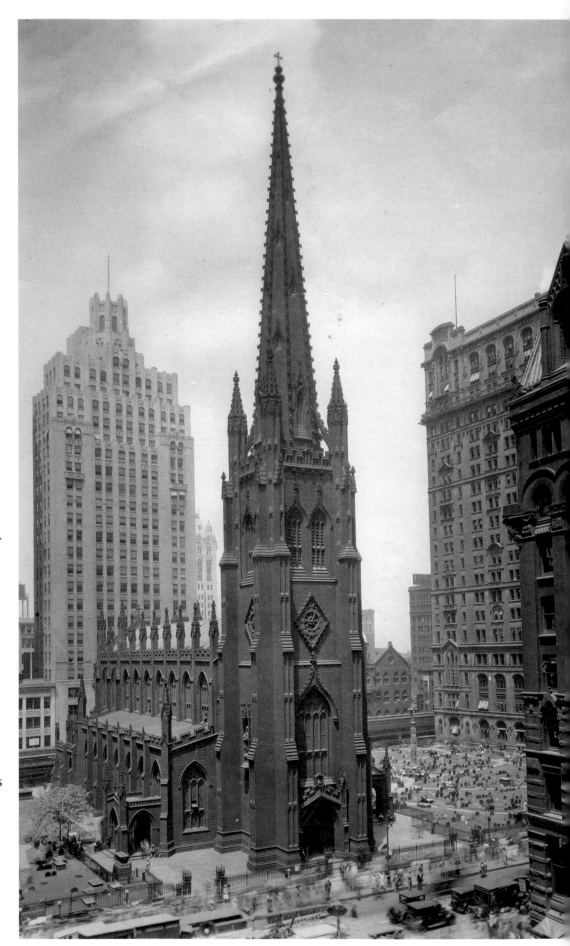

1 Trinity Church

Officially the Holy Trinity Episcopal Church, the most recent building serving a parish was granted its charter in 1697 by England's King William III. Designed in the Neo-Gothic style by architect Richard M. Upjohn, Trinity was built in 1846. For many years it was the tallest structure in the city, but by the time of the 1935 view, Trinity Church was beginning to get lost in Manhattan's man-made canyons. Since that time many even taller buildings have grown up around the historic church and at times it is lucky to catch a ray of sun.

2 Wall Street

Wall Street was named in Dutch times for the wall that marked the northern border of New Amsterdam. In modern times Wall Street has served as the heart of New York's financial district and has become synonymous with big business.

3 Federal Hall

The first capitol of the United States, this is where George Washington was inaugurated as the first president (his statue can be seen at the bottom of the steps) on April 30, 1789. It is also the place where the United States Bill of Rights was passed. Demolished in the nineteenth century, the current building opened in 1842.

4 14 Wall Street

The Gillender Building, an

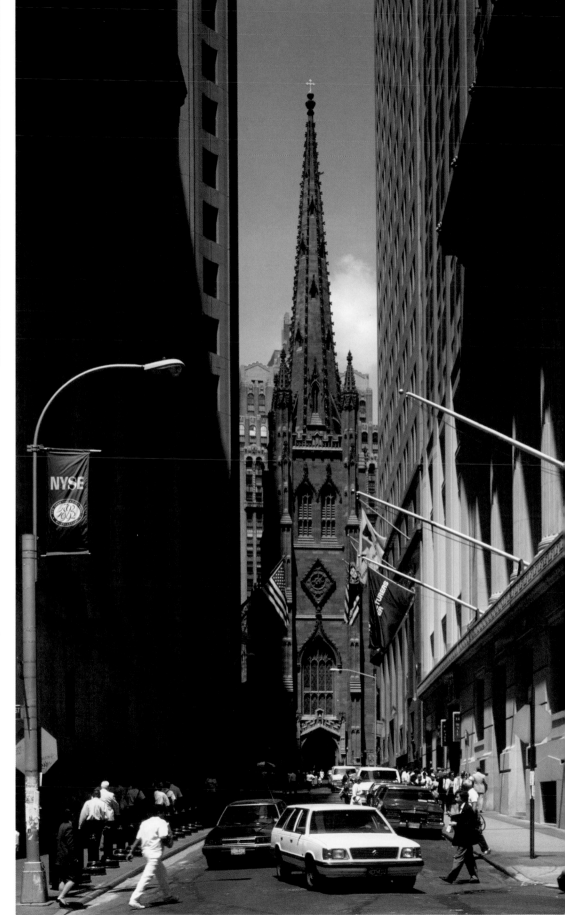

early twenty-story skyscraper, is famous for being the first modern skyscraper to be demolished to make way for a taller building. This happened between April and June 1910 to make way for the 41-story Bankers Trust Tower. Completed in 1912 by Trowbridge & Livingston, today's 14 Wall Street is 539 feet tall and has thirty-seven floors. It occupies a block on Nassau Street from Wall Street to Pine Street, opposite the New York Stock Exchange and Federal Hall.

Wall Street toward Trinity Church, 1935 (left)

5 Trinity Court Building
Designed by architect Henry I. Oser and completed in 1927, this 312-foot building at 74 Trinity Place stands opposite Trinity Church, whose real estate company owns it—Trinity Church is one of the largest landowners in New York City.

6 Elevated railway structure
Difficult to make out in the photograph but the New York Elevated Railway ran down Trinity Place. The elevated line was part of the Sixth Avenue El and was constructed during the 1870s. Its route ran north from the corner of Rector Street and Trinity Place, up Trinity Place,

and continued north along Church Street. The Sixth Avenue El was closed on December 4, 1938, and taken down during 1939.

7 Trinity Church Graveyard
The only remaining active cemetery in Manhattan, it contains the graves of many famous men including Alexander Hamilton, William Bradford, Robert Fulton, and Albert Gallatin. The oldest carved gravestone in New York City is also here, that of Richard Churcher (1676–1681).

Wall Street toward Trinity Church, 2009 (right)

8 The Bank of New York Mellon
The Bank of New York was founded by Alexander Hamilton on June 9, 1784. Just over 222 years later, on December 4, 2006, it was announced that the bank and Mellon Financial Corporation would merge, creating the world's largest securities servicing and asset management firm. It is housed today in one of the most prestigious addresses in the business world: 1 Wall Street. Voorhees, Gmelin & Walker were the architects of this fifty-story building that opened in 1932 as the Irving Trust Company Building.

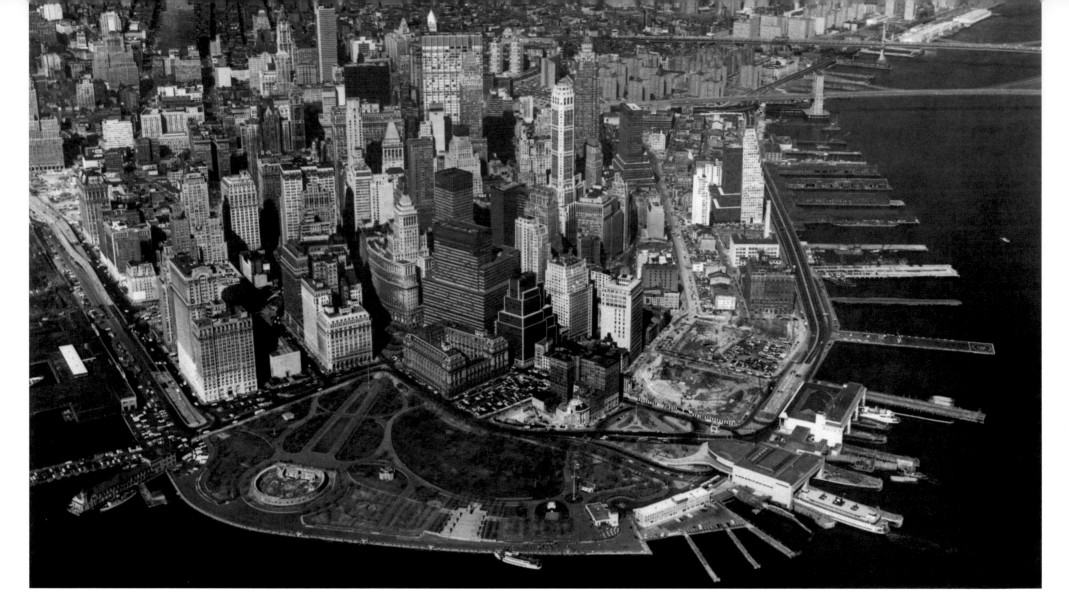

Manhattan, 1967

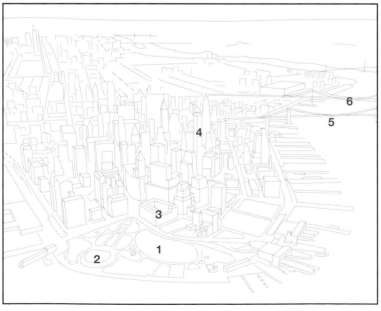

1 Battery Park
A twenty-five-acre park at the tip of Manhattan named for the area traditionally known as "The Battery" after the artillery unit that served here in the seventeenth century.

2 Castle Clinton
Originally a fort situated on a man-made island just off the tip of Manhattan built during the War of 1812. Filled land has gradually surrounded the facility, which was named for renowned New York politician, and one-time New York City mayor, DeWitt Clinton. It has served a variety of uses over the years, and significantly from 1855 was the world's first immigration center, a role later assumed by Ellis Island in New York Harbor.

3 United States Custom House
Located at Bowling Green, this Beaux-Arts masterpiece was designed by architect Cass Gilbert, and erected between 1902 and 1907. It served as the Custom House until Customs moved to the new World Trade Center in August 1973. In 1979, Senator Daniel Patrick Moynihan helped save the classic structure from demolition. Today it houses the National Museum of the American Indian.

4 Irving Trust Company Building
Designed by Ralph Walker of Voorhees, Gmelin & Walker, this strategically located office tower at Broadway and Wall Street is famous for its unusual and powerful Art Deco appearance. Key to the style is its crystal shaped crown which houses the exclusive Observatory Room where members of the bank could invite guests to gaze over the city. Today the building is owned by the Bank of New York Mellon.

5 Brooklyn Bridge (see page 150)

6 Manhattan Bridge
Opened in 1909, the bridge carries seven lanes of traffic and four subway tracks between Manhattan and Brooklyn.

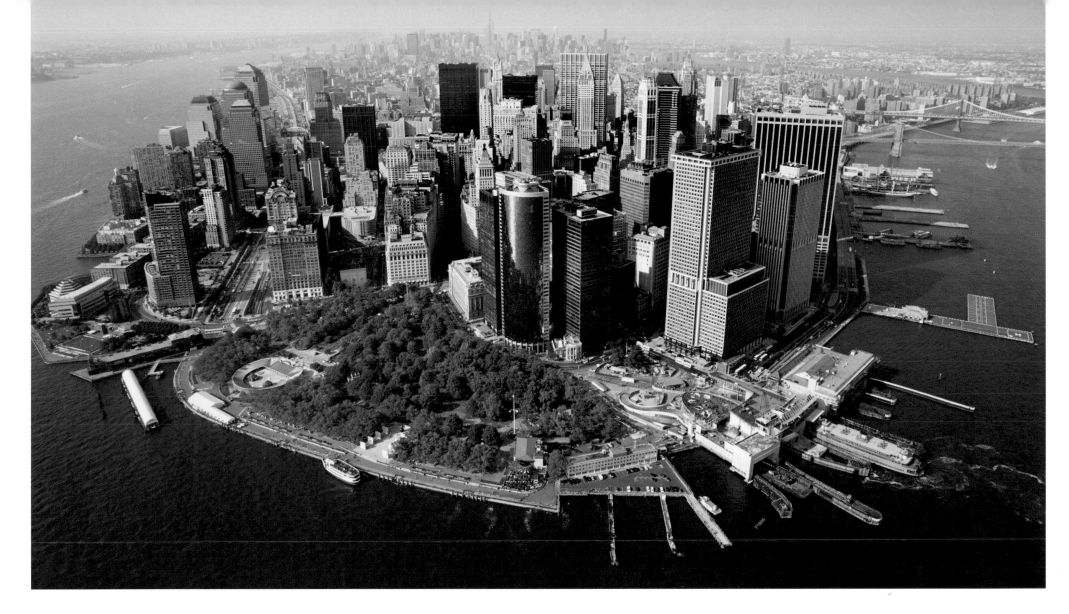

Manhattan, 2002

7 The Trump Building
Located at 40 Wall Street and known as the "Crown Jewel of Wall Street," it was originally built as the Bank of Manhattan Building. This 645-foot, seventy-floor steel frame skyscraper designed in the Neo-Gothic style was completed in record time in 1930 and briefly held the title as the tallest building in the world. The Trump organization acquired it in 1995.

8 Two World Financial Center
Also known as the Merrill Lynch Building, this 645-foot, forty-four-story tower was completed in 1987. It was designed by Haines Lundberg Waehler of Cesar Pelli & Associates as part of the World Financial Center which was built on landfill. Near to the World Trade Center towers it was damaged when they collapsed in the 9/11 attacks, but it was repaired and reopened in 2002.

9 Whitehall Terminal
Previously known as South Ferry, this is the marine terminal for ferries to Staten and Governor's Islands.

10 17 State Street
This forty-two-floor, Modernist glass-lined steel-frame skyscraper designed by Emery Roth & Sons has been a prominent feature of the Lower Manhattan skyline since completed in 1988. The bottom floors house an archeology museum of artifacts discovered while building modern Manhattan.

11 One State Street Plaza
Completed in 1969, this thirty-three-story tower is only noticeable in a virtual sea of skyscrapers because of its prominent waterfront location.

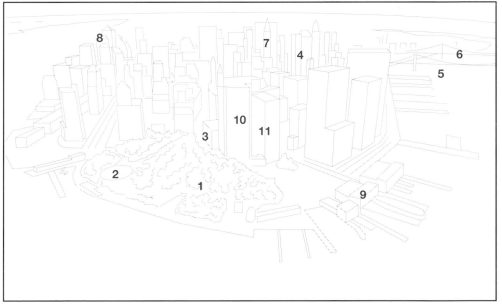

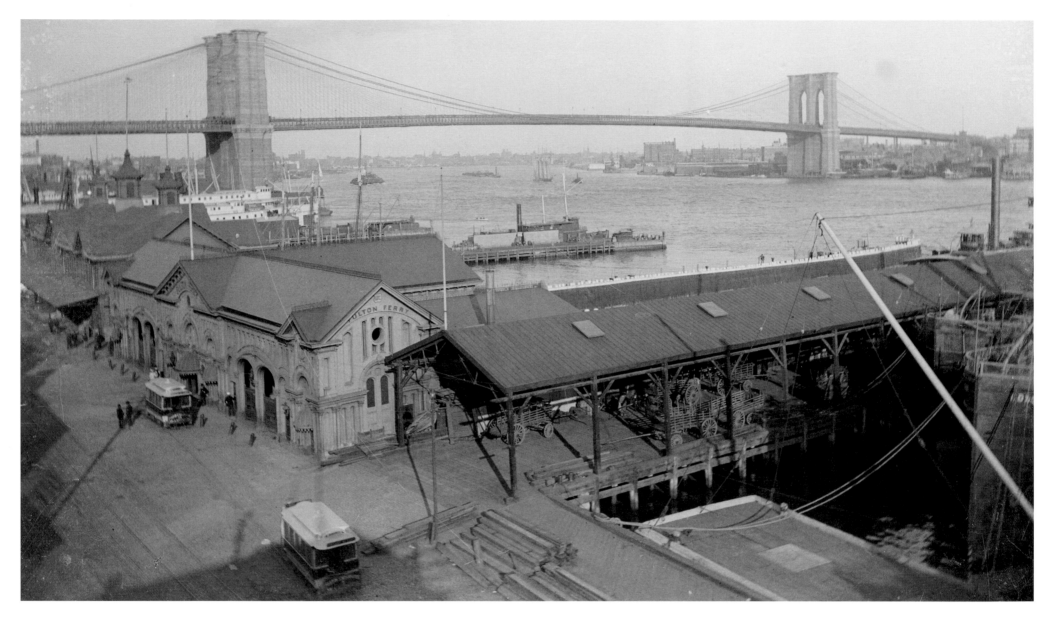

Brooklyn Bridge, 1900

1 Perhaps New York's most famous span, this is the Brooklyn Bridge from the Manhattan side as it appeared in 1900 before the age of skyscrapers. Approved by President Ulysses S. Grant in 1869, the bridge was designed by John A. Roebling—father of the cable suspension bridge—and executed posthumously by his son Washington Roebling. After years of construction difficulties and other problems the bridge was opened on May 24, 1883. Traditionally there was a three-cent toll for pedestrians. At the time of construction Brooklyn and New York City were separate cities.

2 Fulton Ferry
The company is named after Robert Fulton's ferry company that was established in 1814 using the steamboat *Nassau*. This revolutionary service (steam power was still a great novelty) served well until the opening of the bridge which took away a lot of business. The ferry service finished in 1924. There are Fulton Streets on both sides of the river and a neighborhood in Brooklyn is named Fulton Ferry.

3 Brooklyn City Railroad
Incorporated in 1853, the BCRR ran horsecars, streetcars, and trolleys—one of its first lines running from the Fulton Ferry to Marcy Avenue.

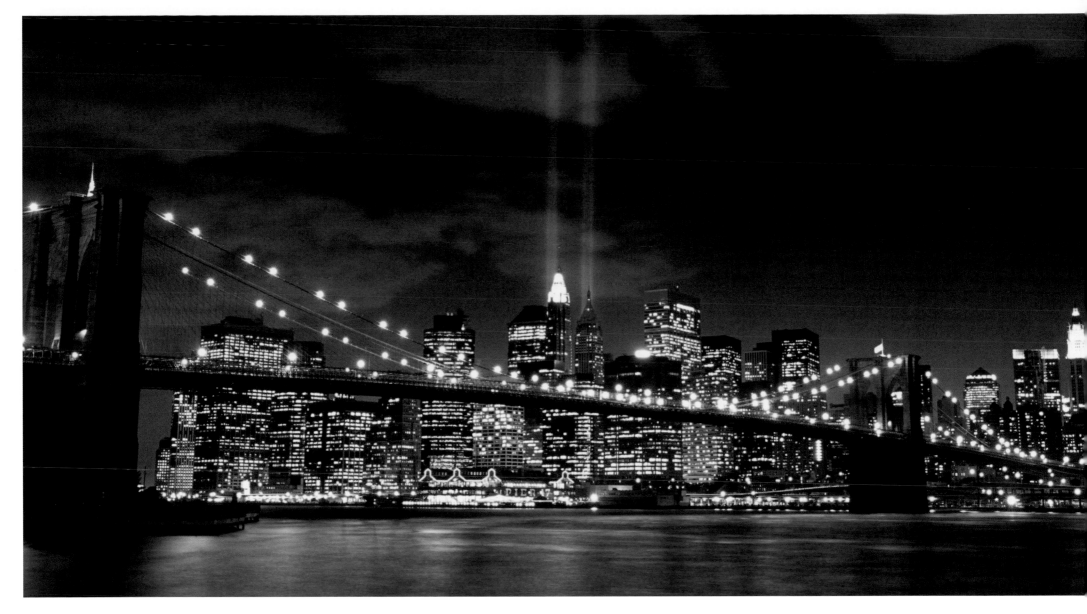

Brooklyn Bridge, 2006

4 The Brooklyn Bridge's masonry towers and duplicate set of suspension cables set it apart in time from the modern skyscrapers that now dominate the New York skyline, as seen from the Brooklyn side of the river. In its day, the bridge was the largest architectural component of New York City. The main span over the East River is 1,562 feet and, as built, the entire bridge, including approaches on both sides measured 5,989 feet. The four primary suspension cables were made from spun steel wire using the method invented and manufactured by John A. Roebling. An estimated 3,600 miles of wire were used in the bridge's support cables.

5 Tribute to Light
The beams mark the sky where the World Trade Center twin towers stood.

6 The Trump Building
The "Crown Jewel of Wall Street."

7 Woolworth Building
Designed by Cass Gilbert in the Gothic Revival Style, and built in 1913 for retail-chain owner Frank W. Woolworth, this was the tallest building in the world until surpassed by the Chrysler Building in 1930. One of New York's icons, it was often featured on tinted postcards in the early decades of the twentieth century.

8 American International Building
Completed in 1932, its Neo-Gothic façade towers over Wall Street.

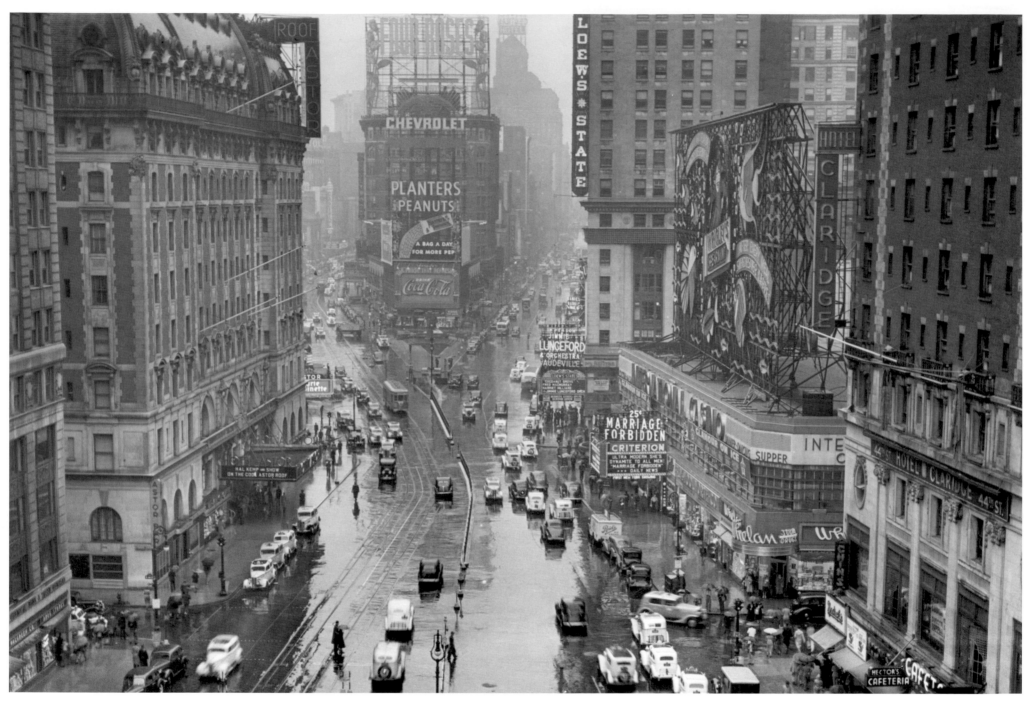

Times Square looking south, ca. 1935

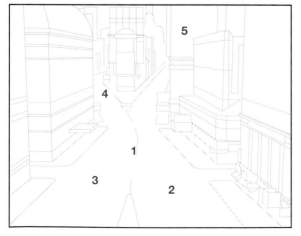

1 Times Square is New York City's most recognizable intersection, where Broadway slices across Seventh Avenue on a shallow angle between 42nd and 45th streets. The southern end of this intersection was named Times Square in the early years of the twentieth century following the relocation of the newspaper offices of the *New York Times* to 42nd Street in 1904. This late 1930s view looks north toward Duffy Square, showing the old Third Avenue Railways electric street car line.

2 Broadway
New York's famous street is synonymous with theater, and many of the street's best known venues are located at Times Square.

3 Seventh Avenue
New York's avenues are numbered from east to west.

4 Duffy Square
Although Times Square has come to reflect the whole intersection, the northern end of the X made by Seventh and Broadway is properly known as Duffy Square, named for Father Francis P. Duffy.

5 Loews State Theater
Designed by Thomas W. Lamb, it was demolished in 1987. A new Loews Theater at Times Square was built in 1997 but survived as such for only a few years.

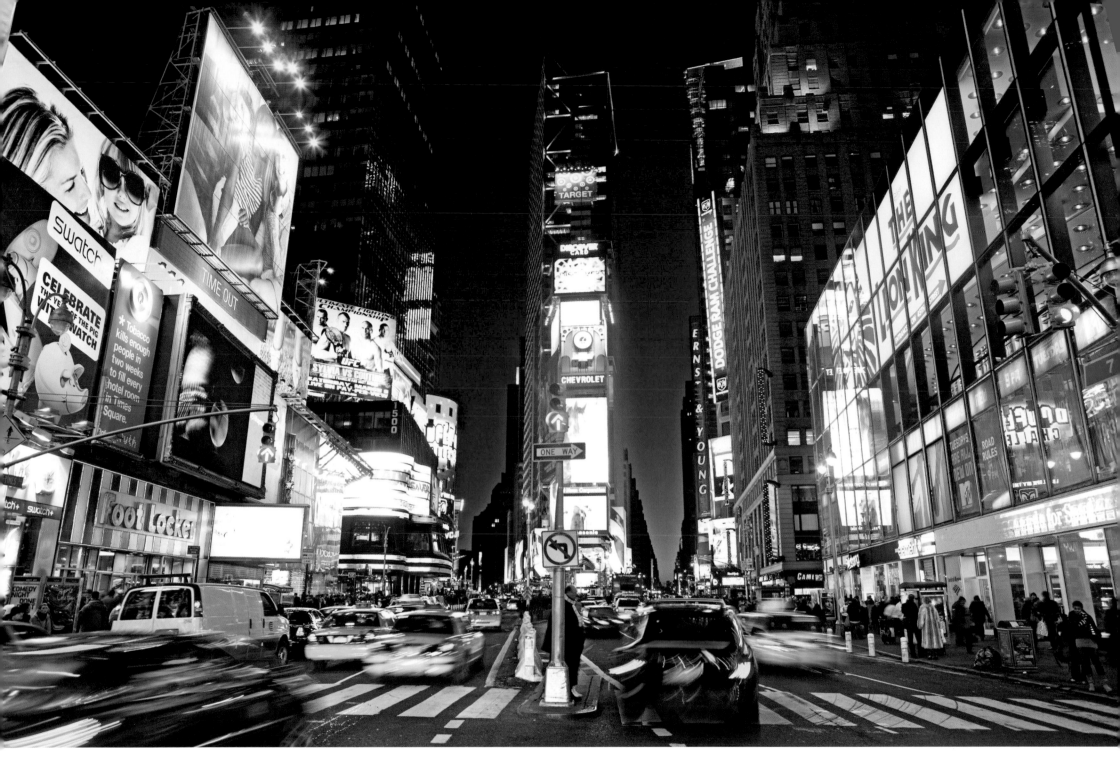

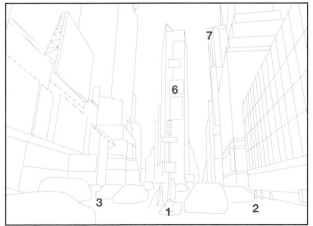

Times Square looking north, 2006

6 Neon
Originally Long Acre Square, Times Square developed as the center of New York's entertainment district in the early years of the twentieth century. With the building of New York's subways, Times Square was a natural hub, serving no less than four different lines. The proliferation of theaters along Broadway was focused at this hourglass shaped intersection. At its peak in 1927, the Broadway Theater District debuted 264 new plays. The square's first electrically lit sign was erected way back in 1897, when electricity itself was still a novelty. By World War I, Times Square was famous for its lights and signs and boasted more than a million bulbs. Today, the old theater buildings have given way to a host of more modern structures, and after decades of decline the square has reclaimed its status as a premier entertainment district. The lights and signs are even more intense with night seeming brighter than day. This modern view looks south along Broadway and Seventh Avenue. Here both thoroughfares are one-way in the southerly direction.

7 Reuters Building
Since 2001, this thirty-floor tower is one of the more prominent buildings at Times Square.

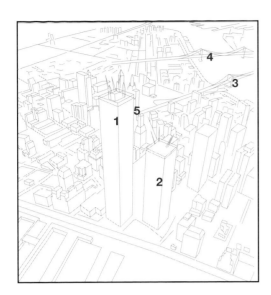

Twin Towers, 1971 (left)

This aerial view of Lower Manhattan shows the World Trade Center under construction. Preparation for building the world's tallest buildings began with the clearing of the thirteen-block site in March 1966. Groundbreaking for actual construction began on August 5, 1966. The World Trade Center Twin Towers were designed by Minoru Yamasaki and Emery Roth & Sons. The size of the buildings and Spartan style drew criticism from the building's neighbors and architects at the time of construction. Although the World Trade Center was best known for the pair of 110-story towers, the building complex consisted of seven buildings.

1 World Trade Center 1
The North Tower was the first of the Twin Towers completed and opened in 1972. Its main structure was 1,368 feet tall making it the world's tallest building at the time of its opening. Six years after it was finished, a telecommunications antenna was installed on the roof which added 360 feet to the total height. The first building completed, this was also the first building to be struck by a plane on September 11, 2001. Hit at 8:46 am, it burned for 1 hour and 42 minutes before collapsing.

2 World Trade Center 2
The South Tower was completed in 1973, and with its external observation deck was 1,377 feet tall, yet only rated as the world's second tallest building, because Chicago's Sears Tower, which measured 1,450 feet, had been finished first. Seventeen minutes after the North Tower, the South Tower was struck by another plane. The damage incurred destroyed the building's essential structure and it was the first of the two buildings to collapse, at 9:59 am.

3 Brooklyn Bridge
This was the first East River crossing and was completed in 1883. The bridge's East River suspension span measures 1,562 feet, making it 206 feet longer than the North Tower was tall.

4 Manhattan Bridge
Among New York's least famous suspension bridges, this was designed by Lion Moisseiff, and opened at the end of December 1909.

5 Woolworth Building
Manhattan's tallest until 1930.

Twin Towers, ca. 1995 (below)

6 World Trade Center 3
Twenty-two-story hotel opened in 1981; destroyed 9/11.

7 World Trade Center 4
Mostly hidden in this view by WTC 2. Nine-story block demolished following 9/11.

8 World Trade Center 5
Nine-story block demolished following 9/11.

9 World Trade Center 6
Destroyed 9/11.

10 World Trade Center 7
Destroyed 9/11; replaced 2006.

11 One World Financial Center
Forty-story tower built in 1986.

12 Two World Financial Center
Forty-four-story tower built in 1987.

13 Three World Financial Center
Fifty-one-story tower built in 1985.

14 Four World Financial Center
Thirty-four-story tower built in 1986.

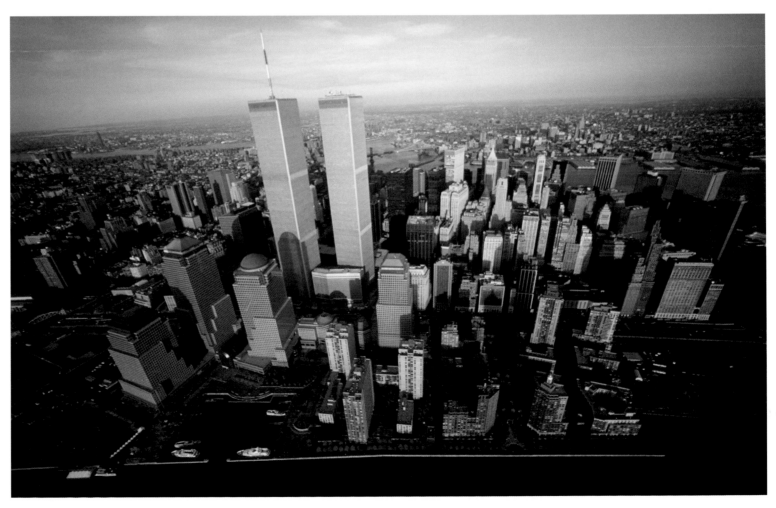

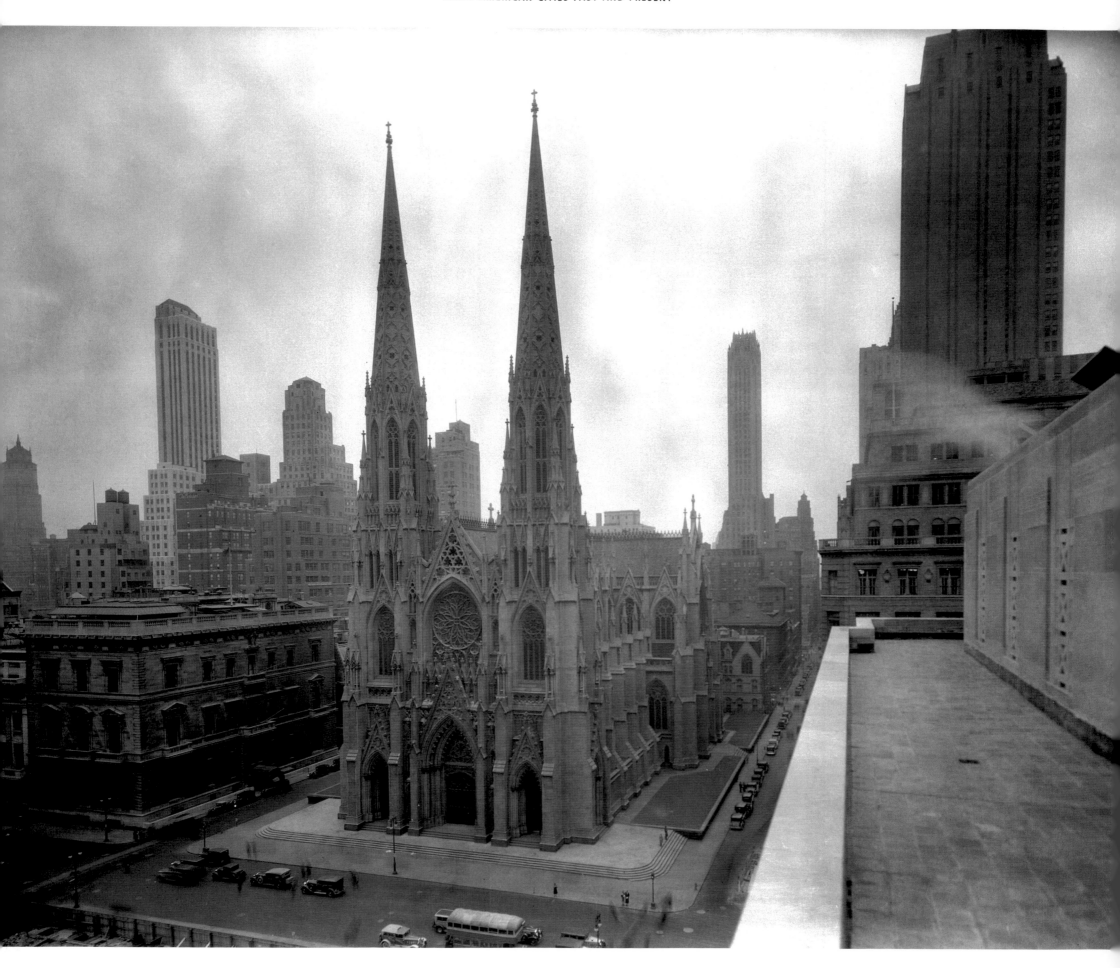

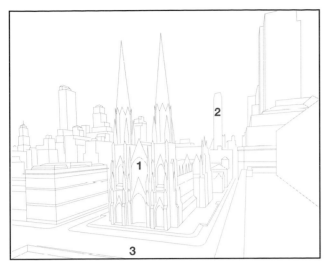

Saint Patrick's Cathedral, 1933 (left)

1 Saint Patrick's Cathedral
Roman Catholic church designed by James Renwick, Jr., in a Neo-Gothic style and constructed between 1858 and 1879. When it was built, the location on Fifth Avenue between 50th and 51st streets was considered well outside the city. By 1933, New York growth had caught up with the church which was already surrounded by taller buildings. The Cathedral under went substantial renovations between 1984 and 2000.

2 Old General Electric Building
This Art Deco masterpiece, originally the RCA Victor Building, at Lexington Avenue and 51st Street was built between 1929 and 1931. Not to be confused with the old RCA Building at 30 Rockefeller Center, also famous for its Art Deco architecture, which is now the "new" GE building. Designed by John W. Cross who incorporated distinctive Gothic motifs in the exterior décor

3 Fifth Avenue
Famous for its department stores, museums, and dynamic elements of New York's commercial life.

Saint Patrick's Cathedral, 2010 (right)

4 Seagram Building
Designed by Ludwig Mies van der Rohe and Phillip Johnson, this rises thirty-eight stories above Park Avenue between 52nd and 53rd Streets. Completed in 1958, it serves as offices for the Canadian distillers known for their high-quality gin and other spirits.

5 Look Building
Built 1948–1950 at 488 Madison Avenue in the International Style for *Look* magazine, this twenty-five-floor, 304-feet-tall highrise has been listed in the National Register of Historic Places since February 24, 2005. It was designed by architects Emery Roth & Sons, architects of over fifty highrises in New York City—including the ill-fated Twin Towers.

6 477 Madison Avenue
Opposite the Look Building on Madison Avenue is this twenty-three-floor 275-foot-tall highrise completed in 1953. The architects were Kahn & Jacobs also responsible for One Penn Plaza.

7 New York Palace Hotel
Incorporates late nineteenth century luxury brownstone townhouses designed by McKim, Mead, and White—of New York's Pennsylvania Station fame—with a fifty-five-story highrise tower. Run as The Helmsley Palace Hotel until 1992.

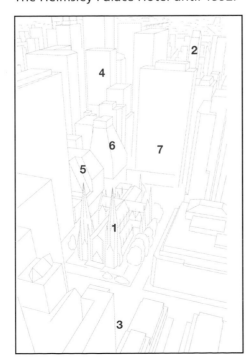

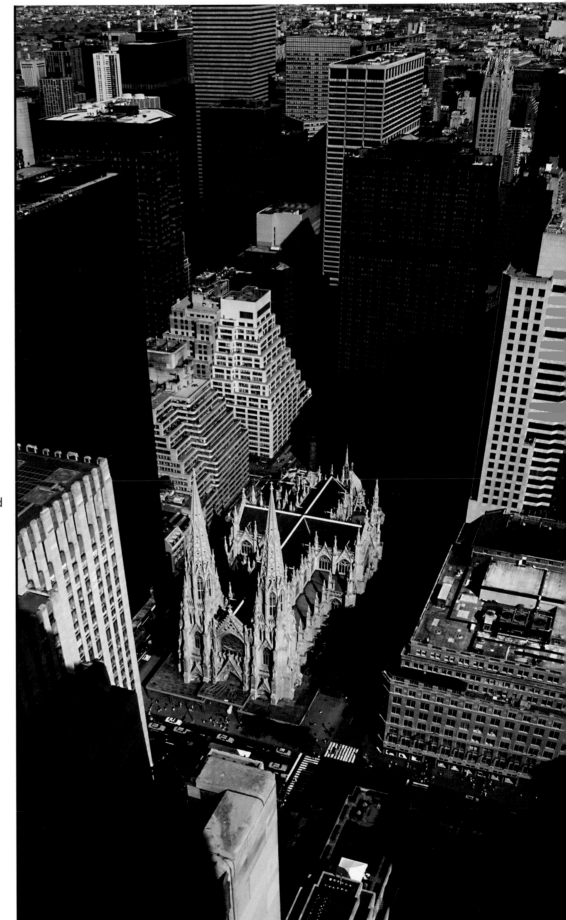

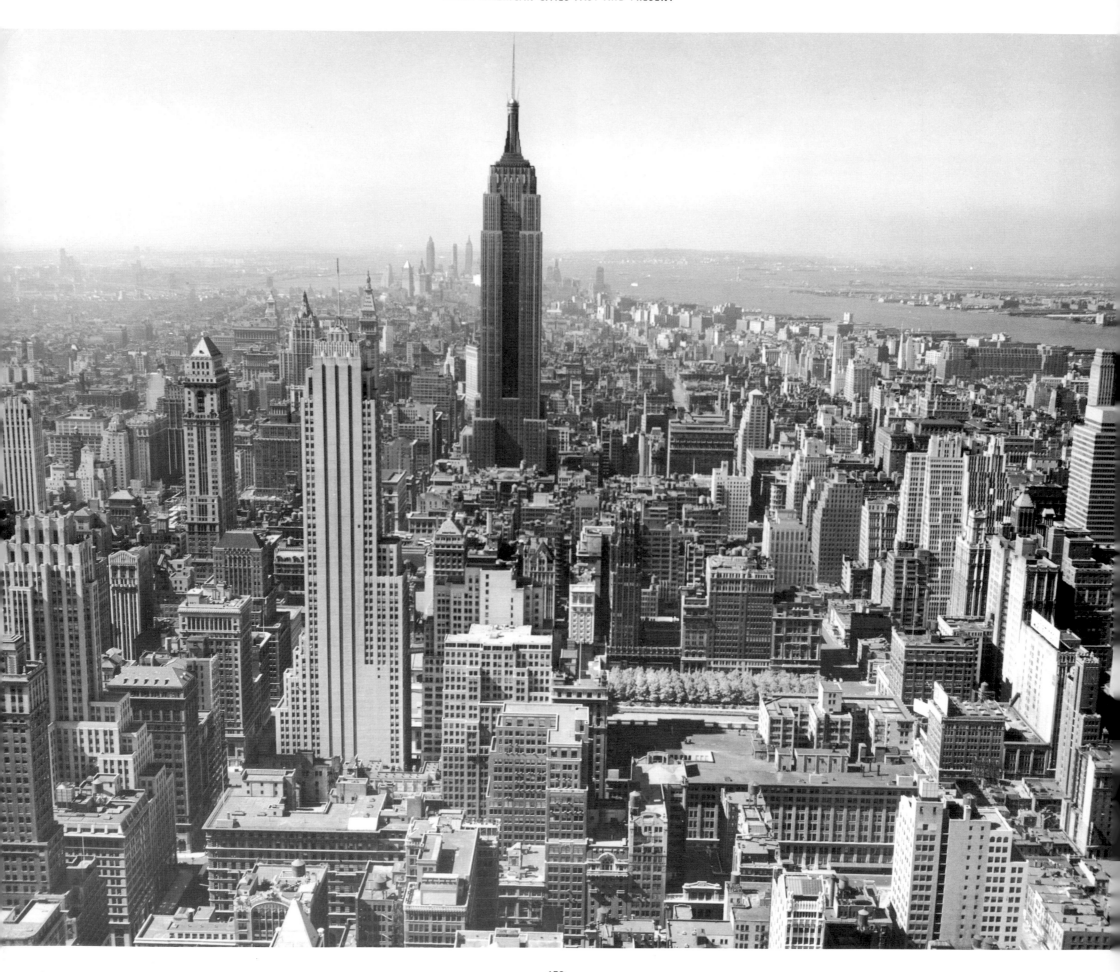

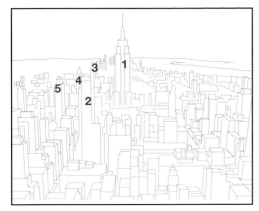

Looking south from the Rockefeller Center, 1955 (left)

1 Empire State Building
Looking south across Midtown as viewed from the RCA Building central observation deck at Rockefeller Center, the Empire State Building rises 102 stories above Fifth Avenue.

2 500 Fifth Avenue
This sixty-story office tower, completed in 1931, was designed by Shreve, Lamb & Harmon Associates who also worked on the Empire State Building.

3 Metropolitan Life Tower
The world's tallest building 1909–1913, this forty-eight-story office tower was designed by Napoleon LeBrun & Sons.

4 New York Life Building
Cass Gilbert (1859–1934), the architect of the Woolworth Building (1913), was a prolific and significant architect who designed many public buildings. This one was completed in 1928.

5 Mercantile Building
Ludlow & Peabody designed this forty-eight-floor building that was completed in 1929.

Looking south from the Rockefeller Center, 2008 (right)

6 W.R. Grace Building
This fifty-story office tower, completed in 1974 was designed by Skidmore Owings and Merrill, architects of many of the world's tallest buildings including the Sears Tower and the John Hancock Center.

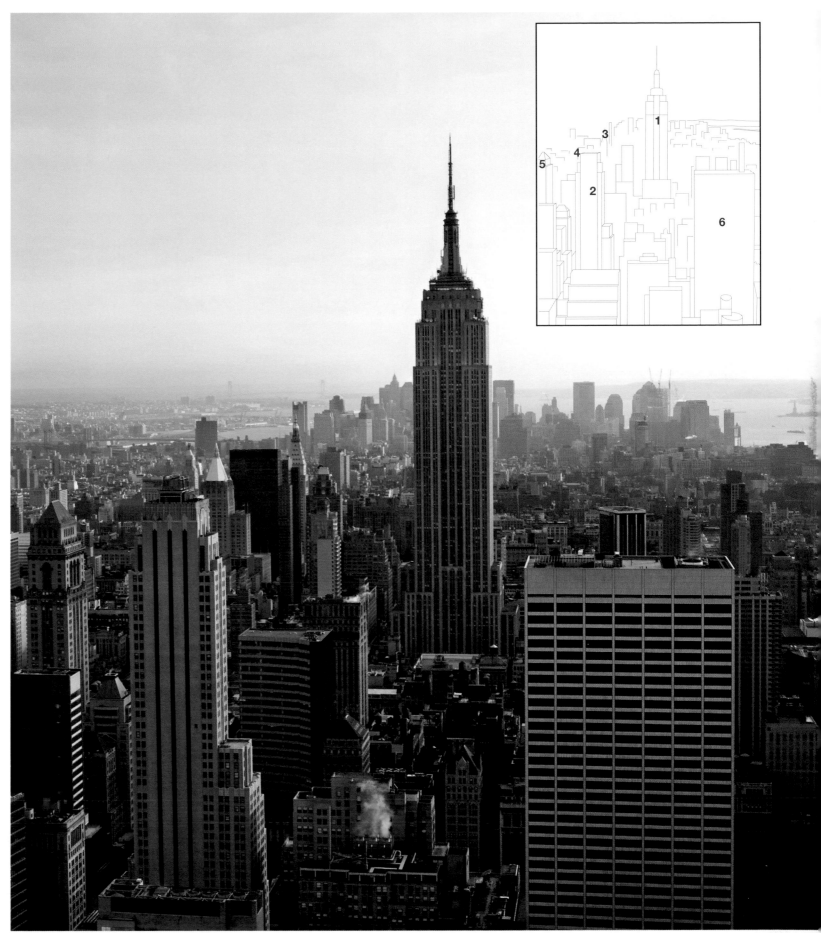

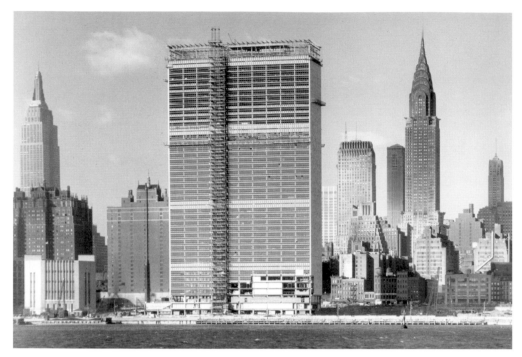

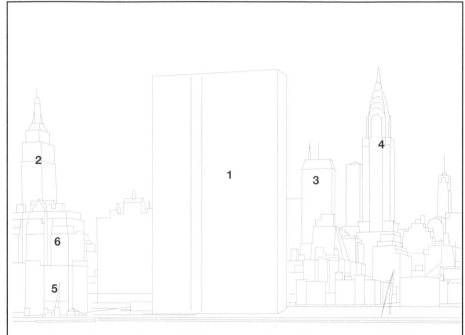

UN and Midtown, 1949 (above)

1 United Nations Secretariat Building
Seen under construction in midtown Manhattan in 1949. Completed in 1950, this was New York City's first building built in the International architectural style. Its thirty-nine floors rise nearly 505 feet above the street. Located at 42nd Street and First Avenue this serves as the primary headquarters for the United Nations, an international organization chartered in 1945 in the wake of World War II to replace the ineffectual League of Nations. Now sixty years old, the massive block-like edifice of the UN headquarters still seems relatively modern when compared with the Art Deco skyscrapers of the previous generation.

2 Empire State Building
At the time this was the tallest, and undoubtedly the most famous building, in New York City. Only four years prior to this photograph, on July 28, 1945, a B-25 bomber accidentally crashed into the building at the seventy-ninth and eightieth floors causing fourteen deaths. Although it has regained the title as New York's tallest, the Empire State is today just one of many very tall skyscrapers in midtown Manhattan.

3 Chanin Building
Located at 374–390 Lexington Avenue, this fifty-six-floor Art Deco office building was the third tallest building in the world when completed in 1929. It is named for Irwin S. Chanin, architect and real estate developer.

4 Chrysler Building
This rigid steel frame skyscraper designed in the Art Deco style rises seventy-seven stories—1,046 feet—above Lexington Avenue. Constructed between 1928 and 1930, it was intended to be the tallest structure in the world, a title it briefly held from its completion on May 28, 1930, until complete of the Empire State Building in 1931. Today it is one of most recognizable buildings in New York (although in the modern image at right only the tip of its spire is visible above the UN building).

6 Ventilation buildings for Queens Midtown Tunnel
The tunnel opened in 1940 and today carries Interstate-495 between Queens and Manhattan.

5 Tudor Tower
One of several high-rise apartment buildings designed by William I. Hohauser in the Neo-Gothic style and

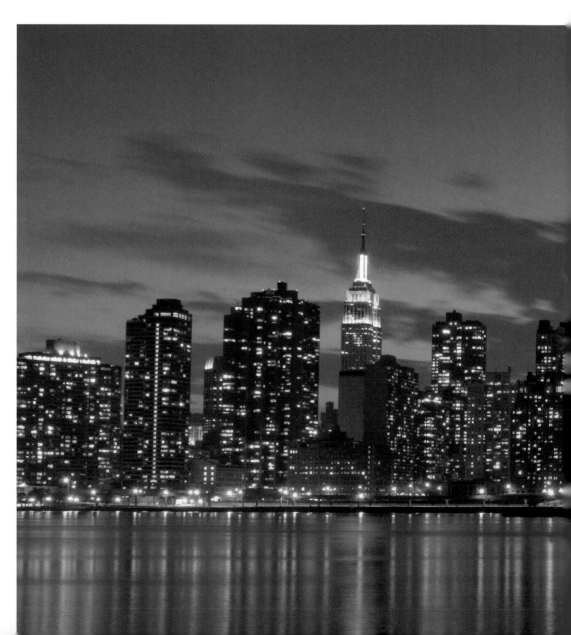

constructed in the late 1920s. This twenty-two-floor building today serves as an upscale apartment co-op.

UN and Midtown, ca. 2010 (below)

7 One Dag Hammarskjöld Plaza
This forty-nine-floor tower (628 feet) located at 47th Street and Second Avenue was completed in 1972. It was named for Swedish diplomat Dag Hammarskjöld, who served as the second Secretary-General of the UN and was killed in a suspicious plane crash in 1961 in Northern Rhodesia (modern Zambia). His work at the UN earned him the posthumous Nobel Peace Prize in 1961.

8 Trump World Tower
The twenty-two-story United Engineer-ing Center's entire existence fits to the fifty-plus year interval between this pair of photographs. Built in 1961 and demolished thirty-six years later, this site now hosts the seventy-seven-story (861 feet) tall Trump World Tower highrise apartment building visible here.Completed in 2001, this was designed by Costas Kondylis & Partners LLP.

9 100 United Nations Plaza Tower
The distinguished silhouette of this fifty-two-story residential building is achieved by the steep north–south alignment set-back of the top eight floors which cul-minate in a triangular peak. The effect is heightened by triangular balconies.

10 Franklin D.Roosevelt Drive
The six-lane parkway runs alongside the East River for 9.5 miles from the Battery to Triborough Bridge.

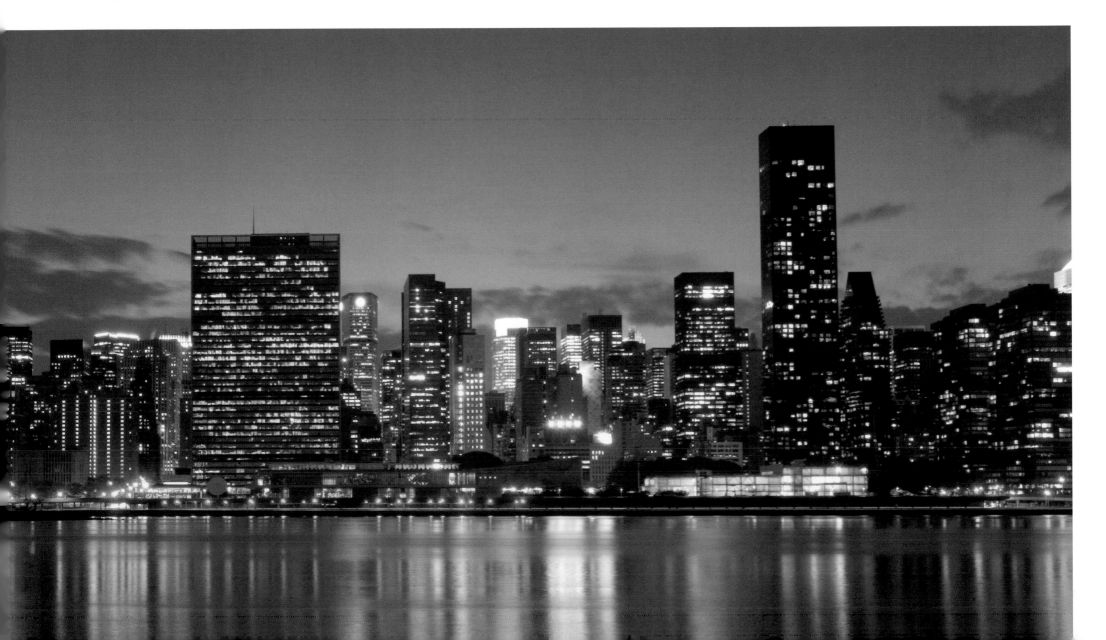

Rockefeller Center, 1933 (right) and 2004 (far right)

1 RCA Building/GE Building

Rockefeller Center is named for John D. Rockefeller, Jr. who developed this area during the height of the Great Depression. The center consists of nineteen commercial structures spread over a twenty-two-acre site between 48th and 51st streets. Since the original buildings (center right) were built between 1930 and 1939, another five skyscrapers have joined the complex— four International Style towers built along the Avenue of the Americas during the 1960s and 1970s. Considered an Art Deco-Gothic design, the RCA Building is among New York's most recognizable tall buildings. It was designed by the Associated Architects and built during 1932–1933 as the focal point for Rockefeller Center. Key to its appearance at night are floodlights which make it appear more foreboding. Until 1987 the skyscraper was known as the RCA Building; now it is popularly called 30 Rock, a contraction of its address of 30 Rockefeller Plaza. The building has been home to the HQ of NBC (since 1933) and the NBC Studios.

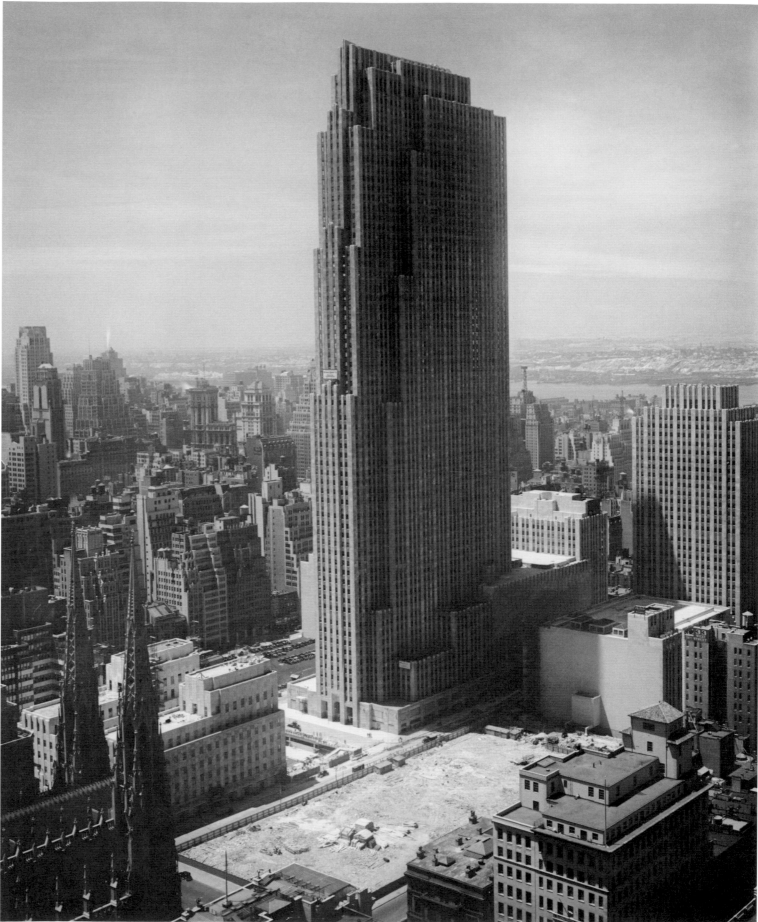

2 St. Patrick's Cathedral
Roman Catholic cathedral located on Fifth Avenue between 50th and 51st streets.

Rockefeller Center, 1939 (below)

3 International Building
4 Palace of Italy
5 British Empire Building (610 Fifth Avenue)
6 Channel Gardens
7 La Maison Française (620 Fifth Avenue)
8 Rockefeller Plaza
9 Manufacturers Hanover Building
10 1 Rockefeller Plaza (Time-Life Building)
11 10 Rockefeller Plaza (Eastern Airlines Building)
12 Simon & Schuster Building
13 The GE Building (30 Rockefeller Plaza)
14 50 Rockefeller Plaza (Associated Press Building)
15 75 Rockefeller Plaza (Time-Warner Building)
16 Radio City Music Hall
17 Rockefeller Center Hotel (not built until 2006)
18 Time-Life Building (1271 Avenue of the Americas)
19 Exxon Building (1251 Avenue of the Americas)
20 McGraw Hill Building (1221 Avenue of the Americas)
21 Celanese Building (1211 Avenue of the Americas)

Niagara Falls, NY

Niagara Falls, 1954 (below)

When 185,000 tons of rock crumbled away from Prospect Point at Niagara Falls, N.Y., in 1954, it showed better than any number of blueprints why the United States and Canada were spending $17,500,000 to give Niagara Falls a facelift. This aerial view of the Falls shows Goat Island at the left (**3**) and Horseshoe Falls on the Canadian side at the right (**4**). The straggly streams at either extremity of the Falls, known popularly as the "Bridal Veil," disappeared following the facelist. This was achieved by excavations and crest-fills at the brink and by construction of a major control dam above the Falls. The work was carried out by the U.S Army Corps of Engineers and the Ontario Hydro-Electric Power Commission.

Niagara Falls, 2007 (opposite)

This contemporary view of the famed Horseshoe Falls on the Niagara River looks southward from the Ontario side. The Niagara River connects Lakes Erie and Ontario and forms a natural border between the United States and Canada. Deemed the most powerful falls in North America, typically between four and six million cubic feet of water cascade over the falls every minute. A favorite honeymoon destination since the nineteenth century, the falls have also attracted more than a dozen suicidal adventurers who have individually attempted to navigate the falls ensconced in a barrel.

1 Prospect Point. Niagara Falls, New York
2 American Falls
3 Goat Island
4 Horseshoe Falls
5 Niagara River Parkway

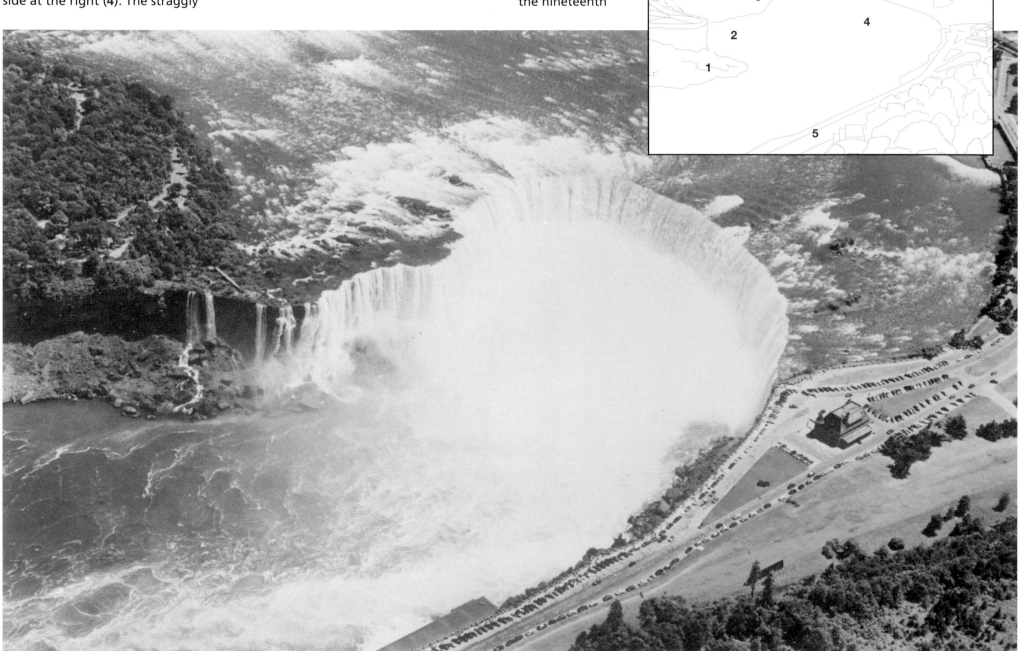

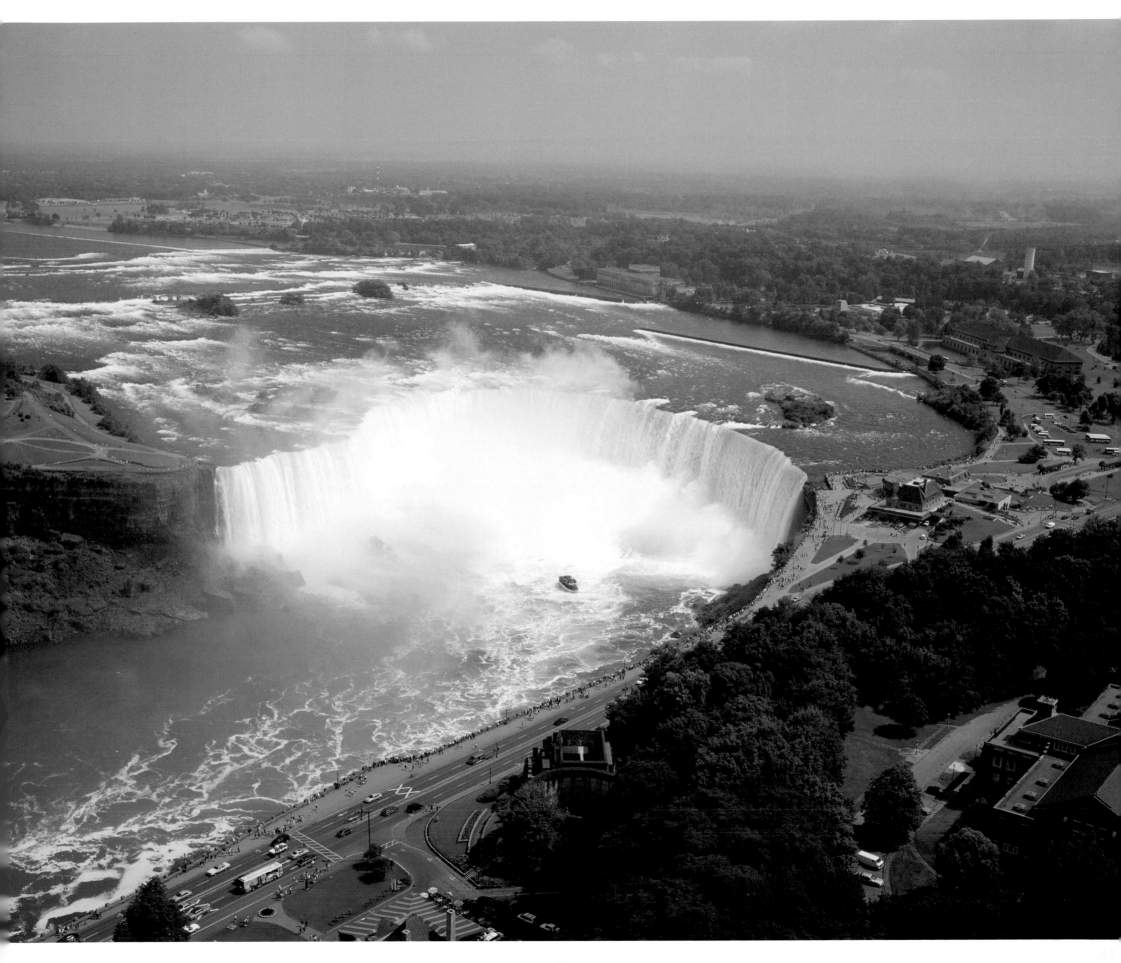

Oklahoma City, OK

Oklahoma City, 1889 (above left)

Indian Territory

This was Oklahoma City in 1889 and it was Indian Territory. The view shows U.S. Government dwellings, a water tank, railroad station, hotel, post office and general store, stage stables, tents of the U.S. Army's 13th Infantry detachment guarding lumber, and an uncompleted cemetery. In building our cities and towns, in spreading over the landscape with farms and ranches, we often forget that people lived here— wherever "here" is in America—prior to the coming of the European settlers, the Africans they enslaved and the Orientals they allowed in to work on the railroads and operate laundries.

Oklahoma City, 1950s (below left)

1 First National Center

In this mid-1950s photo, this thirty-three-story highrise finished in 1933 anchored the OKC skyline. Although it is dwarfed by several buildings today, it is still the third tallest building in the city.

2 City Place

The thirty-two floors of this skyscraper at 204 North Robinson Avenue were finished just two years prior to the opening of the neighboring First National Center. It was originally named Ramsey Tower.

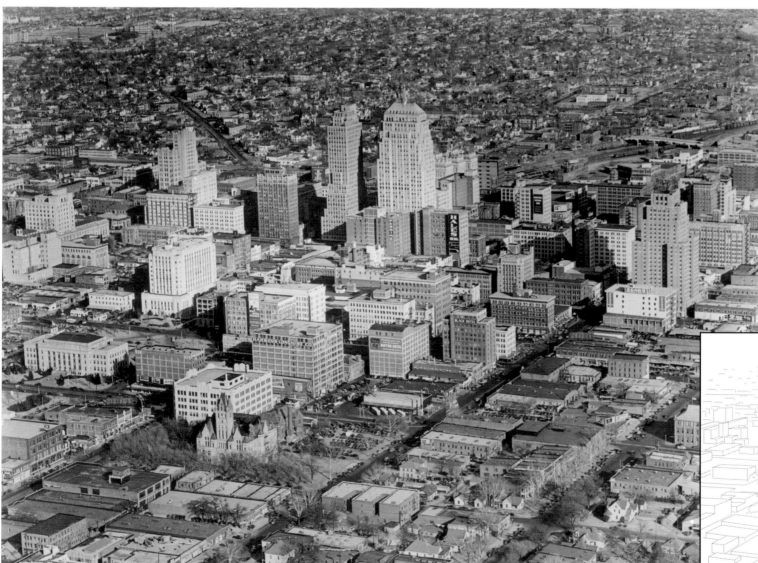

Oklahoma City, 2000

3 National Memorial
The Reflecting Pool, a thin layer of water flowing over polished black granite, is the center of the National Memorial that commemorates the 168 lives lost when a domestic terrorist bombed the Alfred P. Murrah Federal Building in April 1995.

4 A Spiritual Balance
The National Memorial with Murrah Plaza and Memorial Overlook is between St. Joseph's Old Cathedral (4a) and the First United Methodist Church (4b).

5 Federal Courthouse
For the trial of the suspects in the April 1995 bombing, the venue was changed from Oklahoma City to Denver for security purposes and to ensure that the three men would receive a fair trial. They did and Timothy McVeigh was sentenced to death.

6 Chase Tower
This thirty-six-story highrise finished in 1971 is the tallest building in the city. The anchor of the USS *Oklahoma*, salvaged after the battleship was sunk at Pearl Harbor, Hawaii, on December 7, 1941, is located on this building's plaza.

7 Kerr-McGee Center
The Center's campus includes the vintage Braniff Building, the Oklahoma Savings & Loan and the India Temple. It is located at 123 Robert S. Kerr Avenue.

8 Oklahoma Tower
The thirty-one-floor First Oklahoma Tower was completed in 1972 with 568,960 square feet of rentable space.

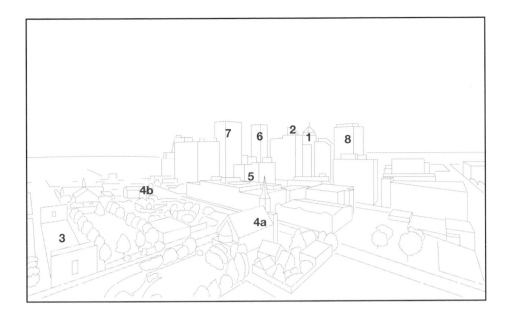

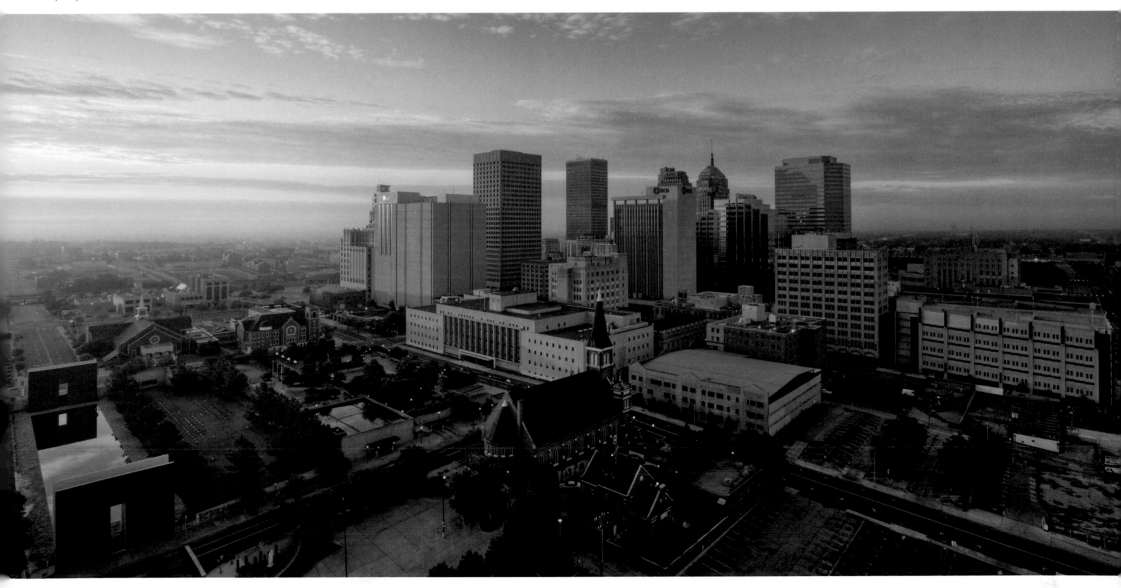

Omaha, NE

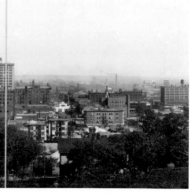

Omaha, 1914 (above)
(numbers identified on photograph)

Bill Brown's ferry across the Missouri River connected the Council Bluff and Omaha sites in 1850. Three years later, the enterprising Brown convinced area businessmen to form the Council Bluffs and Nebraska Ferry Company, to speculate in land and purchase a steamboat. When the group built the log cabin St. Nicholas Hotel in 1854, Omaha was born.

1 Omaha High School
Usually known as "Central High," this Renaissance Revival-style building was designed by architect John Latenser, Sr. Built between 1900 and 1912 the school and ten-acre campus are located in downtown Omaha on Dodge Street.

2 Hotel Fontenelle
Fontenelle is a historic name in Omaha. Built in 1814 and torn down in 1983, the hotel was named for Omaha Indian chief Logan Fontenelle, who gave away his people's land to the U.S. government. The hotel remained open until 1970, but was vacant for its final thirteen years after which it became a parking lot. The 350,000-square-foot Roman L. Hruska Federal Courthouse occupies the Fontenelle site.

3 Old Post Office
The Old Post Office was built at 16th and Dodge streets in 1898 and demolished in 1966.

4 Old City Hall
The "Red Castle" on 18th and Farnam streets was another building from the late nineteenth century (completed in 1890) that was demolished in the 1960s. As elsewhere in the United States the controversy that resulted meant that much more care was taken over landmark preservation in the city and today a number of buildings within the Omaha Rail and Commerce Historic District are listed on the National Register of Historic Places or are significant for their local history.

Omaha/Council Bluffs was the eastern terminal for the original "Pacific Railroad." The Union Pacific Railroad built west from Omaha to meet Central Pacific which built eastward from Sacramento. Omaha thrived as a result of its role as a railroad terminal and remains the operational headquarters for Union Pacific which is one of the oldest surviving railroad companies in the U.S., and one of the largest. Train operations as far away as Seattle and Los Angeles are governed remotely from Omaha.

Omaha, 1947 (below)

5 St. Mary Magdalene
A Catholic church located on the corner of 19th and Dodge streets. Omaha, ca. 2000.

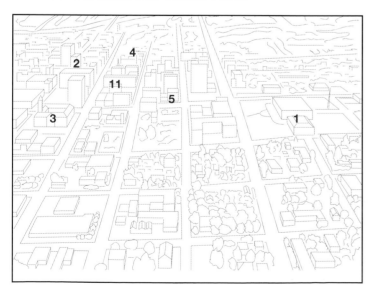

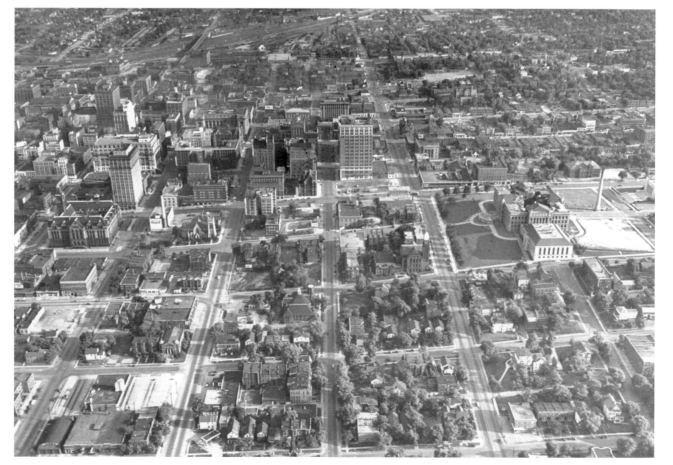

Omaha, 1947 (below)

6 One First National Center

Finished in 2002, the forty-five-story glass and granite skyscraper at 1601 Dodge Street is the tallest building between Minneapolis and Denver.

7 Woodmen Tower

At 1700 Farnam Street, the thirty-floor tower was completed in 1969. Headquarters for the Woodmen of the World Insurance Company, it is just west of the JL Brandeis & Sons Store (11)—a landmark building.

8 Central Park Plaza

Distinctively rust red, Buildings 1 and 2 on South 15th Street downtown were completed in 1982.

9 Union Pacific Center

This nineteen-floor center located at 1400 Douglas Street opened in 2004. The interior features a nineteen-floor atrium.

10 Joslyn Art Museum

The major—and only significant—museum in the state of Nebraska with a comprehensive collection opened in 1931, in memory of George A. Joslyn (1848–1916) who ran the Western Newspaper Union, the largest newspaper service organization in the world.

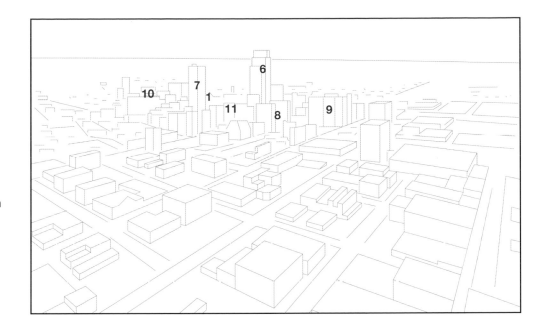

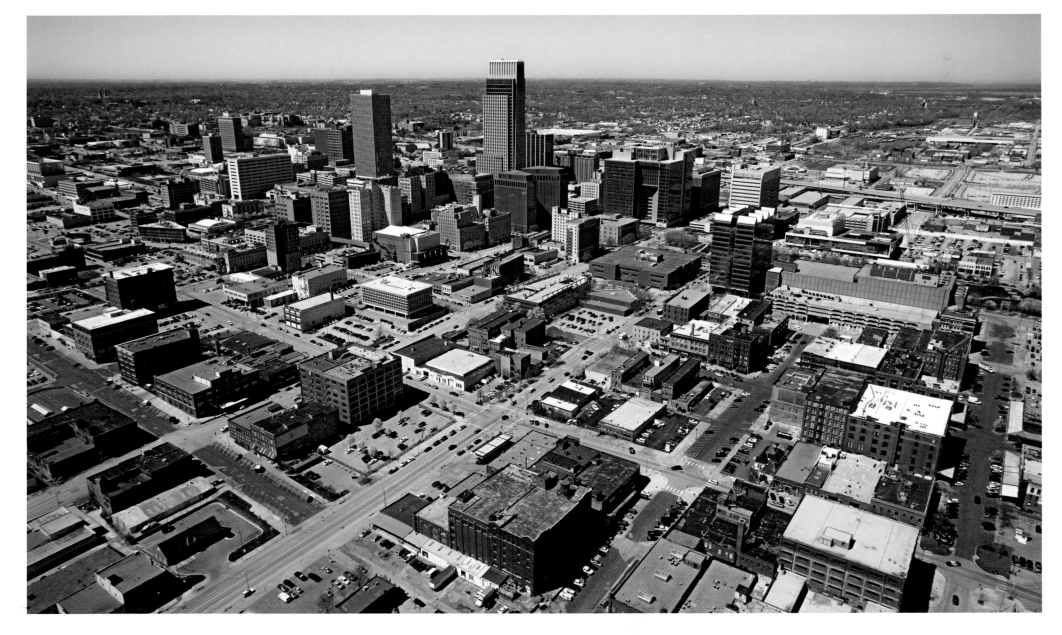

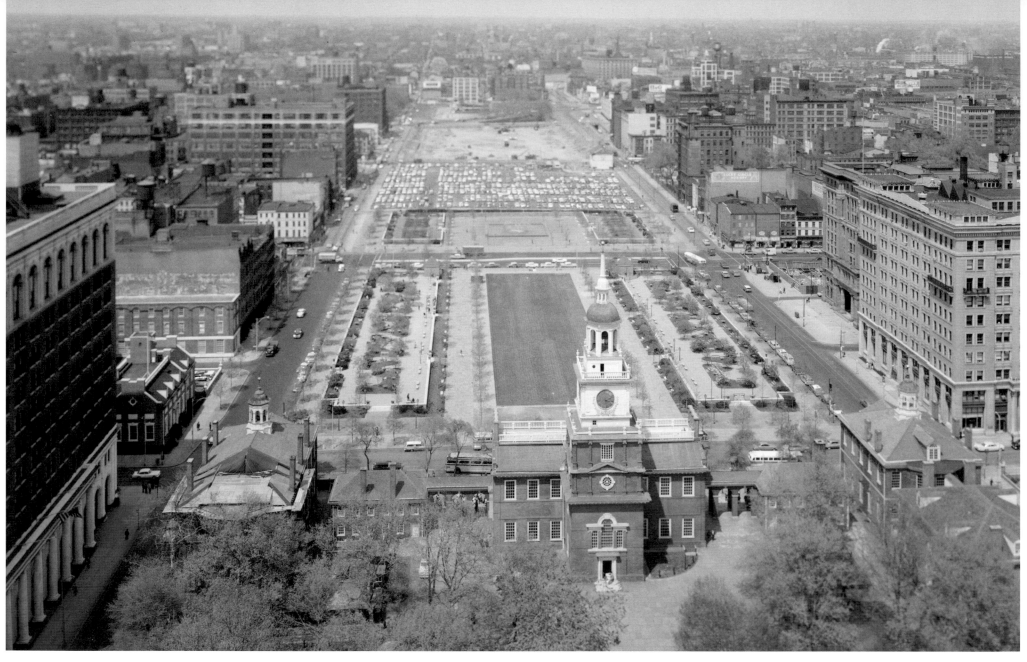

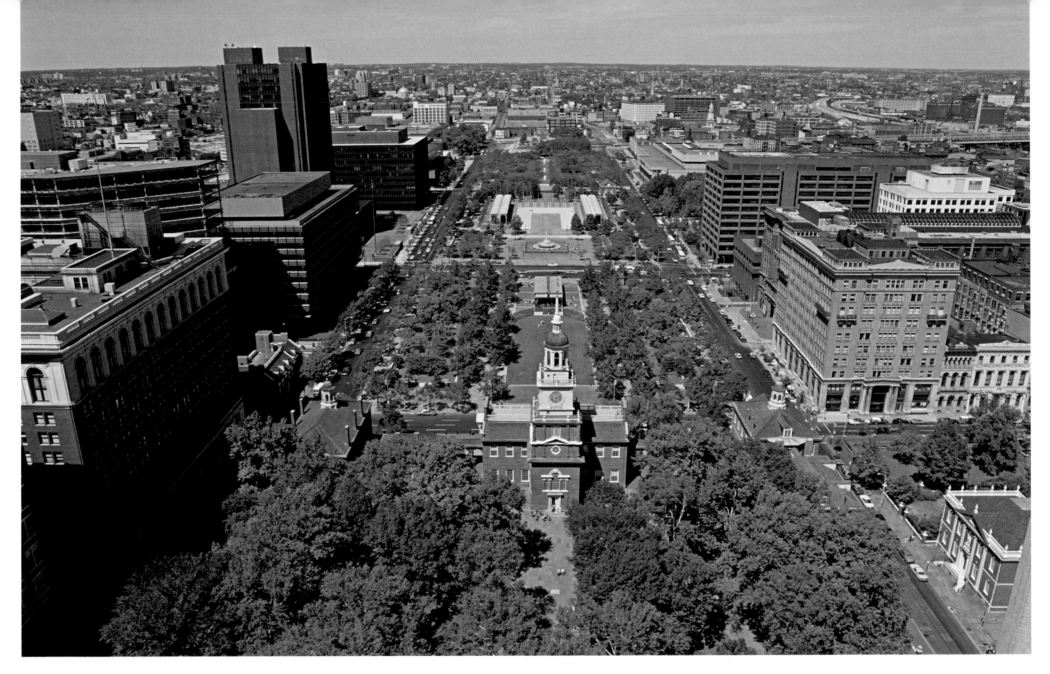

Philadelphia, PA

Independence Hall, 1915 (lower far left—numbers identified on photograph), 1964 (above left), and 1980s (above)

1 Philadelphia's Independence Hall
One of America's most significant historic buildings seen in May 1938. Constructed between 1732 and 1753, it is often cited as the "Birth-place of the United States" since the Declaration of Independence was signed here on July 4, 1776. This view looks north at the south side of the hall.

2 Sixth Street
Today numerous entertainment and musical venues are located in the vicinity of Philadelphia's Sixth Street.

3 Chestnut Street
Many buildings were demolished in the late 1950s to make way for the Independence National Historical Park.

4 Independence Mall
Known by this name since 1945, now part of Independence National Historical Park.

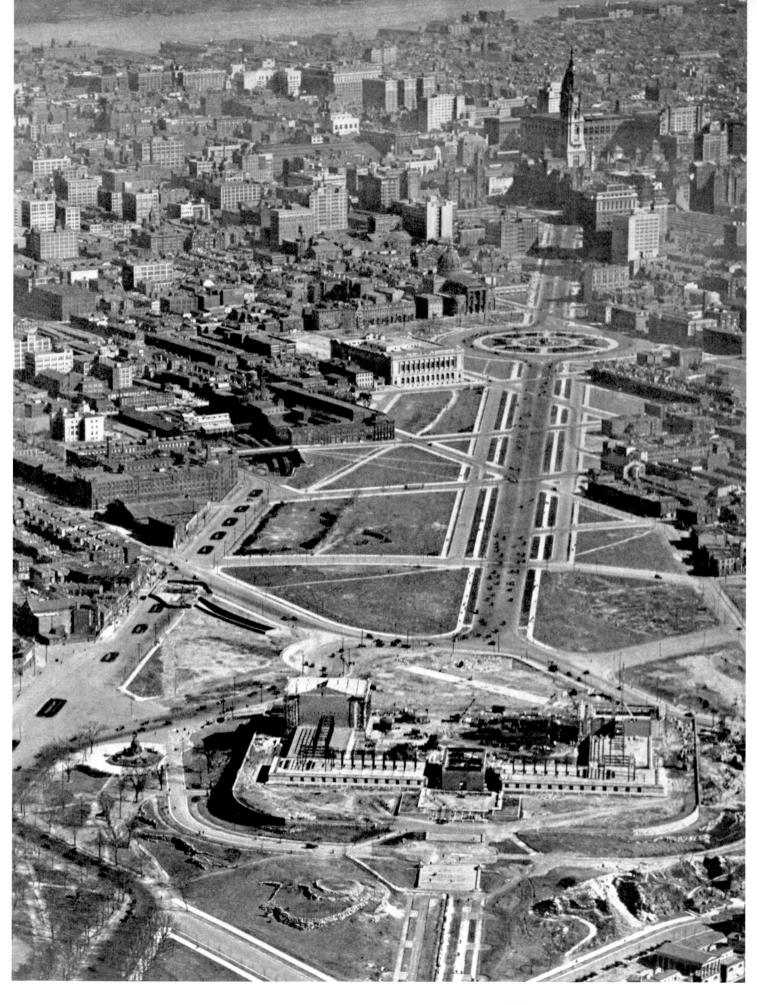

Philadelphia Museum of Art, ca. 1920 (left)

1 Philadelphia Museum of Art
Looking southeast toward "center city" (rather than "downtown") Philadelphia. Construction of the museum's building began with the laying of the corner stone by Mayor Thomas B. Smith in 1919. Prior to this "new" building the museum's collection resided at the Centennial Exposition Memorial Hall.

2 Logan Square
Since this photo was made both the Franklin Institute and Free Library of Philadelphia have been built along this broad open square.

3 Philadelphia City Hall
Centerpiece of modern Philadelphia and one of the city's icons. Designed by John McArthur, Jr., and built between 1871 and 1901; at 550 feet, it is considered the world's second tallest masonry building (the first being the Mole Antonelliana in Turin, Italy).

4 Benjamin Franklin Parkway
This broad and well-landscaped parkway runs diagonally across the established Philadelphia grid linking many of the city's best-known museums.

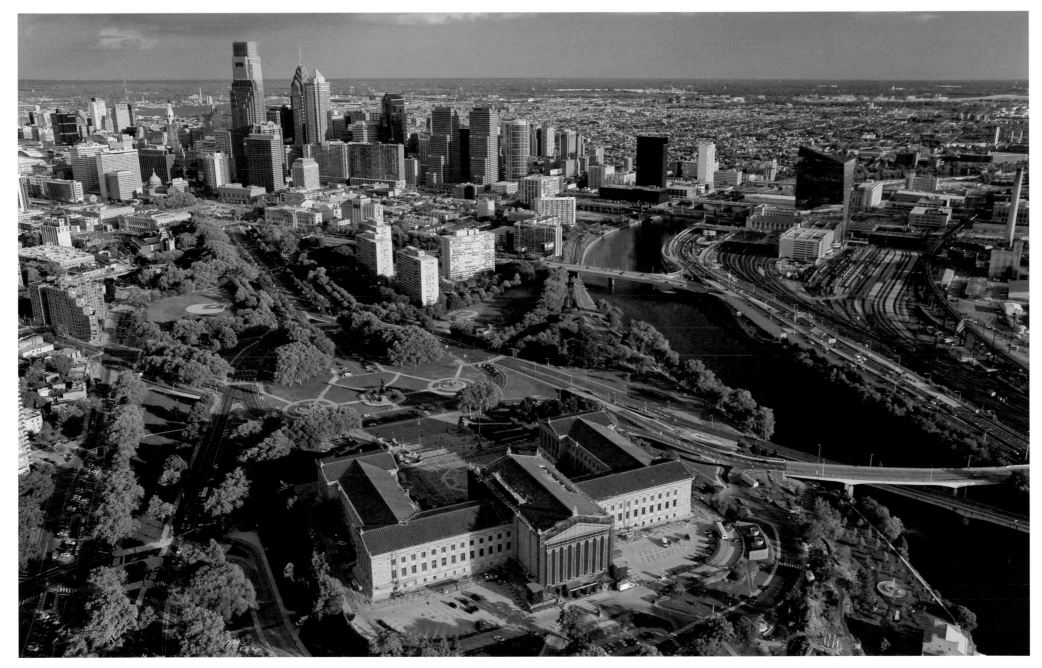

Philadelphia Museum of Art, 2008 (above)

5 Free Library of Philadelphia
The present building at Logan Square was built between 1920 and 1926 and opened in June 1927.

6 Franklin Institute
Named for inventive early American patriot and life-long Philadelphian, Benjamin Franklin (1706–1790), this is one of the oldest scientific institutions and museums in the United States. It has been at its present location since the late 1920s.

7 Schuylkill River
This river divides Philadelphia before flowing into the Delaware.

8 30th Street Station
Designed by Alfred Shaw and built by the Pennsylvania Railroad in 1933 this was one of the last classic large city railways constructed in the United States. Today it serves Amtrak and Philadelphia's SEPTA suburban services.

9 Park Towne Place Apartments
Four nineteen-story apartment blocks built in 1959.

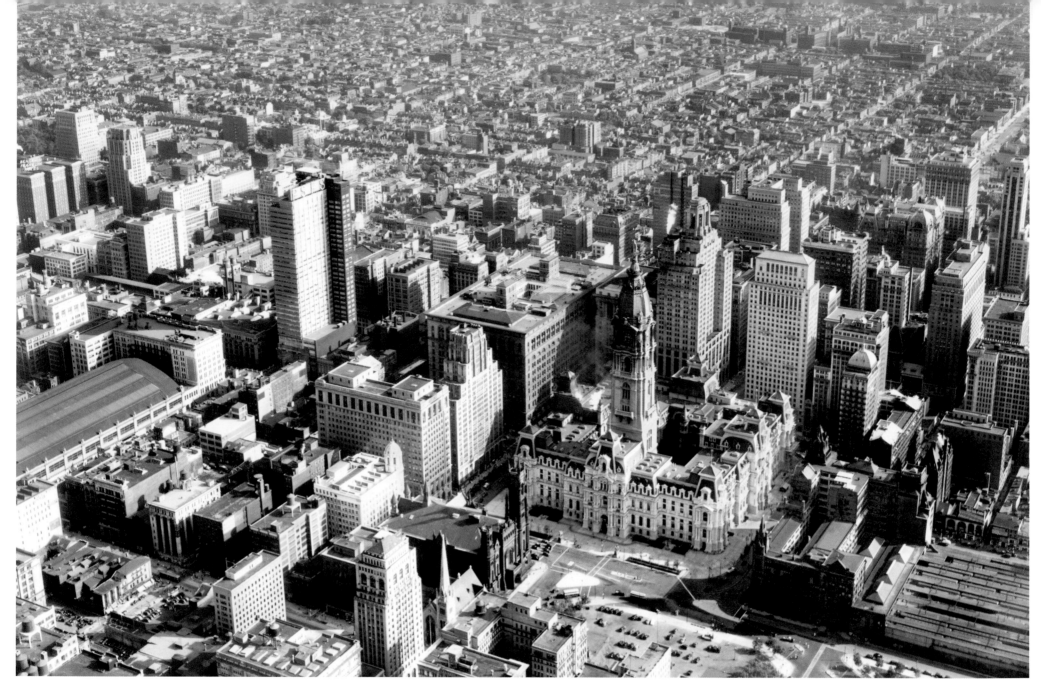

Philadelphia City Hall, ca. 1935

1 City Hall

Designed by John J. McArthur, Jr., it was under construction for nearly thirty years starting in 1871. Characterized by the super ornate "Second Empire" style, it was the tallest inhabitable building in the world when built, and consisted of an estimated eighty-eight million bricks. Unlike modern steel-framed skyscrapers it uses a traditional masonry load-bearing structure. Its tower reached 550 feet above the street. Near the top is a public observatory that offers panoramic views of the city. Atop the roof of the tower is an immense twenty-six-ton bronze of Pennsylvania founder William Penn, who helped plan Philadelphia in its formative days. City Hall remained the tallest building in the city until 1987 and today ranks the ninth tallest. Comcast Center is the tallest at 974 feet (see page 177).

2 Broad Street Station

The station's immense balloon train shed was destroyed in a spectacular fire in 1923, but Broad Street remained in service until 1952. One of the great American railroad terminals and the crown jewel of the Pennsylvania Railroad, Broad Street's demolition by the railroad that built it represented one of the great acts of corporate vandalism in midtwentieth century

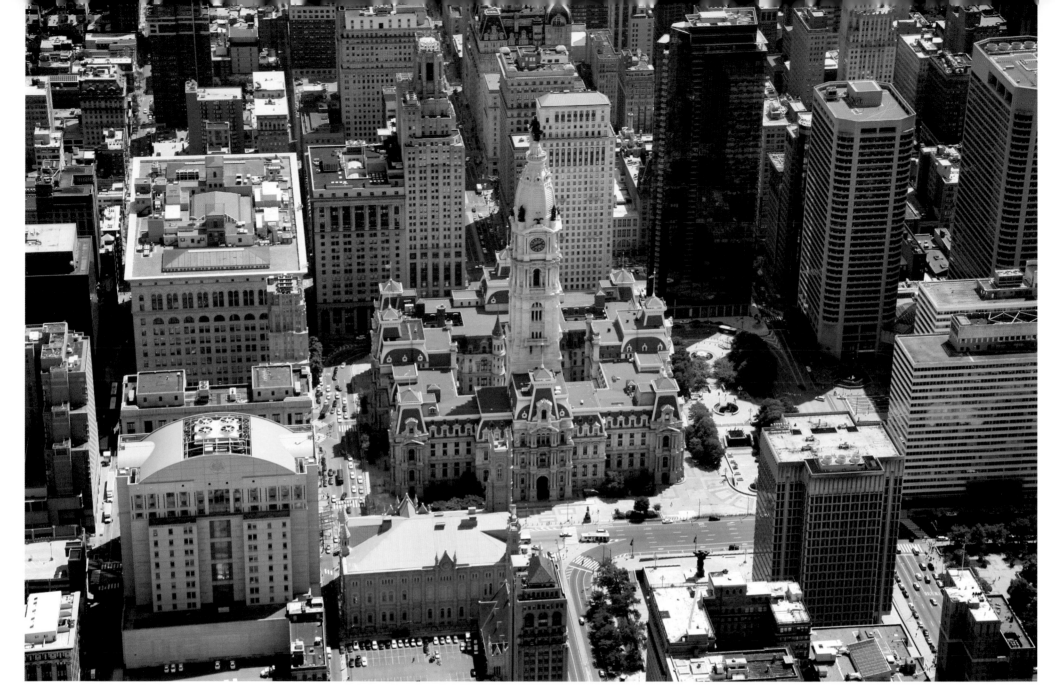

America. It was replaced by the buildings of the Penn Center (5)

3 Reading Terminal
The main passenger terminal for the Philadelphia & Reading. Last used as a railroad station in 1984, the shed survives as a convention center.

4 Masonic Temple
The Pennsylvania Grand Lodge Temple was built 1868–1873.

Philadelphia City Hall, 2009

6 Residence Inn Philadelphia Center City
This 348-foot twenty-four-floor Art Deco skyscraper was designed by

architects Ritter & Shay, also responsible for Philadelphia's U.S. Custom House. Completed in 1930 the office building was reconfigured into a hotel in 2002.

7 The Residences at The Ritz-Carlton
In 1991, less than twenty years after completion, a fire broke out on the twenty-second floor of One Meridian Plaza. So bad was the damage that the thirty-eight-floor (492 feet) building was demolished in 1998–1999, the sixth-tallest building ever to be destroyed like this. The new building was completed in 2009 and is 518 feet tall. It was designed by Handel Architects, the firm commissioned to create New York's World Trade Center Memorial.

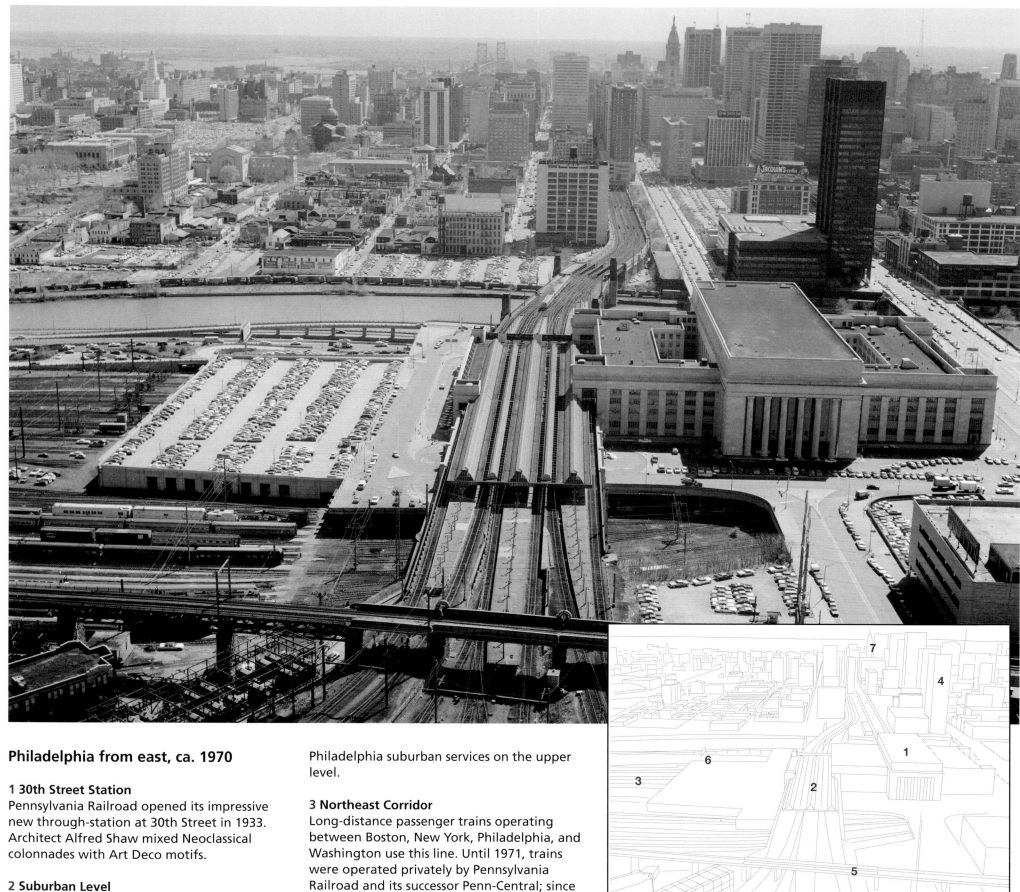

Philadelphia from east, ca. 1970

1 30th Street Station
Pennsylvania Railroad opened its impressive new through-station at 30th Street in 1933. Architect Alfred Shaw mixed Neoclassical colonnades with Art Deco motifs.

2 Suburban Level
Trains serve 30th Street on two levels, with long distance trains serving the lower level, and

Philadelphia suburban services on the upper level.

3 Northeast Corridor
Long-distance passenger trains operating between Boston, New York, Philadelphia, and Washington use this line. Until 1971, trains were operated privately by Pennsylvania Railroad and its successor Penn-Central; since that time trains have been operated by national rail service provider Amtrak.

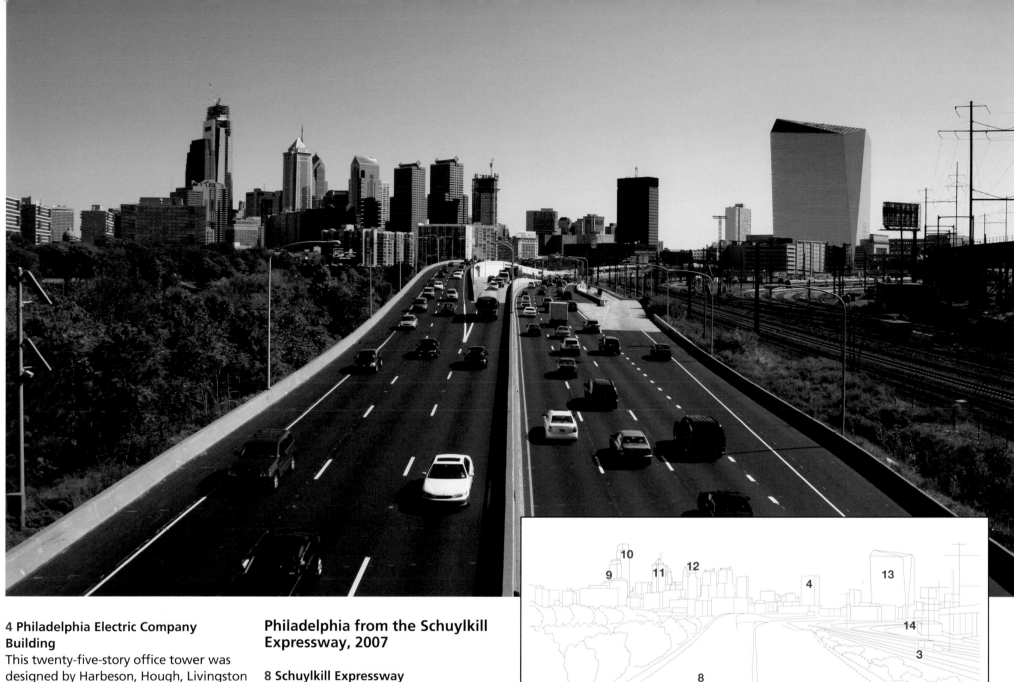

4 Philadelphia Electric Company Building
This twenty-five-story office tower was designed by Harbeson, Hough, Livingston & Larson. Also known as the PECO building, and rising 384 feet above the street, it was Philadelphia's highest when completed in 1970, but today ranks unremarkably as the city's thirty-second tallest structure.

5 High Line
This elevated railroad line is used by through freight trains to avoid 30th Street Station.

6 Schuylkill River
Named by Arendt Corssen, an explorer working for the Dutch West India Co.

7 City Hall
In 1970 City Hall was still visible from across the Schuylkill River.

Philadelphia from the Schuylkill Expressway, 2007

8 Schuylkill Expressway
Part of Interstate-76. Looking southwest toward City Center Philadelphia.

9 Bell Atlantic Tower
Philadelphia's fifth tallest building since 2008.

10 Comcast Center
Building of this controversial fifty-seven-story (975 feet) office tower took place 2005–2008—making it the tallest building in Pennsylvania and one of the most prominent structures on the Philadelphia skyline. Here, in mid-2007, construction was in progress.

11 Mellon Bank Center and Two Liberty Place
From this spot three of Philadelphia's tallest buildings meld into one. To the front is the Mellon Bank Center (792 feet), behind Two Liberty Place (848 feet), and (just visible) the spire of One Liberty Place (945 feet).

12 G. Fred DiBona, Jr., Building
Located at the corner of 19th and Market streets in Center City Philadelphia, this forty-five-floor, glass-façade skyscraper has changed hands several times since it was completed in 1990. Named for a prominent Philadelphian, president and CEO of the Independence Blue Cross insurance firm.

13 Cira Center
Completed in 2005, this Modernist tower is the tallest building outside of Center City Philadelphia. Its location on top of a parking garage at 30th Street Station gives it unusually good access to public transport.

14 High Line
Provides an easy path for long freight trains transiting Philadelphia. As one of the first cities to embrace the railroad, Philadelphia has an unusually high degree of railroad infrastructure for an American city.

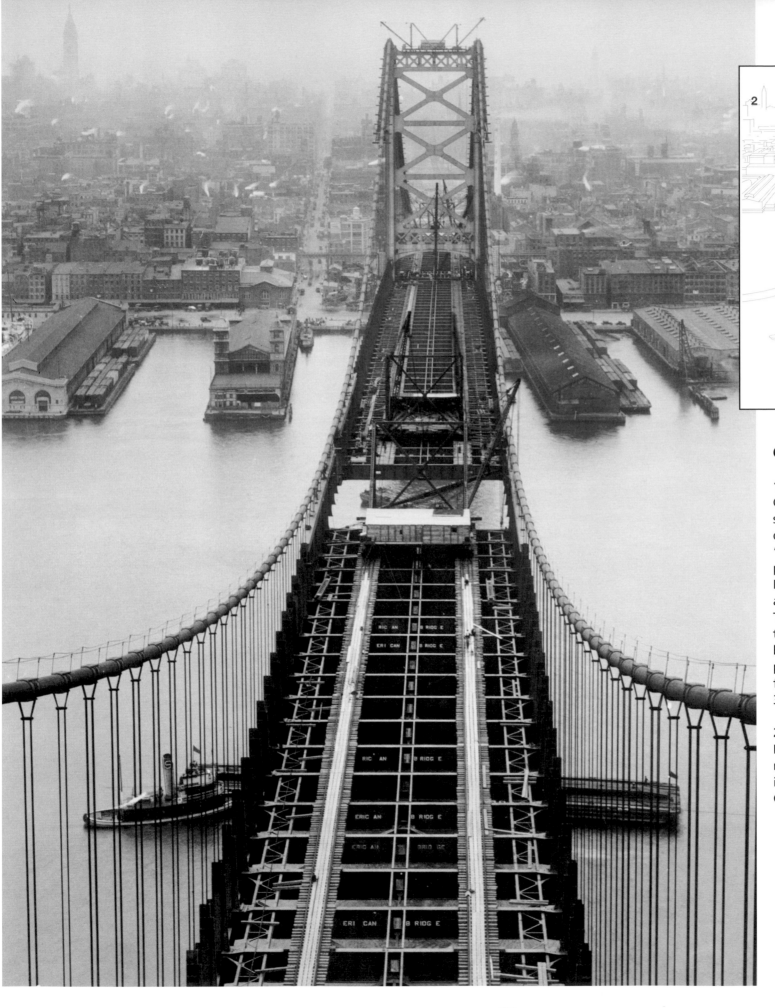

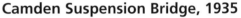

Camden Suspension Bridge, 1935

1 Camden Suspension Bridge
Completed in 1935, this period view shows the Benjamin Franklin Bridge during construction. Then known as the "New Camden Suspension Bridge," it provided a direct connection between Philadelphia and the city of Camden across the Delaware River in New Jersey. The Benjamin Franklin Bridge is among the few American long-span suspension bridges to carry rapid transit trains. The primary span over the Delaware is 1,750 feet, while the total length is just over 3,183 feet.

2 City Hall
For many years this towered over the rest of Philadelphia's buildings; today it is virtually lost in the growing tide of Center City skyscrapers.

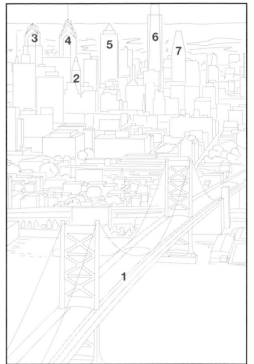

Benjamin Franklin Bridge and Downtown Philadelphia, 2008

3 One Liberty Place
Located at 17th and Market, this sixty-one-story office tower was Philadelphia's second tallest building from 2008 following construction of the Comcast Center.

4 Two Liberty Place
Completed in 1990, three years after its sister tower, One Liberty Place. Although both are forty-five-stories tall, this tower doesn't feature the prominent antenna and is approximately ninety-eight feet lower.

5 Mellon Bank Center
A thirty-two-story office tower, now Philadelphia's fourth tallest building.

6 Comcast Center
Since 2008, Philadelphia's and also Pennsylvania's tallest building. At 974 high feet it is taller than all but four of New York City's skyscrapers.

7 Bell Atlantic Tower
Now dwarfed by the Comcast Center, this is Philadelphia's fifth tallest building.

Phoenix, AZ

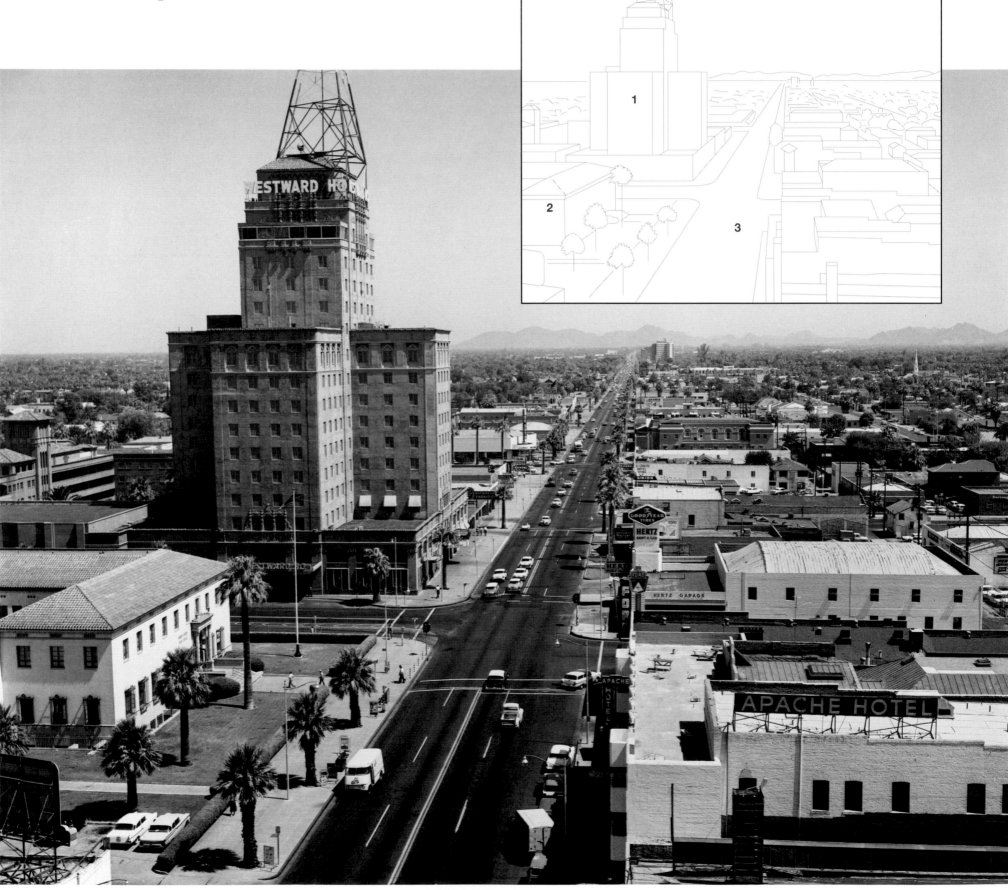

Downtown Phoenix, 1959 (left)

At the end of the 1950s, this city in the Salt River Valley of the Sonoran Desert was poised for growth. The largest city in Arizona, Phoenix has the hottest climate of any major city in the U.S. Average high temperatures regularly exceed 100 degrees for three months of the year, and occasionally top 120 degrees. This photo looks north toward Phoenix Mountain Preserve.

1 Westward Ho

The famous Westward Ho, a sixteen-story luxury hotel at 618 North Central Avenue, was completed in 1928. At 208 feet, it was the tallest building in Arizona until 1960. In 1981, it was remodeled for senior citizen housing. The distinctive, asymmetrically mounted radio tower reaches a height more than twice that of the building itself.

2 United States Post Office

Built 1932–1936 by Lescher and Mahoney the Phoenix Federal Building is today a post office building.

Downtown Phoenix, 2000 (right)

3 Central Avenue

Looking north past the Central Avenue business district skyline of Phoenix and the Westward Ho just one generation after the photograph at left. No dusty corrals in this thoroughly modern city.

4 Quest Plaza

The skyscraper at 20 East Thomas Road was completed in 1989. A twenty-five-floor glass, steel and concrete structure, it is part of the Phoenix Plaza which now includes Phoenix Plaza I (twenty stories, completed 1988) and Phoenix Plaza II (twenty stories, completed 1990).

5 Viad Corporate Center

Plans called for a second and matching tower turned ninety degrees to the twenty-four-floor Corporate Center. A national scandal in the Savings & Loan industry in the early 1990s required cancellation of the second tower.

6 Great American Complex

Constructed in 1985, this twenty-four-floor tower is rotated forty-five degrees from the Phoenix street grid system and features balconies for tenants on the top floor.

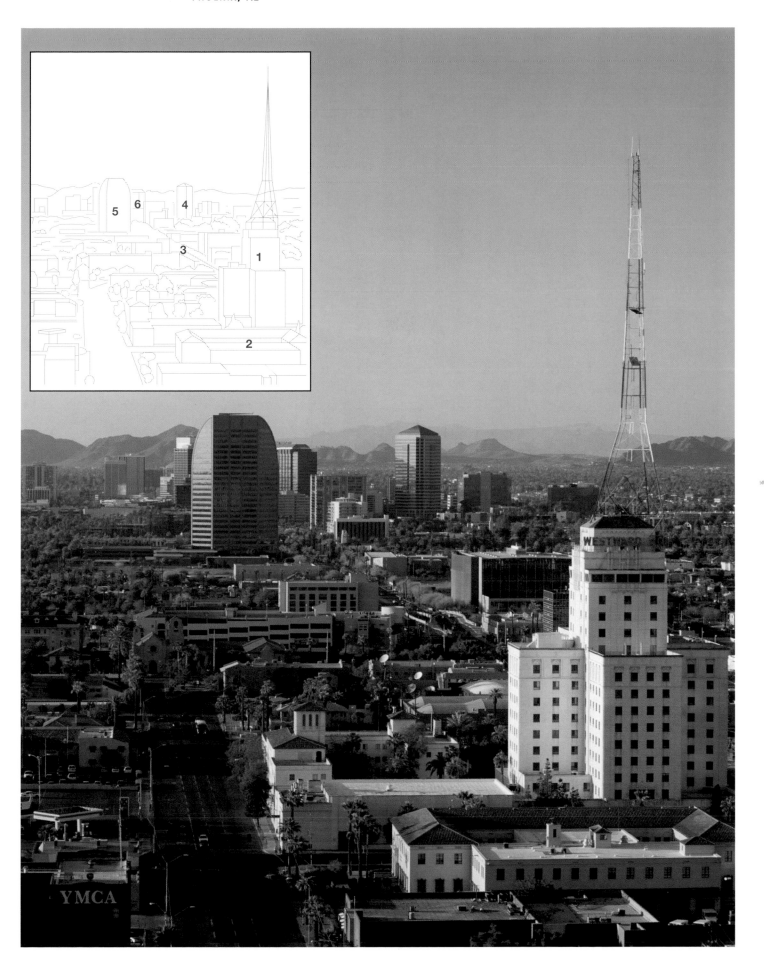

Pittsburgh, PA

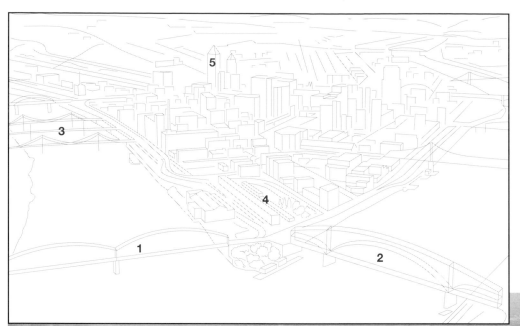

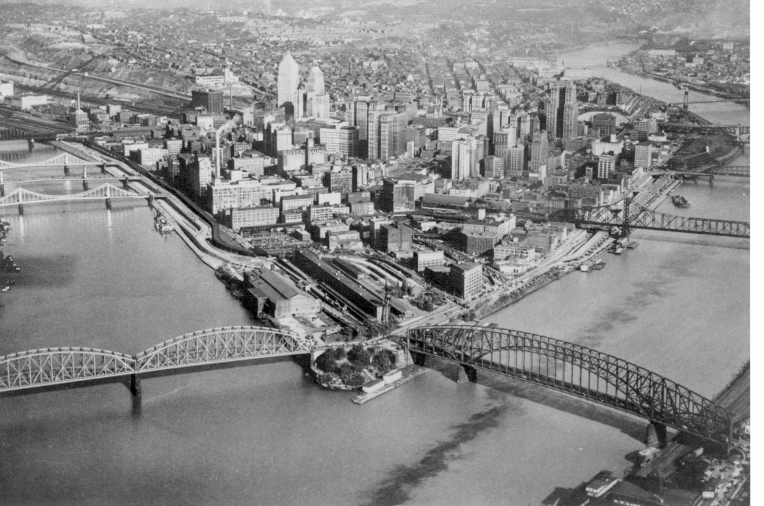

Pittsburgh, ca. 1930 (below)

1 Manchester Bridge
Historically Pittsburgh was among America's great industrial centers famous for coal, steel, and glass industries. Its Golden Triangle business district is located on a peninsula bordered on the north by the Allegheny River and on the south by the Monongahela, each of which is spanned many times in a relatively small area, making Pittsburgh known as "A City of Bridges." Opened on August 9, 1915, Manchester Bridge twin-span Baltimore-style truss over the Allegheny River provided seventy feet of clearance to navigation. Each of the trusses measured 531 feet. The bridge was demolished in 1970s after completion of the nearby Fort Duquesne Bridge.

2 Point Bridge
The original Point Bridge over the Monongahela dated to 1875 and was closed and replaced by the bridge pictured here in the mid-1920s. The second Point Bridge used a distinctive cantilever truss arch with a suspended central span and opened in 1927. Its impressive appearance did not meet traffic requirements and by the 1950s it was outmoded. It was closed to traffic in 1959 when the new Fort Pitt Bridge opened.

3 The Three Sisters
These three virtually identical eye bar suspension bridges span the Allegheny at Sixth, Seventh, and Ninth streets in downtown Pittsburgh.

4 Pennsylvania RR's Freight House and Duquesne Yards
Ideally situated during Pittsburgh's industrial heyday, these yards were vacated in the later twentieth century, although elsewhere railroading remains vital to Pittsburgh's industry.

5 Gulf Building
This forty-four-floor Art Deco-style tower was built on the site of America's first oil refinery. Pennsylvania's nineteenth century oil boom preceded the larger strikes in California and Texas that spurred development of America's petroleum-based transport economy in the early years of the twentieth century. The Gulf Building, designed by Trobridge & Livingston, was completed in 1932, and stood for many years as Pittsburgh's tallest.

Pittsburgh, 2009 (right)

6 Point State Park
Located at the tip of the Golden Triangle where the confluence of the Allegheny and the Monongahela join to form the Ohio, this thirty-six-acre park is on manicured land near areas associated with Pittsburgh's early history, some of which were used by railroad yards and industry into the midtwentieth century. The stone fortifications at the park's top right is an interpretive recreation of historic Fort Pitt.

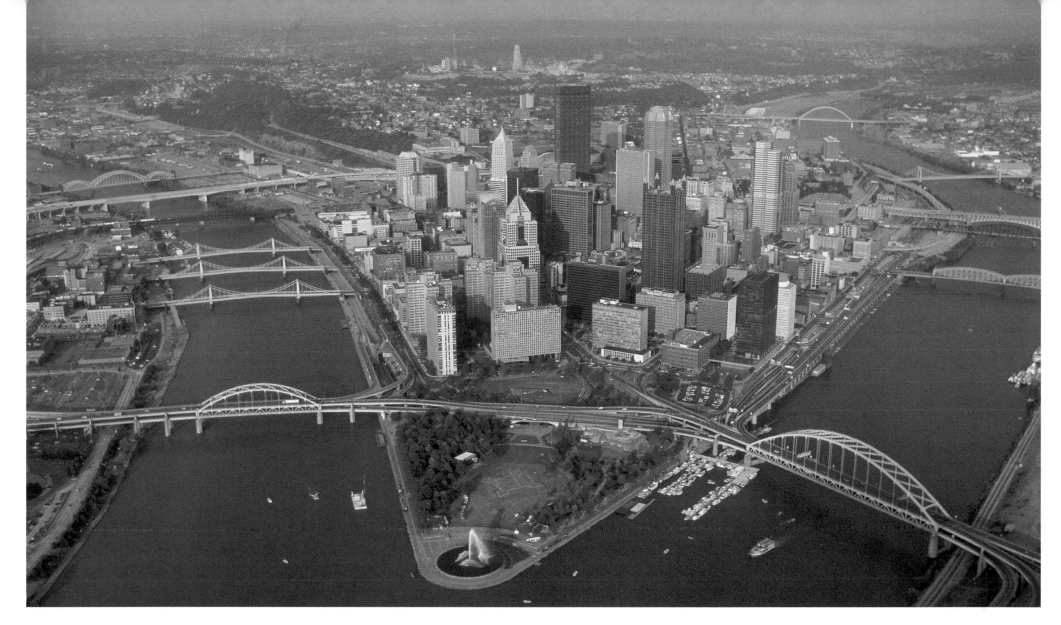

7 Fort Duquesne Bridge
This steel tied-arch bridge was built across the Allegheny River as a replacement for Pittsburgh's Manchester Bridge. Constructed between 1958 and 1963, for six years the bridge lacked connections and it wasn't opened until 1969.

8 Fort Pitt Bridge
A twin-deck steel bowstring arch bridge over the Monongahela River is 1,207 feet long, including the 750-foot arch span. It was built to the east of the old Point Bridge that it replaced in 1959.

9 One PPG Place
A visually striking building complex was designed by John Burgee Architects and Phillip Johnson blending neogothic forms in a distinctive postmodern building complex completed in April 1984. Tallest of the six structures is the prominent forty-floor tower. It was intended as a showcase for glass manufacturer PPG, and features 19,750 sheets of energy-saving Solarban 500 glass.

10 U.S. Steel Tower
Pittsburgh's tallest building, and until 1987 the tallest in the Commonwealth of Pennsylvania, sixty-four floors, it rises 841 feet above the street. Completed in 1970, its façade, made from Cor-Ten steel, demonstrated one of U.S. Steel's products.

11 One Mellon Center
With fifty-four floors, at a height of 725 feet, this is Pittsburgh's second tallest building and built on the site of the old Carlton House—demolished in the early 1980s to make way for the modernist-style skyscraper.

Portland, OR

Portland, 1900 (below)

Set on Oregon's Willamette River, Portland has grown up along both banks to become the state's largest city. This view dates from before the urban expansion of the mid-twentieth century.

Downtown Portland, 1990s (right)

1 Morrison Bridge
A bridge has spanned the Willamette River at this location since 1887. The present structure, built in the mid-1950s, was opened in 1958 and represents the third Morrison Bridge. This bascule lift bridge has been considered the largest piece of mechanical equipment in Oregon.

2 Burnside Bridge
Portland's "B" Street was renamed Burnside Street in the mid-nineteenth century to commemorate Daniel Burnside, a prominent Portlander. The present bascule bridge opened in 1926, and was designed by Joseph Strauss, Hedrick & Kremers, and Gustav Lindenthal—known for his work on Pittsburgh bridges and New York City's famous Hell Gate Bridge.

3 North Steel Bridge
Among Portland's best known icons, the present Steel Bridge dates from 1912 when it replaced the 1888 span over the Willamette. It is a rare example of a dual-lift truss bridge. The top deck carries highway traffic, the bottom deck railway tracks.

4 Governor Tom McCall Waterfront Park
This riverfront park along the west bank of the Willamette was built in the 1970s, and renamed for former Oregon Governor Tom McCall in 1984.

5 United States Interstate 5
Also known as the Pacific Highway, I-5 runs north-south from the Canadian border to the Mexican border near San Diego.

6 U.S. Bancorp Tower
Commonly known as "The Big Pink," this 1973-built forty-two-floor tower is the tallest of Portland's skyscrapers. Unlike most buildings, when viewed from above its profile doesn't use right angles and instead has the shape of a parallelogram.

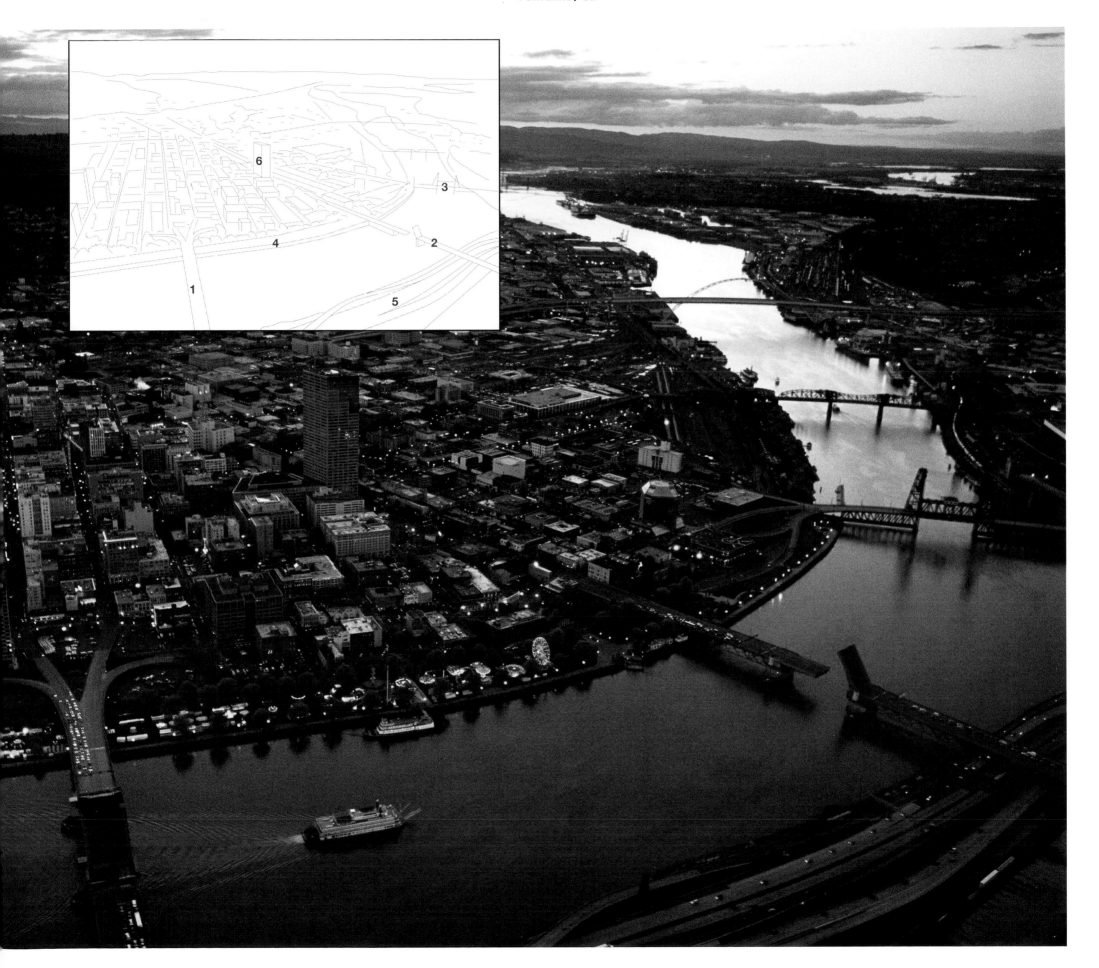

Portland, 1935 (below)

1 Mt. Hood
Part of the Cascade Range, looming over 11,239 feet tall, Mt. Hood can been seen from Portland on clear days.

2 Public Service Building
Designed by A.E. Doyle—who died only weeks after the building opened in 1928. Although only sixteen stories tall, it remained Portland's tallest building for more than three decades.

3 Wilcox Building
A twelve-story tower built in 1911, featuring a terra-cotta and brick façade.

Portland, 2003 (right)

4 Pacwest Center
Known locally as the "Icecube building." Previously a Keybank center, this thirty-story office was built on the site of an old parking lot.

5 Standard Insurance Center
Completed in 1970, and originally known as the Georgia Pacific Building, this twenty-seven-story modern office block was designed by Skidmore Owings and Merrill. It is among Portland's many offices towers famous for not having a thirteenth floor.

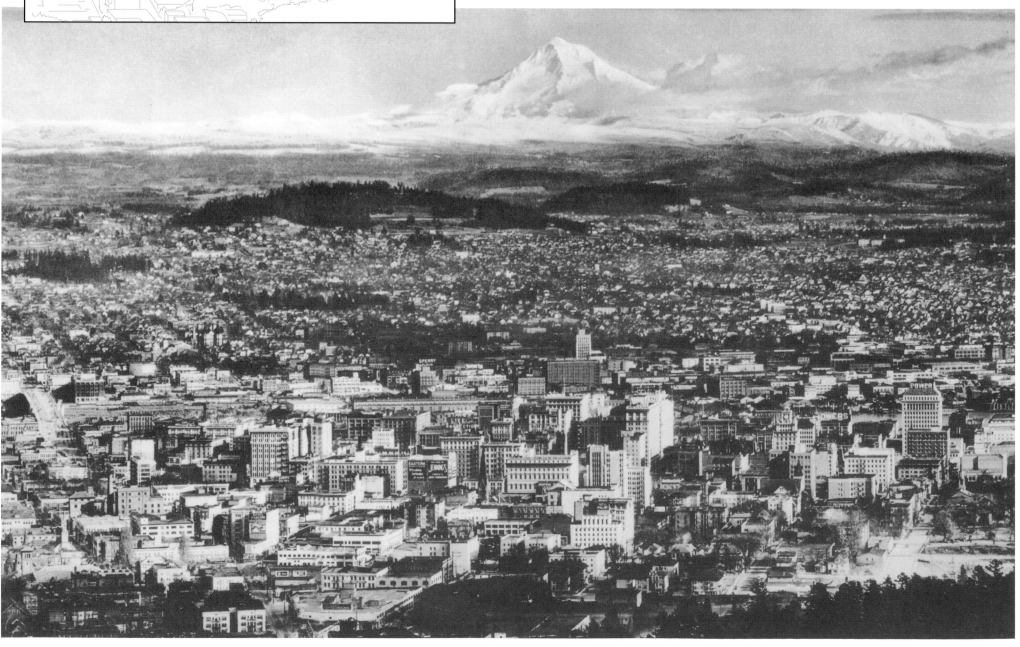

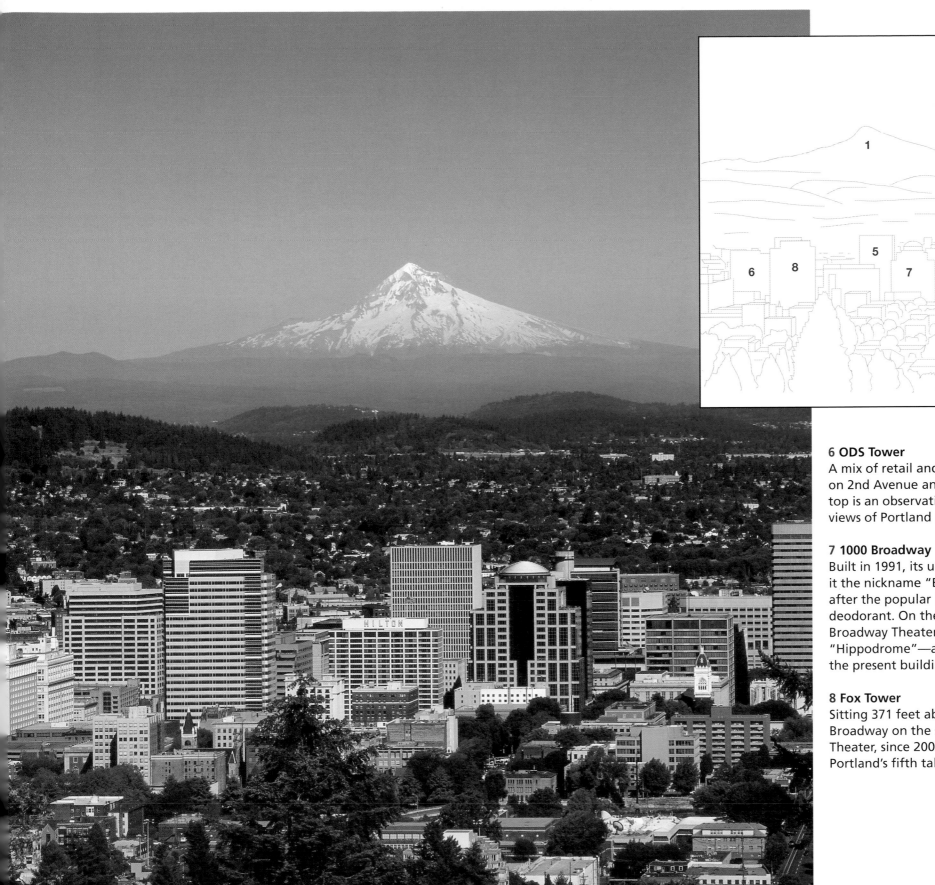

6 ODS Tower
A mix of retail and office space located on 2nd Avenue and Alder Street. At the top is an observation deck offering views of Portland and Mt. Hood.

7 1000 Broadway
Built in 1991, its unusual shape has lent it the nickname "Ban Roll-on Building" after the popular brand underarm deodorant. On the site of Portland's old Broadway Theater—once known as the "Hippodrome"—among the tenants of the present building is a cinema.

8 Fox Tower
Sitting 371 feet above South West Broadway on the site of the old Fox Theater, since 2000 this has been Portland's fifth tallest skyscraper.

Providence, RI

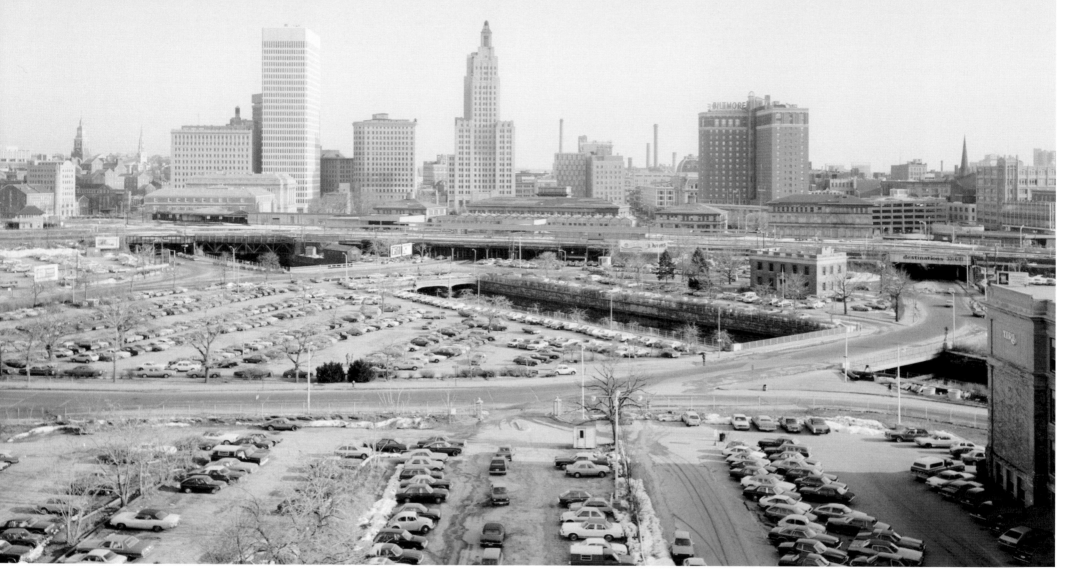

Providence, ca. 1975 (above)

1 Industrial National Band Building
Designed in the Art Deco style by Walker & Gillette and George Frederick Hall to emulate contemporary New York City skyscrapers. Built in 1927, it remains the tallest building in Providence and the entire state of Rhode Island although now called the Bank of America Building.

2 Providence Union Station
Built by the New Haven Railroad in 1898, this station served downtown Providence until 1986 when it was replaced by the new station (7), located on a revised track alignment closer to

the Capitol Building. Since 1975, Amtrak's railway line has been relocated to the north and the station building has been adapted as a popular brewery/brew pub restaurant.

3 Hospital Trust Building
This twenty-seven-floor modern office tower appeared on the Providence skyline in 1973, and ever since has been the city's second tallest building. Today it is called One Financial Plaza.

4 Omni Biltmore Hotel
This eighteen-story downtown hotel was designed in the Beaux-Arts style by Warren & Wetmore—architects that participated in design of New York's

Grand Central Terminal—and completed in 1922. Since 1977 it has been on the National Register of Historic places.

5 Union Station Viaduct
Spanning Gaspee, Francis, Promenade & Canal streets the viaduct was demolished in 1982 as part of the Northeast Corridor Improvement Project.

6 First Baptist Church in America
Providence's Baptist church organization dates to 1638. This church meeting house blends traditional Georgian style with the New England Meetinghouse style and was built in 1774–1775. The steeple went up

last, erected by out-of-work shipbuilders from Boston following the Tea Party.

Providence, 2005 (below)

7 Providence Amtrak Station
Designed by Marilyn Taylor of Skidmore, Owings and Merrill, the new station opened in 1986. It has four tracks for passenger service, with a fifth track for the Providence & Worcester Railroad freight trains.

8 Center Place
Designed by architects Bargmann Hendrie + Archetype, Inc., this Postmodern building is a block of rental apartments.

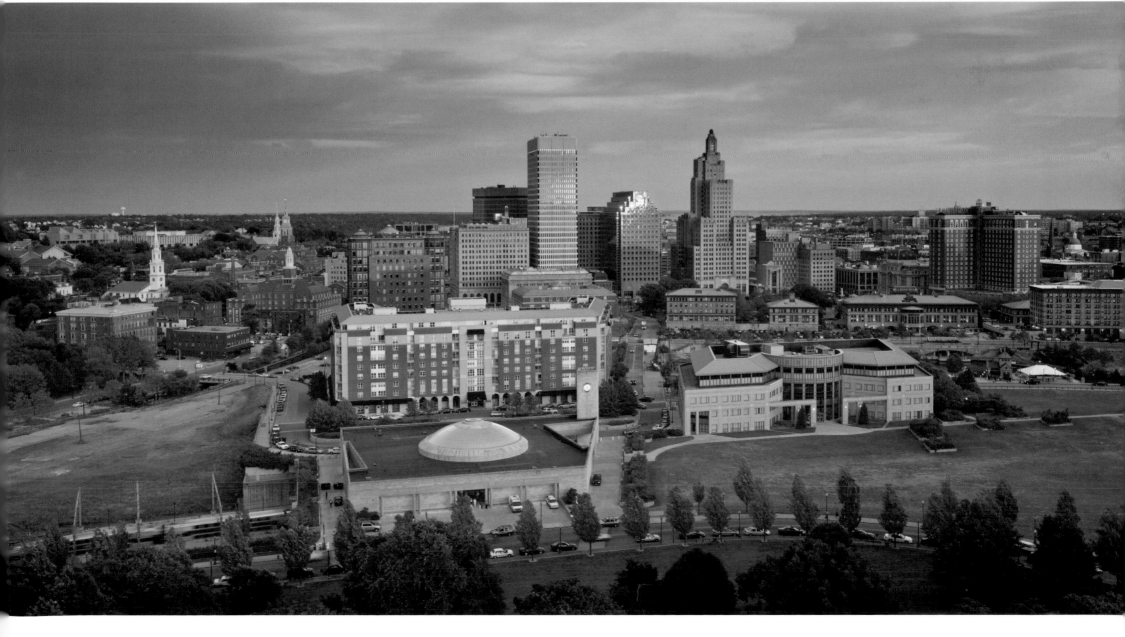

Richmond, Va

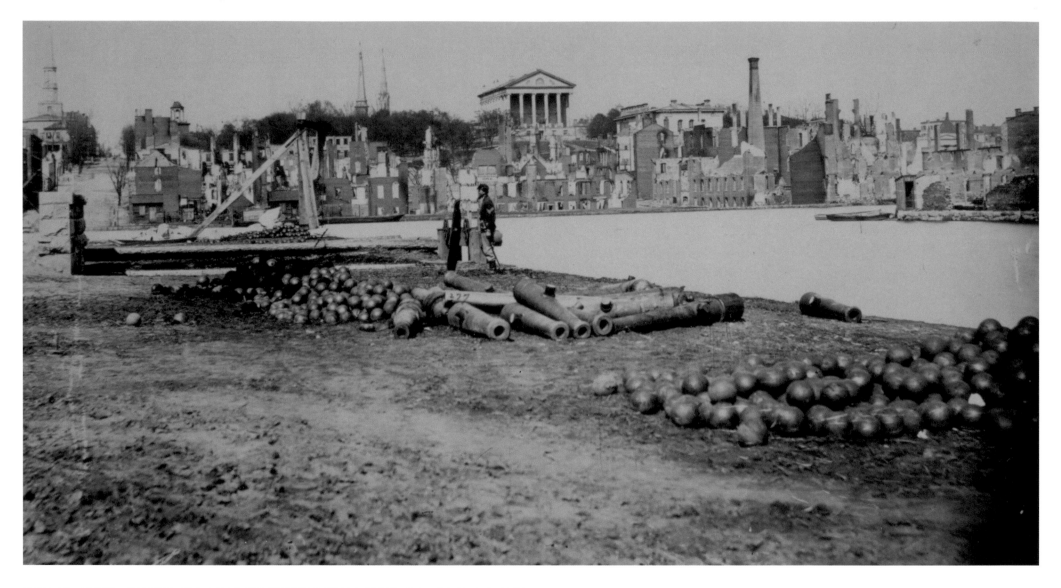

Richmond, 1865 (above)

1 Virginia State House
Among Virginia's most iconic structures, it was designed by none other than Thomas Jefferson in collaboration with Frenchman Charles-Louis Clérisseau and patterned in the Corinthian style after the famed Roman-era Maison Carrée at Nîmes in France. Construction commenced with the placing of the cornerstone in 1785; the main building was completed in 1792. After the Civil War, it underwent a number of modifications—including the addition of wings. In 1870 an internal balcony collapsed in the second floor court that then itself collapsed, killing sixty-two. In 2004–2007 a major renovation took place in time for the visit by Queen Elizabeth II.

2 Custom House
A historic building often featured in Civil War-era images of Richmond.

3 Bridge
This point would be bridged by the Ninth Street ("Singing") Bridge.

Richmond, 1993 (right)

4 Federal Reserve Bank Building
Richmond's third tallest building, this twenty-six-floor International-Style office tower was designed by Minoru

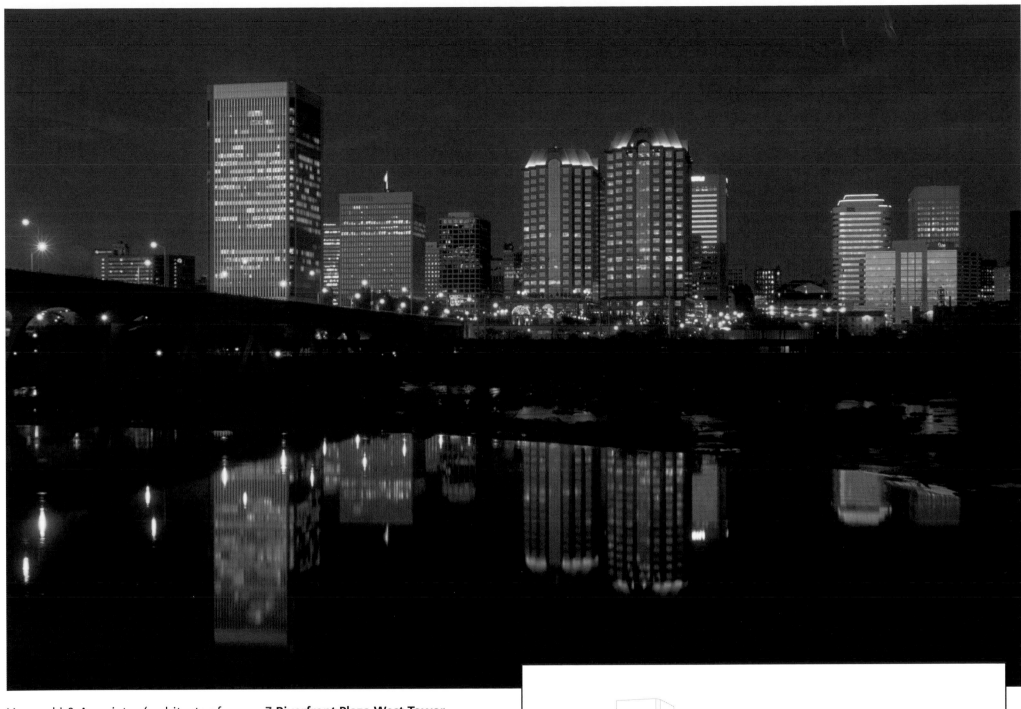

Yamasaki & Associates (architects of New York's World Trade Center towers) and completed in 1978. It has considerable underground storage facilities.

5 Manchester Bridge
Built in 1970, this carries Ninth Street and U.S. Route 60 across Brown Island and the James River.

6 One James River Plaza
A downtown-Richmond office block twenty-two-floors high.

7 Riverfront Plaza West Tower
This twenty-story (312 feet tall) commercial office block was built in 1990.

8 Riverfront Plaza East Tower
A twin to Riverfront Plaza West Tower.

9 Two James Center
Also known as the Central Fidelity Bank Building. This twenty-one-story office building on East Cary Street is part of the greater James Center, completed in 1987.

Sacramento, CA

State Capitol, 1922 (below)

1 California State Capitol

Sacramento's city charter was recognized by the state in 1850; it is the oldest incorporated city in California. State government moved permanently to Sacramento four years later. The city was the western terminus of the short-lived Pony Express and, later, of the first transcontinental railroad. The massive railyard can be seen here (4). Construction of the capitol began in 1860 and it was not completed for fourteen years. Architects squabbled but finally decided that it should mimic the classic revival style of the U.S. Capitol in Washington, DC.

2 I Street Bridge

An old metal truss swing bridge still in place.

3 California Fruit Building

This ten-story building was completed in 1914 and renovated in 1975—the first concrete skyscraper west of the Mississippi.

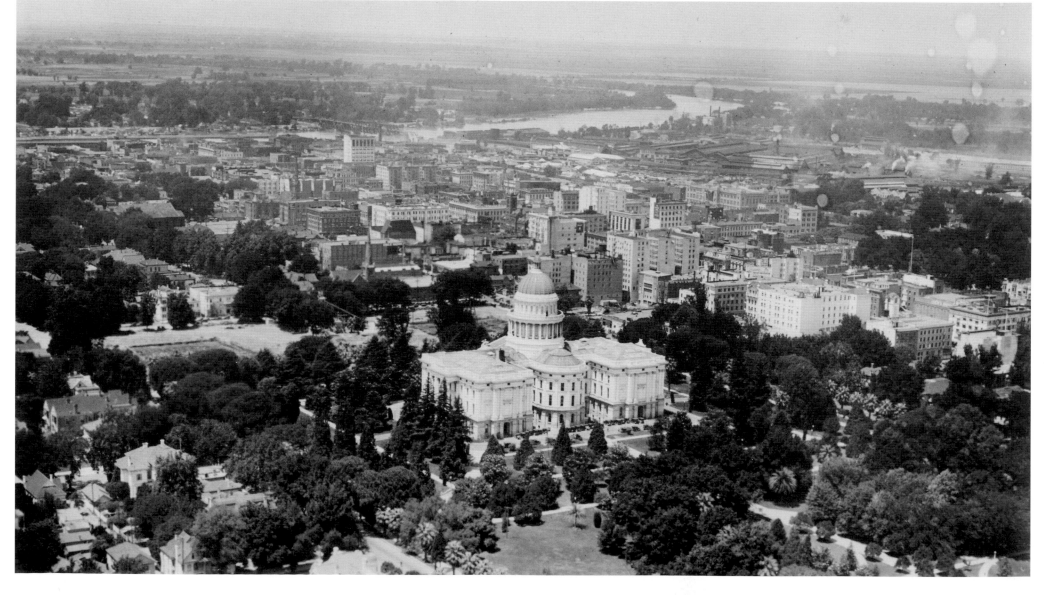

State Capitol, 2009 (right)

5 Tower Bridge
It is a straight line from the capitol along the mall to the gold-painted Tower Bridge. Opened as a lift bridge (allowing ships to steam beneath it) in 1935, it had four vehicle lanes and a center lane for trains.

6 The Ziggurat
This $60 million ten-story office building on the west bank of the river was opened in 1998 and is leased by the state Department of General Services. The Ziggurat is built on a pre-stressed concrete pile foundation system and is designed to resist a seismic event of up to 6.9 on the Richter scale.

7 Wells Fargo Center
Construction on this thirty-story, 423-foot building lasted from 1990-1992. The tallest building in Sacramento, it houses the Wells Fargo Museum. A distinctive curved copper roof with a cleft in its middle caps the building.

8 Capitol Square
Opened in 1992, the state Board of Equalization uses all of this modern building's twenty-five floors.

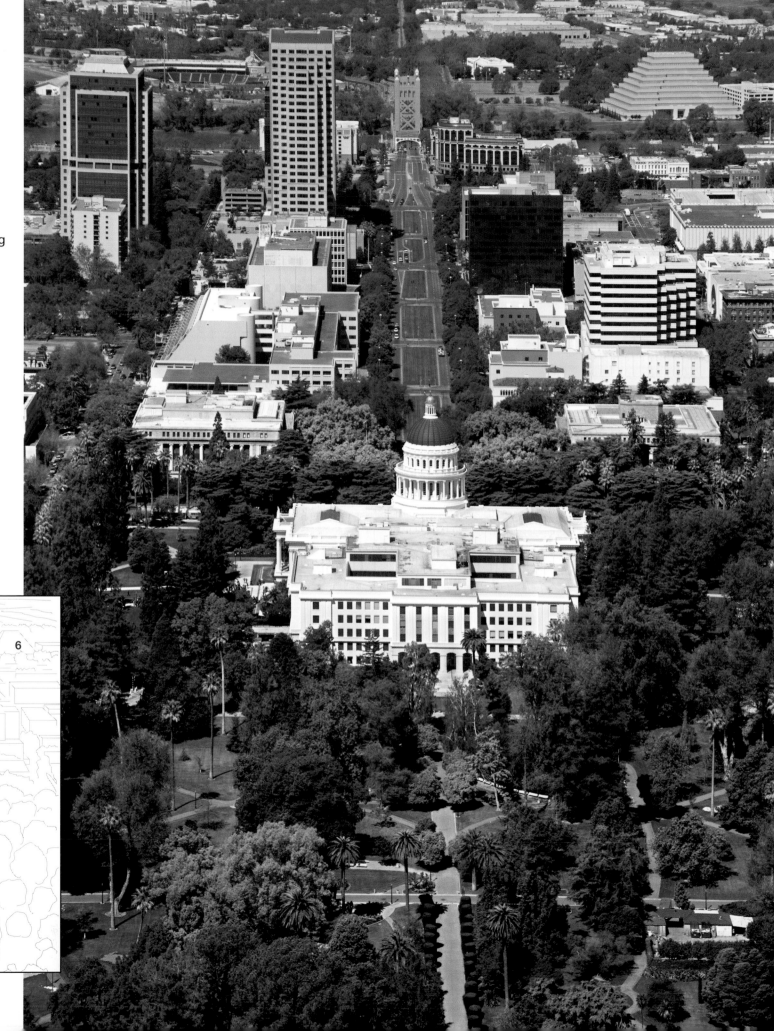

Temporary Bridge, ca. 1933 (left)

A temporary bridge is being built beside the M Street Bridge across the Sacramento River. The M Street Bridge will be demolished and replaced by the classic Tower Bridge (**1**) which opened in 1935. Dating from 1910, the M Street Bridge was built to carry the railroad. By the 1930s as the population of Sacramento had risen to more than 100,000, the bridge was inadequate for increasing vehicular traffic. The temporary structure, known as the "shoofly bridge," was built to accommodate rail traffic during the construction of Tower Bridge.

Tower Bridge, ca. 1980s (below)

This view of Historic Sacramento shows the area between Tower and I Street bridges.

Tower Bridge, 2009 (right)

2 Mountain Snows to Ocean Waves
The Sacramento River is the longest river entirely within the state of California. It trickles out of the Cascade Mountain Range near Mount Shasta and flows 447 miles southward to San Francisco Bay.

3 I-5
U.S. Interstate Highway 5 is the principal north-south highway on the West Coast, stretching 1,381 miles from Canada to Mexico. Sections opened in the late 1950s, cutting Sacramento off from its views of the river. Not picturesque, but efficient.

4 Embassy Suites
The Embassy Suites Sacramento, Riverfront Promenade is at 100

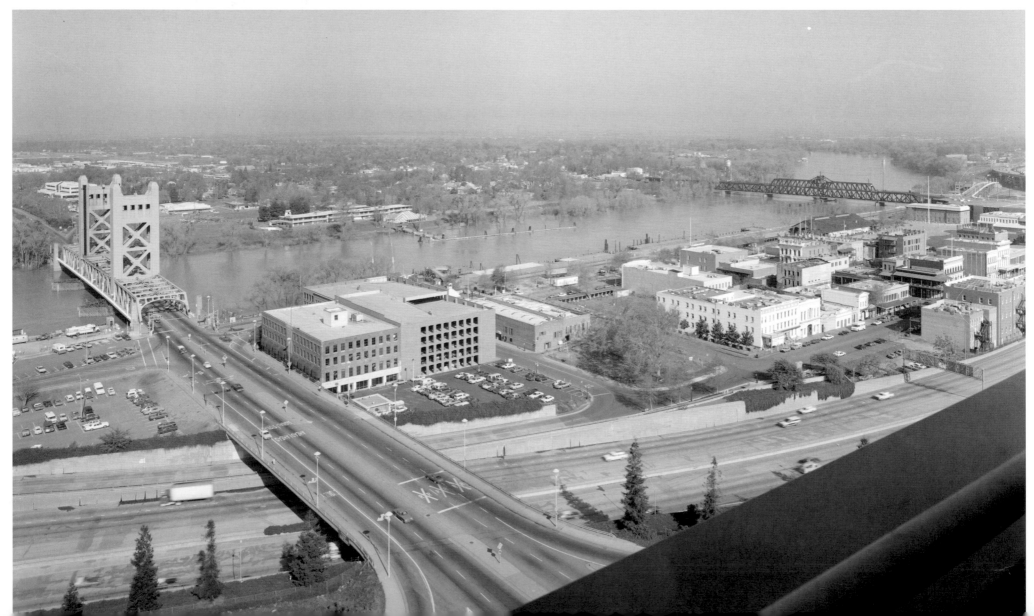

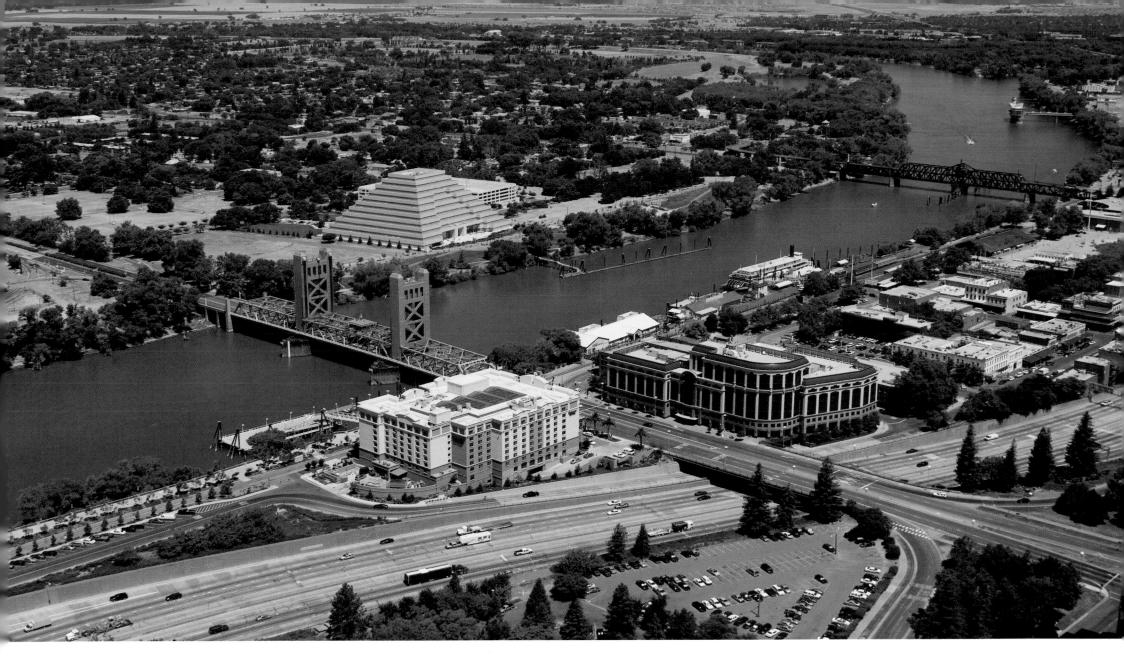

Capitol Mall. Within walking distance of the capitol, it is directly across the road from historic Old Sacramento.

5 One Capitol Mall
This office building houses businesses and affiliates such as the Sacramento Metro Chamber. Technically, it is due east of Tower Bridge.

6 The Ziggurat
Located in the city of West Sacramento, The Ziggurat is a terraced pyramid-shaped office building. Architect Ed Kado designed the building in accordance with traditional principles of the Chinese philosophy of Feng Shui, which reveals how to balance the energies of any given space to assure the health and good fortune of people inhabiting it.

7 Old Sacramento Schoolhouse Museum
The museum is a replica of traditional one-room schoolhouses found throughout America in the late 1800s.

8 *Delta King*
An authentic riverboat permanently moored in Downtown Old Sacramento; it's a hotel and restaurant.

9 California State Railway Museum
A major museum opened from 1976. Exhibits include twenty-one preserved steam locomotives.

10 I Street Bridge
Built in 1911 and was originally part of State Route 16.

St. Louis, MO

Old Busch Stadium, 1967 (below)

Opened in 1966, the downtown stadium served both professional football and baseball teams. For the St. Louis Cardinals baseball team, the stadium seated 49,696; for the St. Louis Cardinals football team, which played there until 1987 (and for four games of the St. Louis Rams in 1995), it seated 60,000. Old Busch Stadium (1) alternated between grass (1966–1969 and 1996–2005) and artificial turf (1970–1995). Its signature roof ninety-six-arch "Crown of Arches" was designed by Edward Durrell Stone.

2 Jefferson National Expansion Memorial

The Memorial occupies ninety-one acres on the west bank of the Mississippi River. The principal feature, the Gateway Arch, is the city's distinctive landmark. Opened in 1967, the arch is 630 feet high. Commemorating the settlement of the west, the interior is hollow and a unique tram system carries visitors to the top observation area from which they can see more than thirty miles.

3 Old Courthouse

Almost lost in a forest of highrise office buildings, the old courthouse was built in fits and starts, the dome being completed in 1864. It is now part of the Jefferson National Expansion Memorial.

4 Millennium Hotel

This distinctive hotel offers stunning views of the arch, the river, the stadium, and downtown St. Louis. Under construction here, it completed in 1968. A second tower (4a) of eleven floors

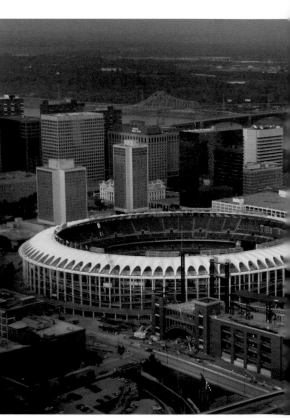

was added in 1975 by William B. Tabler Architects who built the first tower.

5 Basilica of Saint Louis, King of France

The first cathedral west of the Mississippi, the "Old Cathedral" was built in Greek Revival style in 1831–1834. Designed by architects Laveille and Morton, it has stood the test of time and

on January 27, 1961, Pope John XXIII designated it a basilica.

Two Busch Stadiums, 2005 (center below)

An aerial view of the Old Busch Stadium and the New Busch Stadium (6) under construction. Last game at the old

stadium was on October 19, 2005, and the old ground was demolished November–December 2005.

7 Deloitte Building

Architects Hellmuth, Obata & Kassabaum designed this twelve-story 188-foot building near the Millennium Hotel. It was built in 1987.

Busch Stadium, 2006 (below right)

Flanked on the east and west by parking garages, the new stadium opened in April 2006, in time for the Major League Baseball exhibition season. With a standing-room-only crowd, it will hold 46,861.

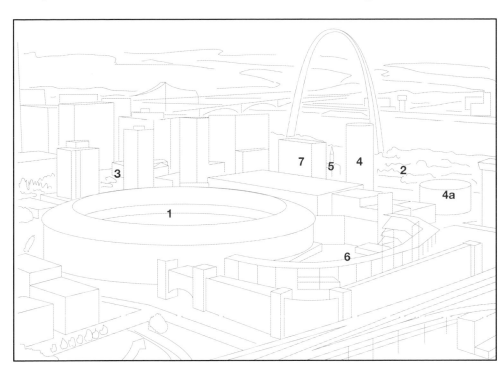

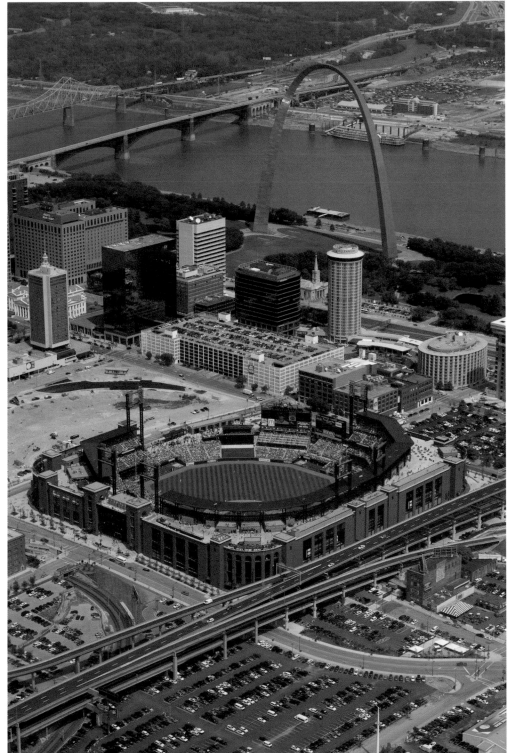

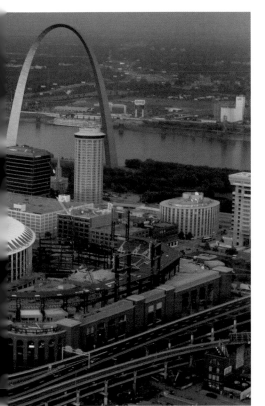

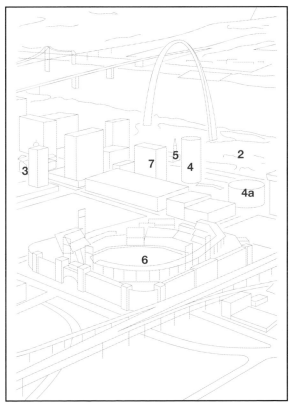

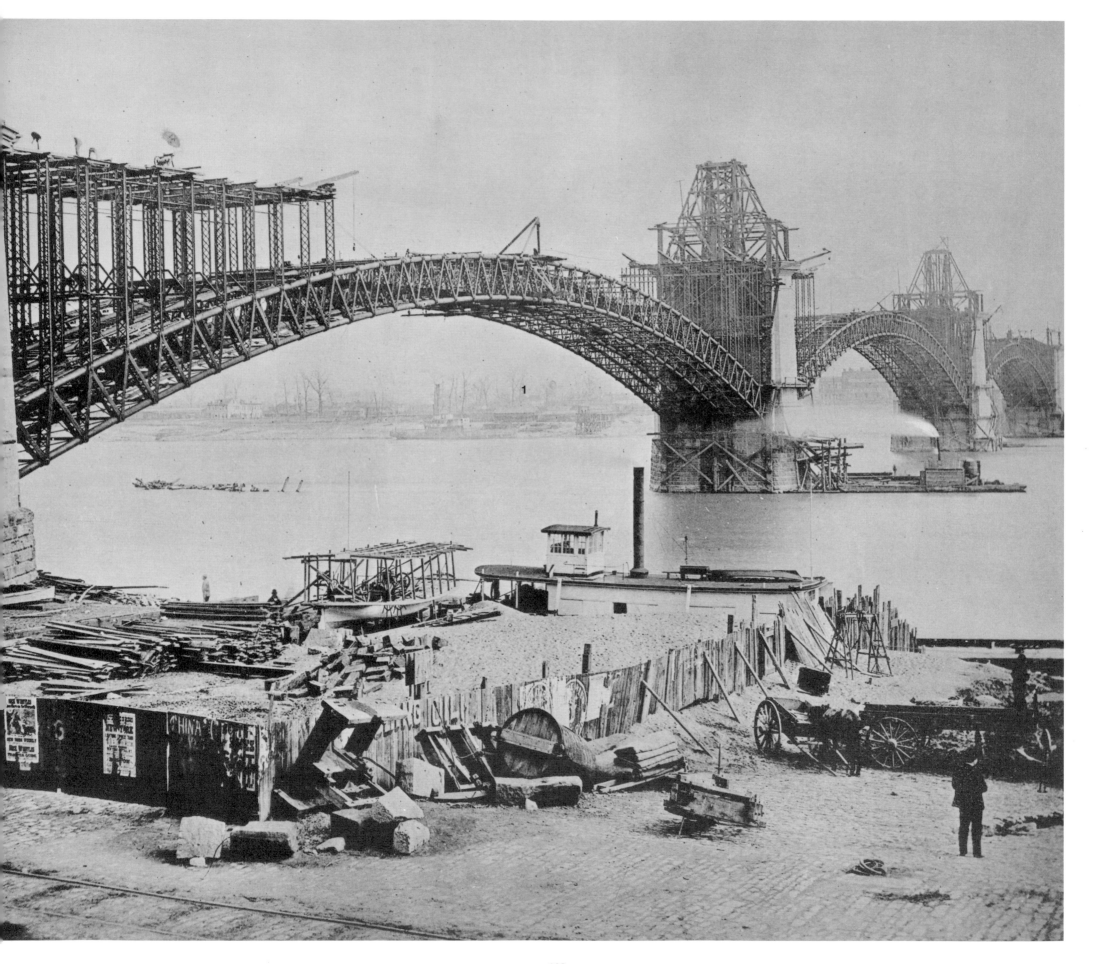

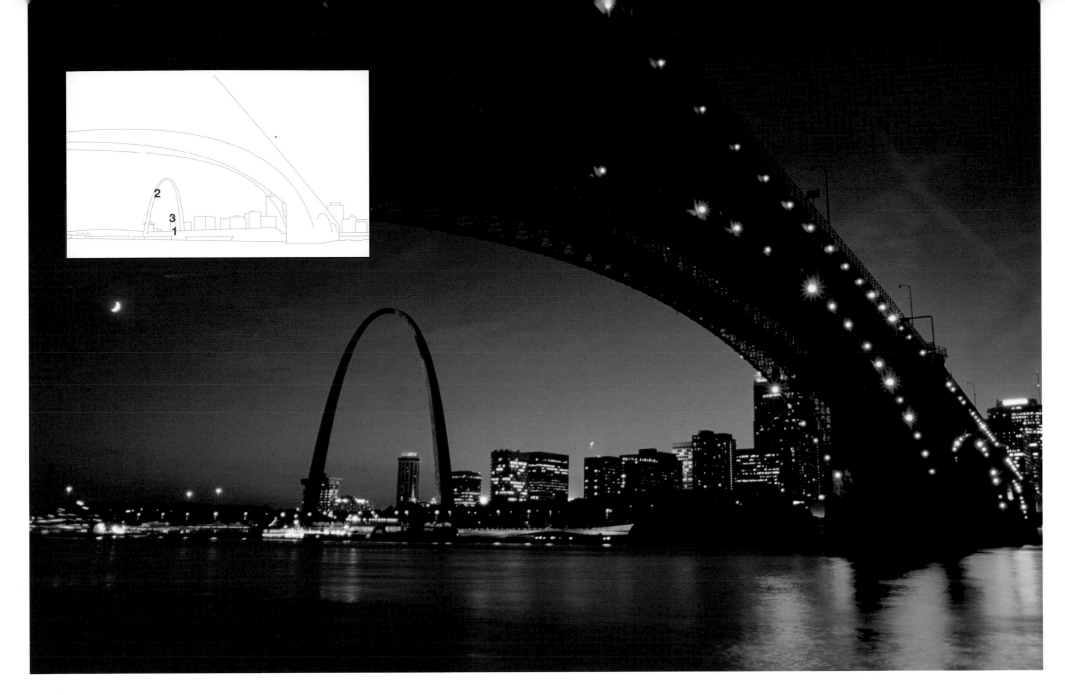

Eads Bridge, 1881 (left)

The days of the steamboat were glorious. No less a talent than Samuel Clemens (Mark Twain) earned a river pilot's license. Still, as railroads became more important, steamboat companies lobbied politicians to limit bridge construction, setting apparently impossible restrictions for dimensions and heights. The true purpose of such restrictions was to prolong the riverboat way of life. Steamboats played a role on America's waterways well into the twentieth century, but the success of the Eads Bridge drove a spike into the heart of their longevity. In this photo, the ribs of the bridge over the Mississippi River have been completed and the roadways begun. When opened in 1874, the bridge's total length was 6,442 feet; width 42 feet; and height above the water, 88 feet. The use of steel in bridge construction was new when James Eads designed the bridge. He also innovated with the cantilever design, which means that structures are supported on only one end. Eads sank deep pneumatic caissons (enclosed and pressurized chambers) beside bridge piers that allowed workers to finish the foundations. The caissons were so deep, however, that fifteen workers died from "caisson disease," now commonly known as the "bends" or decompression sickness, when dissolved gases form painful expanding bubbles inside the body. The Eads Bridge was innovative, and frightening. Prior to its opening in 1874, a "test elephant" was led across the bridge to prove that it was safe. A crowd cheered as the elephant—hired from a traveling circus—lumbered across. It was popularly believed that elephants possessed instincts that would prevent them from walking on unsafe structures. Two weeks later, Eads himself dispatched fourteen locomotives back and forth over the bridge at one time. Through the bridge's incomplete spans can be seen the other bank with just a suggestion of the "Old Cathedral" (**1**).

Eads Bridge, 1995 (above)

Some hundred years later and Eads' innovative bridge is still there, although the scene under its arch is a glittering reminder of how much urban America has changed over the years. Visible immediately are the soaring Gateway Arch (**2**), the Millennium Hotel (**3**), and the Old Cathedral (**1**). Change is ongoing, however, as this photo shows. It is only fifteen years old but the city profile has already grown with the addition of highrise buildings and the renovation of others.

Salt Lake City, UT

Salt Lake City, 1871 (left)

The round domed 8,000-seat Mormon Tabernacle (1) was built between 1864 and 1867; the dome is supported by forty-four exterior sandstone piers. The distinctive and innovative roof measures 150 x 250 feet. It is nine feet thick and built with a truss system of timbers pinned together with wooden pegs, nails being rare in Utah at the time. Green rawhide was wrapped around the timbers and when the rawhide dried it tightened around the pegs. When the roof's structural work was completed, sheeting was applied on the roof, which was then covered with shingles. The interior was lathed and then plastered—the hair of cattle being mixed with the plaster to give it strength.

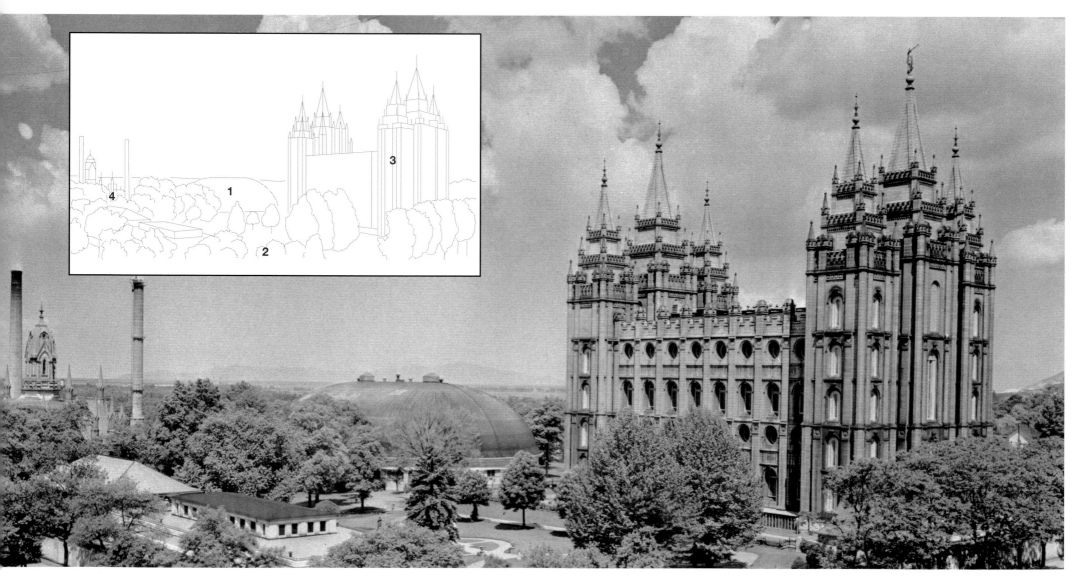

Salt Lake City, 1871 (below left)

2 Temple Square
The Church of Jesus Christ of Latter-day Saints (Mormon) Temple Square includes the temple (3), the domed tabernacle (1) and assembly hall (4). This photograph was taken 104 years after Mormon pioneers arrived in the Salt Lake Valley. According to church history, church president Brigham Young selected the plot and the city grew around it.

3 Salt Lake City Temple
Dedicated in 1893, the Mormon Temple on the grounds of the ten-acre Temple Square covers 253,015 square feet and is 210 feet high.

Salt Lake City, 2002 (below)

Temple Square today encompasses thirty-five acres and thirteen buildings of the LDS Church. Most prominent are the Tabernacle (1), the Temple (3), the Assembly Hall (4—in front of which is the famous seagull statue), North Visitor Center (5), the thirteen-floor Joseph Smith Memorial Building (6), LDS Relief Society (7), the twenty-eight-story church headquarters (8), the conference center (9), the Church History Museum (10), the Family History Library (11) and other establishments.

12 Gateway Towers
At 15 West South Temple, this twenty-floor office building was completed in 1998. The eighteen-floor east tower at 10 East South Temple (13) was completed in 1965.

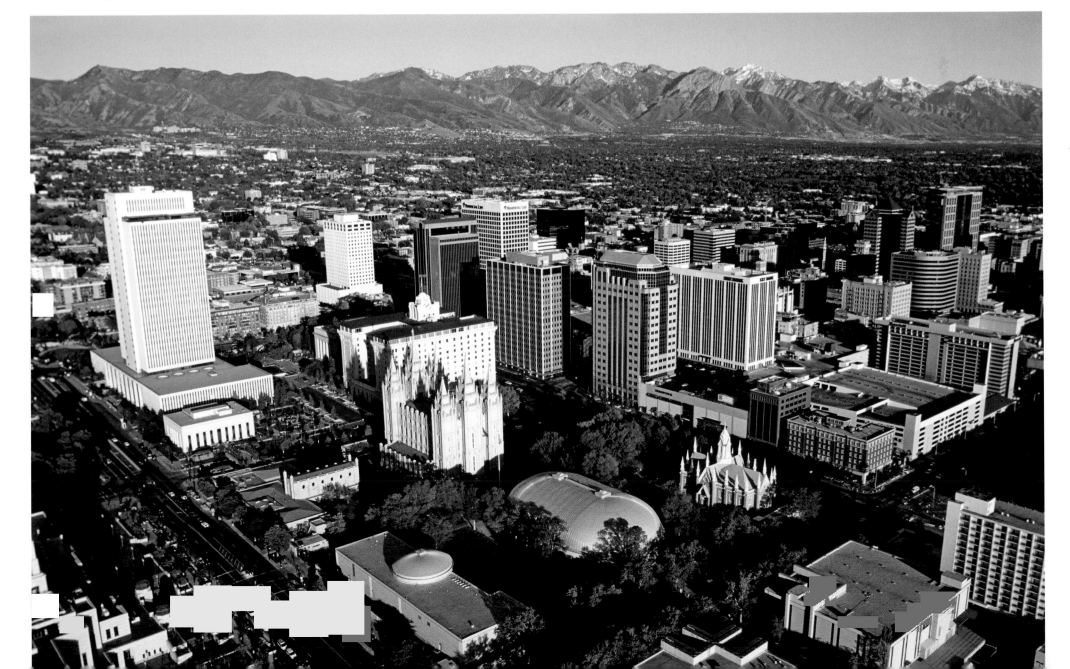

Salt Lake City, 1926 (below)

1 Capitol Building 1926

Built on a hill overlooking downtown, the Utah capitol building was only ten years old when this photo, looking north and east toward Ensign Peak and the Wasatch National Forest, was taken. The capitol's interior has four floors and the former basement level now holds base isolators meant to make the building more resistant to earthquakes.

2 Ensign Peak

Approximately a mile north of the Utah State Capitol, the peak has a strong significance to the Church of Jesus Christ of Latter-day Saints as it was climbed on July 26, 1847, by Brigham Young. He had seen a vision of the Prophet Joseph. In the vision Young was shown the peak and told to "build under the point where the colors fall, and you will prosper and have peace." On July 26, 1996, Ensign Peak Nature Park was dedicated. It includes Ensign Peak and an additional sixty-six acres surrounding it.

3 Alfred McCune Home

A Gothic revival house with East Asian influence, it is a replica of one seen while McCune and his wife were driving on Riverside Drive in New York City. The 1999 Salt Lake City Tornado damaged one of the building's smokestacks. Restoration work was completed in November 2001.

Salt Lake City, 2009 (right)

4 The Kimball-Whitney Cemetery

Heber C. Kimball, first counselor to Brigham Young, and Newel K. Whitney dedicated a plot of ground as a private cemetery for both families. Thirty-three Kimballs, thirteen Whitneys, and ten others are interred here, including Heber C. Kimball and Newel K. Whitney.

5 Salt Lake City Council Hall

The first city hall was too small for Salt Lake City almost as soon as it was built. It sufficed from 1866 to 1894 when the Salt Lake City and County Building took over. It would itself be superseded by the Utah State Capitol in 1916.

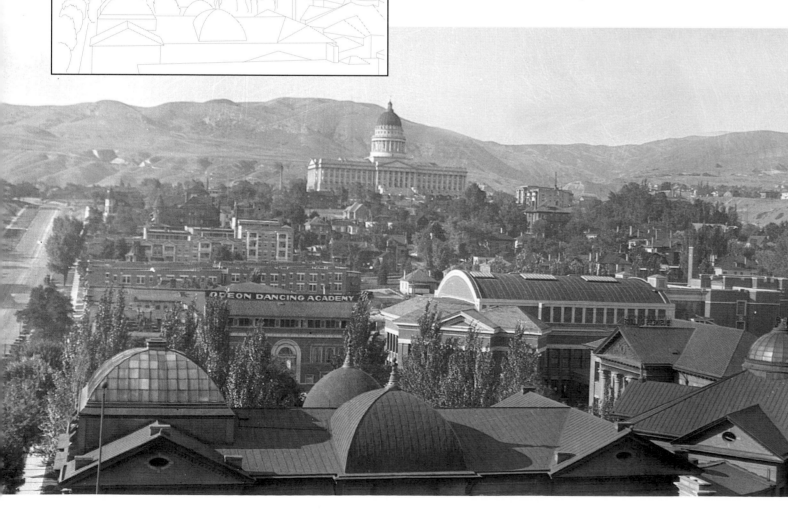

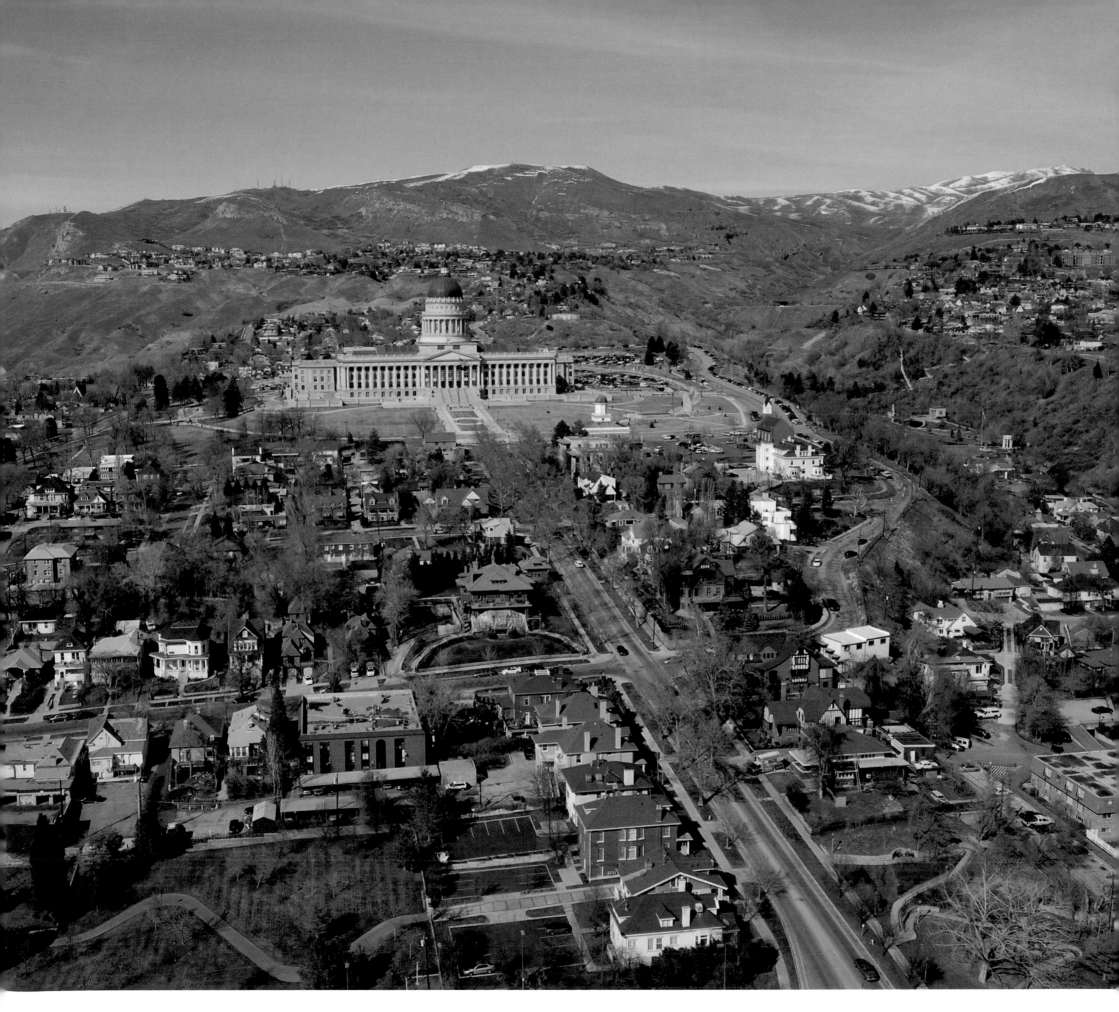

San Antonio, TX

San Antonio, 1939

Even in 1939 as America stood on the precipice of world war, signs were present that San Antonio was on the verge of boom times. Extension of the railroad ended long cattle drives and barbed wire closed the once open range, but San Antonio had become a rich tapestry of cultures.

1 Heart of the City
The urban hub of San Antonio is the Alamo, which lies at the heart of

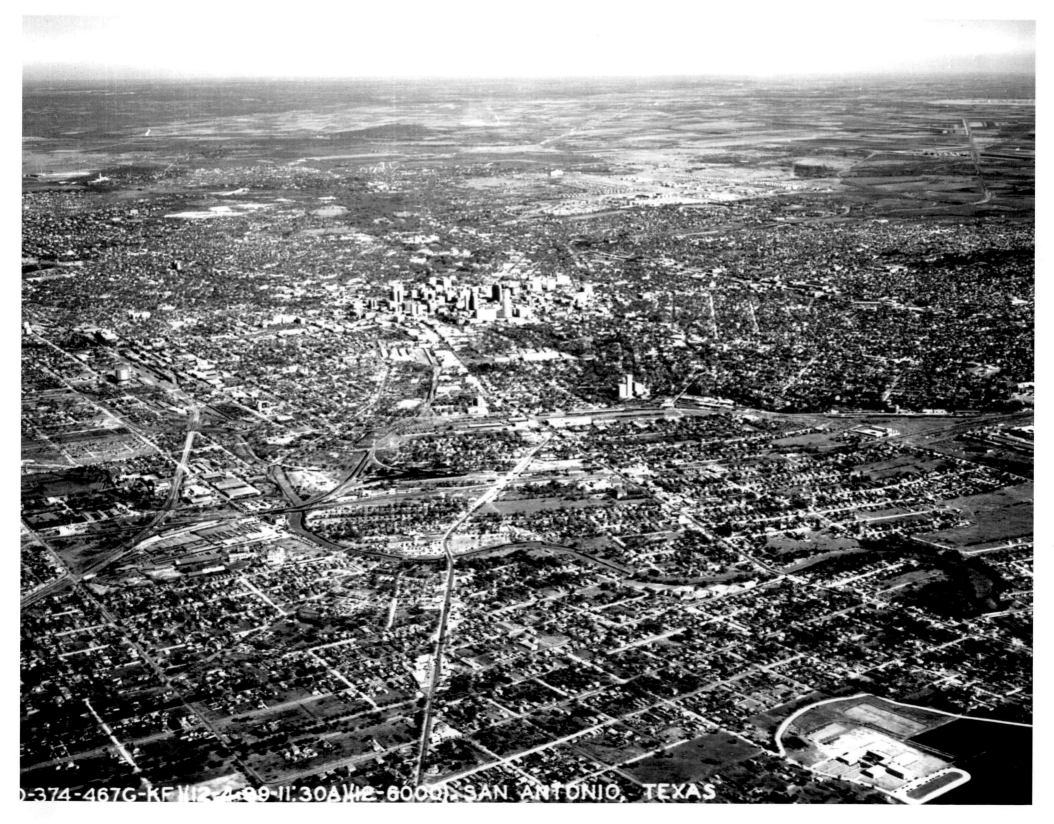

downtown. The old mission, founded in 1718, has been preserved as a Shrine of Texas Liberty, and is featured prominently on San Antonio's flag and seal. It is, by far, the most popular tourist attraction in San Antonio, perhaps the most popular tourist attraction in Texas.

San Antonio, 2007

2 Weston Centre
Completed in 1989, the thirty-two-floor Weston Centre at 112 East Pecan Street is faced with Texas granite and limestone. The famous Riverwalk flows directly east of the building.

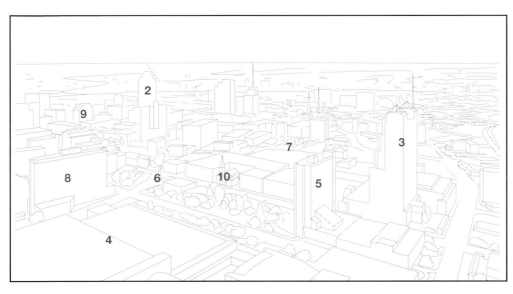

3 Marriott Rivercenter
The thirty-eight-floor 546-foot Marriott Rivercenter Hotel has been described as looking "like a giant chair with a high back." Across the river from the convention center (4), where two branches of the famous Riverwalk intersect, it is the tallest building in San Antonio, after the Tower of the Americas.

5 Marriott Riverwalk
Finished in 1979, this hotel has thirty floors and 512 guest rooms.

6 Torch of Friendship
The bright red, sixty-five-foot Torch of Friendship (*La Antorcha de la Amistad*) sculpture was created in Mexico by sculptor Sebastian and dedicated in 2002. It is located in the circle of Convention Plaza where Alamo, Losoya and Commerce streets intersect.

7 The Alamo
Dwarfed now by the city it helped create, The Alamo remains a symbol of the spirit of independence. Seized by Texas patriots, it was quickly overrun by the army of Mexican General Santa Anna in March 1836. The few survivors, possibly including frontiersman David Crockett, were executed.

8 Hilton Palacio del Rio
At 200 South Alamo Street, the twenty-floor Hilton Hotel was built for the 1968 World's Fair in San Antonio. Built in just a few short months, it was constructed by stacking square tube-shaped pre-cast modules fabricated near San Antonio.

9 Holiday Inn Riverwalk
San Antonio's Riverwalk is immediately to the west of this twenty-four-floor hotel.

10 St. Joseph's Downtown Church
The cornerstone was laid in 1868; the church was completed in 1871.

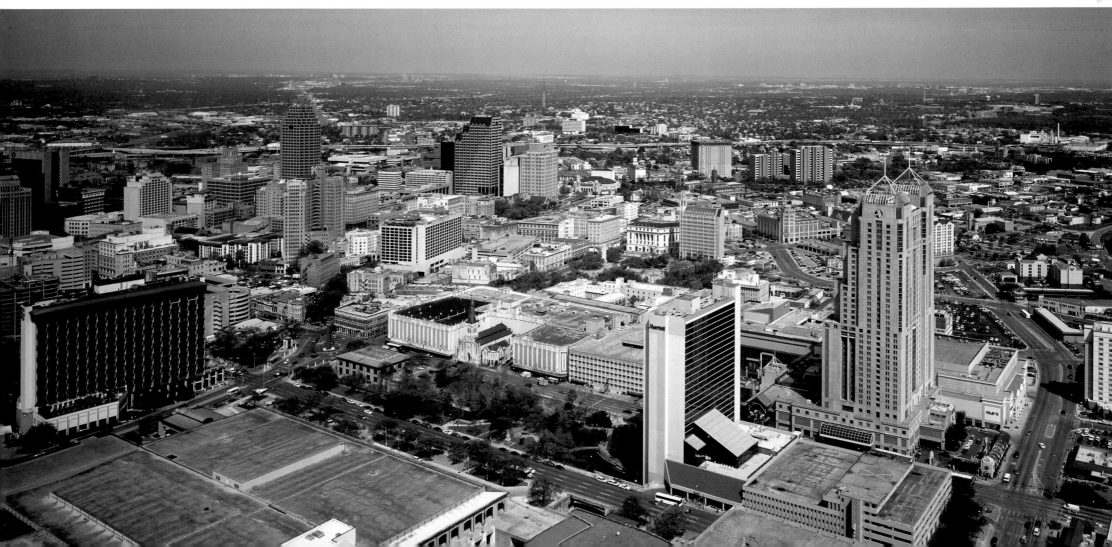

San Diego, CA

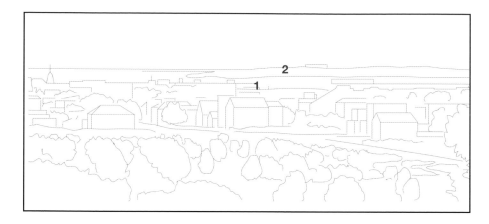

San Diego, 1900 (below)

San Diego's history is deep in the culture of the Kumeyaay Indians who lived on the shores of the bay for 10,000 years. Nevertheless, in 1542 a Portuguese explorer named Juan Rodríguez Cabrillo, sailing under a Spanish flag, saw the New World bay and in essence said, "It now belongs to us." By 1900, San Diego was a well-established city with plenty of anchorage (**1**) and a promising future. The original town was situated at the foot of Presidio Hill, in the area which is now Old Town San Diego State Historic Park. It lies north of the International Airport. In the late 1860s, a "New Town" movement relocated the city several miles south to a location more convenient to shipping. This photograph looks out on Coronado Island (**2**), today one of the world's most expensive locations to live.

San Diego, 2009 (right)

3 Grand Hyatt
Looking back toward the mainland from Coronado Island. The Manchester Grand Hyatt at One Market Place fronts Embarcadero Marina Park. Opened in 1992, the 500-foot tall hotel has 875 rooms on forty floors. It is the tallest waterfront building on the West Coast. In the background an aircraft carrier rides at anchor near the 2.1-mile San Diego-Coronado Bridge (**4**) that crosses the bay to the Coronado Peninsula.

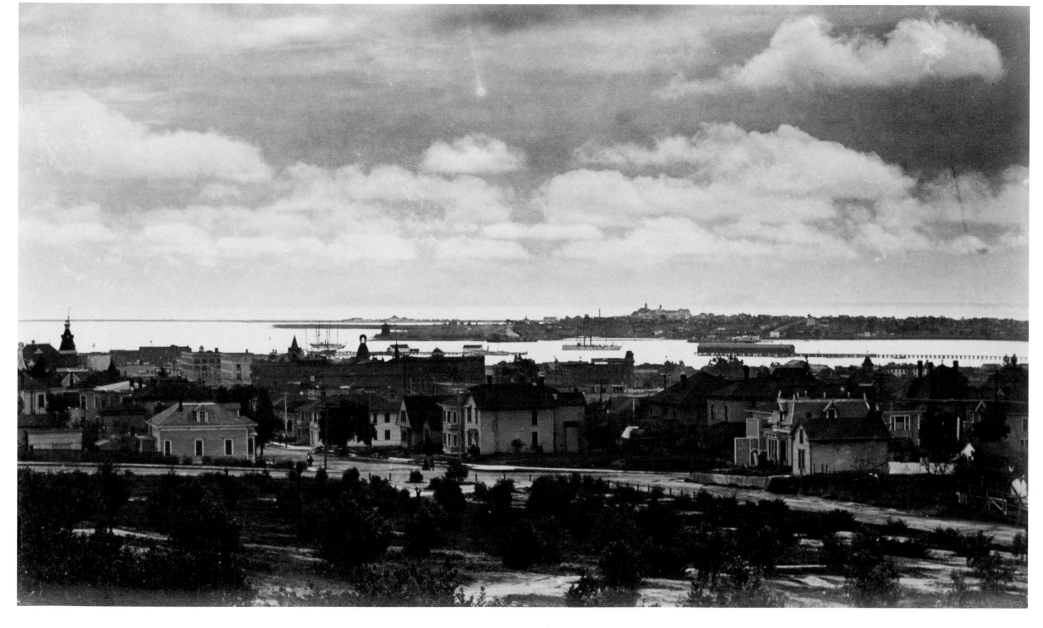

5 600 West Broadway

One America Plaza is the tallest building in San Diego, having been built exactly to the city's height limit of 500 feet. It includes a steel-and-glass encased trolley station at its base and is irreverently called the "Phillips screwdriver building."

6 Emerald Plaza

The three-pod Wyndham Emerald Hotel is part of a thirty-floor complex linked to a five-pod office tower by a 100-foot glass enclosed atrium.

7 Advanced Equities Plaza

Opened in December 2004, the 23-floor highrise was sold to Wereldhave, a real estate holdings corporation headquartered in The Hague, Netherlands, in July 2007. The price was $210 million.

8 Symphony Towers

It took five years to build the towers, which opened in 1989. The tallest building in San Diego, the thirty-four-floor tower was overtaken in height by one foot in 1990 when One America Plaza was completed.

9 Electra

At forty-three floors Electra was completed in 2008 and is 476 feet tall.

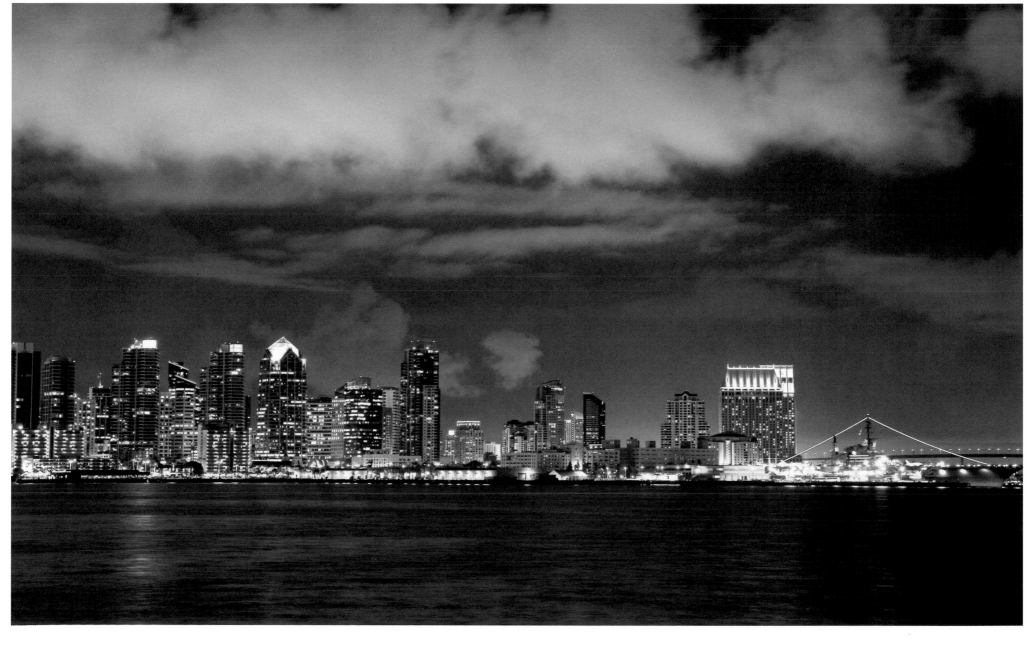

San Francisco, CA

Market Street, 1935

1 Bay Bridge
A generation has passed since the earthquake and fire of 1906. The Bay Bridge to Oakland is under construction. Opening in 1936, the 4 ½-mile five-lane bridge carries automobile traffic on its upper deck, trucks and trains on the lower. In 1963 the lower deck was converted to road traffic.

2 Russ Building
At 235 Montgomery Street, this thirty-one-floor office structure was the tallest building in San Francisco upon completion in 1927 until 1964, when 650 California Street was completed.

3 140 New Montgomery
Completed in 1925, the twenty-six-floor PacBell Building used ten elevators and measured 435 feet to the penthouse cupola.

4 The Shell Building
Built in just 300 days this thirty-floor Art Deco masterpiece opened in 1929. Restored in the early 1990s, the two-story mezzanine lobby entrance features bronze doors, marble walls, and a sweeping twenty-five-foot-high ceiling.

5 The Ferry Building
With a clock tower modeled after a twelfth century example in Seville, the Ferry Building has been visible at the bottom of Market Street since 1898. Fortunate to survive the 1906 and 1989 earthquakes, the opening of the Bay and Golden Gate bridges reduced much of its trade.

Market Street, 2009 (opposite)

6 Market Street by Twilight
In this telephoto view from the top of Twin Peaks to the Ferry Building and beyond that to Berkeley, some of the city of 1935 remains, but much is now buried beneath a forest of skyscrapers.

7 Castro Theatre
At 429 Castro Street, the Castro is best known as a popular venue for film festivals. Built in 1922 by the Nasser brothers, the Castro's designer was well-known bay area architect Timothy Pflueger. In 1977, the City of San Francisco designated the Castro

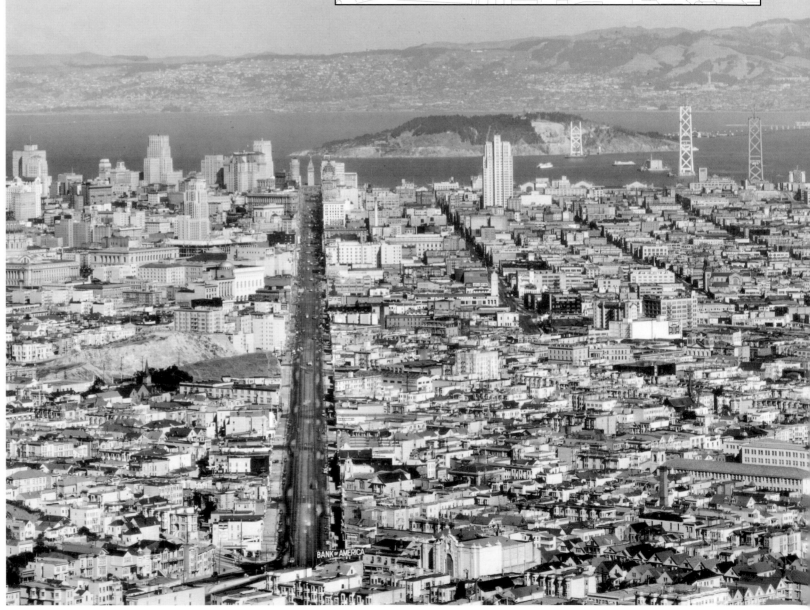

registered landmark #100. It is one of America's few remaining movie palaces from the 1920s that is still in operation.

8 One Rincon Hill, South Tower

The fifty-four-floor steel and glass building at 425 1st Street is the tallest residential-only building in California, and the tallest west of Chicago. A North Tower is planned.

9 Transamerica Pyramid

The forty-eight-floor Transamerica Center at 600 Montgomery Street opened in 1972. It is 853 feet to the roof. Beginning at the twenty-ninth floor, "wings" protruding from the sides contain elevator shafts and stairwells. The Pyramid has 3,678 windows which take a month to wash. Though distinctive of Transamerica and San Francisco, the building is not Transamerica's headquarters.

10 Bank of America Center

Construction of this fifty-two-floor building was completed in 1969. Although it has more floors, it is not as tall as the Transamerica Pyramid.

11 San Francisco City Hall

Built in 1915 and renovated in 1999, the 308-foot hall boasts a dome that is some twelve feet taller than the Capitol in D.C.

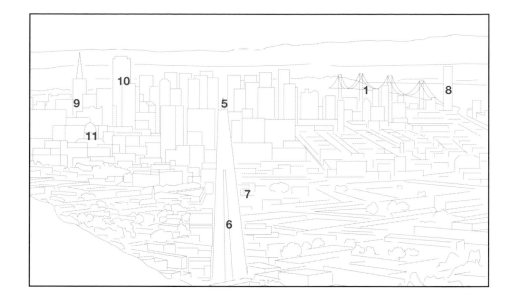

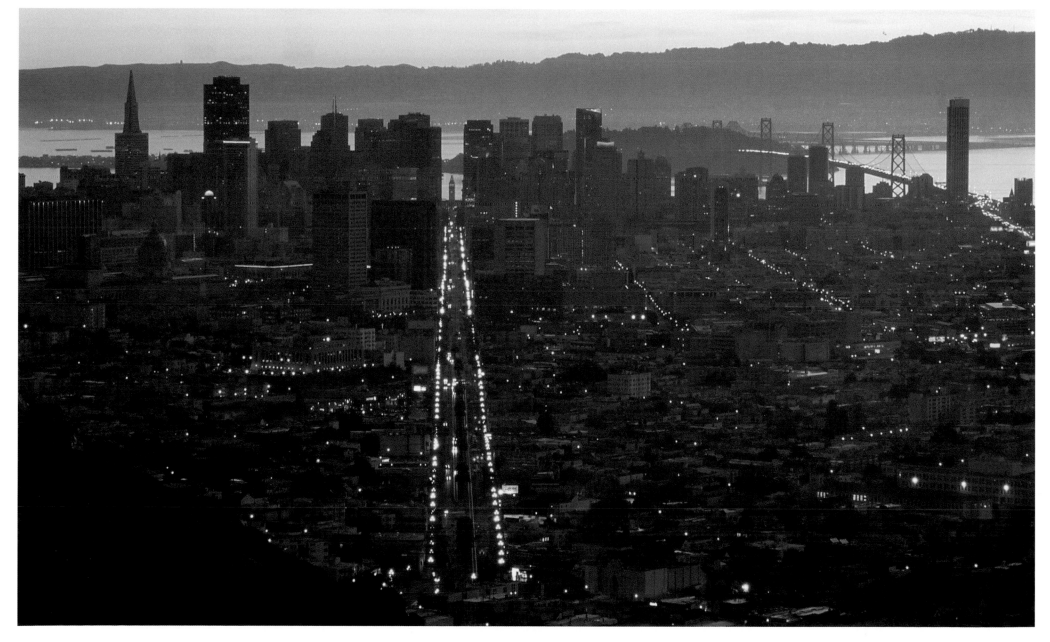

Golden Gate Bridge, 1935

Ferry service across the strait began in 1820 and discussion of a bridge lasted almost a century before the designs of Joseph Strauss were accepted in the 1920s. Before proceeding, he was required to raise funds and generate support for the bridge, and that took more than ten years. Strauss was significantly assisted by Charles Ellis and Irving Morrow.

In places, the cold waters of the strait are 500 feet deep; currents are strong and fickle; winds often gust to hurricane strength; persistent fogs are common; and fault lines beneath the bay and surrounding cities contribute to foundation instability.

Concerned with his timetable for completion and with worker safety, Strauss developed movable safety netting for the construction site. The innovation is credited with saving the lives of at least nineteen otherwise unprotected steelworkers; they formed the celebrated but informal Halfway to Hell Club. Eleven men died from falls, ten at one time toward the end of construction when Strauss' net failed under the stress of a scaffold that had fallen.

Golden Gate Bridge, 2009 (right)

The Golden Gate Bridge is a universally recognized symbol of San Francisco and the Bay Area. The 1.7-mile, six-lane suspension bridge connects the city to Marin County to the north by spanning the entrance to San Francisco Bay. When completed in 1937, it was the longest suspension bridge span in the world.

Bridge architects selected the distinctive reddish-orange color—"international orange"—in the 1930s. Amid the bay's frequent fogs, the bright color provides enhanced visibility for passing ships. The term "Golden Gate" actually refers to the Golden Gate Strait, the entrance to the bay from the Pacific Ocean.

According to the Golden Gate Bridge Highway and Transportation District, nearly forty million vehicles cross the bridge each year which generates about $100 million in tolls. Bus ridership contributes another seven million passengers; and ferry ridership is close to two million. Tolls are increasing annually, especially during periods of peak load, while bus and ferry fees have risen at least five percent a year since 2003.

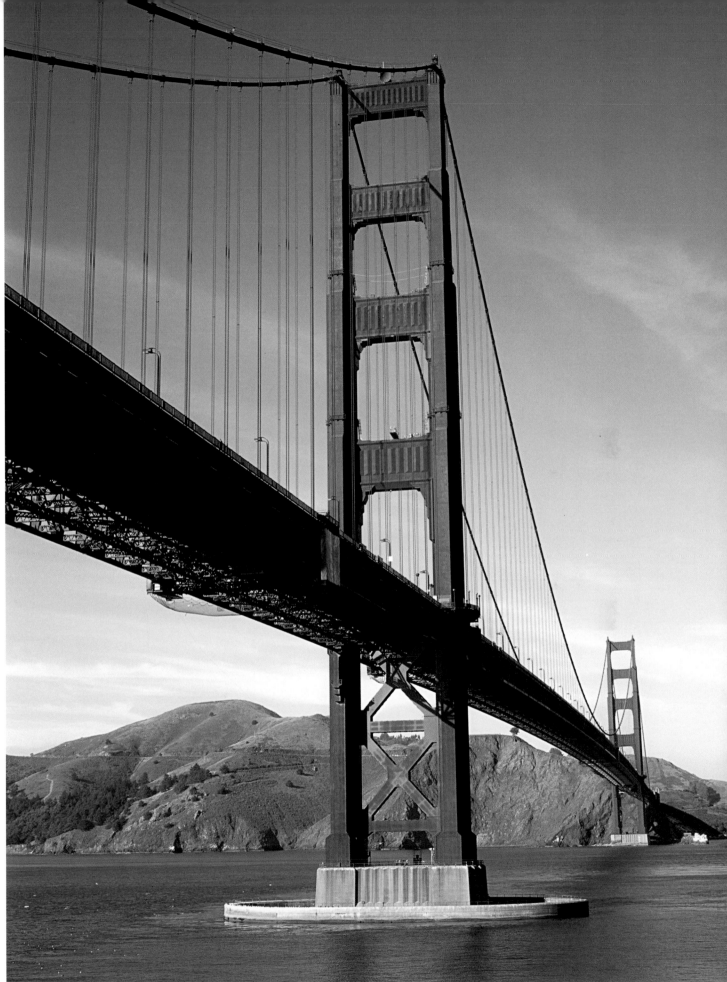

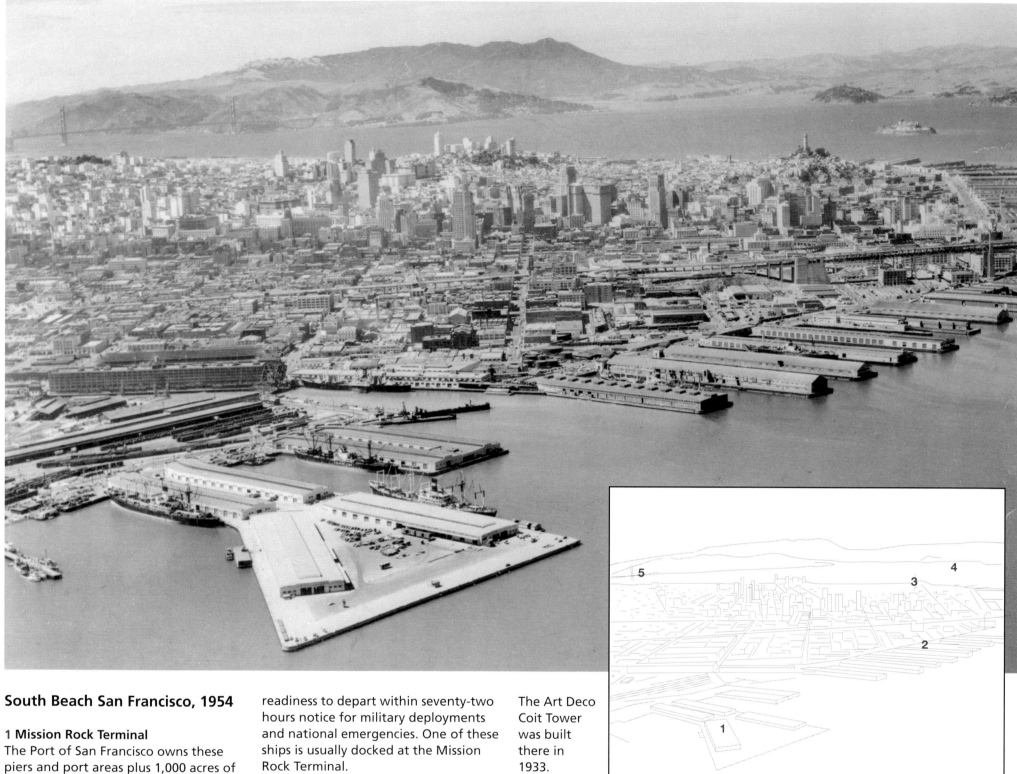

South Beach San Francisco, 1954

1 Mission Rock Terminal

The Port of San Francisco owns these piers and port areas plus 1,000 acres of shoreline and numerous buildings from Fisherman's Wharf east and south to India Basin. Maintenance shops for port properties are located in a warehouse on Pier 50, at the Mission Rock Terminal. Most of the big gray transport ships docked in the area are part of the Maritime Administration's federal fleet. They are maintained in a state of readiness to depart within seventy-two hours notice for military deployments and national emergencies. One of these ships is usually docked at the Mission Rock Terminal.

2 Bay Bridge

3 Windmill Hill

The hill is named for the semaphore tower erected in September 1849. In 1876—to commemorate the U.S. centennial—Pioneer Park was established at the top of Telegraph Hill. The Art Deco Coit Tower was built there in 1933.

4 Alcatraz

Often referred to as "The Rock," the twenty-two-acre Alcatraz Island is 1.5 miles offshore. It has served as a lighthouse, a fortress, and most famously until 1963 a maximum security prison. The penitentiary claimed that during its twenty-nine years, no prisoners ever successfully escaped, although thirty-six men were involved in fourteen attempts, two men trying twice; twenty-three were recaptured, six were shot and killed, and three were lost, presumably drowning in the bay. Today, the island is administered by the National Park

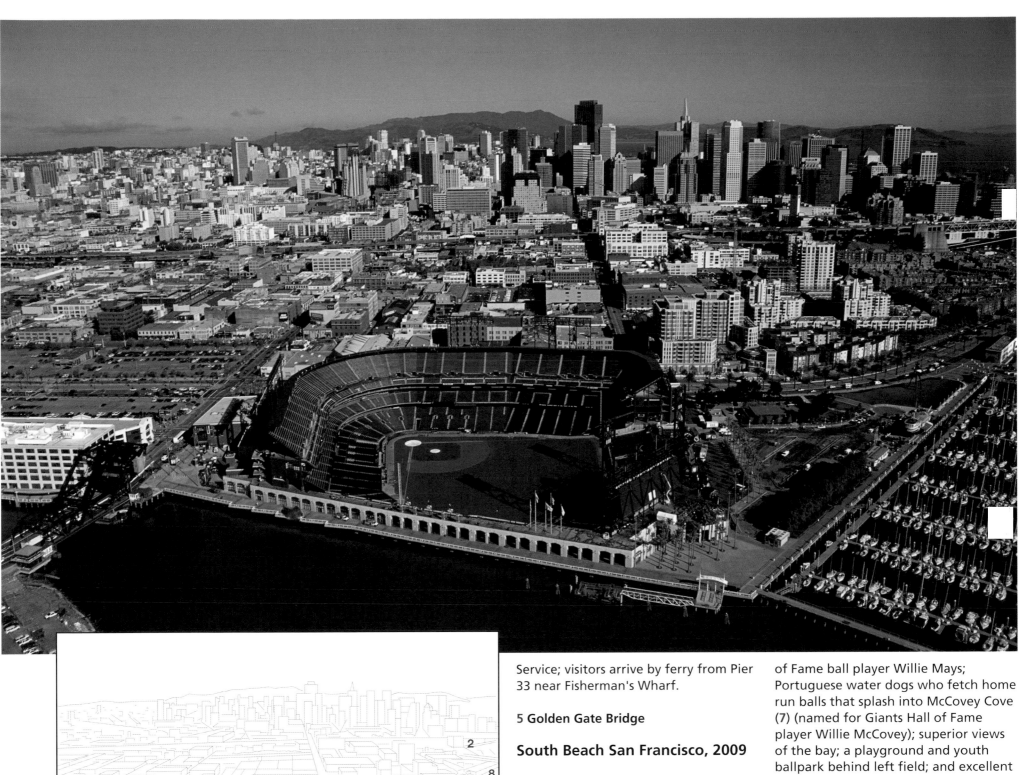

Service; visitors arrive by ferry from Pier 33 near Fisherman's Wharf.

5 Golden Gate Bridge

South Beach San Francisco, 2009

6 AT&T Park

The San Francisco Giants played their first baseball game at the new 41,500-seat stadium on April 11, 2000. It was the first privately financed ballpark in Major League Baseball since Dodger Stadium (1962). Opened as Pacific Bell Park, it was renamed AT&T Park in 2006. Numerous attractive features include a nine-foot statue of Giants hero and Hall of Fame ball player Willie Mays; Portuguese water dogs who fetch home run balls that splash into McCovey Cove (7) (named for Giants Hall of Fame player Willie McCovey); superior views of the bay; a playground and youth ballpark behind left field; and excellent public mass transit service. The park was conceived, built and paid for by Giants owner Peter Magowan and a group of area business leaders to save the Giants from moving to Florida.

8 Embarcadero

The waterfront road begins at the intersection of 2nd and King streets and goes on to Pier 45.

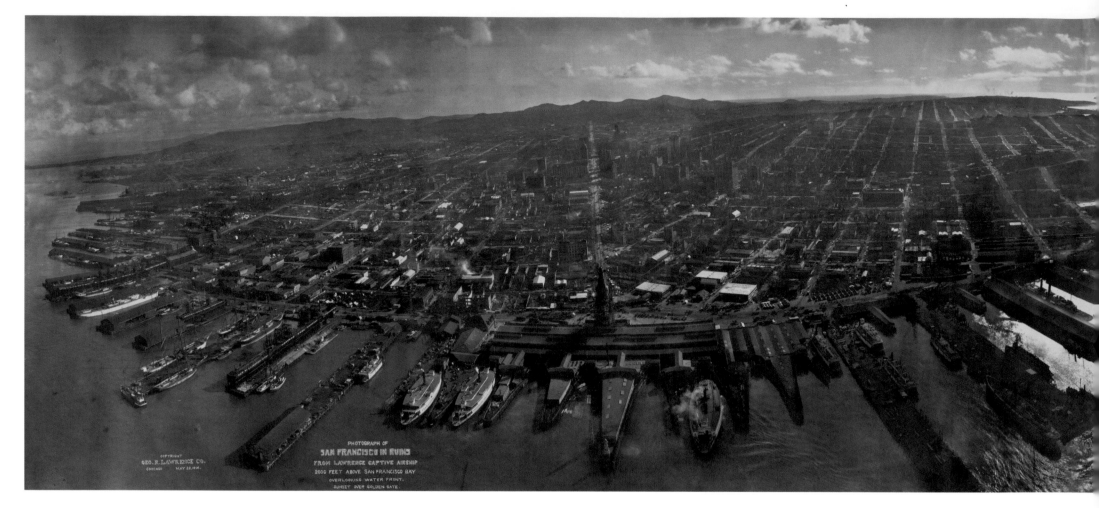

PHOTOGRAPH OF
SAN FRANCISCO IN RUINS
FROM LAWRENCE CAPTIVE AIRSHIP
2000 FEET ABOVE SAN FRANCISCO BAY
OVERLOOKING WATER FRONT.
SUNSET OVER GOLDEN GATE.

COPYRIGHT
GEO. R. LAWRENCE CO.
CHICAGO MAY 28,1906.

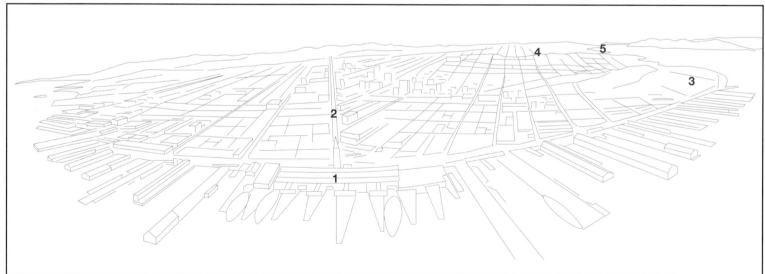

west of the fault on the Pacific Plate is moving to the northwest. Land east of the fault is moving southwest. The rate of slippage averages about 1.5 inches a year. With no change, Los Angeles will eventually slide past San Francisco and continue northwest, perhaps to disappear in the deep Aleutian Trench … in 20 million years.

1 San Francisco Ferry Building
Built in 1898, it survived both the 1906 earthquake and the 1989 earthquake with little damage.

2 Market Street

3 Telegraph Hill

4 The Presidio
Now a park within the Golden Gate National Recreation Area, the Presidio of San Francisco was a fortified place for the Spanish and the Mexicans before the U.S. took control in 1847. The San Francisco Earthquake led to an

North Beach in ruins, 1906

After the earthquake and fire of 1906, the great city lay in ruins. A few weeks after the disaster, Chicago-based photographer George Lawrence seized an opportunity to capture a unique image of the sprawling ruins using his

"captive airship," a hand-built, forty-nine-pound panoramic camera suspended from a series of Conyne kites. The result was a negative measuring 22 x 55 inches, capable of being enlarged to wall-sized prints with astonishing detail. Lawrence's foresight earned him a small fortune of $15,000

(more than $300,000 today) selling copies of his achievement. The photograph looks past the Ferry Building southwest along Market Street. Discovered only eleven years before the quake, the fault-line runs more than 800 miles through the U.S. and into Mexico's Baja California. Land

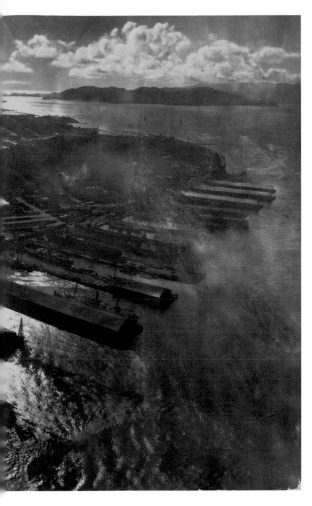

immediate Army response directed by General Frederick Funston, who earned the Medal of Honor for bravery in the Philippines. Army units provided security and fought fires at the direction of the city government. In the three days following the 1906 earthquake, the Army's refugee camps at the Presidio issued 3,000 tents, 12,000 shelter halves, 13,000 ponchos, 58,000 pairs of shoes and 24,000 regulation blue shirts.

5 The Golden Gate strait
The strait was bridged 1933–1937 (see pages 210–211).

North Beach San Francisco, 2009 (below)

The northeastern tip of the peninsula is highlighted in early evening. The city skyline behind The Embarcadero is magnificent in the setting sun: from the vicinity of the Transamerica Pyramid (6) on the right past the Ferry Building (1) at the foot of Market Street ((2), and continuing past the thirty-floor Providian Financial Building at 201 Mission Street (7) and the 100 First Plaza (Delta Dental Tower 8), the forty-three-floor 50 Fremont Center (9) ... and so many more.

10 Millennium Tower
Completed in 2009, it has fifty-eight floors (645 feet), and is the tallest residential building in San Francisco and the fourth tallest building in the city.

11 555 California Street
The second tallest building in San Francisco at 779 feet, in September 2005 the building was sold for $1.05 billion, a record for the city.

12 345 California Center
Third tallest building in the city, completed 1986, it's 696 feet tall.

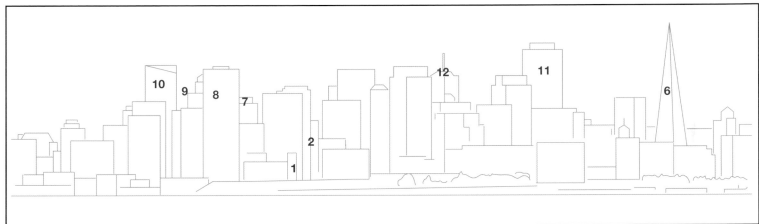

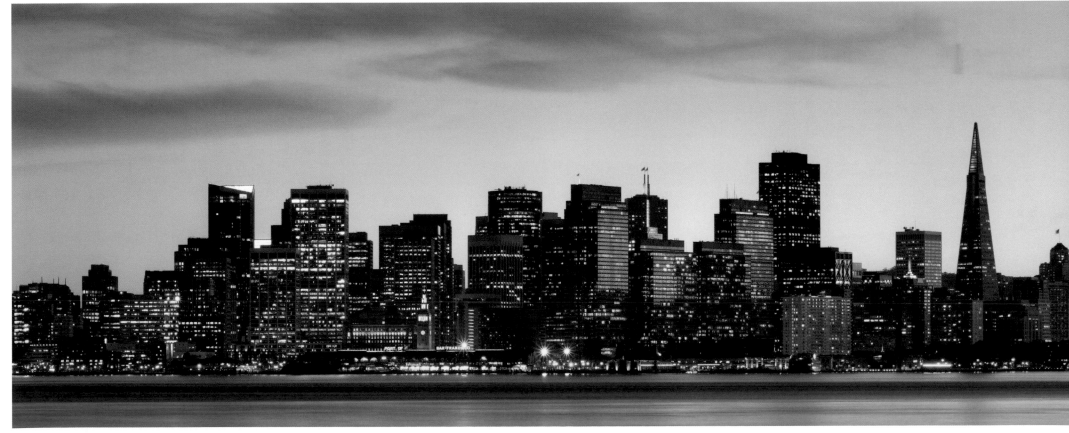

San Jose, CA

Aerial view of San Jose, 1906 (below)

Even in 1906 San Jose had come quite a distance from its rural roots. Founded on November 29, 1777, as El Pueblo de San José de Guadalupe, it thus became the first town in Spanish California.

When California gained U.S. statehood in 1850, San Jose served as its first capital and was surrounded by rich agricultural fields.

1 Market Street Station
San Jose's Market Street Station was the main railroad station for the city from the 1880s through 1935. Just north of downtown near Bassett and Market streets, today its location is under the Coleman Avenue overpass. Amtrak still serves San Jose. Restoration of Diridon Station to the west of the Guadalupe Parkway, formerly Cahill Depot, was finished in 1994.

2 Santa Clara County Courthouse
Built in 1868 with a large dome covered in solid copper (as can be seen here), the courthouse survived the 1868, 1906, and 1911 earthquakes largely unscathed but a fire in 1931 caused extensive damage. Restored in 1932, a third-floor was added in place of the dome. St. James Park (3) sits behind.

4 Cathedral of Saint Joseph
Built in 1876 to replace a predecessor destroyed by fire in 1875, it was expensively renovated in 1990 and elevated to a minor basilica by the Vatican in 1997—now named the Cathedral Basilica of Saint Joseph.

5 San Jose Post Office
Designed by architect Willoughby J. Edbrooke the San Jose Post Office was built in 1892. It became the city's library 1937–1969, before becoming the Civic Art Gallery in 1972. Today it is the San Jose Museum of Art's Historic Wing.

6 California State Normal School
The wooden buildings that housed the forerunner of San Jose State University were built in Washington Square in 1871. Replaced in stone and brick in 1881, they withstood the 1906 earthquake and attempts to demolish them afterwards. Tower Hall was built in 1910, four years after this photograph was taken.

Aerial view of San Jose, 2000s (right)

7 Spaghetti Junction
The photo looks north over the incredible junction of California 87, the Guadalupe Parkway running north-south, and U.S. Interstate 280, the Sinclair Freeway running east-west.

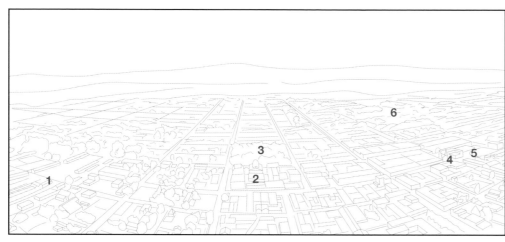

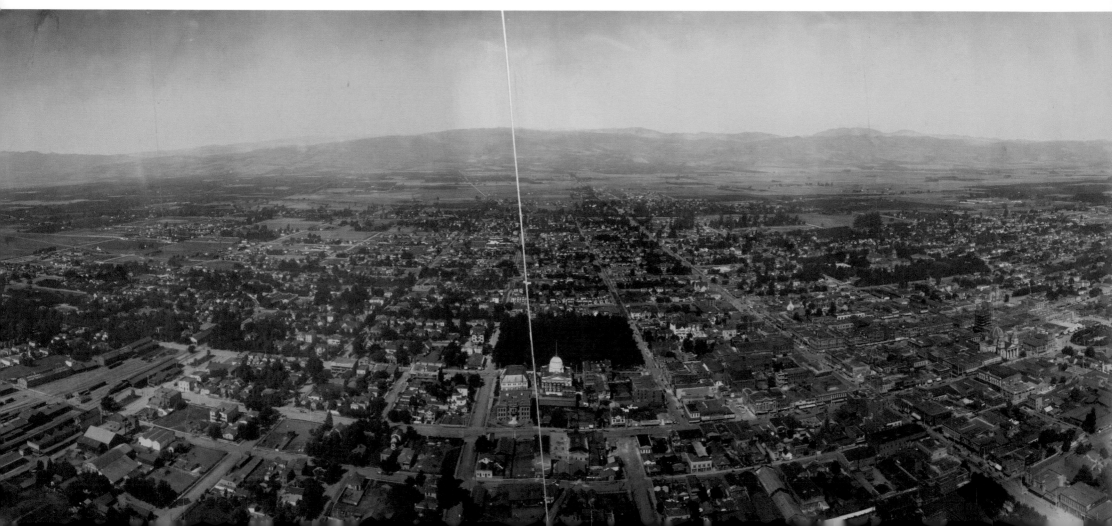

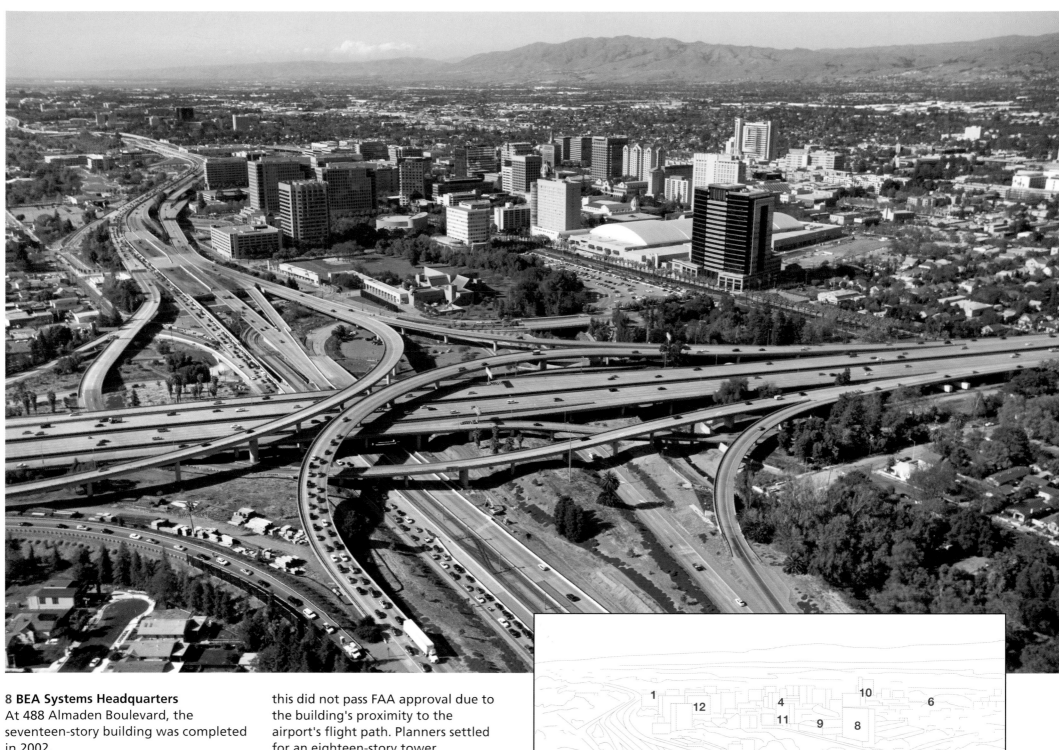

8 BEA Systems Headquarters
At 488 Almaden Boulevard, the seventeen-story building was completed in 2002.

9 San Jose McEnery Convention Center
The convention center has 143,000 square feet of column-free exhibit space.

10 City Hall
Designed by Richard Meier and located at 200 East Santa Clara Street, City Hall opened in 2005. The original design called for a peak height of 320 feet, but this did not pass FAA approval due to the building's proximity to the airport's flight path. Planners settled for an eighteen-story tower.

11 Hilton
The Hilton Hotel at 300 Almaden Boulevard is positioned to take advantage of convention business. Immediately to the north is the Crowne Plaza Hotel.

12 Adobe
The twin tower headquarters of Adobe Systems.

Santa Monica, CA

Ocean Park Bathhouse, 1908 (below)

Ocean Park resort was built on a plot of land that extended 1.5 miles south of what is now Pico Boulevard in Santa Monica to Mildred Avenue in Venice. It boasted a 1,250-foot-long pier at Pier Avenue—it burned down in 1924.

Joseph Cather Newsom built the Moorish-style Ocean Park Bathhouse adjacent to the beach at Navy Street for Alexander Rosborough Fraser. Construction in 1905 cost $185,000. The Bathhouse was an ornate and monumental structure and offered heated salt water swims for those who

found the Pacific Ocean too cold or too dangerous. In 1912 the Bathhouse was completely destroyed by fire. This photo looks toward the southeast.

Santa Monica Pier, 2000 (bottom)

1 Santa Monica Pier
At twilight the famous pier has a special charm. Now more than 100 years old, the pier at the foot of Colorado Avenue is often featured in movies and television series. It hosts Pacific Park (2),

a family amusement park with a Ferris wheel and a carousel from the 1920s. Curiously, in North America carousels (merry-go-rounds) turn counter-clockwise, but in Europe they turn clockwise.

3 Pacific Plaza
Completed in 1963 at 1431 Ocean Boulevard the towers are 180 feet tall and offer the residents wonderful views of the ocean and pier.

4 Bay Cities Guaranty Building
This Art Deco building, with its signature clock tower, was completed in 1931.

5 Original Muscle Beach
In the 1950s, bodybuilders concentrated to work-out and perform south of the pier. Initially, the city responded positively and the area became Muscle Beach. A variety of complaints led to its closure in 1959 and Venice, a few miles

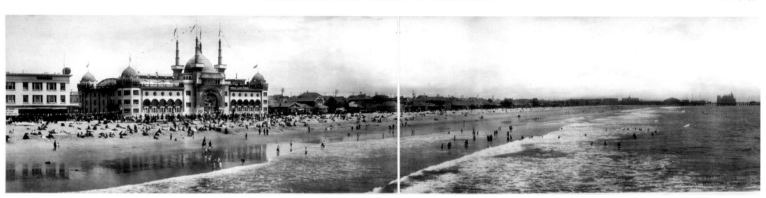

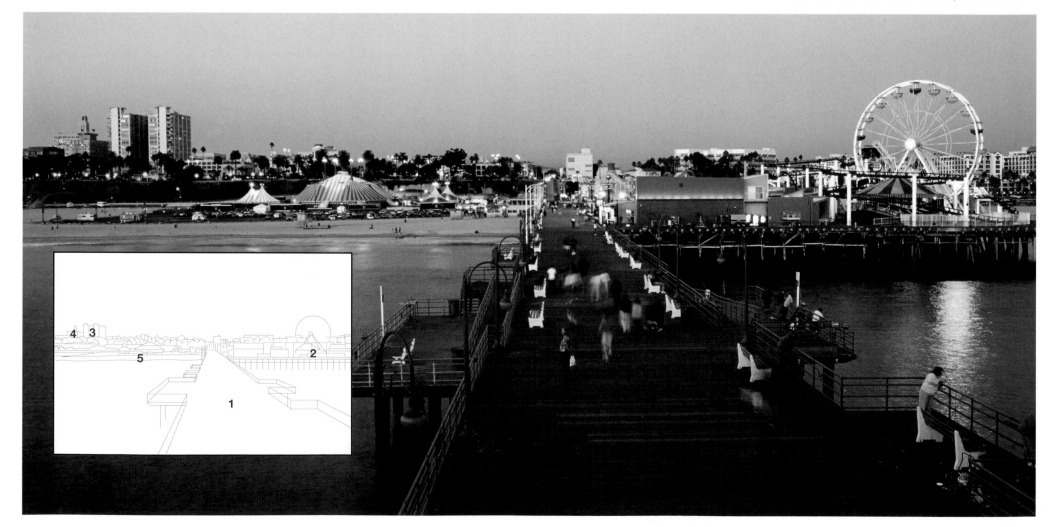

to the south, inherited the attention and the crowds. Santa Monica reopened its beach to bodybuilders and gymnasts in 1989 and thus there are rival "Muscle Beaches" only miles apart.

Ocean Avenue, 2007 (below)

6 Pacific Coast Highway
A view looking north past the boutique Hotel Shangri-La (7), an Art Deco beauty that dates from 1939, and the

unusually shaped Wilshire Palisades (8) of 1980 that is a parallelogram-shaped building. Difficult to see in this photograph but below Ocean Avenue there is a lower road, Pallisades Beach Road, part of the coastal highway that runs along most of the Californian coast.

9 100 Wilshire
Situated on a bluff overlooking Santa Monica Beach, this residential highrise is the tallest building in the city and offers stunning views of the ocean and greater Los Angeles.

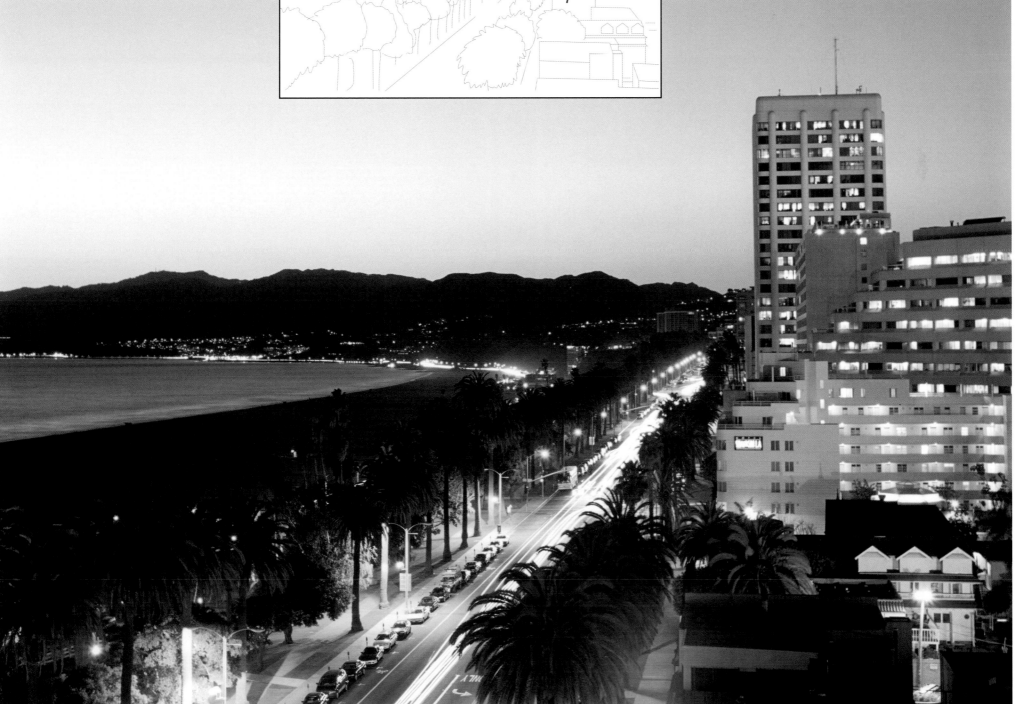

Savannah, GA

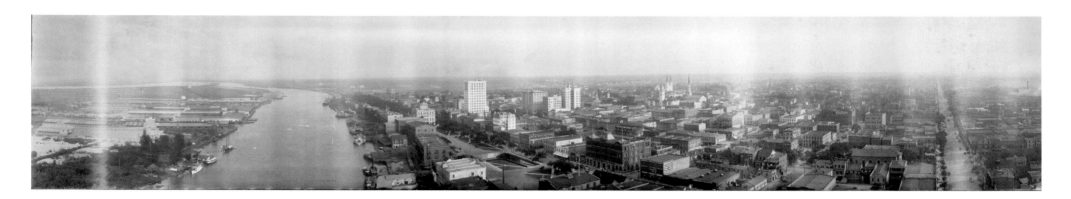

Savannah, 1912 (top)

Savannah was formed in 1733 when James Oglethorpe established a British Royal Crown Colony on the banks of the river and created a town. It was built as a frontier outpost to protect the Carolinas from Spanish incursions from Florida. By 1912, it was a thriving, if warm and sleepy, commercial port.

1 City Hall
Tall (141 feet), built in 1905, designed in Beaux-Arts style by architect Hyman Wallace Witcover (1871–1936).

2 East Bryan Street
Mowbray & Uffinger were the architects of the fifteen-floor 225-foot First Union Bank Building completed in 1911.

3 Cathedral of St. John the Baptist
Established in the late 1700s, constructed 1873–1896, it had to be rebuilt in 1898–1899 after a fire. Fully restored in 2000.

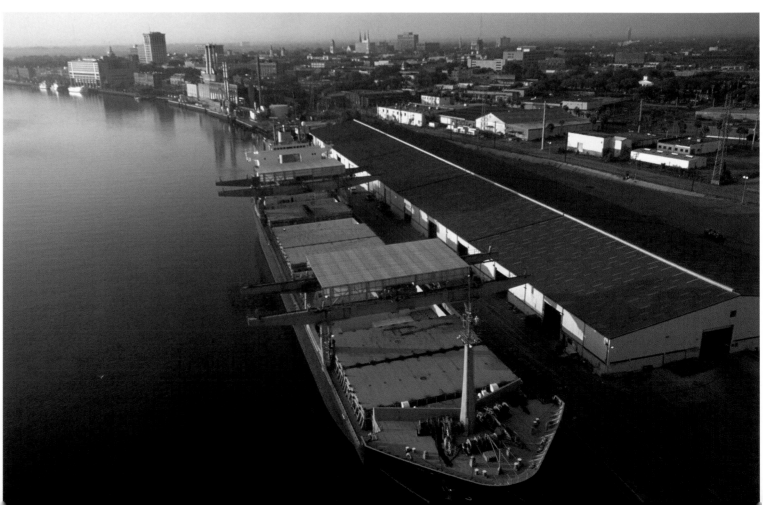

4 Broad Street
Union Station was built at 419 Broad Street, to the design of architect Frank Pierce Milburn, and completed in 1902 at a cost of $150,000.

Savannah, 1995 (below left)

5 Yamacraw Bluff
Savannah was established on a bluff eighteen miles upstream from the Atlantic Ocean. In the beginning, James Oglethorpe drew a map with blocks of houses and public squares aligned in parallel rows to the "Strand" or the waterfront. Here, a cargo ship is docked at the Port of Savannah, that same strand from 1733. Founded with perpendicular streets and plenty of parks, Savannah remains a city of trees and pleasant neighborhoods.

6 Manger Building
Completed 1912 as the Hotel Savannah, to the design of William Lee Stoddart (1869–1940) who was known for urban hotels.

View of Savannah from the Southeast, 2005 (below)

7 Colonial Park Cemetery,
Established in 1750, the park-like cemetery has been closed to interments since 1853.

8 Drayton Towers
This wonderful example of early Modernist architecture was completed in 1950 to the design of William P. Bergen.

9 Talmadge Memorial Bridge
Completed 1990 (see pages 222–223).

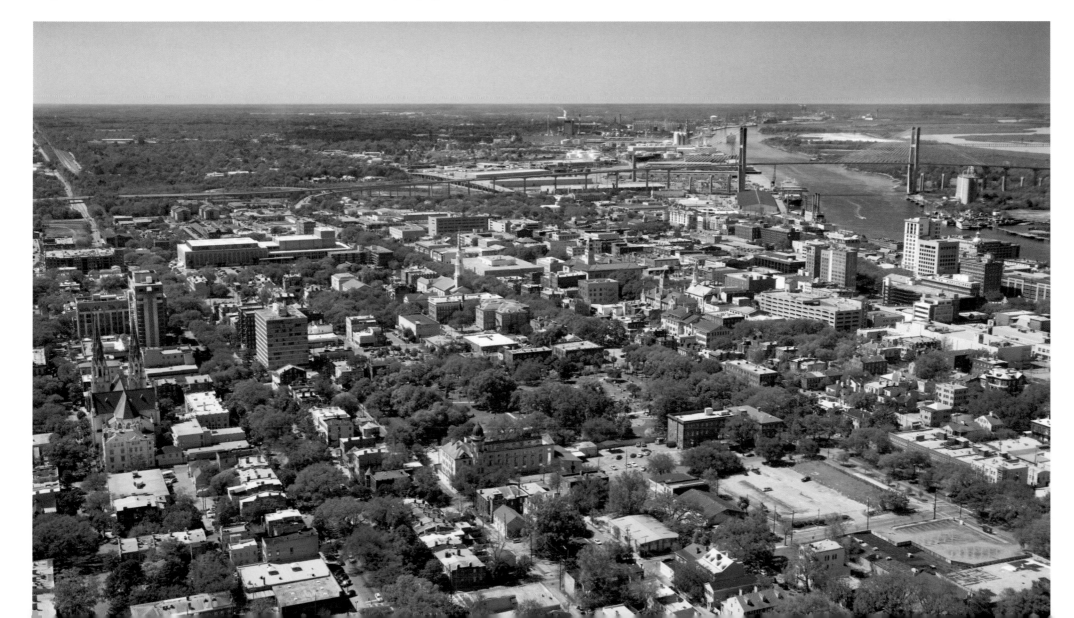

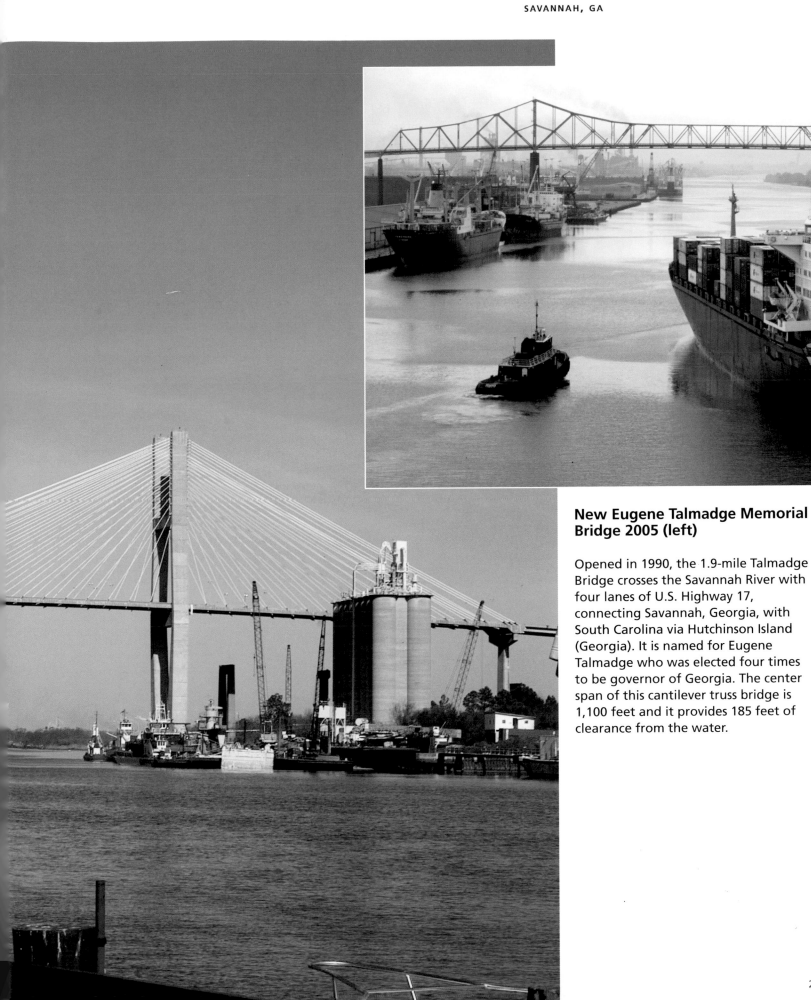

New Eugene Talmadge Memorial Bridge 2005 (left)

Opened in 1990, the 1.9-mile Talmadge Bridge crosses the Savannah River with four lanes of U.S. Highway 17, connecting Savannah, Georgia, with South Carolina via Hutchinson Island (Georgia). It is named for Eugene Talmadge who was elected four times to be governor of Georgia. The center span of this cantilever truss bridge is 1,100 feet and it provides 185 feet of clearance from the water.

Old Savannah Bridge 1985 (above)

A tugboat accompanies a loaded cargo ship upstream on the Savannah River toward the old Talmadge Bridge from the Atlantic Ocean. Opened in 1953, the old bridge became a danger for large ships entering the Port of Savannah, the largest single terminal container port on the U.S. eastern seaboard.

Seattle, WA

Seattle and Space Needle, 1962 (below)

1 Space Needle
The city's most iconic structure, the Space Needle is to Seattle as the Eiffel Tower is to Paris. Built in 1962 for the World's Fair, it rises 605 feet above the street. At the time of completion it was the tallest structure in the Western Hemisphere.

2 Monorail
Opened in 1962 as part of the World's Fair, the mile-long Seattle Monorail provides regular transit from the Westlake Center Mall to the Seattle Center Station. These articulated trains straddle a central rail in what was envisioned as a futuristic mode of public transport. At the time of construction planners anticipated the Monorail system would be expanded, but as of 2010 it remains in essentially its 1962 configuration.

3 Mt. Rainier
Washington state's highest peak, 14,411 feet above sea level, this part of the Cascade Range of volcanic mountains includes Mt. St. Helens to the south. While Mt. Rainier is a little more than fifty miles from Seattle, Mt. St. Helens is more than ninety-five miles distant. Yet when Mt. St Helens blew its top in 1980, it was clearly visible from the city.

4 Puget Sound
Part of the network of estuaries that provides a maritime link with the Pacific Ocean.

5 Wall Street Tower
On the corner of Wall Street and 5th Avenue, this distinctive eighteen-story high-rise was separated from all other tall buildings in the city. It is noted for being wider than it is tall, and for proximity to the famous Monorail. Situated in the Denny Regrade area of downtown Seattle, this well-known building was substantially renovated in 2001.

6 Seattle Center Station
The northern terminal for the Monorail.

Seattle and Space Needle, 2006 (right)

7 One Union Square
A thirty-six-floor tower designed by TRA Architects and completed in 1981.

8 Fourth & Blanchard Building
Known colloquially as the "Darth Vader" building because of its unusual shape—the roof features a distinctive

forty-two-degree incline—and dark glass façade. This twenty-five-story office building was designed by Chester L. Lindsey Architects and completed in 1979, two years after the commercial release of the motion picture *Star Wars*.

9 1201 Third Avenue Tower

Completed in 1988, and also known as the Washington Mutual Tower when it was the headquarters of the failed bank. It gained the unofficial moniker the "Spark Plug." At 771 feet, it remains Seattle's second tallest building.

10 Two Union Square

Completed in 1989, it stands 740 feet above the street and consists of fifty-six stories. Designed by NBBJ international firm founded in 1943 by four Seattle architects Naramore, Bain, Brady and Johanson.

11 Pacific Science Center

The Seattle science museum original buildings were the U.S. Science Pavilion, part of the 1962 World's Fair in Seattle. Today it includes two IMAX theaters and Laser Dome theater.

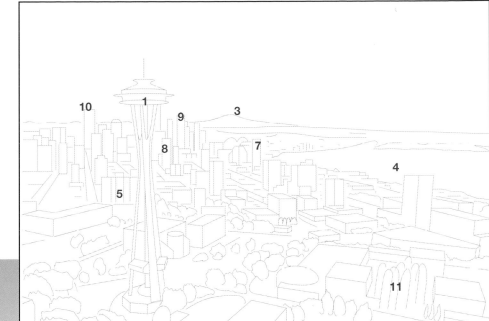

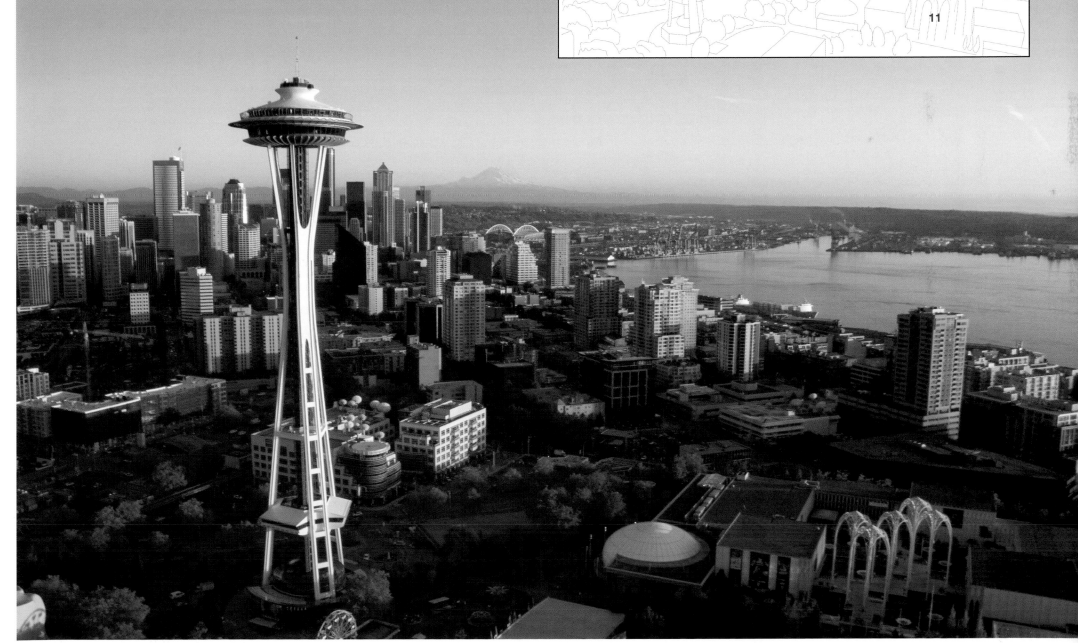

Tulsa, OK

Tulsa, 1908 (top) and 1910 (above)

Lewis Perryman's 1846 log cabin trading post at a bend in the Arkansas River near what is now 33rd Street and South Rockford Avenue established the site of Tulsa, or Tulsey Town as it was first known. Only thirty-three years later when the first post office opened and a railroad arrived did the fledgling hamlet adopt the current name. By the turn of the century, Tulsa barely held 2,000 inhabitants. It was the discovery of Black Gold, oil, at Red Fork that

made Tulsa a city. A giant reserve of oil and natural gas, called the Glenn Pool Strike, was discovered in Red Fork, just across the river. Almost immediately, a group formed to map out a commercial strategy to promote Tulsa. They began building in anticipation of boom times, soon building an airport, and Tulsa briefly shared the title Oil Capital of the World. In 1910, the date of the panoramic photo taken at the corner of Main and Second streets, Tulsa's population was about 18,000. Note the trolley lines (1) along Main Street beside Fischer's department store.

2 First National Bank of Tulsa (identified on top photograph)

"The Oilman's Bank" celebrated its fifty-fifth anniversary by moving into a new headquarters on July 29, 1950. Years later, it unveiled plans for a forty-one-story First National Tower that would connect with the bank's existing twenty-story tower.(9)

3 A. Y. Boswell Company

The successful jewelers' (this was their fourth store) building on the northeast corner of Second and Main.

Tulsa, 2010 (right)

4 Boston Avenue United Methodist Church

This Art Deco masterpiece has catered to the Methodist congregation in the downtown Tulsa area since 1929. It was designed by Adah Robinson and Bruce Goff, although to this day there is controversy about this: Robinson was an art teacher; Goff, her former student,

worked at architects Rush, Endacott and Rush. It has a semicircular auditorium, a 225-foot tower reminiscent of Gothic cathedrals in Europe, and a wing containing classrooms. The exterior terra-cotta sculptures are by another of Robinson's students: Robert Garrison.

5 110 West 7th Street

Dating from 1971, this twenty-eight-story office tower frames the Roman Catholic Cathedral of the Holy Family and the round dome of the First Christian Church building.

6 Oneok Plaza

Originally designed as a fifty-two-story highrise, it was reduced to thirty-seven and once again to the present height of seventeen floors after the building was sold during construction.

7 Mid Continent Tower

Finished in 1918, the original sixteen-story building was restored in 1980 and a twenty-story tower was constructed

over the original building; it now reaches to thirty-six floors.

8 First Place Tower
At 15 East Fifth Street, this forty-one-floor glass, steel and concrete structure opened in 1973.

10 320 South Boston Building
With its signature spire for docking airships, designed by George Winkler, the original ten-story building was heightened in 1928 to twenty-two stories (400 feet).

11 Philtower
Built 1927; twenty-four stories; unique feature is the sloping brightly-colored tile roof.

12 Bank of America Center
A thirty-two-floor skyscraper built in the modern style, it opened in 1967.

13 Holy Family Cathedral
A Neo-Gothic Roman Catholic cathedral that opened its doors in 1914 was the tallest building in Tulsa at 251 feet until 1925.

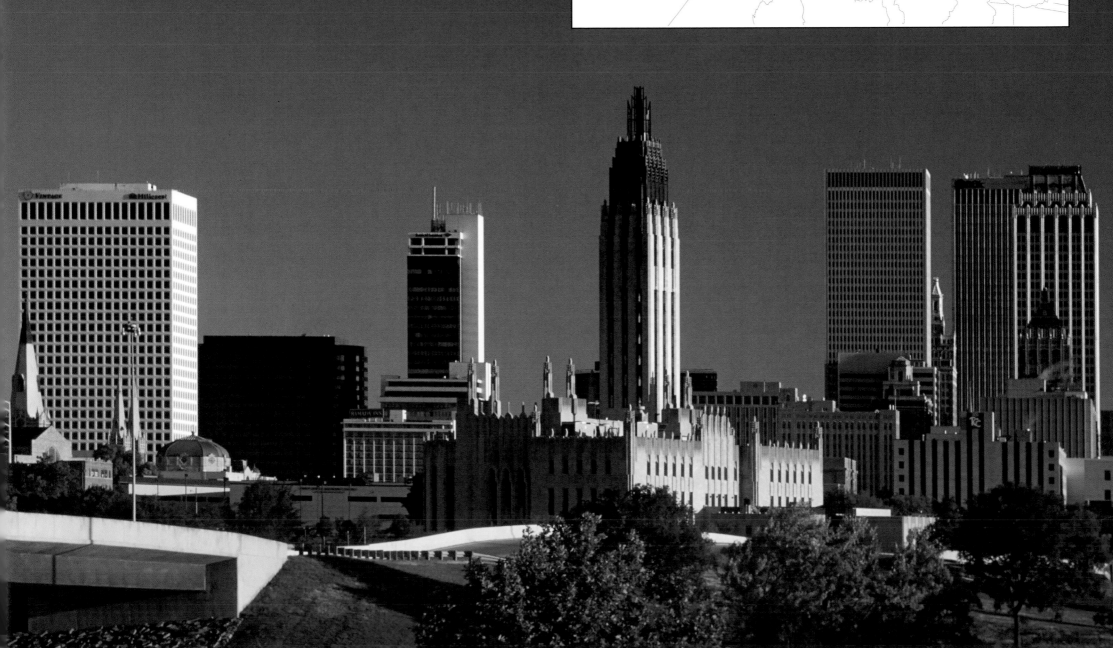

Washington D.C.

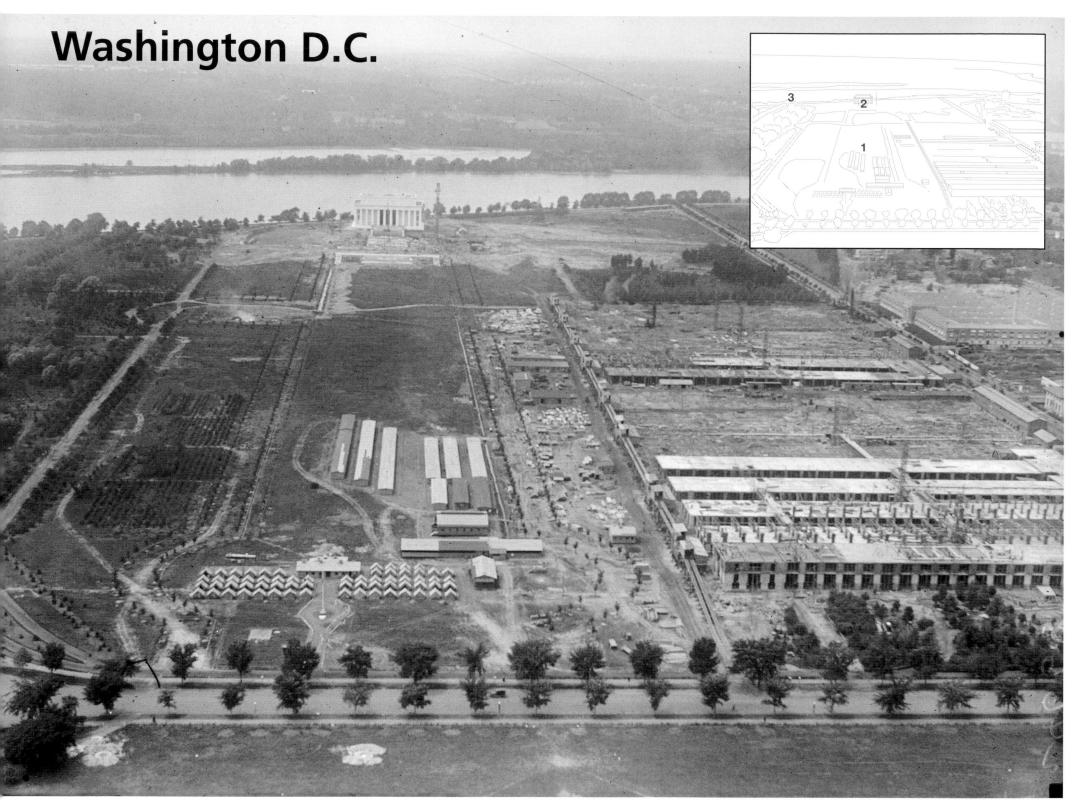

West end of the National Mall, 1918

Aerial view looking west towards the Lincoln Memorial. This image was exposed about 1918, prior to completion of the memorial building and construction of the Refection Pool.

1 Future site of Reflection Pool
So often is the famous reflection pool pictured in images of the Lincoln Memorial and Washington Monument, it seems odd to view the land around these monuments without it. Designed by Henry Bacon, this shallow pool is 167 by 2,027 feet which makes it the largest

such pool in Washington. Its construction during 1922–1923 coincided with completion of the Lincoln Memorial.

2 Lincoln Memorial
Located at the western end of Washington's National Mall, the Lincoln

Memorial is one of the city's best-known icons. It features thirty-eight Doric columns. Also designed by Bacon, it was dedicated in 1922, and built as a monument to America's sixteenth—and many would say greatest—president. Abraham Lincoln was president during most of the Civil War (1860–1865) and

was the first president murdered in office. The memorial features an enormous statue of Lincoln by Daniel Chester French.

3 Potomac River

Beginning as a mere creek in the hills of West Virginia, the Potomac meanders an estimated 383 miles before flowing into Chesapeake Bay.

West end of the National Mall, ca. 1925 (below)

Aerial view of the Lincoln Memorial in Washington D.C. looking east toward the Capitol.

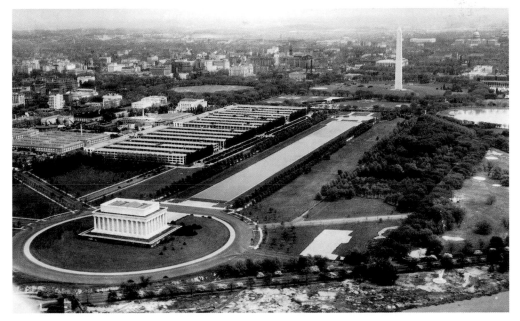

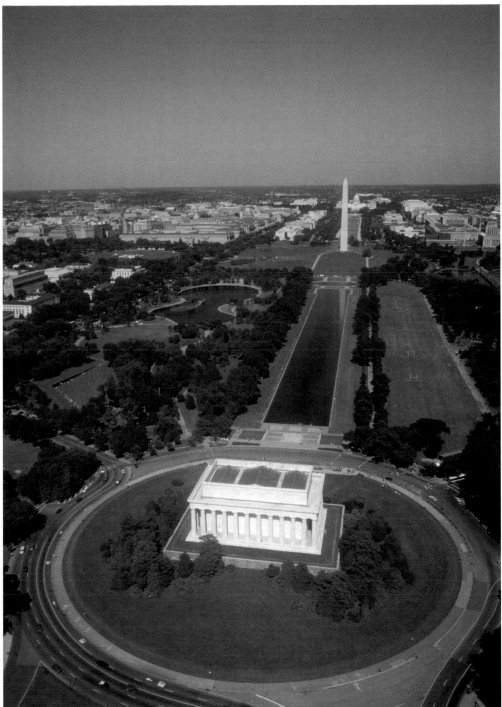

4 Washington Monument

Dedicated to America's first president, and designed to emulate a classical Egyptian obelisk, many years were required for its construction. It was finally completed in 1884—thirty-six years after work began.

5 Capitol Building

Venue for assembly of the United States Congress. Building the Capitol took place over many years from 1793— including rebuilding parts burned by the British in the War of 1812.

West end of the National Mall, ca. 2005 (above)

6 Vietnam Veterans Memorial

One of a number of memorials to the fallen in war (such as World War II and the Korean War), the main part is a wall upon which are listed the 58,159 names of those killed in the Southeast Asian war.

Capitol Hill, 1961 (below)

1 United States Capitol
Groundbreaking occurred in 1793, and while the building was partially complete by 1811, it was badly damaged in the War of 1812. Reconstruction was initiated in 1815 and the basic structure was finally completed four years later. The Capitol's crowning iconic dome is made of cast iron and constructed between 1855 and 1866.

2 Russell Senate Office Building
A Senate office building built between 1903 and 1908 to relieve overcrowding in the Capitol. Largely designed by John Carrere in the Beaux-Arts style.

3 Washington Union Station
Designed by William Peirce Anderson of Daniel Burnham and Company and completed in 1907 to replace several older railway terminals. Traditionally the station served several major railroads including: Pennsylvania

Railroad, Baltimore & Ohio, Southern Railway, and Richmond, Fredericksburg & Potomac. After years of decay, it was nearly demolished in the 1970s, but was instead restored and rededicated in 1988.

4 Dirksen Senate Office Building
The second of three office buildings constructed for the Senate was completed in 1958, although an entire interior center wing of the building was omitted. The latter was finally

completed in 1982, as part of an entirely new building that was named the Hart Senate Office Building (13), which boasts an Alexander Calder sculpture—"Mountains and Clouds"—in its atrium.

5 United States Supreme Court Building
Housing the highest judiciary in the U.S. The building was built at the height of the Great Depression and completed in 1935. The Neoclassical design was the work of Cass Gilbert.

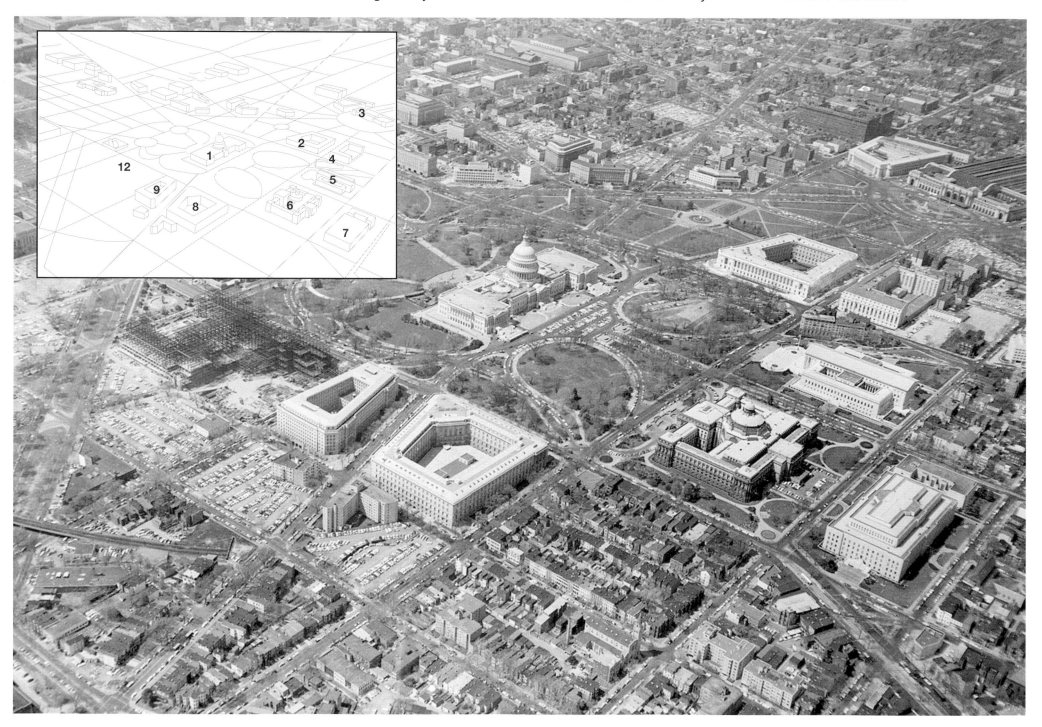

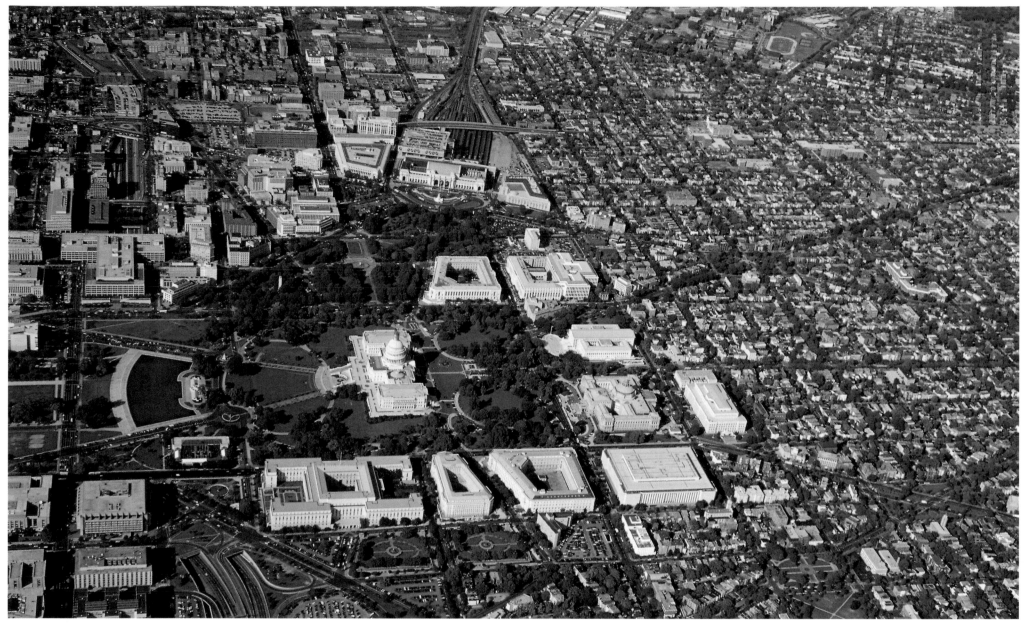

6 Library of Congress—Thomas Jefferson Building
Opened in 1897, and originally known as the Library of Congress Building.

7 Library of Congress—John Adams Building
An annex to the Jefferson Building; opened in 1939.

8 Cannon House Office Building
Built in 1908, the oldest Congressional office building.

9 Longworth House Office Building
Opened in 1933, this office building was named in 1962 after former Speaker of the House Nicholas Longworth.

10 United States Botanical Gardens
Moved to this location in 1933, it houses an estimated 26,000 plants for exhibition and study.

Capitol Hill, 2000 (above)

11 Library of Congress—James Madison Building
Official monument to James Madison fourth president of the United States (served 1809–1817), opened in May 1980.

12 Rayburn House Office Building
Under construction in the 1961 photograph, this building was constructed 1962–1965 to give space to members of the House of Representatives.

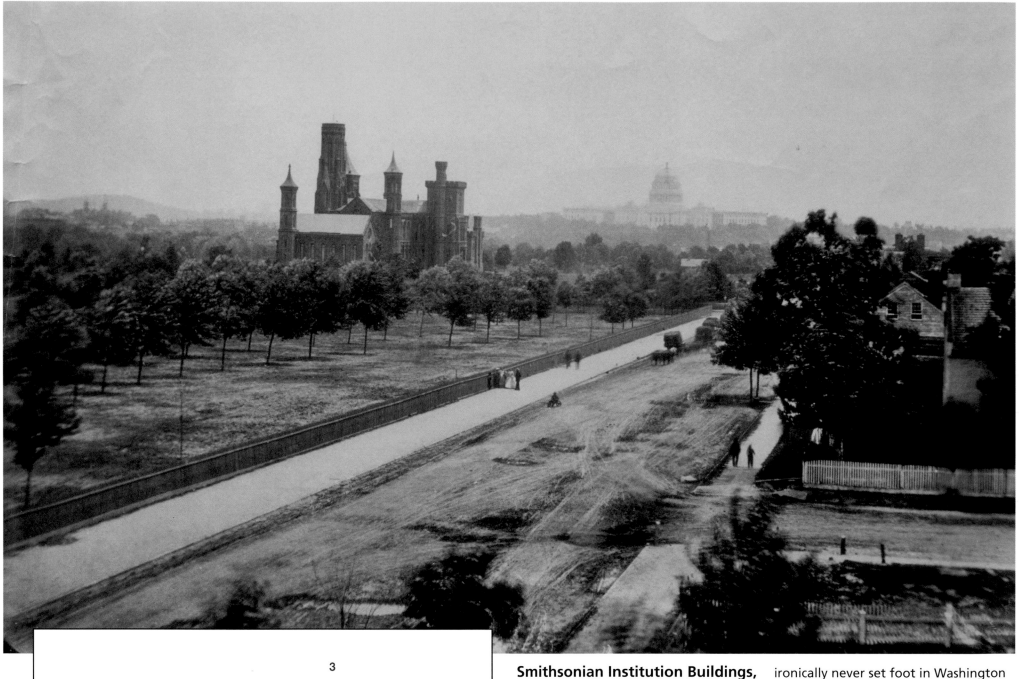

Smithsonian Institution Buildings, 1865 (above)

1 Independence Avenue
Primary Washington D.C. thoroughfare that runs east-west along the south side of the National Mall.

2 Smithsonian "Castle"
Located on the National Mall, this famous brick building was designed by James Renwick, Jr., and finished in 1855. It is the first and oldest of the Smithsonian buildings in Washington. Founded by James Smithson (1765–1829)—a British scientist who ironically never set foot in Washington or anywhere in the United States—who established a financial legacy to encourage the pursuit of knowledge and ultimately willed it to the United States Government.

3 United States Capitol Building.
Washington's most imposing structure.

Smithsonian Institution Buildings, 2009 (right)

4 Arts and Industries Museum
A classic Victorian structure designed by architectural firm Cluss and Schulze. It

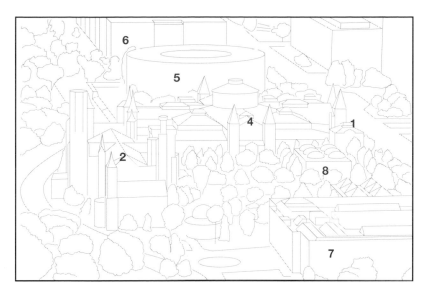

opened in 1881, and originally served as the home to the National Museum. The building has been undergoing substantial renovation in recent years.

5 Hirshhorn Museum

Established in 1974, this modern building was designed by Gordon Bunshaft and, in order to provide a suitable venue for modern art and sculpture, it was intended to present a great contrast with its surrounding traditional architecture.

6 Air and Space Museum

Originally the National Air Museum, the present building was opened in 1976 and represents one of Washington's most popular attractions.

7 Freer Gallery of Art

Specializes in art from ancient Egypt, Near East, Asia, as well as America. Founded by railroad car supplier, Charles L. Freer (1854–1919), the gallery opened in 1923, and was the first Smithsonian museum focused on fine arts.

8 National Museum of African Art

Its mission statement: the museum "fosters the discovery and appreciation of the visual arts of Africa, the cradle of humanity."

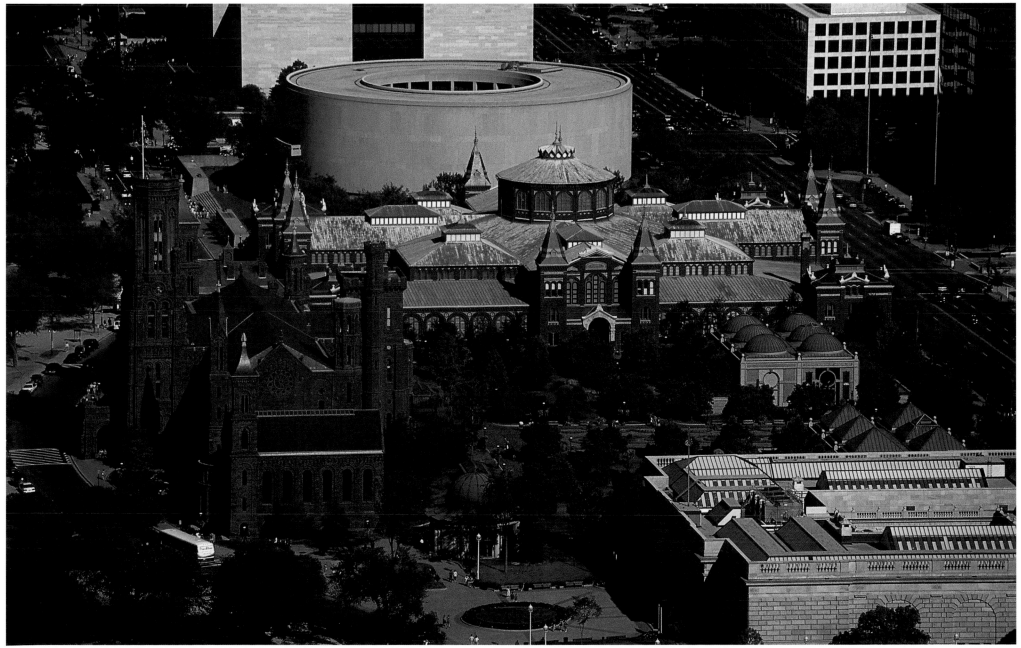

Montreal

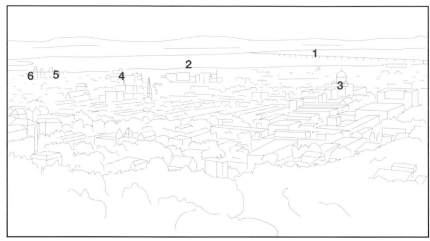

Montreal from Park Mount Royal ca. 1902

1 Victoria Jubilee Bridge
Built in 1859 as part of the Grand Trunk Railway route, this multiple span bridge was the first to cross the St. Lawrence River. It connects Montreal with Saint-Lambert. Originally a tubular bridge it was rebuilt as a more conventional truss bridge. Also known as Pont Victoria, this old railroad bridge has been modified to accommodate both railway and highway traffic and carries Route 112 across the St. Lawrence.

2 St. Lawrence River
Considered the longest deep-draft river in the world, the St. Lawrence connects the Great Lakes with the Atlantic Ocean.

3 Cathédrale Marie-Reine-du-Monde
Located on Rue De la Cathédrale, this handsome church was modeled after St. Peter's Basilica in Rome. Designed by Victor Bourgeau, the magnificent dome was completed in 1886, yet the church wasn't entirely finished until 1900.

4 Basilique Notre-Dame-de-Montréal
Designed by Irish architect James O'Donnell in the Neo-Gothic style and constructed in 1829.

5 Court House

6 City Hall

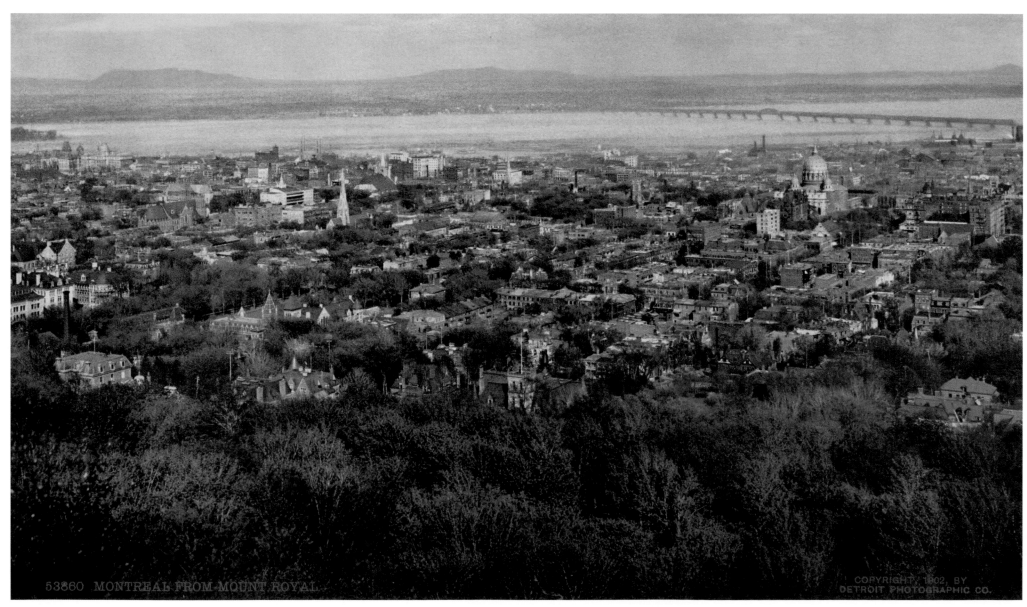

53860 MONTREAL FROM MOUNT ROYAL

Montreal from Park Mount Royal ca. 2009

7 Le 1250 Boulevard René-Lévesque

Montreal's tallest building—forty-seven floors (743 feet), designed by Kohn Pederson Fox, it is conveniently situated adjacent to Windsor Station—originally Canadian Pacific's primary Montreal station, now the terminal for suburban passenger service to the west.

8 Le 1000 de la Gauchetière

Several of Montreal's tallest skyscrapers were built in the early 1990s including this fifty-one-story (673 feet) skyscraper, located adjacent to the Cathédrale Marie-Reine-du-Monde. Since 1992 there have been been no major new skyscrapers added to Montreal's skyline.

9 La Tour CIBC

A forty-five-story office tower for the Canadian Imperial Bank of Commerce that features an aluminum and limestone façade. The tower was built in 1962 and was among the earliest tall skyscrapers in Montreal.

10 Le 1501 McGill College

Sometimes known as Tour McGill, this thirty-six-floor postmodern tower—built in 1992—is famous for its pyramid at the top.

11 Édifice de la Sunlife

Among Montreal's older tall buildings,

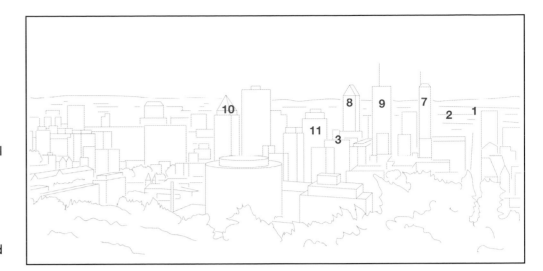

known to English speakers as the "Sunlife Building," this twenty-six story office was opened in 1918, enlarged twice, and for many years stood as the largest building in the British Empire.

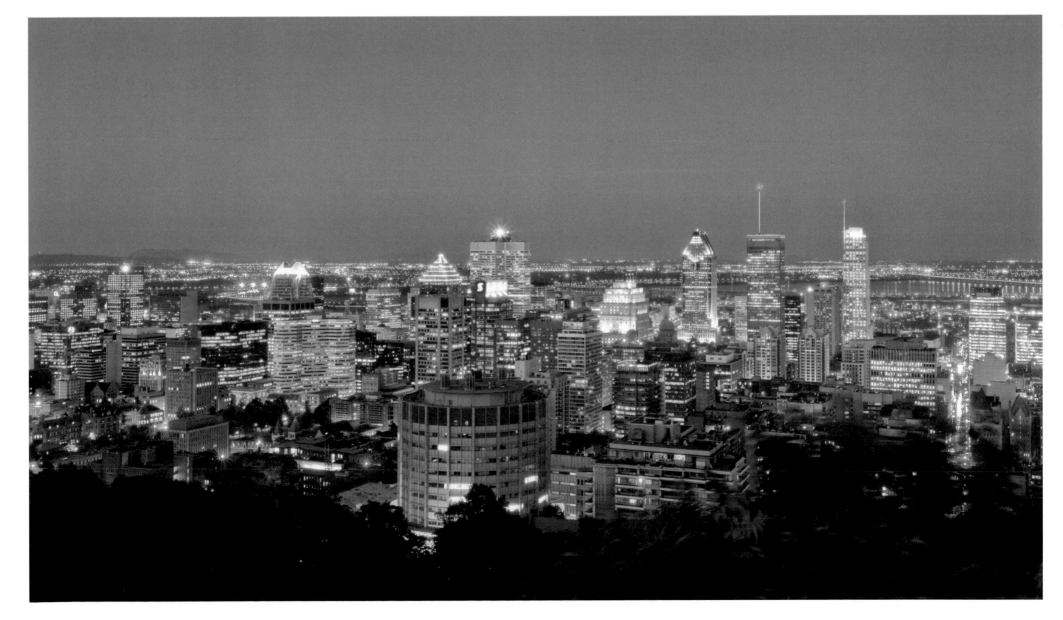

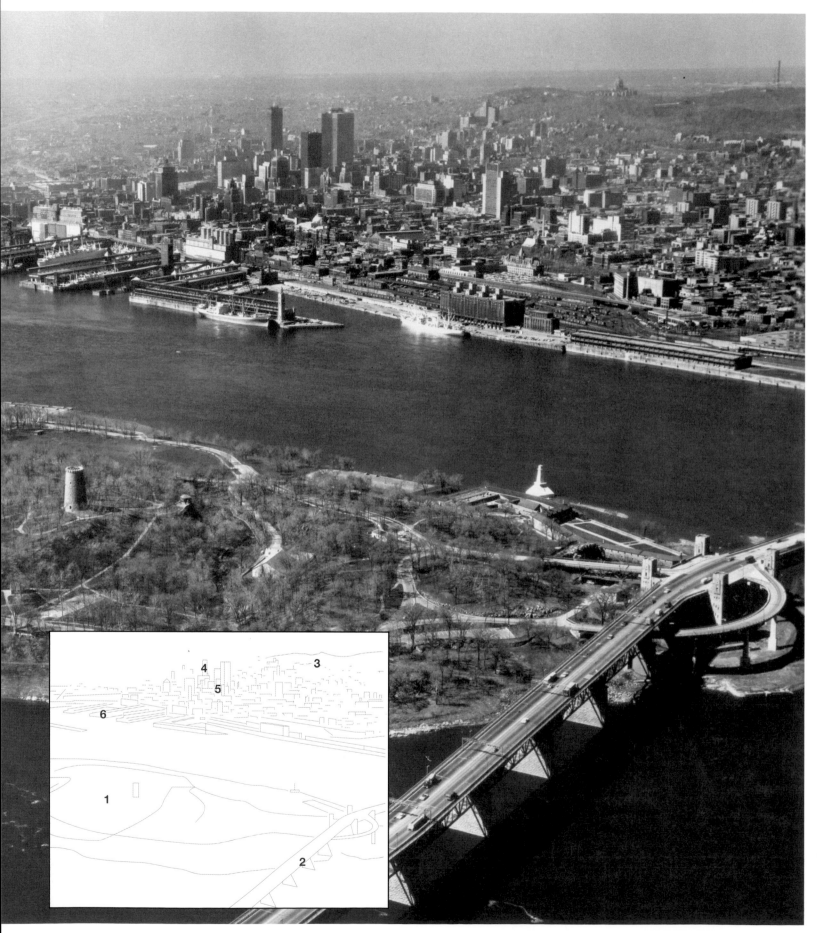

Looking west across the St. Lawrence to Montreal, 1963

1 St. Helen's Island
In French known as Île Sainte-Hélène, it was named in the seventeenth century for Hélène de Champlain. In the early nineteenth century it served as part of Montreal's defenses. Since the 1870s it has been a public park, although it hosted prisoner of war camps during World War II.

2 Jacques Cartier Bridge
Opened in 1930, and originally known as the Montreal Harbor Bridge, it was renamed after the famous French explorer in 1934. This bridge includes a substantial steel cantilever span on the Montreal side of the St. Lawrence crossing. The building beneath the bridge on St. Helen's Island is used as a maintenance base.

3 Parc Mt. Royal
Prominently located in Montreal, north of the downtown, the park actually features three distinct peaks. The tallest is Mont Royal (known in French as Colline de la Croix), 769 feet above sea level. One of Montreal's largest open areas, the park itself was landscaped by Frederick Law Olmsted, famed for his designs for New York City's Central Park. Until 1920, the park hosted a funicular railway to bring visitors to the top.

4 Canadian Imperial Bank of Commerce
A forty-five-floor (591 feet tall) office skyscraper built in 1962.

5 Tour TELUS
Designed by architects Skidmore Owings and Merrill this was among the earlier skyscrapers to grace the Montreal skyline. It was renovated in 1992, the same year that Montreal's tallest buildings were finished.

6 King Edward Basin
Now known as King Edward Quay, it has been developed for recreational purposes.

Looking west across the St. Lawrence to Montreal, 2009

7 Clock Tower Quay
Constructed between 1910 and 1916, this was the last of the quays built at the old Port of Montreal. The clock mechanism is considered to be a replica of that of "Big Ben" in London.

8 Place Ville-Marie
Among Montreal's earliest skyscrapers, this unusual cross-shaped tower, designed in the International Style, remains among its tallest. It is forty-three-stories and 617 feet high.

9 Tour de la Bourse
Known as the Stock Exchange Tower, this eighteen-story office building features a distinctive exterior design with a tinted anodized-aluminum curtain façade and pre-cast concrete corners. Built in 1964, it was renovated in 1995.

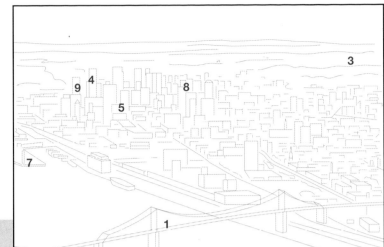

Bank of Montreal, 1900 (left)

The Bank of Montreal (at right in photo) on the Place D'Armes was under construction when photographed from the Church of Notre Dame about 1900. Mt. Royal looms in the distance. Today, the bank is commonly known by its initials BMO.

Bank of Montreal, 2007 (below)

The facade of the Bank of Montreal on the Place D'Armes glows at dusk on September 7, 2007. This famous Neoclassical structure remains as the bank's main Montreal branch. Today the bank operates more than 900 branches across Canada.

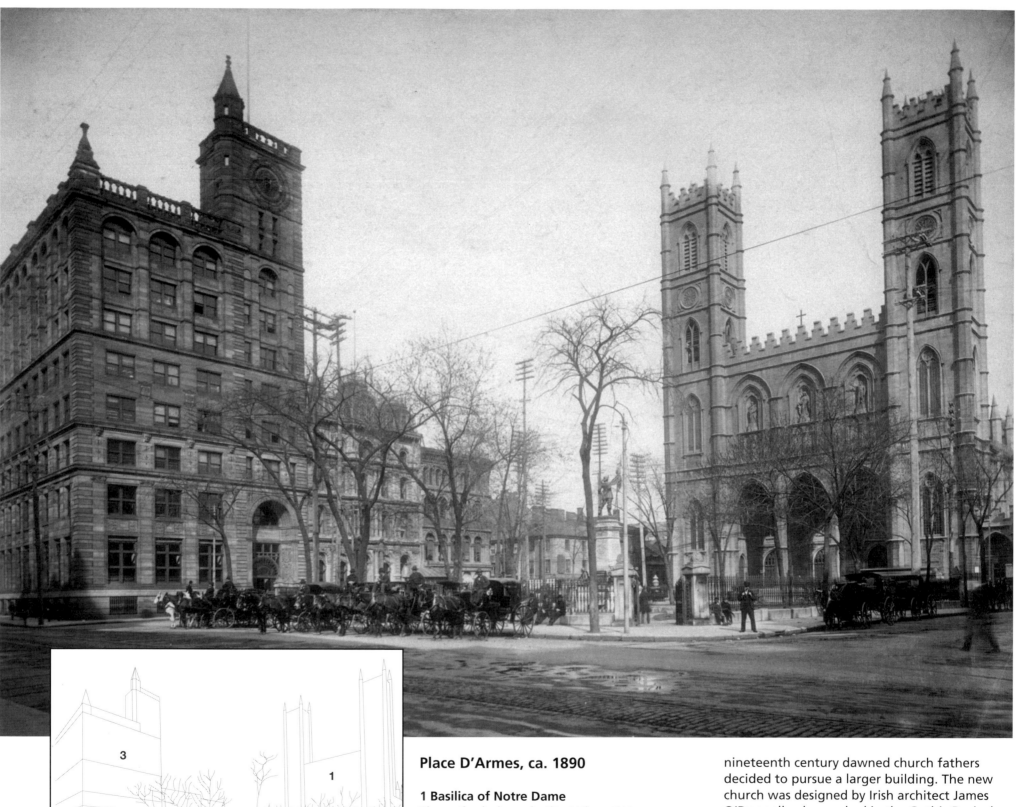

Place D'Armes, ca. 1890

1 Basilica of Notre Dame

The cathedral was built at Place D'Armes, one of Montreal's first significant squares and an early center of culture and commerce. The origins of the church date from the earliest settlement of Ville-Marie, which later developed into Montreal. Although there had been a significant church building on this site since the midsixteenth century, as the nineteenth century dawned church fathers decided to pursue a larger building. The new church was designed by Irish architect James O'Donnell, who worked in the Gothic Revival or Neo-Gothic style. Famous for its twin towers. The church was constructed between 1824 and 1843, when the eastern of the church's twin towers was finally completed. Architect O'Donnell died in 1830 and never saw his work completed.

2 Statue

The work of Philippe Hébert in 1895, depicting pioneer Paul Chomedey de Maisonneuve who founded the famed mission Ville-Marie de Montréal.

3 New York Life Insurance Building

Montreal's first skyscraper, of eleven stories, designed by architects Babb, Cook & Willard and completed in 1888.

Place D'Armes, 2009 (below)

4 The Aldred Building

The work of Ernest Isbell Barott, this classic Art Deco tower rises 316 feet above Place D'Armes. The original design was for just twelve stories, although when completed in 1931 it was nearly twice that height.

5 Duluth Building

Constructed during the period 1901–1923 when Montreal set a height limit on new construction at ten stories or 130 feet, the steel-framed skyscraper is dwarfed by many of Montreal's more modern buildings, the tallest of which (Le 1250 Boulevard René-Lévesque) reaches 743 feet.

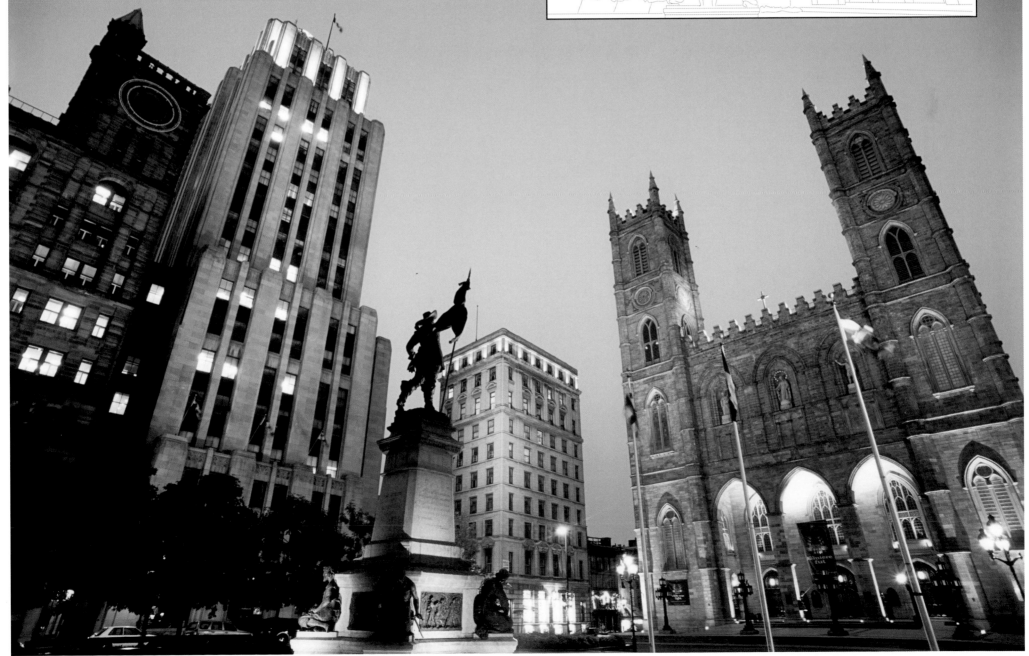

Ottawa

Looking toward Parliament from above St. Andrews, 1968

1 Parliament of Canada
The tower near the center of the complex is known as the Peace Tower; it rises 302 feet above Parliament Hill. Its massive clock is sixteen feet in diameter.

2 West Block
Offices of the Parliament and some of the Cabinet.

3 Alexandra Bridge
A cantilever design built by the Canadian Pacific Railway between 1899 and 1900. It was adapted for joint railway-highway use in the 1950s, and trains last crossed the bridge in 1966 after which it was fully adapted for highway and pedestrian use.

4 Macdonald-Cartier Bridge
A 227-feet box-girder span over the Ottawa River built between 1963 and 1965 and considered a symbolic cultural link between English- and French-speaking Canada.

5 Confederation Building
Serves as the offices for the House of Commons Representatives; this ornate Neo-Gothic design was executed by Clarence Burritt. Construction began in 1927 and was completed in 1931.

6 Bank of Canada
Five-story Neoclassical granite building designed by S. G. Devenport and completed in 1938. Today it also houses the Currency Museum.

7 St. Andrew's Presbyterian Church
Built in 1828 for the laborers who were constructing the Rideau Canal.

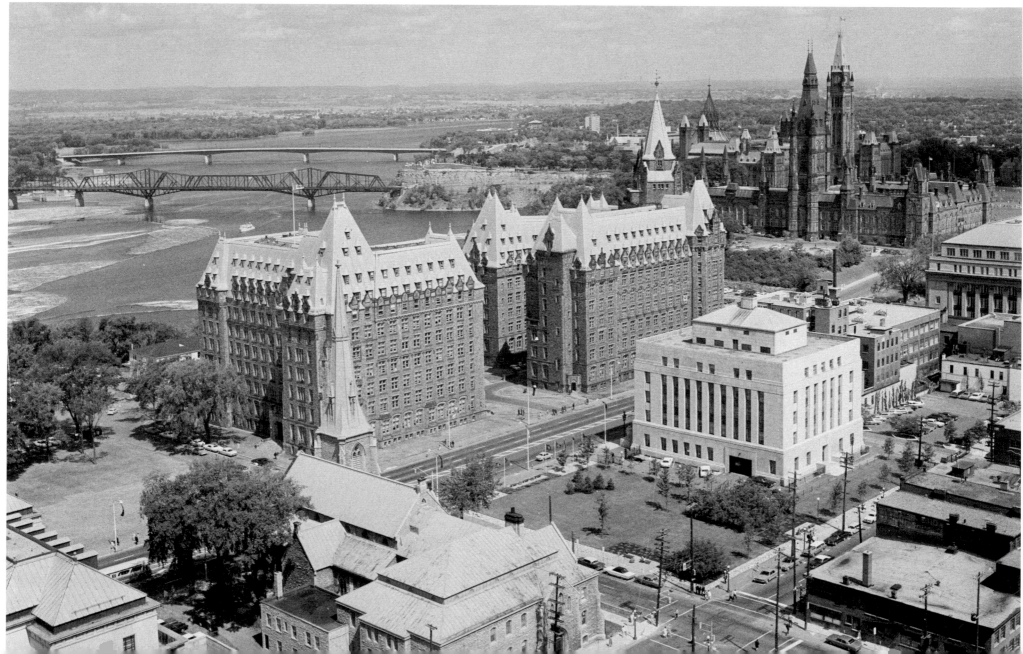

8 Wellington Street

Looking toward Parliament from above Old Union Station, 2009

9 Fairmont Chateau Laurier Hotel
Built by Canada's Grand Trunk Railway in 1912, the hotel has remained one of Ottawa's most famous landmarks ever since. It was named for Sir Wilfred Laurier, Canada's seventh Prime Minister. The Grand Trunk Railway was a major component of the Canadian National Railways system created in the 1920s.

10 Old Ottawa Union Station
Built in 1912 by the Grand Trunk Railway, it served in its original capacity until 1966, when an

unenlightened planning decision opted to discontinue railway passenger service to downtown Ottawa. Today the station building serves as the Government Conference Center.

11 Confederation Square
Near Ottawa's Parliament Hill, this has been a popular site for tourists and some public events.

12 National War Memorial
To commemorate Canada's fallen in the Great War, ironically it was officially unveiled by King George VI in 1939 on the eve of World War II.

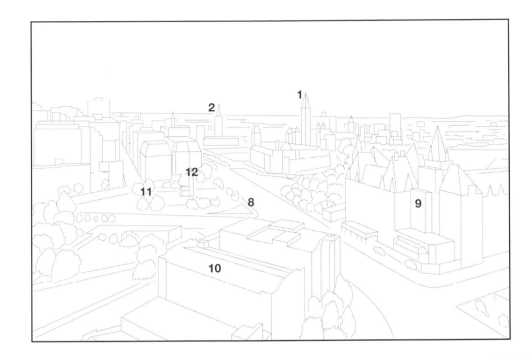

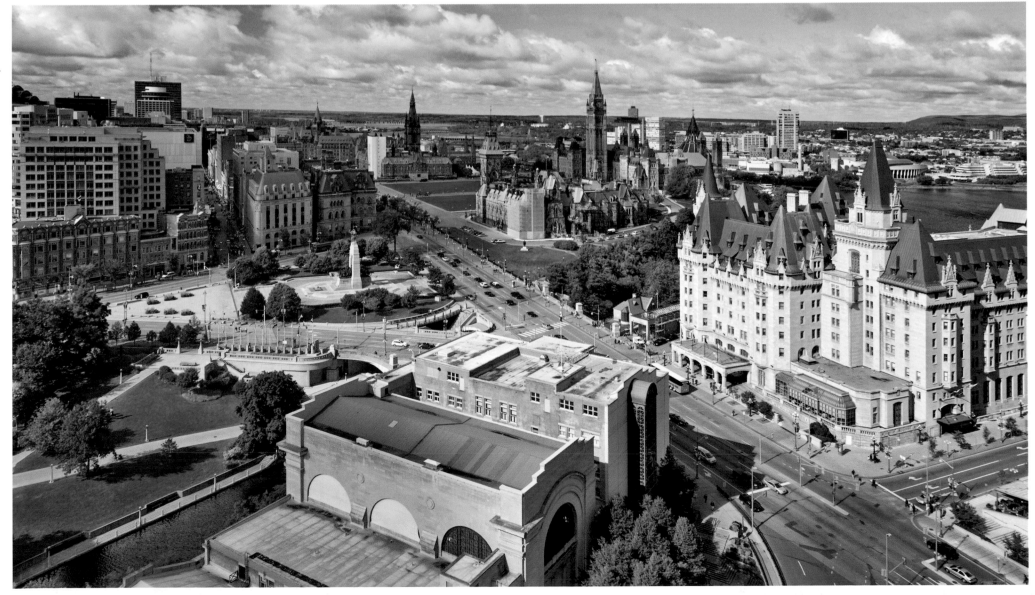

Quebec

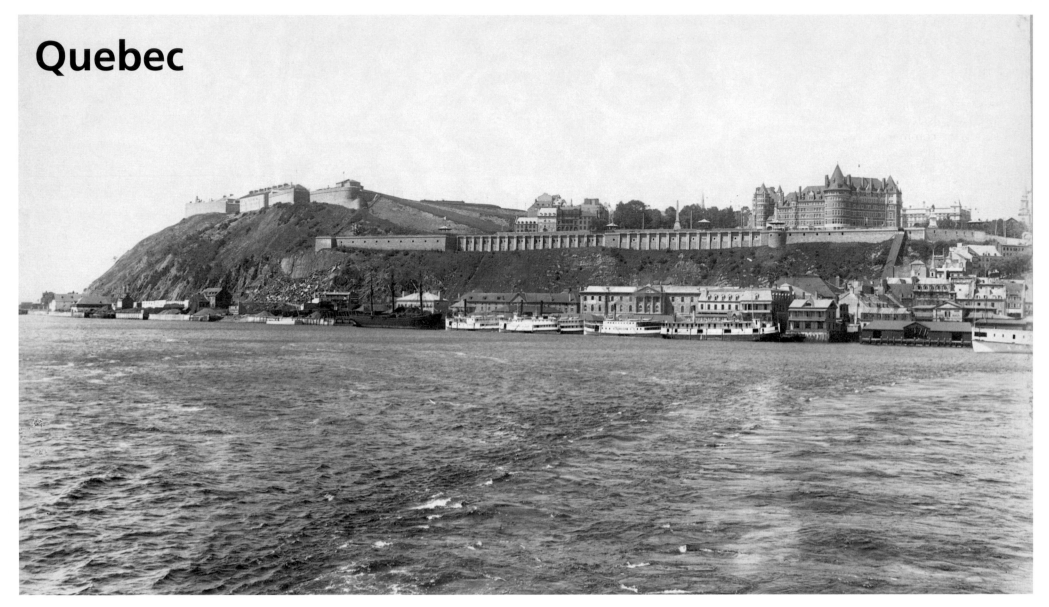

Quebec from the St. Lawrence, 1901 (above)

1 Le Château Frontenac

Quebec's most famous building, this has been visited by numerous dignitaries from around the world, including Alfred Hitchcock, Princess Grace of Monaco, and French Premier Charles de Gaulle. It's one of Canada's premier hotels, named for Louis de Buade, Count of Frontenac, who was governor of New France in the late seventeenth century. Built by the Canadian Pacific Railway, also one of Canada's primary operators of luxurious hotels, the Frontenac was constructed in stages over a thirty-year period. This image was made prior to completion of the central tower in 1924 (3).

2 Quebec City Ramparts

The old wall makes Quebec the last surviving fortified city in North America. Dating to 1608, it was the first city in Canada and among the oldest significant European settlements in North America. Yet, the city's history predates French settlement; in 1535, when pioneer explorer Jacques Cartier reached the area now occupied by Quebec City, there was already a thriving Iroquois village there known as Stadacona.

Quebec from the St. Lawrence, 2005 (right)

3 Tour Centrale

This eighteen-story high portion of Le Château Frontenac was for many years

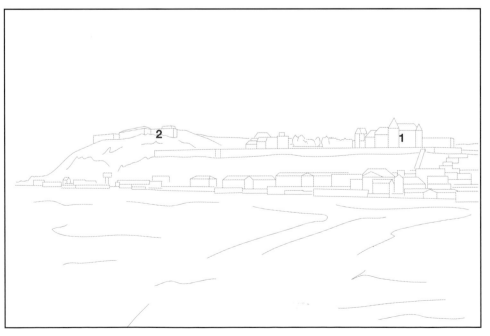

Quebec's tallest and best known structure. It is still an impressive addition to the château.

4 Edifice Price

On Rue Saint-Anne, Quebec's pioneer skyscraper—built 1930—rises from within the old city walls. It serves both as residential and commercial office building. Today it is only the twenty-first tallest in the city, but still stands out because of its premier location.

5 Royal Battery

Built in 1691 by Governor Louis de Buade, Count of Frontenac, to help defend the city. It was key during the Siege of Quebec in 1759 and again in 1760, and 1775.

6 Quebec Funicular Railway

One of Canada's shortest, yet steepest railway lines. Dating from 1879, this 210-foot cable-operated line climbs from the Lower Town at a very steep angle.

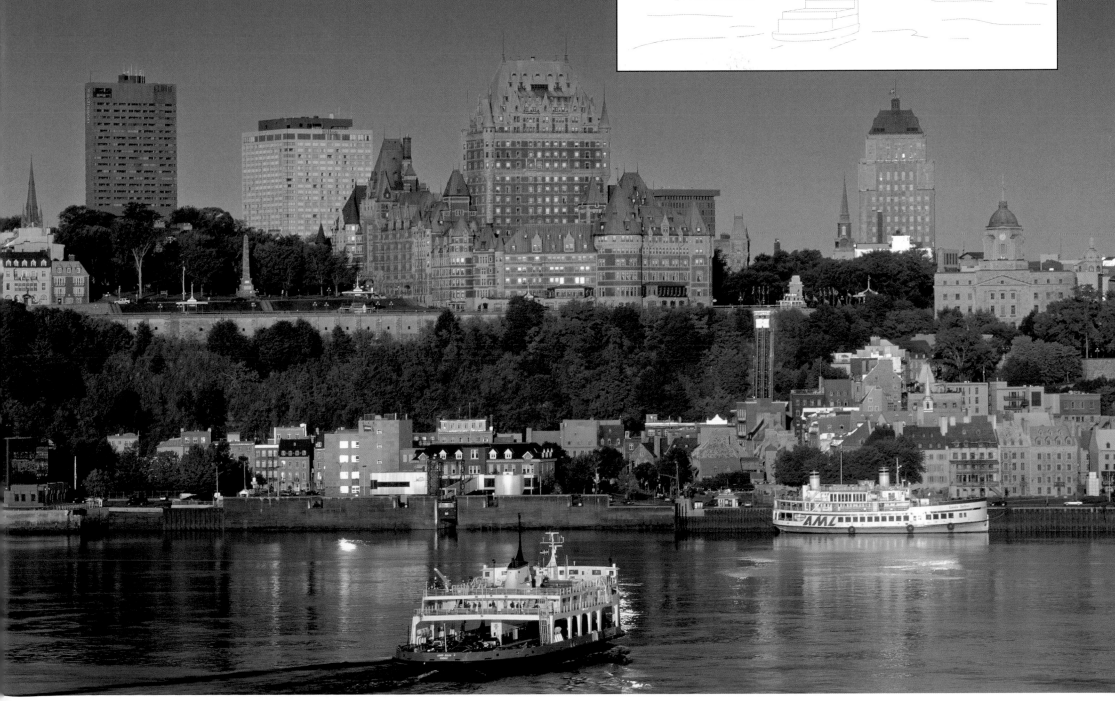

Toronto

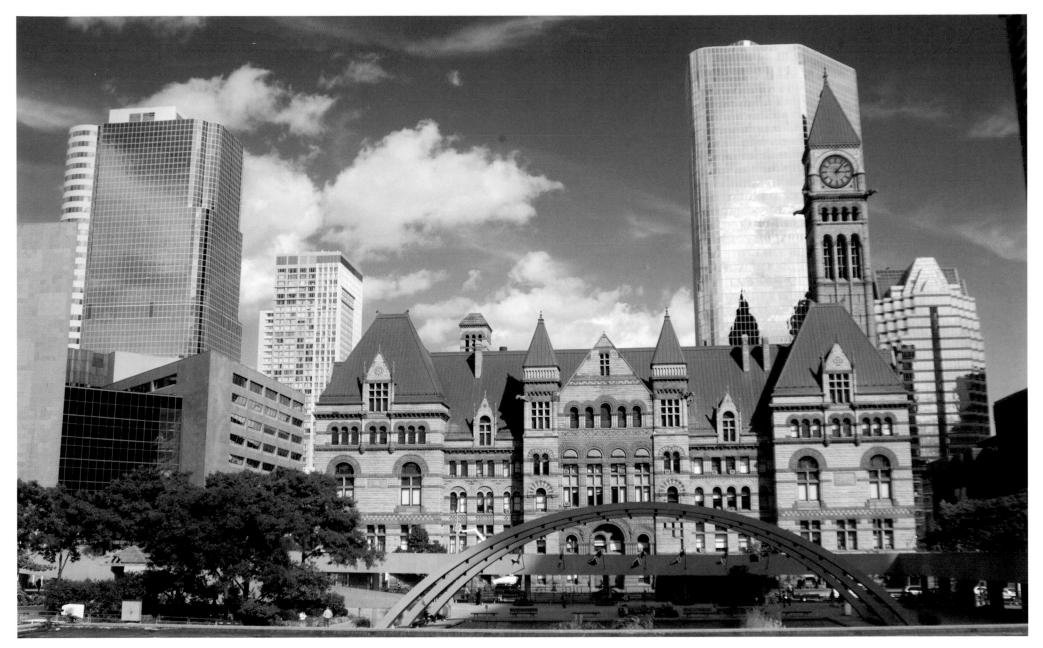

Toronto City Hall, 1939 (left)

1 City Hall

Toronto's City Hall is one of the city's best known structures. Architect E. J. Lennox designed this building in the Romanesque style. When completed in 1899 it was Toronto's largest public building. It continued to serve in its original civic capacity until 1966, when the new City Hall was opened. It later served as a court house. Despite the risk of demolition during the 1960s and 1970s, the building was preserved, and celebrated its centennial in 1999. Located on Queen Street in downtown, it is now a city landmark and a Canadian National Historic Site.

Toronto Old City Hall, 2007 (above)

2 The 250

A thirty-five-story commercial office tower designed by Zeidler Partnership Architects and Crang & Boake that is part of the Eaton Centre at Yonge-Dundas Square. Completed in 1992, it is the newest of the four primary buildings at Eaton Centre.

3 Cadillac Fairview Tower

Also part of the Eaton Centre, this thirty-six-storey office block was completed in 1981 and makes for a stark contrast with the Old City Hall below. In the 1960s, planners hoped to demolish the Romanesque City Hall to make way for modern office blocks, but preservationists prevailed.

4 Nathan Phillips Square

Opened in 1965, a modern public open-space designed by Viljo Revell—the Finnish architect who also designed the new City Hall—serves as a regular venue for public events.

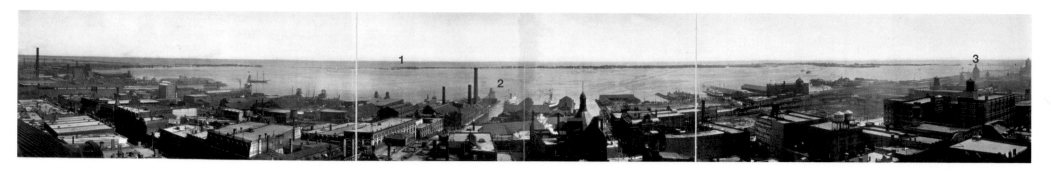

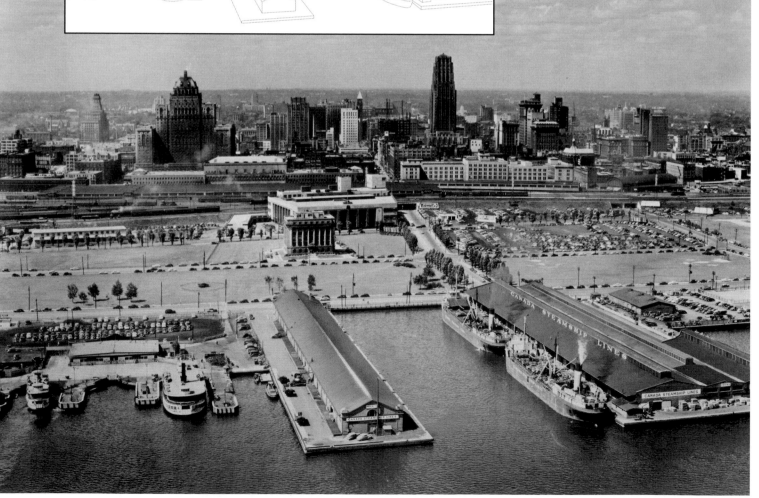

Toronto Harbour, 1910 (identified on photograph above)

1 Island Park
A network of interconnected islands in Lake Ontario off the shore of downtown Toronto that may be reached from the mainland by ferries.

2 Toronto Harbour
Protected by Island Park and a breakwater.

3 Old Toronto Union Station
Designed by Bradford Gilbert who embraced a Romanesque design. Completed in 1896, the station featured three towers and a large train-shed. Railway commerce was growing rapidly and within a few years this facility was already outmoded and in 1915 work on a new Union Station began. Although delayed by World War I, this station finally opened in 1927.

Toronto Harbour, 1940 (left)

4 Royal York Hotel
Opened in 1929, this twenty-eight-floor Château-style building was at the time the largest hotel in the British Commonwealth.

5 Union Station
The "New" Union Station was completed in 1927, and represents Toronto's third Union Station; it was built to serve passenger trains of Canadian National Railways and the Canadian Pacific Railway.

6 Bank of Commerce Building
Designed by architects York & Sawyer, and Darling & Pearson, it was built between 1929 and 1931. Once one of Toronto's tallest buildings its observation deck offered spectacular views of the city and harbor.

7 Canadian Steamship Lines
Wharves and ferry terminals.

8 The Toronto Harbour Commission Building
A six-story building that when built in 1917 by Alfred Chapman sat at the end of a wharf. It is now several hundred yards inland, illustrating infill of the harbour over the years—the difference

being highlighted by the distance between the sea and the coast in these two photographs.

Toronto Harbour, 2005 (below)

A winter view from the CN Tower—Canada's tallest structure—looks across the frozen Key Harbour towards the islands and Lake Ontario. To the right, and out of frame, is Toronto airport.

9 Queen's Quay Terminal
A converted cold storage terminal, now a shopping mall and residential/office complex, Toronto Terminal Warehouse, was built in 1926 by Moores & Dunford (NYC) and converted to a condo/mall complex in 1983

10 Westin Harbour Castle Hotel
A large, modern, two-towered thirty-four-story hotel located on 1 Harbour Square built in 1975.

11 33 Harbour Square (11a); 55 & 65 Harbour Square (11b)
Designed by Bregman + Hamann Architects the two towers were completed in 1978 and 1979. They are thirty-three and thirty-eight floors tall respectively.

12 Number One York Quay, North (12a) and South (12b) towers
Clarke Darling Downey Architects built these two towers of forty and thirty-nine floors respectively, completing in 1990.

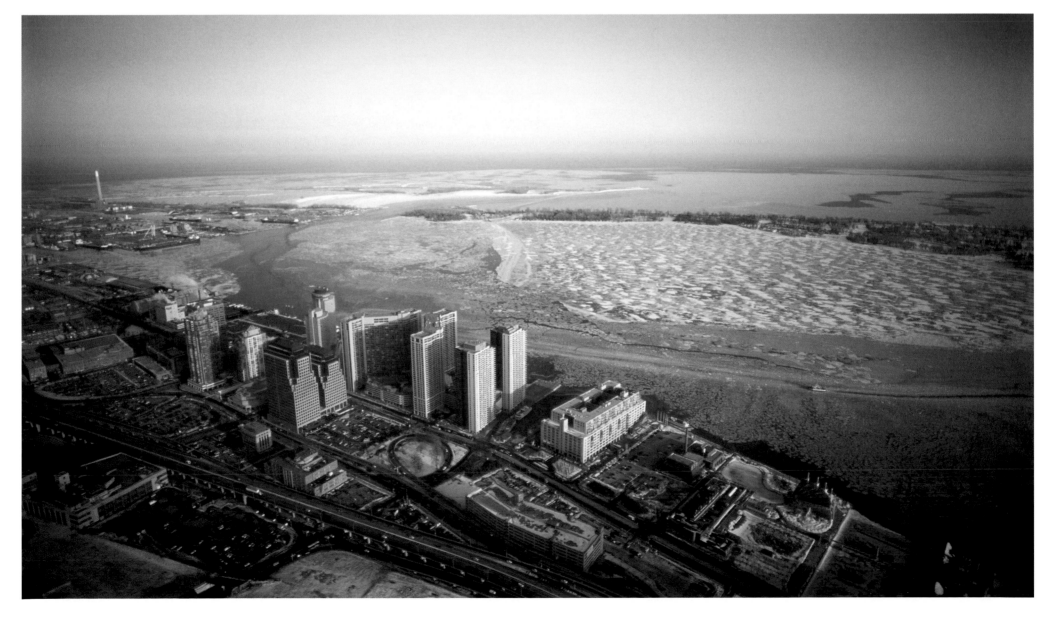

Vancouver

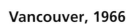

Vancouver, 1966

Vancouver has been described as Canada's gateway to the Orient. In 1966, it was the nation's third largest city with a population of 900,000.

1 Burrard Bridge
This important highway link was designed by architect Lister T. Sharp and engineer John R. Grant and completed in 1932. It consists of five spans including a central Pratt-truss supported by a pair of large concrete Art Deco-styled supports

2 Railway Bridge
This multiple span railway bridge over False Creek has been removed since this image was made in late 1966.

3 Granville Bridge
Carries Granville Street over False Creek to Vancouver's downtown.

4 Granville Island
A conveniently situated peninsula along False Creek south of downtown Vancouver. Traditionally an industrial part of the city, by the 1970s it languished from urban decay and industrial decline; it has since been redeveloped as a shopping and arts center.

Vancouver, 2005 (left)

An aerial view looking northeast over False Creek and Granville Harbour toward downtown Vancouver.

9 Granville Island Public Market
A collection of shops, markets, restaurants, and galleries in a lively marine environment.

10 Hornby Street Ferry Terminal
Aquabus provides a frequent reasonably priced ferry service to small terminals on False Creek.

11 Harbour Centre
Completed in 1977, this twenty-eight-floor, 481-feet building was designed by WZMH Architects. It is capped with a "Space Needle" platform on a pedestal with a revolving restaurant on the top level accessed by two outside glass

5 Downtown Vancouver
Vancouver has a fantastic collection of skyscrapers and highrise buildings that dominate the downtown skyline. While the financial and central districts are known as business centers, the downtown also has residential neighborhoods in Yaletown and Coal Harbour. By 2010 Vancouver boasted more than 600 buildings over twelve floors tall—ranking it thirty-first on the Emporis scale. Number 1, Hong Kong, has 7,681! Toronto was twelfth with 1,794.

6 Stanley Park
Opened in 1888 by the Governor-General of Canada, Lord Stanley of Preston, this extensive urban parkland covering nearly 405 hectares is located on the end of the peninsula occupied by downtown Vancouver.

7 False Creek
An inlet that separates downtown Vancouver from the rest of the city. The eastern portion of the creek was filled in the early decades of the twentieth century for use by Canadian Pacific and Great Northern Railways as freight yards.

8 Lion's Gate Bridge
Not directly visible in this photograph, the Lion's Gate Bridge—officially known as the First Narrows Bridge—was designed by Monsarrat and Pratley and built 1937–1938. The designers were well known for their work on bridges—they were also responsible for the Pont Jacques-Cartier (the South Shore Bridge) between Montreal and Longueuil in Quebec. The length of the bridge including the north viaduct is 5,890 feet.

Winnipeg

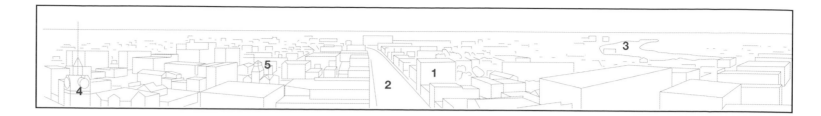

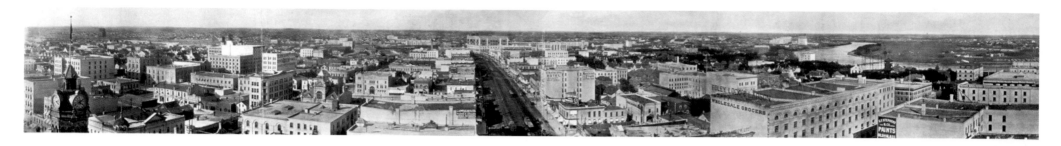

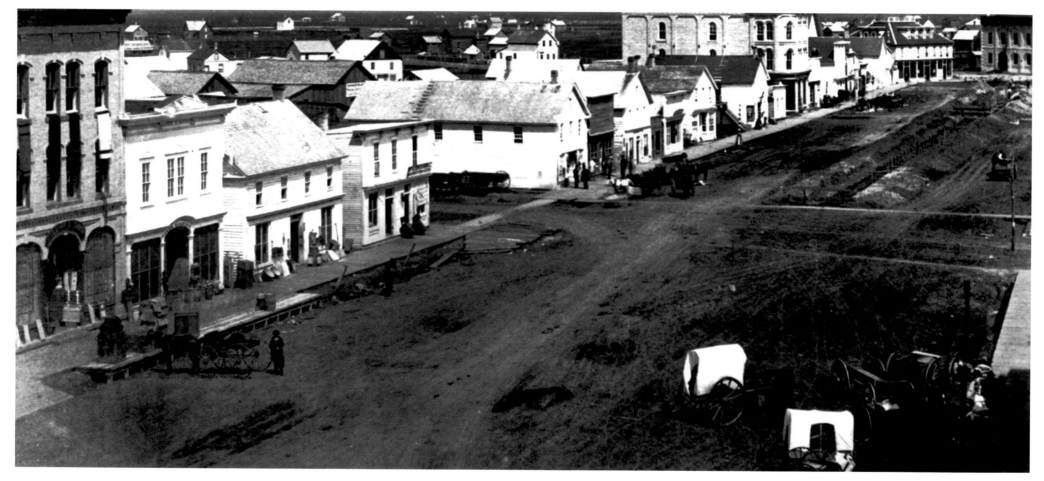

Winnipeg, 1870s (above)
Winnipeg experienced unusually rapid growth in the early 1870s, swelling from a mere 700 people in 1871 to an estimated 5,000 by 1874.

Winnipeg, 1907 (top)

1 Strathcona Hotel
Located at the corner of Main and Rupert.

2 Main Street
The city was early to embrace electric street cars, having tested its first trolley in 1891, and in 1892 tracks were laid down along Main Street. By 1907, Winnipeg's main street was alive with electric street cars. Traditional trolley cars were disposed of in 1955 when the transit routes were converted to buses.

3 Red River

4 Winnipeg City Hall
Designed by local architects Barber and Barber, it was built in 1886 to replace an earlier City Hall. Famous for its imposing clock tower, the building served until 1962 when it was demolished.

5 King Street
Runs north–south one block to the west of Main Street.

Winnipeg, ca. 2005 (right)

Evening skyline at Winnipeg looking from The Forks towards Portage and Main Street.

6 CanWest Global Place
Strategically located at Winnipeg's Toronto Dominion Center at the corner of Portage Avenue and Main Street, this thirty-three-story postmodern office tower is the tallest of the city's skyscrapers. For convenience in winter it is connected to a network of subterranean pedestrian walkways.

7 Richardson Building
At Lombard Place near Portage and Main, designed by skyscraper specialists Skidmore Owings and Merrill, this was the tallest building in Manitoba from 1969 until 1990.

8 Commodity Exchange Tower
Designed by Smith Carter and Le Groupe Arcop, this thirty-one-story tower was completed in 1979 and like the other large downtown office towers is linked by underground pedestrian passages.

9 Fairmont Winnipeg
Nineteen floors of shops and hotel space built as part of Winnipeg's Lombard Place that includes the adjacent Richardson Building.

10 MTS Place Main
Known as the Bank of Montreal Building.

Index

Photo Credits

Alamy: 134 (Paul Wood), 171 (ClassicStock), 175 (Robert Quinlan), 195 (Aerial Archives), 207 (David R. Frazier Photolibrary, Inc), 227, 237 (First Light), 252 (Vosts Images)

Corbis: 2 (Raimund Koch), 4, 10, 10 inset (Stefano Bianchetti), 15 (Roger Ressmeyer), 16T (Robert Sorbo), 16B (Bob E. Daemmrich), 17 (U.S. Navy/Science Faction), 18, 19 (Douglas Peebles), 21 (Kevin Fleming), 22 (Bettmann), 23 (Rainer Kiedrowski/Arcaid), 24L (Bob Krist), 34B (Macduff Everton), 35 (Gerald French), 36 (Bettmann), 37 (Michael T. Sedam), 38 (Bettmann), 39 (Bill Ross), 40 (both), 41 (Brooks Kraft), 42B (Dermot Conlan/PPSOP), 43 (Daniella Nowtiz), 44T (Bettmann), 44B (Underwood & Underwood), 45 (Barry Howe), 47 (Dave G. Houser), 52 (Hulton-Deutsch Collection), 53 (José Fuste Raga), 54 (Bettmann), 55 (Bob Krist), 56 (Bettmann), 57 (Bob Krist), 58 (Bettmann), 59 (Ed Boettcher), 61 (Mark Abraham/epa), 63 (Barry Howe), 64, 65 (Mark Karrass), 67 (Alan Copson/JAI), 68 (Gérard Rancinan/Sygma), 71 (Richard Cummins/Robert Harding World Imagery), 72, 72–73 (Joseph Sohm/Visions of America), 74 (Bettmann), 75 (Molly Riley/Reuters), 76B (Bettmann), 79 (Richard Cummins), 80B (Michael T. Sedam), 81 (Charles E. Rotkin), 82 (Bettmann), 83 (Ethel Davies/Robert Harding World Imagery), 84 (Charles E. Rotkin), 85 (Galen Rowell), 86 (Bettmann), 87 (Bob E. Daemmrich/Sygma), 89 (Mark E. Gibson), 91 (Richard Cummins), 92B (Richard Cummins), 96, 97 (Stuart Westmorland), 99 (Walter Bibikow/JAI), 102 (Bettmann), 103 (Richard Cummins), 105 (Comstock), 106L (Atlantide Phototravel), 106R (Gavin Hellier/Robert Harding World Imagery), 107T (Lindsay Hebberd), 108B (Charles E. Rotkin), 109 (Comstock), 110 (Bettmann), 111 (Ted Soqui), 112, 113 (Bill Varie), 115 (Alan Copson/JAI), 116 (Bettmann), 117 (Richard Cummins), 119 (Farrell Grehan), 122 (Bettmann), 123 (Alan Schein Photography), 124 (Bettmann), 125 (Mike Theiss/Ultimate Chase), 127 (Raimund Koch), 128–129 (Comstock), 131 (Gavin Hellier/Robert Harding World Imagery), 132 (Medford Historical Society Collection), 135 (Michael Ochs Archives), 138 (Bettmann), 139 (David Ball), 140, 142 (The Mariners' Museum), 143 (Michael Yamashita), 144 (Bettmann), 146L (Bettmann), 148 (Bettmann), 149 (David Jay Zimmerman), 150 (Photo Collection Alexander Alland, Sr.), 151 (Rudy Sulgan), 152 (Bettmann), 153 (Alan Schein Photography), 154 (Bettmann), 155 (Michael S. Yamashita), 156 (Bettmann), 159 (Tony Savino), 160L (Bettmann), 160–161 (Jeff Spielman), 162 (Bettmann), 163 (James Leynse), 164 (Bettmann), 165 (Robert Harding World Imagery), 166 (Bettmann), 169 (Comstock), 173 (Bob Krist), 178 (Bettmann), 179 (Bob Krist), 180, 182 (Bettmann), 183 (Comstock Select), 184L (Michael Maslan Historic Photographs), 184–185 (Jim Richardson), 191 (Richard T. Nowitz), 193 (Comstock), 196 (Bettmann), 196–197 (Peter Newcomb/Reuters), 199 (Kelly-Mooney Photography), 200T, 199B (Bettmann), 201 (Hoberman Collection), 202L (E.O. Hoppé), 206 (Michael Maslan Historic Photographs), 208 (Underwood & Underwood), 210–211 (Underwood & Underwood), 211R (Image Source), 212 (Bettmann), 213 (Douglas Peebles), 215 (Raimund Koch), 217 (Comstock), 218B (Terraqua Images), 219 (Robert Landau), 220 (Kevin Fleming), 222 (Natalie Tepper/Arcaid), 223R (Stephanie Maze), 224 (Bettmann), 225 (Joel Rogers), 229L (Underwood & Underwood), 229R (Larry Lee Photography), 230 (Bettmann), 231 (Harold Flecknoe), 232 (Medford Historical Society Collection), 233 (Hisham Ibrahim), 235 (Atlantide Phototravel), 236 (Bettmann), 240 (Hulton-Deutsch Collection), 241 (Tibor Bognár), 242 (Bettmann), 243 (William Manning), 244 (Hulton-Deutsch Collection), 245 (Walter Bibikow), 246 (Bettmann), 247 (Richard T. Nowitz), 248 (Bettmann), 249 (Robert Estall), 250 (Bettmann),

Getty: 20B (Greg Pease), 24–25R (Driendl Group), 25T (Panoramic Images), 26T, 28 (SuperStock), 29 (Richard Cummins), 31 (David Zimmerman), 32, 33 (Jumper), 49 (Panoramic Images), 50 (Science & Society Picture Library), 69 (Jeremy Woodhouse), 70 (Leonard G. Alsford), 93 (National Geographic), 95 (Jupiterimages), 98 (Time Life Pictures), 104 (Bernard Gotfryd), 120–121 (Panoramic Images), 130 (Donovan Reese), 133 (Jerry Driendl), 136 (National Geographic), 137, 145 (Robert Harding World Imagery), 146R, 147 (Dorling Kindersley), 158, 166, 167, 168R (Time Life Pictures), 172, 174, 181 (Morey Milbradt), 186, 187 (Bruce Forster), 189 (Michael Melford), 197, 204, 221 (Jupiterimages), 239 (National Geographic), 251 (Steve Allen), 253 (Ken Gillespie Photography)

LoC: 1, 6, 7, 8, 9 (both), 13, 14, 20T, 26B, 30, 34T, 42T, 46 (both), 48, 60 (both), 62 (both), 66, 76T, 78, 80T, 88 (both), 90 (both), 92T, 94, 100, 108T, 114, 118, 120 (both), 126, 128 (top), 168T, 170T, 170 (L, smaller), 176, 188, 190, 192, 194, 198, 205, 214–15, 216, 218T, 220T, 226 (both), 228, 234, 238, 248T, 252T, 51, 128, 202–3

Topfoto: 11 (The Image Works), 12 (The Grainger Collection), 77

J.D. Frick: 107B
Todd Klassy: 119
Guillén Pérez: 157
Jimmy Rocks: 177
Brian Solomon: 20, 134, 141
John Steedman: 101
Itinerant Wanderer: 27